AHMANSON · MURPHY
FINE ARTS IMPRINT

THE AHMANSON FOUNDATION

has endowed this imprint

to honor the memory of

FRANKLIN D. MURPHY

who for half a century

served arts and letters,

beauty and learning, in

equal measure by shaping

with a brilliant devotion

those institutions upon

which they rely.

THREE ARTISTS
(THREE WOMEN)

THREE ARTISTS

(THREE WOMEN)

*Modernism and the Art
of Hesse, Krasner,
and O'Keeffe*

ANNE MIDDLETON WAGNER

University of California Press
Berkeley Los Angeles London

University of California Press
Berkeley and Los Angeles, California

University of California Press, Ltd.
London, England

© 1996 by
The Regents of the University of California

Library of Congress Cataloging-in-Publication Data
Wagner, Anne Middleton, 1949–
 Three artists (three women) : modernism and
the art of Hesse, Krasner and O'Keeffe / Anne
Middleton Wagner.
 p. cm.
 Includes bibliographical references and index.
 ISBN 0-520-20608-8
 1. Art, American. 2. Art, Modern—20th
century—United States. 3. O'Keeffe, Geor-
gia, 1887–1986. 4. Krasner, Lee, 1908–
1984. 5. Hesse, Eva, 1936–1970. 6.
Women artists—United States—Biography—
History and criticism. I. Title.
N6512.W285 1996
709'.2'273—dc20 96-14058

Printed in Canada
9 8 7 6 5 4 3 2 1

The paper used in this publication meets the mini-
mum requirements of American National Standard
for Information Sciences—Permanence of Paper for
Printed Library Materials, ANSI Z39.48-1984.

For my brothers,
Rob and George

"Braque, c'était ma femme."
Picasso on the moment of Cubist collaboration

I find myself again. I am no shadow
Though there is a shadow starting from my feet. I am a wife.
Sylvia Plath, "Three Women," March 1962

Contents

List of Illustrations

Figures

Acknowledgments

One of the pleasures of making this book has been the opportunity of working in and corresponding with archives, museums, libraries, and galleries in the United States. Used to the Darwinian protocols of some French institutions, I appreciated the cooperative and helpful reception I encountered back home, and am glad to acknowledge it here. I thank in particular the Allen Memorial Art Museum, Oberlin College, especially Christine L. Mack, Registrar; Judy Throm and the Archives of American Art, Smithsonian Institution; the American Art Study Center, M. H. de Young Memorial Museum, San Francisco; Patricia C. Willis, Curator of American Literature, Beinecke Rare Book and Manuscript Library, Yale University; the Robert Miller Gallery, New York, N.Y., particularly Robert Miller, John Cheim, and current and former staff members Kristen Petersen and Diana Bulman; Eugene V. Thaw of the Pollock-Krasner Foundation, New York, and Helen Harrison of the Krasner-Pollock House and Study Center, East Hampton, N.Y.; Sarah Greenough, Curator of Photography, Marla Prather, Curator of Twentieth Century Art, and Sarah Sibbald at the National Gallery of Art, Washington, D.C.; the Zabriskie Gallery, New York, N.Y., particularly Virginia Zabriskie and Tom Gitterman.

I also want to thank Tom Doyle, Mary Beth Edelson, and Peterskin Wolf for assistance and permission to reproduce their work here, and Mel Bochner, Richard Tuttle, and Hans Haacke for conversations about Eva Hesse and the 1960s. Other scholars working on the artists and issues discussed in these pages—particularly Barbara Buhler Lynes, Ellen G. Landau, and Charles C. Eld-

redge—have responded to my ideas and questions with courtesy and interest, for which I am grateful. Barry Rosen was generous in assisting my efforts to track down works by Hesse, and in granting the permission of the Estate of Eva Hesse to reproduce passages from her journals and papers. A number of private collectors have allowed me to reproduce objects in their collections, and often supplied photographs as well.

A second great pleasure involved in writing this book has been doing so in the special climate of the University of California, Berkeley. Svetlana Alpers not only had a hand in the origin of the book, but also gave an early draft of the manuscript a helpful reading. Mary Ryan had useful answers to several questions. The support and interest of Michael Rogin have meant much to me: his responses have seemed models of critical sympathy. And a great number of students have assisted in the book's genesis and production, some unknowingly, others more directly. I am pleased to thank by name Cherie Caswell, Beth Dungan, Linda Graham, Nan Hill, Sabine Kriebel, Richard Meyer, Jeannene Przyblyski, Kate Small, Lucia Tripodes, and Emilie White; and to express more general gratitude to several years of seminars, both graduate and undergraduate. I would also like to acknowledge research support provided by Dean of Humanities Anthony Newcomb and the Committee on Research at Berkeley. My completing this book during my stint as departmental chair owes much to Helen Workman.

Denise Riley has kindly allowed me to reproduce her poem "A note on sex and the 'reclaiming of language,'" from *Marxism for Infants*, as the epigraph to my last chapter; Lyndsey Stonebridge, in sending me a copy of the poem, seemed to anticipate how much it would resonate with the themes of this book.

Several invitations to present versions of my research as lectures and essays have marked opportunities to advance my thinking: my thanks to Michael Fried and the Department of Art History, the Johns Hopkins University; to Hal Foster, Cornell University; and to the other editors of *October*, where an excerpt from chapter four was published; to Marie Aquilino and the Kress Department of Art History, University of Kansas; to Nancy Locke and the Department of Art, Wayne State University; to Whitney Chadwick, San Francisco State University, and Isabelle de Courtivron, Massachusetts Institute of Technology, together editors of *Significant Others*, in which a version of chapter three appeared.

My thanks to James Clark, Director of the University of California Press, for insisting that the Press ought to publish this book, to Nola Burger, for her fine and sympathetic design, and to Stephanie Fay, for her editorial tact and generosity.

As this list concludes it comes closer to home: to friends—particularly Alex Potts, Michael Leja, Jenny Marcus, Greil Marcus, Joseph Matthews, and Sanjyot Mehendale—who have mattered in various ways to the making of this book, though it would take too long to say how. Some of the names listed in the paragraphs above could recur here as well. And finally to family: Rob, Denise, and George Wagner and Tim, Sam, Hannah, and Ruby Clark have mattered most of all.

"Sex Differences"

This is a book about three artists. In particular it concerns the character of their imagery, the paths of their careers, and the ways these were influenced, for good and ill, by one central circumstance: the fact that the artists were women.

My concern with this subject seems in retrospect to have come about slowly, and to have passed through several stages. The event most like a catalyst was a heated conversation with Svetlana Alpers about the "quality" of women's art: we were debating an annoying old question, the one that asks why there are— or at least are ordinarily said to be—no "great women artists."[1] The result was an invitation to join a panel, "Engendering Art," which Alpers put together to address the annual meeting of the College Art Association in 1988. Its four papers were subsequently published: the ideas and research that went into my own effort, "Lee Krasner as L.K.," survive more or less unchanged at the core of the third chapter of this book.[2] Studying Krasner's art, its relation to the painting of other artists, including that of her husband, Jackson Pollock, and the relative impact of artistic style and social circumstance (being a "woman," being a "wife") on the terms of her reputation, made clear the broader relevance of such questions. To recognize that they are exemplified at other moments of the American twentieth-century past in the art and careers of other women is to begin to frame that past as a particular history of likenesses and differences where certain recurrent issues are concerned. Those issues involve the social and professional experience of women who make art, as well as the forms their art takes; they require both public and private negotiation of the roles of woman

and wife, as well as that of artist; they shape the various means used to claim authorship or voice or identity in a work of art, as well as the value placed on that art in the public realm. I think it is right to see these as peculiarly modern questions, part of the ongoing quandary as to how the roles of American women can or should be diversified, perhaps even remade, in response to new economic and social demands.

The book's title, *Three Artists (Three Women)*, is meant not just to name its main concern but also to mime it graphically: being a woman, for these artists, has been *the* condition of artistic identity, bracketing and modifying it in ways that were and continue to be inescapable—so much so that the brackets could change places and still have much to say. My title offers an emblem for the coupling of social and professional identity in twentieth-century American usage if and when the artist was a woman. To identify an artist in this way, as a woman, has never been a merely parenthetical remark. The qualification has customarily been offered as a limit to, rather than a guarantee of, suitability for the artist's role—with mostly irritating results for the artists themselves. Take for example Elaine de Kooning, speaking of "that term, 'women artists,'" in 1971: "I was talking to Joan Mitchell at a party ten years ago when a man came up to us and said, 'What do you women artists think. . . .' Joan grabbed my arm and said, 'Elaine, let's get the hell out of here.'" [3]

Although I recognize that the weight of institutional usage goes against me, I do not consider that the status of womanhood alone necessarily provides enough reason to group artists as objects of study. The linkage of the three considered here—Georgia O'Keeffe, Lee Krasner, and Eva Hesse—is motivated by a variety of social and artistic factors: these crop up in each instance to form patterns notable for their similarities, despite the generational and stylistic differences among the artists themselves. Each, for example, had an art school education; each was married to another artist; each was childless. Each, while she lived, gained no small measure of success and reputation—was culturally *useful*, albeit in different ways. Still valued after death, each continues as the object of critical and media attention. Each produced an art profoundly concerned, not just with abstraction, but also with the close relation between abstraction and figuration; each was acutely aware of her status as a female practitioner of her art; each was a modernist by ambition and choice.

I imagine that readers of these pages will have no trouble translating at least some of these generalities into particulars: most will recognize an O'Keeffe

when they see one, know that she was married to the photographer Alfred Stieglitz, and remember Krasner's role as Pollock's wife. If the details of Hesse's life and career—her education at Yale, her failed marriage to the sculptor Tom Doyle, her contributions to Minimalism, her death in 1970, aged thirty-four—have not become so much a part of the general cultural capital, her artistic achievement is, I believe, the greatest of the three, and her reputation, thanks to recent retrospectives, is currently ascendant.

It is important for my purposes that my examples be familiar—important enough to risk the complaint that they are overly so. Their quasi-canonical status necessarily means that other scholars have preceded me: I have been able to profit from their labors, rather than myself spend time piecing together the broad outlines of biographical circumstance and critical reception, as might well have been necessary had I chosen other cases. But their familiarity has other consequences: it means that these examples can never be seen as neutral. Their cultural utility precludes that view. They have become—in some sense always were—part of what we might call the Kahlo effect, in honor of its chief representative: like Frida Kahlo, Hesse, Krasner, and O'Keeffe have been treated as properties in the ongoing merchandising and mythologizing of artistic identity. The late-century rediscovery of the artist as possibly female has only re-energized the project of giving her a public face, making her up and over for contemporary use. These are transformations that have much to do with style, though not mainly in the artistic sense. Leafing past O'Keeffe look-alikes modeling New West ensembles in *Vogue* or *Elle*, or reading of the two "major motion pictures" being planned on the subject of Pollock and Krasner, makes it clear that style mostly means lifestyle these days. The standard narrative is packaged as "a woman's passionate struggle for independence," complete with necessary successes and inevitable failures. Win or lose, it's a myth. You can do it too: just make sure you have the right clothes.

This study is linked to these same appetites and interests in ways that are not simply a matter of presumed overlap in market and audience. Its format and concerns maintain, for a start, the same preoccupation with discrete individuals—their personal circumstances, careers, reputations, and artistic practices—that motivates the other forms and media in which these lives are being distributed. In fact the first version of the Krasner essay has been taken to task as "overly personalized," so myopic in its focus as to sacrifice scrutiny of the forest of "women's experience" to inspection of too few trees.[4] Despite such

criticism, I have not widened the field of my inquiry. More is to be gained from detailed examination of a few exemplary cases than from a broad-brush account if, as in the present instance, the purpose is to explore the hypothesis that gender is an actively determinant factor in the production and reception of art.

Although this is not a specially controversial thesis, it is one that nonetheless takes proving. In what follows I give some historical weight and interpretative substance to the main terms of the proposition. I hope in so doing to contribute to a feminist history of art that is still in the making. This notion of an unfinished history may seem more novel than my central thesis, since by now feminism appears so well established, maybe even old hat. That panels like "Engendering Art" are regularly included at professional meetings bears witness to the institutionalization of feminist art history in America. The discourse is said to be expanding, and indeed this seems to be the case, despite (or because of) the fraught roles of sexuality and women and feminism in American public culture, despite the 1980s antifeminist backlash, despite the susceptibility of academic study to intellectual fashion (feminism cedes to gay studies to multiculturalism to . . .). Yet such institutionalization is not necessarily hegemonic; the culture is diffuse enough that academic panels and women's studies courses do not inevitably mean either widespread acceptance or structural change. Note that the exhibition review in this morning's *New York Times* examines a show, "Sense and Sensibility: Women Artists and Minimalism in the 90's," mind-bogglingly billed as "the first exhibition that the Museum of Modern Art, New York, has devoted exclusively to art by women."[5] Can it *really* be the first? Another Austen title, *Pride and Prejudice*, comes to mind unbidden.

Nor have either feminism or feminist art history necessarily cut much ice with artists who are women—including the artists in this study. They did not automatically sanction the various feminisms they encountered, nor did they respond consistently to feminist issues at every moment in their careers.[6] Like many other people, they hesitated over how to understand an artist's status as a woman (and vice versa) and worried about the relationship of feminism to art and aesthetics. Such disquiet is by no means exceptional, least of all among artists who are women, even artists practicing today. Let me give one example—an example whose authenticity I can guarantee. In 1992 I wrote an essay on the work of the Cologne artist Rosemarie Trockel.[7] Its title, "The Feminism of Trockel's Objects," seemed not only unobjectionable but also ap-

4

propriate to an effort to define her work. Wrong. When the essay came out, it had been rechristened "How Feminist Are Rosemarie Trockel's Objects?"—the new title evidently considered an improvement precisely because it placed in jeopardy the claim for the feminism of Trockel's art. Keeping the jury out on the feminism question can be considered an asset for any number of reasons, from the ideological to the economic.

One justification for such hesitancy might be rooted in the conflict that some-times arises for an artist between her grasp on herself, not just as a feminist, but also as a woman—her sense of identification with some contemporary pattern of generalizations concerning the social status and being of women—and her sense of herself as an artist. There is no reason to assume—and every reason *not* to assume—that those self-understandings are identical, or even that they nec-essarily overlap in important ways. Hence, of course, one reason for the notable reluctance of many artists to align their work with notions of woman's art or feminist art. To give a first example among the many I might cite: in 1987 the painter Elizabeth Murray spoke to an interviewer about the disconnectedness of her feminist and artistic selves; that disconnection in turn uncouples the fe-male from her art: "I'm a feminist," she said, "but I don't think I'm making feminist work; in art the sex differences fall away."[8] Alice Neel put the same point a different way. Looking at one of her pictures— a portrait of a woman— in the company of an interviewer, she said: "Look at her, she's women's lib already, though that's 1930. . . . You see, you have these beliefs all your life. I never fought the fight out on the street, but when I was in my studio I didn't give a damn what sex I was. Nor did I feel I couldn't learn from any male artist either. I thought art is art."[9]

For Trockel, the lack of relatedness between her various identifications emerges less as a willed, willful declaration than as the effect of the contradic-tions that are so much a part of her art and speech. Nowhere are these contra-dictions more evident than in an interview she gave to the critic Jutta Koether back in 1987. Let me extract two separate exchanges from the whole:

JK: What is the relation between you and the models of modern art as far as the ques-tion of artistic conduct is concerned. I refer, for instance, to Duchamp's *Negation of Art as Life-Work* or, at the opposite pole to Joseph Beuys's *Enlargement of the Conception of Art in Social Sculpture.*

RT: Unfortunately, there are too many cases that have shown that the historical models were only used and consumed to bolster the theories of younger artists. For me and in my position as a woman it is more difficult, as women, have historically, always been left out. And that's why I'm interested not only in the history of the victor, but also in that of the weaker party.

JK: With this "offensive," with the so-called women's art, do you want finally to get over this painful difficulty [women's status as sexual objects]? Does part of your work deal with this analysis of women and women's art?

RT: What is most painful, what is most tragic, about the matter is that women have intensified this alleged inferiority of the "typically female." The stumbling-block lies, therefore, in consciousness itself. Art about women's art is just as tedious as the art of men about men's art. Sniping at madonnas is as questionable as the eternal citing of the *Black Square* by Malevich.[10]

What interests me about these statements is the shifts they evidence in Trockel's identification with notions of "woman" or "women." She recognizes her "position as a woman" as necessarily operative in any alignment she might forge with the "history of the victor"—with, that is to say, the various male-defined precedents and practices offered up as exemplary by twentieth-century modernism. Yet her position as a woman does not have fixed, predictable consequences; it does not mean that she will automatically be sympathetic to other women's positions toward the female, or choose her own targets on the basis of their advice. Above all it does not mean that she will choose to have her work defined as feminist; that verdict is to be held in abeyance, kept suspended by a tacit denial that is first cousin to Murray's more explicit declaration.

This book proceeds from the assumption that these various expressions of disjunction and recognition, these moments in which the self apprehends and claims its difference from and similitude with other selves, should be thought of as profoundly typical: I will argue that they define, in a special and salient way, not only the self-understanding but also the professional experiences and aesthetic practices of most women who have worked as artists in twentieth-century America. I believe, moreover, that though the male artist may well apprehend himself in such disjunctive terms, the pattern is more likely to occur when the artist is female. There are many reasons this might be so. Even a partial list covers real historical and disciplinary ground: there is, for example,

the long-standing tendency to view the female personality itself as specially labile, defined by multiplicity. It was the female, or so it was claimed early in this century, who fell prey most often to multiple personality disorders; beneath the surface of a proper young woman might well lie a whole gamut of other personae, whose separate and distinct characteristics and selves nonetheless added up to an array of feminine personality "types," from immodest hoyden to self-possessed tomboy.[11] These were once the beliefs (and the research topics) of therapists and would-be therapists; Eve had at least three faces, as movie-goers were soon to learn. But personality aside, the *social* identity of the woman has been equally subject to elaboration by recourse to roles or types. Wife, mother, virgin, harlot, servant, teacher, healer: what is striking about this list of roles is not that a woman might be thought of—or might think of herself— as playing any one of them, but that she could be understood, if not simultaneously to occupy them all, then at least to put them on and take them off with the practiced frequency of a trouper in the Christmas pantomime. And no strain or contradiction is meant to be visible between the roles. Such an image is not just the product of the 1980s updating of the discourse on women, with its emphasis on "having it all" by being it all (this is not precisely the same thing as Phyllis Schlafly's concept of the "Total Woman"). Remember the conceptual parallels provided by the Victorian model of respectable womanhood, above all by its most cherished notion of the "woman's sphere": within that sphere, a range of distinct tasks kept the woman moving from schoolroom to sitting room to scullery, changing roles in each new setting, just so long as the new function remained part of her strictly delimited domestic world.[12] And even when that world could be left behind and a professional identity established, the general principle remained the same. She may have been called the "New Woman," but like—perhaps even more than—the "Old," she played roles. To cite the psychoanalyst Joan Riviere, modern women—by which she meant professionally successful females of the late 1920s—exemplify "complete feminine development. They are excellent wives and mothers, capable housewives; they maintain social life and assist culture; they have no lack of feminine interests, e.g. in their personal appearance, and when called upon they can still find the time to play the part of devoted and disinterested mother-substitutes among a wide circle of relatives and friends. At the same time they fulfill the duties of their

profession at least as well as the average man. It is really a puzzle," concludes Riviere, "to know how to classify this type psychologically."[13]

It may seem that I am having recourse to expert testimony simply to back up what every woman—and many men—already know: how often, how insistently, and from how many quarters they have been urged to believe that women do and should change roles and colors like chameleons, inhabiting each new guise with equal comfort, with all those transformations encouraged—no, policed—by the media and commodified by their relentless association with any number of product lines. Is there any wonder, given the impossible demands of this most persistent element in the makeup of the modern female, that we can read this protesting entry in one of Eva Hesse's notebooks (the date is January 4, 1964): "I cannot be so many things. I cannot be something for everyone. . . . Woman, beautiful, artist, wife, housekeeper, cook, saleslady all these things. I cannot even be myself, nor know what I am. I must find something clear, stable and peaceful within myself within which I can feel and find some comfort and satisfaction."[14] Is there any wonder that Lucy R. Lippard, in first citing the entry, called it the "classic female complaint"? Would we be wrong to conclude that Hesse's litany, rather than the more usual version of the "female complaint," achieves the status of a "classic" exactly because it is less biological, more evidently the product of a culture at a particular phase of its development? Both the proliferation of female roles and the way in which they all compete for a single individual's identity, slicing up the self into inconsistent, even conflicting parts, give evidence of the continuing unease, in the twentieth century, with the notion of a female person who is the equivalent of the male.

The female person is known empirically to exist, of course, but she does not yet exist fully in the eyes of the law. Does anyone need a rehearsal of the major facts in the case? The battle for the Equal Rights Amendment began early in the 1920s, on the heels of the ratification in 1920 of the Nineteenth Amendment to the Constitution, which finally secured female suffrage. Although Congress approved the Equal Rights Amendment in 1972, its simple provision ("Equality of rights under the law shall not be denied or abridged in the United States or by any State on account of sex") failed by a slim margin to win the necessary support of thirty-eight states. Since the states' ballots had to be taken within a decade of congressional approval, it was declared moribund in 1982. The principle of equal rights was forced to cede to the notion of equal protec-

tion: the two standards are not the same.[15] This languorous route toward an elusive equality is the proper background against which Hesse's "classic" lament ought to be placed: the state's persistent quandary as to how to see the female throws into relief—makes culturally symptomatic—any individual confusions concerning identity and serves as their ultimate explanation. If the state does not provide conditions in which the equivalent personhood of its various members is legally enregistered, it can be held responsible for the constellation and character of the identities engendered in their absence.

Yet of course Hesse, as a female person, knows herself to exist, if unequally (even the state has been forced to admit as much). Her very activity in writing offers her its own version of the time-honored assurance of that existence—the *scribo*, we might call it, inventing for the occasion this offshoot and subset of the *cogito*. Note, however, that in this particular instance the assertion of being couches its existence in the negative, or the imperative: "I cannot," "I must." The self here registers its being in disconnection; it proclaims its alienation even from itself: "I cannot even be myself, nor know what I am." And its proclamation echoes, in ways that should strike us as significant, the self-diagnoses of other artists: for example, that of Georgia O'Keeffe. Although her down-home diction may seem artless, this is the effect of style, not substance: "I grew up pretty much as everybody else grows up and one day seven years ago found myself saying to myself—I can't live where I want to—I can't go where I want to—I can't do what I want to—I can't even say what I want to—. School and things that painters have taught me even keep me from painting as I want to."[16] Unlike Hesse, O'Keeffe writes after the moment of revelation and thus couches her alienation in the past, as a problem now marginally solved, at least where painting is concerned. (The passage continues: "I decided I was a very stupid fool not to at least paint as I wanted to and say what I wanted to when I painted as that seemed to be the only thing I could do that didn't concern anybody but myself—that was nobody's business but my own.") And again unlike Hesse, she seems to realize that her predicament is profoundly social—it follows in the wake of growing up like "everybody else." Yet like Hesse's, her words both relive and reproduce a rhetoric of separation as the very stuff of selfhood; she writes alienation, rather than erasure, into her very core. The effect is of self-constitution in alienation; in its utterances, the self ultimately insists on asserting itself, no matter how thoroughly it is elsewhere dispersed and undercut.

This is a book about the efforts of three American women—O'Keeffe, Hesse, and Krasner—to negotiate the specialized identity of the artist in circumstances that made even their general cultural identities as women difficult to inhabit comfortably in any thoughtful, let alone stable or self-affirming, way. I want to show how assumptions concerning female identity—including the assumptions of the artists themselves—have inevitably shaped, to their benefit and detriment, the course of their careers and the character of their art. My choice of these three examples in particular demonstrates my intention to claim for my case histories paradigmatic or exemplary status. They cannot be taken as entirely representative—the sheer measure of success, however uneven, achieved by all three women would be enough to undermine that possibility for good and all—yet if they are exceptional in their individual successes, they are typical in a whole range of other aspects. Their lives and art seem to me to outline a social history of the twentieth-century female artist (when she is white, that is), without burdening it with the dull weight of apparently random generalizations. These are women whose working lives span this century—from 1905, say, when O'Keeffe enrolled in the School of the Art Institute of Chicago, to her death in 1986, two years after Krasner's demise at the age of seventy-six. Hesse's brief existence, from 1936 until a brain tumor took her life in 1970, is all too easily encompassed by her elders' longevity. These various rhythms of vitality and mortality map out the basic possibilities; so in many ways do their personal histories as Americans and immigrants. The Midwestern-born O'Keeffe came from stock with the deepest roots in the New World; hers was the third generation born in Wisconsin. Krasner was raised in Brooklyn in a family of Russian Jews, the fourth of five children and the first born in the United States. Hesse's Jewish parents escaped from Hamburg and settled in New York in 1939 with their two girls.

These snippets of proto-demographic information may seem trifling, but they have real implications for an understanding of the individuals in question, and for the suggestion that their careers might be taken as somehow typical. They mean that though each was a member of a different generation, all three were positioned to receive an education in art—to obtain the necessary "cultural capital" to play an artist's role. A career somewhere in that field was not ordained as unattainable from the outset; institutions established and in place— formally constituted schools like Chicago's School of the Art Institute or New

York's Cooper Union or the Yale School of Art, or more idiosyncratic private studios on the lines of those run by William Merritt Chase and Hans Hofmann—ensured that this need not be the case. All these schools accepted women; in the training they provided, they fulfilled a social function, though not necessarily the one for which they were explicitly (or even implicitly) intended. Thus it was not necessarily to be predicted that Hesse or Krasner or O'Keeffe would ultimately put her schooling to use as a fine or "high" artist, rather than as a teacher or illustrator or designer. There are always discrepancies between the sheer availability of an education, let alone its rhetorical content, and the actual possibilities its teaching envisions or promotes. Or to put the matter in slightly different terms: for a woman to be educated as an artist is not the same thing as her becoming one. It is not simply a matter of following the rules. Bricolage and luck are helpful (when are they not?), but there is a certain amount of grafting, transfusion, and hybridization involved, because where women are concerned, the implicit and explicit goals of a fine arts education have sometimes been at odds.[17] That Hesse, Krasner, and O'Keeffe all followed such a route is thus to be attributed not only to the availability of artistic education but also to the special uses they made of it. Nor can other factors be discounted, including what we might think of as the newly invented cultural "utility" of artists who were women. About that utility there is more to come.

No less significant was another demographic constant linking the three, one that returns us from the realm of modern institutional structures to older, more familial usages that traditionally decided careers for both men and women. All were married to men who were artists: O'Keeffe to Alfred Stieglitz, Krasner to Jackson Pollock, Hesse to Tom Doyle. In each case the pattern of the marriage was different: O'Keeffe's, for example, is recognizable as taking much from the model of companionate marriage urged by feminists in the 1920s. Hesse's ended in separation and estrangement. Krasner's, I think, lay somewhere in between. Yet some brand of marriage—as long as it was marriage to an artist—emerges as a circumstance central to artistic success for women. It is central too because of the problems of identity it brings in its wake. Think of Sylvia Plath, in her poem "Three Women," trying in vain to separate the substance of the female self from the shadow of being a wife. Recall the utter economy of Picasso's description of Braque's contribution to Cubism: "C'était ma femme." Need he say more? And remember that elsewhere in her diary, in an entry of 1963, the

year before the entry I have quoted, Hesse wrote, "I guess I am doing well but I am not happy in how I feel. . . . There is a tenseness and anxiousness that never leave me. . . . I am constantly dissatisfied with myself and testing myself. I have so much anger and resentment within me. Why still now? . . . It is as difficult as it is said to be to be an artist's wife and an artist also." [18] These sentences stand as another of Hesse's comments about the conflictual status of women's roles, but here the conflict is stripped down to a face-off between opposites: "It is as difficult as it is said to be to be an artist's wife and an artist also." We would not be listening very carefully if we failed to hear both the substance and the tone of Hesse's self-diagnosis—tension, anxiety, dissatisfaction, anger, resentment—all symptoms provoked by her particular social circumstance. And she writes in the voice of the exhausted initiate into a formidable ancestor cult. We sense that she had not always believed what she was told about the penalties of membership in that group; by 1964 she was forced to admit the truth.

As did other artists: here is May Stevens's version of the wife's catechism, offered in reply to an interviewer's question:

ss: Have you personally felt that you were discriminated against because you are a woman artist?

ms: I know I have been. Being married to a man who is an artist makes it clear.

I was considered the artist's-wife-who-also-paints for a long time. Even though my education, commitment, amount of time devoted to work, etc., were always equal if not superior (in certain respects) to my husband's. When there were similarities in our work it was always assumed that I was influenced by him, never the reverse. [19]

I suspect that if someone were to encounter this passage without its attribution to Stevens, it would be a thankless task to narrow down, much less identify, the probable speaker, so much does it articulate a shared predicament. Yet in citing these various testimonies—whether Stevens's or O'Keeffe's, Murray's or Trockel's—my purpose is not to suggest that they are all somehow seamlessly equivalent, mere reeditions of each other. Grasping relationships does not necessarily entail obscuring differences. That is one reason I have chosen to present a set of case studies rather than a more general examination of "women in twentieth-century art" or "women in modernism." My intention is to grant these various speeches some real determinative weight in an account of their

authors' artistic identity. They are valuable, however, not as truth but as testimony, as manifestations of the artist's voice. Such speeches are always solicited; they have an audience; they have work to do in the world and are shaped by its demands. Some are the product of the twentieth-century enthusiasm for the artist's interview and the artist's statement. Others—I am thinking particularly of Hesse's journal entries—are shaped by the twin protocols of self-scrutiny supplied by the journal format and by psychoanalysis: Hesse was in therapy from 1956 until her death, and the experience was essential to her habits of mind and speech.

I do not intend, in other words, simply to let these artists "speak for themselves" or to let their testimony, however valuable, go unexamined. And if it comes to a conflict between their art and their words, I shall take the former to count as much as the latter, if not more. Or to put it another way: I am committed to the view that we ought to consider the artist's painting or sculpture as the material site of her voice—indeed, as her voice itself. Thus I will be concerned particularly in what follows to account for the ways in which art instances the special priorities and predicaments of female artistic identity.

What are the consequences of that intention? While I am prepared to grant from the outset that female makers work "as women"—for I take the point that there is no satisfactory answer to the question, "How else would they work?"— I see that difference as being most helpfully understood, in the first instance, as one of *position* rather than of consciousness. (Speaking of a female position, of course, necessarily invokes the parallel notion for the male. And both "positions" are inevitably modified by circumstances of class and race.) If we take twentieth-century discourses on "Woman," "the feminine," even the "female," as naming not only a position—one particularly unfixed yet closely regulated— but also thoughts and perceptions to which women themselves fall heir despite themselves, there are necessary consequences for a notion of working "as a woman." Making art from such a position is inevitably rhetorical; it must often be strategic, must often employ assertion, denial, tactical evasion, subterfuge, deception, refusal. To the reader already initiated into even a handful of writings about the twentieth-century avant-garde, these strategies may sound like a familiar enough catalogue. They are among the devices of modernism—or better, the modernisms—in which these artists eventually made a place for themselves. Nor, in keeping with their modernist derivation, are they put to merely

formal ends. (Modernism is not formalism, in other words.) In what follows, I take the various modernisms of Hesse, Krasner, and O'Keeffe to be profoundly symptomatic of their social and historical position as women, and aim for a reading of their work that will show this to be the case. Thus I see their modernism as inevitably registering not only the strength and complexity but also the weaknesses of their work. It might be more comforting to claim their art as "subversive"—this seems to be the highest accolade these days—but the term will not do here as a verdict. It lacks subtlety, leaving out too much history and offering too mechanical, too reductive, a notion of artistic achievement. To say *subversive*, in other words, is to offer a diversion from more careful consideration of an art fiercely determined to be *seen* to make a difference. This is a project to be distinguished from subversion.

In this view I depart from one line of recent feminist thinking on the issue of modernism—from which, incidentally, I have also learned much. It has become customary, where some recent art-historical feminism is concerned, to take modernism as an enemy, perhaps *the* enemy. Much of the lucidity of Mary Kelly's early definition of the term in "Re-viewing Modernist Criticism" (perhaps still the best essay on the subject of feminism's relation to modernism) has accordingly been lost. "In this article," wrote Kelly in 1981, "modernism is defined as a determinant discursive field with reference to critical writing since 1945. It is maintained that modernist discourse is produced at the level of the statement, by the specific practices of art criticism, by the art activities implicated in the critic/author's formulations, and by the institutions which disseminate and disperse the formulations as events."[20] By dint of her reading of Foucault, Kelly is able to understand modernism as a discipline, an abstraction. To cite her still further: "The effectivity of that discourse [modernism] can be described as the production of a norm for pictorial representation which does not necessarily correspond to definite pictures, but rather to a set of general assumptions concerning 'Modern Art.'"[21] Yet in 1987, when Griselda Pollock turned her attention to the same subject, the argument seems to me to take a rather different political direction. Modernism, we learn, is the "dominant ideology," and its "paradigm of the artist is inevitably masculine." So far, so good? But what of the following form of words: "Modernism is structured around sexual politics but these are displaced by the manifest content of modernist discourse, the celebration of creative masculine individualism."[22] Even if we grant that the final phrase offers an adequate view of the content of modernist discourse, why

should we then conclude that the celebration of creative masculine individualism "displaces" sexual politics, rather than instances them? Why should displacement be involved at all, as opposed to blatant demonstration? And what of the historical ground covered in the following paragraph? It seems to plot its route with the coordinates on modernism's map.

> Modernism can therefore be grasped in several dimensions. It refers to the paradigm for the practice of art initially produced in Europe in the 1860–90's. By the beginning of the twentieth century these marginal activities had become an effective component of a still highly diversified cultural formation. By the 1930's and 1940's, however, these practices were made official, institutionalized in the Museum of Modern Art, New York, and the other museums of modern art which were shaped in its mould, thus having an extensive influence on art history and art education. Modernism was positioned as the living culture of the capitalist West and its position of authority was secured with the economic, political and ideological domination by the metropolitan countries (particularly the United States) and their ruling classes over a world market.[23]

Feminists should, I think, be wary of placing too much confidence in what modernist criticism says about itself. And Pollock, like Kelly, has elsewhere done much to urge that view. But in the passage in question, more skepticism might have been in order, particularly concerning the pronouncements of modernism's most defensive, least nuanced phase—the moment of the late 1960s when, to cite Pollock once again, it "constituted the dominant paradigm of art, art criticism and art history." Yet revisionisms that take modernist domination as an article of faith may find themselves impoverished, for all their grand scope, when it comes to addressing visual phenomena—particular artistic practices, Kelly's "definite pictures"—in their historical and material dimensions. If there is or was, as Kelly argues, no univocal modernism, except as produced in and by critical discourse, and if that discourse can only be understood as wreaking a kind of interpretative havoc to meet its main analytic and descriptive purposes—omitting any troublesome phenomena that might get in the way—then singular claims as to the importance and content of particular images are inevitably reopened for scrutiny. (Logical consistency would require the same response to claims concerning their possible celebration of "creative masculine individualism.")

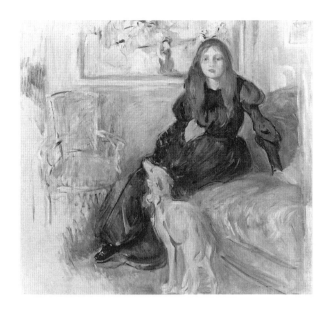

FIGURE 1. *Berthe Morisot, Girl with a Greyhound (Julie Manet), 1893, oil on canvas, 28¼ × 31½ in. (73 × 80 cm.). Musée Marmottan, Paris.*

Modernist practice likewise becomes a phenomenon always potentially in excess of the descriptions provided of it. The plural that results—the modernisms of which we can now speak—emerges as a boon, particularly for feminist art history. The benefit it offers is not akin to happy pluralism—simply letting the requisite hundred flowers bloom. Another, older, phrase says it better: "In my Father's house are many mansions." In some of them, I think, female modernists found a home. Their practice was within patriarchy, yes; they may have sometimes been camping or squatting or doing dishes for their keep, but there were sites within that structure that provided more critical space for redefinition and reinflection, to say nothing of exploration and invention. It should be possible to think seriously about their work with modernism as something other than failure or false consciousness, and in so doing to put paid to an exaggerated lingering hostility. Modernism is better understood and analyzed. The point is an important one. The antipathy of feminist theory toward the reified modernism of its own invention has helped to obscure just those protocols that have made modernism a serviceable, downright expressive choice for female artists.

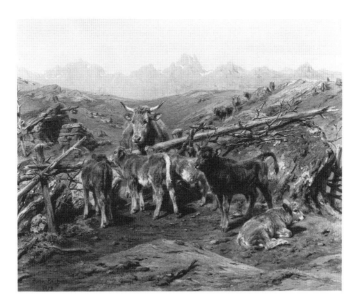

FIGURE 2. *Rosa Bonheur, Weaning the Calves, 1879, oil on canvas, 25⅝ × 32 in. (65.1 × 81.3 cm.). The Metropolitan Museum of Art, New York, Bequest of Catherine Lorillard Wolfe, 1887. Catherine Lorillard Wolfe Collection (87.15.109).*

Consider the alternative, if public reputation as a painter or sculptor was one's ambition. The path of "tradition"—whether painterly or female—more or less automatically foreclosed the kind of fame a woman could achieve. Painting still lifes would only get one so far after 1860, that is, if the still life was very "like." To make a nude à la Bouguereau seems to have been more or less out of the question for a female, though to make one while revising Degas/Matisse was one of Suzanne Valadon's prime contributions. Yet becoming a modernist was not merely a matter of visibility—a "career move"—though it certainly was that. Modernism was customarily, significantly a *political* position for its practitioners, one often linked to class, religion, education, income, domestic arrangements, and sexual choice. Still more important (as if these factors were not important enough), it inflects the political uses and import of art in ways that are separable from artistic identity. I am thinking of the differences in effects and meanings in pictures—in a domestic interior by Berthe Morisot, say, and an animal scene by Rosa Bonheur. Take Morisot's *Girl with a Greyhound* (*Julie Manet*) and Bonheur's *Weaning the Calves* (figs. 1, 2): they both might be lovingly

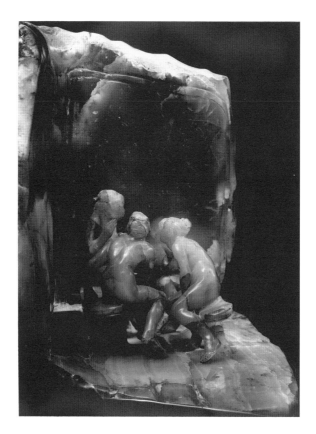

FIGURE 3. *Camille Claudel,* Les Causeuses, *1897, onyx and bronze, 17½ × 16½ × 15³⁄₁₆ in. (44.9 × 42.2 × 39 cm.). Musée Rodin, Paris. S.P.A.D.E.M.*

painted, but their meaning and cultural value rest (and I think will continue to rest) on a use of modernism, or its lack. This does not mean that modernism was hegemonic in the later nineteenth century, or is so now, for that matter, but rather that it was a main site for the invention and rethinking of social and pictorial meanings—rethinking to which women (some women) had access, and to which they contributed, as Morisot did in attributing such immediate consciousness and subjecthood to an adolescent girl. Or, to cite another example, there are the differences between an innovative work by Camille Claudel—her 1897 *Les Causeuses* has always been one of my favorites—and her bust *Count Christian de Maigret in the Costume of Henri II,* carved in marble in 1899 (figs. 3,

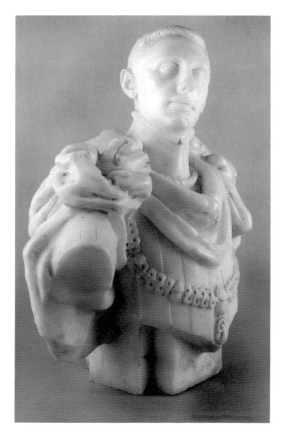

FIGURE 4. *Camille Claudel,* Count Christian de Maigret in the Costume of Henri II, *1899, marble, 25¾ × 25⅜ × 16¾ in. (66 × 65 × 43 cm.). Private collection. S.P.A.D.E.M.*

4). One looks like a calculated offering to aristocratic self-affirmation, and it is not *Les Causeuses.* About the meaning of those small chattering figures it is possible to be in several minds—is this a stereotypical or celebratory view of female interaction, or both, you might well ask—but it is the formal revisionism of the piece that sparks such productive indecision. Or there is the contrast between the means and effects of a piece by Lynda Benglis—one of the 1975 *Eat Meat* sculptures (an example chosen almost but not entirely at random)— and the mealtime scenario masterminded by Judy Chicago, *The Dinner Party* (1974–79; figs. 5, 6). Again the recalcitrant interpretative possibilities provoked by Benglis's more modernist work, which unlike Chicago's leaves to the

FIGURE 5. *Lynda Benglis, Eat Meat, 1975, cast bronze, 24 × 80 × 54 in. (61 × 203.2 × 137.2 cm.). Private collection, Chicago, courtesy Paula Cooper Gallery, New York (Photograph: Geoffrey Clements).*

imagination who may eat what, seem to offer the most by way of political potential: Chicago's closure on the various possibilities is absolute and brooks no contradiction.

I want to suggest that modernism was what many of the most ambitious artists (male and female) of the last hundred years or so found they had to work with. I hear them saying—or at least practicing—some version of the following: "Modernism is our resource. We may have problems with it, and it may have problems with us. We may in some sense be, and feel ourselves to be, on its margins, but it's still a resource. We cannot do without it." Such a statement, however wishful, however fraught, would, when translated into artistic terms, always involve the kind of dialogue or counterpoint with a fictional norm that Kelly so effectively describes.[24] What have women had to make art about, in the twentieth century? Most efforts at protest or utopianism, most attempts to imagine a world outside the body or to describe its interior or to invent another body entirely, most efforts to express presence or absence, voice or voicelessness, have had to reside somewhere in the modernist mansion (or make clear their refusal to do so), however uncomfortably, whatever the price. Consider the alternative.

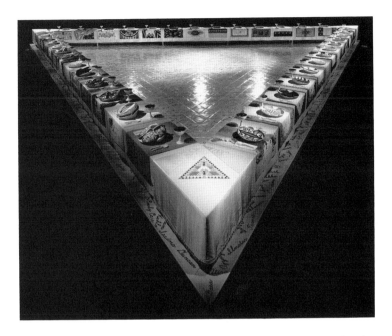

FIGURE 6. Judy Chicago et al., *The Dinner Party, completed 1979, mixed media. Photograph courtesy of Through the Flower,* © *Donald Woodman.*

Modernism provided a better alternative because for much of its history it was one: it described and endorsed the representational effects to which artists turned as a means of investigating the relationship of their imagery to other visual forms—to commercial imagery, for example, illustration and advertising—or spelling out its links to, and distance from, tradition and its various reinventions (for which read the weight of painterly routine and the masterpiece, and the onus of the various nationalisms constructed from those materials). Like any other vocabulary of artistic representation (like *all* such vocabularies) it could only ever be communicated and made available through institutionalized means sited in the public sphere. One of the great changes and advantages modernity has offered women is art's migration to that sphere. It could be learned outside the family and seen both outside the home, at museums and public exhibitions, and within the home, in reproduction. The invention of the camera itself was no small aid to women's becoming educated and skilled in art—not least, the art of photography itself. And now women themselves left the parental orbit, even though unmarried; the mail brought books and little

magazines, and the libraries did their share. Remember O'Keeffe, at her various teaching jobs in North Carolina and Texas, feeding herself on the reproductions of Rodin and Cézanne in issues of *Camera Work* sent straight from New York.

Of course it will not do to sound too chirpy about all of this. Siting women within modernity and modernism is not the same as providing an account of "equal opportunity." There is no such account to give. Rozsika Parker and Griselda Pollock were undoubtedly right when they wrote in 1980, "Equal opportunities are apparently available but they are effectively contradicted by disguised but profound levels of constraint, containment and oppression."[25] One key contribution of Parker and Pollock's work is the formulation of such judgments: they extend into the realm of ideology Linda Nochlin's demonstration that institutional structures (their limits and constraints) should be thought of as more determinant of female artistic roles than genius or its lack.

Parker and Pollock sum up their conclusions in the following terms:

> Far from failing to measure up to supposedly "objective" standards of achievement in art, so unproblematically attained by men by virtue of their sex, we discover that art by women has been made to play a major role in the creation and reproduction of those very standards. This represents a fundamental re-reading of the history of women artists and the historical significance of women's art. The focus shifts from the peripheries to the centre—that centre is the historical development of the definitions of art and identities of the artist as the exclusive prerogatives of masculinity.[26]

It is possible to be in fundamental sympathy with this view, but still find it oddly unsatisfying. The craving sets in almost immediately, in the wake of the statement that women's art ought not to be glossed in terms of its failure to "measure up." The alternatives to failure are bad faith and misreading, at least in this account: women's art has been "made to play" a role in its own oppression. A provocative judgment, particularly if it is asked how far it might be extended: From art to artists? To women in general? To men, in *their* oppression? What if we read *made* as *produced*? All these readings are possible; they all contain more than a grain of truth, yet grasping the validity of this judgment might send the critic in another direction. Not, that is, into the (fictive) center of ideology critique, which too often erases consideration of art in favor of atten-

tion to its definitions and/or the constitutions of artistic identity. What about a return to the field of artistic practice, critique in hand? Cannot women's art itself be reread? Could it now be "made to play" another role (might it actually have been *made* to play another?), one best understood, not by surrendering a feminist understanding of its circumstances of production—indeed, they should be taken as determinant of visual form—but by resisting the assumption that those circumstances also determine quality or value with the same historical irrevocability? Might art by women now become the subject of a different understanding?

The present study subscribes to this proposition—indeed, affirms it. This is one mark, I think, of its historical moment. I am reminded in this context of a central passage in "Why Have There Been No Great Women Artists?" when Nochlin declares, going against the grain of some feminist thinking: "The fact of the matter is that there have been no supremely great women artists, as far as we know, although there have been many interesting and very good ones who remain insufficiently investigated or appreciated."[27] I admire this statement on Nochlin's part: such unblinkered realism is no small achievement.[28] I shall not counter it by claiming that "we" now know that women have indeed been among the supremely great. But what if the terms of the debate were shifted? Does feminist art history really need its own canonical roster, its pantheon of great artists? The answer is yes and no.

These are feminism's own answers to the question, the disagreement a key aspect of its history. The *yes* is first of all the response of "rediscovery" and reversal: of telling "herstory" and diving into the "hiddenstream" of female endeavor and production. *Yes* is Judy Chicago's *Dinner Party* and Mary Beth Edelson's *Some Living American Women Artists* (fig. 7), which both make a meal of the notion of a new community of the elect. (Chicago honors O'Keeffe as the only living artist represented at her imaginary dinner; Edelson's Leonardo image comes complete with O'Keeffe the Savior, the lynchpin of the whole. Why Alma Thomas gets assigned to play Judas is not for me to say.) *Yes* is also the answer of the artist's biography, the monograph and monographic exhibition, and the National Museum of Women in the Arts. Saying no means refusing the simple annexation of women to the institutional forms and disciplinary regulations of an art world made to invent and safeguard male greatness.[29]

Phrased in this way, *no* is the better answer, the one to have given more

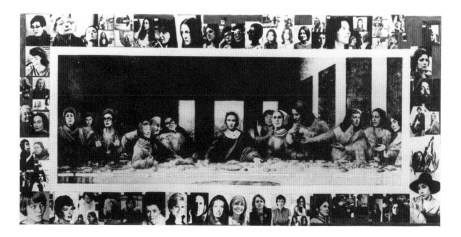

FIGURE 7. *Mary Beth Edelson,* Some Living American Women Artists / Last Supper, *1972, offset poster. (Photograph: Julie Wolf).*

thought to some of the social functions of "greatness." But only some. How exactly does greatness come to be seen and named? Has it visual and conceptual causes? (To this question Nochlin, for one, would certainly say yes.) Is there anything about the rubric that exceeds its disciplinary function? What are the political consequences when a woman—a feminist—agrees that a work by Raphael or Rembrandt or Manet is indeed great? If to call a work great is to name it a vehicle and repository of cultural value—or meaning and understanding—why not hope that this epithet might come to be used of women's art? Its employment would signal a transformation in art's understanding and estimation, but it would be a political change as well. As John Guillory has declared, "The most politically strategic argument for revising the canon remains the argument that the works so revalued are important and valuable cultural works." [30]

What are the means toward such a transformation? It is one thing to ask such a question, another to answer it. I used to imagine that the sheer accumulation of "interesting writing" about works by women would be enough to do the trick. According to Michael Baxandall, this is what art historians can do, sometimes well: they point verbally, rather like the self-appointed guide on a bus tour who insistently directs others to "the beauty or interest of the things they encounter, *even though the others can see the things, too.*" [31] Of course a good job of pointing is a complex business, as Baxandall's own writing exists to demon-

strate. Yet ultimately the quality of the account is not the main issue: if and when enough accounts accumulate, or so I thought, a literature emerges that in turn is part of a discourse of value: hey presto, sea change on the way! So far, so good—but not nearly far enough. What my simple model failed to take into account (among many things) is that it is not yet clear that "others can see the things, too." Or to put the problem slightly differently: the issue is what gets said while pointing. We have failed to find the terms in which to *see* women's art, failed to point to it in ways that make enough cultural or aesthetic sense. Too often the strategy is merely a reversal: for what was once male, read female; where once was Jesus is now O'Keeffe. And in place of Leonardo, who? Until art by women can be seen as offering different accounts of the experiences art has long sought to convey—the body, its solidity, vulnerability, and sexuality; the mind, its order and passions; nature, its potency and waning—the transformation feminists are aiming at will not have arrived.

One wider context of feminist cultural history is the critique of the canon, to which, not surprisingly, it is directly connected. "We don't need another hero": the declaration has been emblematized by Barbara Kruger in a work whose strategies (billboard, appropriated imagery, purposefully ambiguous *we*) exemplify the polemic in picture-perfect form. But what to put in his place? If it is a new list of required books and masterpieces, how are they to be chosen? What is to be said about them? Now that "Sex Equity Art Problems for Understanding the Artistic Heritage" have been diagnosed, what "Expressions/Activities" and "Responses/Discussions" are in order? Is it enough, for example, to "examine works of art for their male and female attributes in terms of scale, style, media, subject matter?" Ought one then to "discuss stereotypes and assumptions that affect interpretation and judgment in criticizing works of art" (fig. 8)? This, let me hasten to say, is a real example, which I cite from a 1984 manual for art teachers aiming at nonsexist pedagogy.[32] I do not think that real understanding of the problems lies along this route.

The institutionalization of feminist art history risks producing a view of works of art as mere compendia of male and female attributes, and the task of criticism as simply spelling out the stereotypes and assumptions that images illustrate. Do these results seem unexceptionable? The problem is not just that nuance is missing; it is the implicit assumption that works are reducible to— indeed, are best perceived as—immediate expressions of their maker's experi-

b. SEX EQUITY ART PROBLEMS FOR UNDERSTANDING THE ARTISTIC HERITAGE

EXPRESSION/ACTIVITY	RESPONSE/DISCUSSION
Start an artist-of-the-week series, alternating male and female artists. Include artist's portrait or photo with an example of work.	Discuss artist, period, work, conditions, education, career patterns, main- or hiddenstream achievements. Relate to other art learning.
Examine works of art for their male and female attributes in terms of scale, style, media, subject matter.	Discuss stereotypes and assumptions that affect interpretation and judgment in criticizing works of art.
Examine contemporary art forms and methods by women artists such as "Womanhouse," "The Dinner Party," as well as body art.	Discuss the relationship between art and life and how these forms raise personal and cultural consciousness.
Study and compare portraits and self-portraits of an artist. For example, compare Picasso's *Self-Portrait* of 1908 with his image in Marie Laurencin's *Group of Artists*.	Discuss personality and image held by self and others as portrayed in art.

FIGURE 8. *Page from Georgia Collins and Renee Sandell,* Women, Art, and Education *(Reston, Va.: National Art Education Association, 1984) (Photograph: Julie Wolf).*

ence as a representative of a social group. This is Realist interpretation run amok. The urgency of the issue emerges when we realize that the problem is the same for the critic responding to the canonical and the noncanonical artist alike. To see either as the representative of a social identity risks asserting the transparency of the image to the social identity it represents.[33]

Then why write a book about "women artists"? The question seems all the more pressing, given my assertion a few pages back that my examples represent certain recurring problems or issues. They may be representative cases, yes—but they do not *mirror* anything much. Nor does their art.

Least of all do they reflect "Woman"—or even "women." My treatment of them, by contrast, demonstrates the conviction that just as images are not transparent to social identity (or anything else), neither are people. In this I follow current thinking that sees sexual identity and behavior as learned and performed in both exemplary and imperfect ways. The protocols of visual representation, while they have other meanings and purposes, are also marked by such performances, in ways that the maker may or may not intend. Likewise I take notions

of sexual identity to be "in circulation," historically, locally, culturally, thus unfixed from universal status or value. Not that one can freely "choose" sexual identity, but it does not follow from this lack of freedom that gender saturates and suffuses the self in an entirely determinant way. To take identity as a rather more unstable construct is to express the modern understanding of the relation between the self and the social, the two great preoccupations of the modern age: it offers a formulation capable of capturing their incommensurability of scale, the opacities they present to the understanding, the possibilities extended and withheld by economic relations and representations that simultaneously encourage and deny the fiction of individuality with equal force.

By these lights, making art "as a woman" seems best understood as an historically contingent act with different cultural weight and allure at different moments in time. Femininity can be assigned as well as claimed, avoided as well as celebrated, with an act of negation potentially as eloquent as affirmation. Or an individual's relation to feminine gender may definitively escape her control. Trying to spell out how those differences *look*, as well as how they came about, and to make those interpretations count toward an understanding of the circumstances of artistic production in twentieth-century America is one way of arguing that case. It is the path I follow here, which my readers are invited to retrace.

O'Keeffe's Femininity

Consider this installment from "I. E. Skin's Guide to All That There Is to Know about the Top Ranking Artists of All Time" (fig. 9). When the artist is Georgia O'Keeffe, "all there is to know" is a parable with four essential points:

As a young child Georgia O'Keeffe's unusual talents were not immediately recognized, and her peculiar behavior often got her in trouble. (Georgia! Must you stand so close to my lilies!?)

Georgia went to the same high school as Frida Kahlo where they co-lead the school painting team to 3rd place in the national finals only to be disqualified for an indecent, inappropriate & unauthorized mural painting of their school administration.

Georgia designed several New Mexico miniature golf courses that made Duchamp so bitterly envious that he bought the courses and closed them down.

The official canonizing branch of the International Art Historians (I.A.H.), on their fourteen hundred third annual session voted Ms. O'Keeffe the 12th greatest art genius ever. Her estate was awarded a small trophy previously in the possession of the estate of Paul Cezanne. Nine different coffee table books were immediately produced to commemorate the occasion.

Now you too know how O'Keeffe entered the canon: she bumped Cézanne himself from his niche. The King Is Dead, Long Live the Queen! In keeping with the traditions of artistic biography, her talent can be traced to its origins

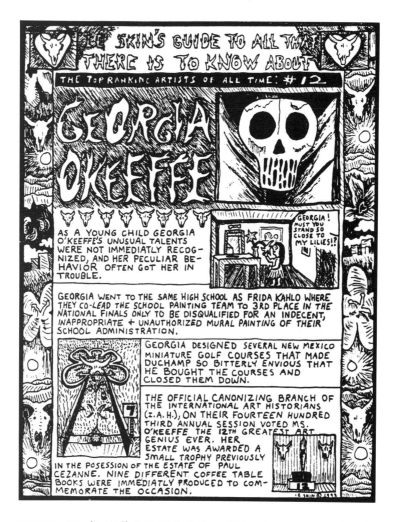

FIGURE 9. *Peterskin Wolf, "I. E. Skin's Guide to All That There Is to Know about the Top Ranking Artists of All Time,"* East Bay Express, *November 13, 1992 (Photograph: Julie Wolf).*

in exceptional and misunderstood childhood behavior. (This is lesson number one in Kris and Kurz's celebrated study, *Legend, Myth, and Magic in the Image of the Artist.*)[1] But her fame is also feminized and updated: it means the (symbolic) sharing of key experiences with another female painter, Frida Kahlo. Their training has something in common (they "went to the same high school"), and so does their uppity imagery: the likeness boils down to sexual excess. But there is still more to this story: O'Keeffe became powerful enough as an artist to

arouse the jealousy of Duchamp (for whom read the category "male modernist"): he tried to shut down her whole operation. The institutions of the establishment, however, eventually endorsed her, and the coffee-table books did the rest.

Odd as it may seem, the story I have to tell about O'Keeffe is not all that different in its main themes from this one. Granted, I am less certain that her rank in the canon has risen to number twelve, despite the endless barrage of books about her life and art. Nor am I confident that she has displaced Cézanne or will. Yet the cartoon sees the other issues pretty clearly: its wager as comedy is that viewers will agree. O'Keeffe's "rank"—or, in my lexicon, her reputation—does matter, from several points of view, the institutional and commercial included. There have always been important reasons to endorse O'Keeffe—not only financial advantages, but also ideological ones that motivated the terms in which her reputation was launched and elaborated. These in turn were the terms in which, as a woman and an artist, O'Keeffe would gain access to such power and privilege as her gender status would allow. Bound up in reputation, moreover, are the two main issues the cartoon spoofs—and relies on: the relation of her work to modernism, both its practices and practitioners, and the implications of her special identity as a female artist—and artist's wife—for the (eroticized) interpretation of her art. These themes are the concern of this chapter. Leaving the cartoon behind, I will explain their special tenor as the product of O'Keeffe's "utterly embedded femininity," to use the characteristically hyperbolic diction of the day. (The phrase was coined by the painter Marsden Hartley, who in the years around 1920 passed for one of her chief supporters).[2]

Such a potentially controversial thesis demands an immediate explanation of how I mean to use its central term, "femininity." Not as Hartley does, certain that it describes perfectly the woman and her art. I write from no such confidence. On the contrary: in what follows I shall not pretend to any special knowledge about what the painter Georgia O'Keeffe might have felt, understood, or experienced by virtue of her qualities and character as a woman. I am not aiming, in other words, to celebrate O'Keeffe's art or person as specially feminine—or even as feminine at all. Unlike Hartley I do not view femininity as the essence of O'Keeffe's art or self, but as the chief quality attributed to both. Of course I cannot reasonably or convincingly deny the fact of her womanhood, or that her art is "that of a woman"—again, how could it be

otherwise?—but the mere circumstance of a person's "being a woman" or a painting's being "made by a woman" is not the same as exemplifying femininity or evidencing some special, characteristic state of womanliness. The status of femininity as cultural fiction means that a person may only occasionally—at some moment or period in a life—appear or feel her- or himself describable by that term.[3]

I shall not myself argue for O'Keeffe's femininity or that of her art, because to do so would mean to fall in with exactly the interpretive tendency I wish to reconstruct and criticize. In what follows I aim to show that from the outset of her career, O'Keeffe's art has been relentlessly equated with the feminine, and with its inevitable synonyms, the bodily and the sexual. I argue, moreover, that this single circumstance should be understood as the most decisive condition under which O'Keeffe worked, the one that had the most serious consequences, both for her reputation and for the direction her painting was to take. We could almost claim that it dictated the form in which O'Keeffe was to confront the most basic of modernist quandaries: the choice between abstraction and figuration—the choice, we might say, jumping ahead in the story, to show the flower, or to work with the line.

O'Keeffe's Reputation

> The next time I saw Duchamp was at my first large show in 1923 on the top floor of the Anderson Galleries. The show had started. There were not very many people there when Duchamp came in. . . . It was a very large room and I saw him walking around. He came up to me quickly and said, "But where is your self-portrait? Everyone has a self-portrait in his first show." Well I didn't have a self-portrait and we laughed about it and that's all I remember about that.
>
> *Georgia O'Keeffe, 1973*

This brief anecdote is part of a longer reminiscence of Duchamp that O'Keeffe wrote for inclusion in the catalogue of the first posthumous retrospective of his art.[4] Even in excerpt there is enough in the passage to give an impression of O'Keeffe's eyes and mind at work as they followed Duchamp around the show

and recorded his words—she even remembered, fifty years later, that he wore a raccoon coat acquired in Chicago. This memory (characteristically, for its author) is couched in concrete terms—a large room, a few people, a quick question. So matter-of-fact is the tone that the message too may seem crisply prosaic—yet nothing could be farther from the truth. A talent for the circumstantial is no barrier to polemic: O'Keeffe is working on her reputation, not Duchamp's, still reacting to the responses her work had provoked half a century before. In the space of only a few lines, she and Duchamp ally to repeat the catechism she urged on devotees of her art. "But where is your self-portrait? . . . Well I didn't have a self-portrait." The remark ought not to be taken as a simple statement of fact. It is a performance, an insistence that Duchamp is invoked expressly to suggest and confirm: the artist's self-representation was nowhere to be seen at this key exhibition. "We laughed about it and that's all I remember about that." Not that O'Keeffe's memory had *really* failed her: why delve further into Duchamp on this or any other occasion, when what mattered in this memory was her own art?

O'Keeffe liked Duchamp, and I wager that she told her story in this commemorative context because she thought it reflected positively on him, as well as defining the essence of her work. And so it does, from her point of view. It shows him going against the grain of the view of O'Keeffe that prevailed at the time, the one she herself wished most to deflect, that the painter's works were best understood—and most to be valued—as self-inscriptions, as the direct and unmediated registration of her person as a woman. By 1923, seven years after her first New York show, this was for critics more like dogma than doctrine. Its roots lay in the circumstances from which her public identity developed: her work was first shown at Alfred Stieglitz's gallery, 291, in 1916, as part of two group exhibitions, the first a presentation of paintings and drawings by three unknowns (O'Keeffe, Réné Lafferty, and Charles Duncan) that hung from late May to early July, the second a roundup of pictures by better known modernists, including Stieglitz regulars Hartley and John Marin, shown in the month before Christmas. A third exhibition at 291, in April and May 1917, was devoted to O'Keeffe alone; it was the last before the gallery ceased its operations. And while the 1923 show, with its hundred canvases, was the next major offering of her work, Stieglitz in the meantime did his best to keep her visible. He regularly sent her canvases to exhibitions of modern art staged by organizations

like the Society of Independent Artists (1917), the Young Women's Hebrew Association (1919), and the Pennsylvania Academy of Fine Arts (1921). When he himself organized a modern art show in Freehold, New Jersey (1922), O'Keeffe's paintings were included there. Moreover, her person and art, rendered photographically, figured importantly in Stieglitz's 1921 presentation of his own work. (He had not shown at all since 1913.)[5]

This bare outline of O'Keeffe's early exhibition history, however, cannot alone convey what being taken up by Stieglitz meant, and would continue to mean, for O'Keeffe's reputation. To debut at 291 was to be associated with the very gallery in New York that functioned, as even a hostile critic like Thomas Craven had to admit (however grudgingly), as "the center for the pullulation of advanced ideas."[6] To put the matter more straightforwardly, 291 was "the jumping off place of modern art."[7] Showing there meant taking a place in a sequence of exhibitions that in the five years before 1916 had included Rodin and Brancusi, Picasso and Braque, *African Savage Art* (meaning, in this instance, objects from the Congo, Nigeria, and the Ivory Coast), and *Unguided Children, Aged 2 to 11* (inaugurating three shows of child art). All of these were American firsts, and while the O'Keeffe exhibit did not play exactly the same founding role in 291 history—the first woman to be presented there was Pamela Colman Smith in 1907—this does not dislodge her work from its (inevitable) location on the spectrum of the avant-garde and the "primitive," the novel and the notorious—Stieglitz's customary enthusiasms.[8] Even Craven had to acknowledge the prescience and value of Stieglitz's various discoveries: "Certainly he was not mistaken in advocating the cultural necessity of naive expression; and he was the first modernist impresario to draw distinctions between American and European art. . . . Stieglitz brought plainly before the critics and the public the value of art as human activity."[9]

Imagine seeing one's own work hung on walls that only lately had been devoted to Rodin and Picasso, and had gained their reputation from that earlier association. O'Keeffe knew what the honor meant; she had been a reader of *Camera Work*, the house organ of the gallery, at least since 1915, had seen some of the landmark shows, and had thought hard about their contents. And Stieglitz himself had become her key "imaginary viewer"—the person whom she envisioned her work as addressing—even before she knew him, or he her art. (Thus she wrote in October 1915 to her friend Anita Pollitzer, "Anita—

do you know—I believe I would rather have Stieglitz like some thing—any-thing I had done—than anyone else I know of—I have always thought that—If I ever make anything that satisfies me even ever so little—I am going to show it to him to find out if it's any good.'')[10] O'Keeffe's tone suggests that she rec-ognized in Stieglitz the qualities and insights Craven was later to describe. Certainly she could not fail to regard him as a champion of modernism, Euro-pean and American style, or to understand his role as an exponent of the "value of art as human activity." But what she could not have anticipated when she threw in her lot with Stieglitz were the manifold results of her own art and identity themselves being seen as manifestations (still following Craven) of "the cultural necessity of naive expression."

O'Keeffe could be claimed to fill that cultural prescription precisely because she was a woman, and because her art was considered—apparently from the moment in 1916 when Stieglitz first clapped eyes on a few charcoals—"that of a woman": henceforth it was to be virtually impossible to confront her work in any other terms. So often repeated is this tale of genesis that one can only marvel when an author refuses to join in. I myself cannot imagine how to do without the story here. As a tale of origin it is simply too fraught with symbolic weight. Legend has it that when Stieglitz first saw O'Keeffe's drawings (a selection was brought to him at the gallery by Pollitzer), he exclaimed "Finally! A woman on paper," and proceeded to mount the exhibition that launched her career. Or perhaps he said, "Finally! A woman on paper. A woman gives herself. The miracle has happened." Or maybe his remarks were actually somewhat less pol-ished and epigrammatic: " 'Finally a woman on paper'—he said. Then he smiled at me & yelled 'Walkowitz come here'—Then he said to me—'Why, they're genuinely fine things—you say a woman did these—She's an unusual woman—She's broad minded, She's bigger than most women, but she's got the sensitive emotion—I'd know she was a woman—Look at that line.'"[11] (This last ver-sion, the one Pollitzer set down in the letter to her friend reporting the fateful meeting, is probably closest to the truth of his remarks at the time—next to it, in the margin of the same letter, the phrase "Finally, a woman on paper" is excerpted, written in pencil, as if to condense Stieglitz's rambling opinion into properly historical, eminently quotable form.)[12]

Stieglitz's slogan concerns reputation, not execution. It figures large in writ-ing about O'Keeffe, not because it is essential to understand her artistic origins

from a stylistic or technical point of view, but because it emblematizes the making of the public O'Keeffe. Stieglitz's role in the generation of that myth has long been emphasized; it escaped no one at the time. The public exhibitions, the quotable phrases were his doing. And from the very first he solicited responses to O'Keeffe's work that would underline and restate his own sense of its profoundly feminine cast. Thus in 1916, for example, he used the pages of *Camera Work* for his first published response to O'Keeffe's work, asserting its interest "from a psycho-analytical point of view" and claiming that "'291' had never before seen woman express herself so frankly on paper."[13] A letter from one Evelyn Sayer about the "woman pictures," as she called them, embroiders this opinion and makes clear that Stieglitz had asked Sayer to set down her views. She wrote (I cite the letter in full):

My Dear Mr. Stieglitz:
 I feel very hesitant about trying to write an appreciation of the woman pictures.
 I was startled at their frankness; startled into admiration of the self-knowledge in them. How new a field of expression such sex consciousness will open.
 I felt carried on a wave which took me very near to understanding how to free and so create forces—it has receded now and so leaves me without the words. I shall never forget the moment of freedom I felt—or the inspiration of how to use it.
 May I leave it this way—if it comes to me before your next issue of *Camera Work*, I will try to write it, if not, please know I should have liked to.
 Self-expression is the first and last difficulty of my living.[14]

It seems likely that Sayer's letter was solicited to serve a corroborative function, more or less in the way that a native speaker might be asked by an anthropologist to confirm his interpretation of a craftswoman's cryptic symbols. The results in this case were no doubt gratifying. The job gets done efficiently: the testimony moves quickly from enthusiastic validation of Stieglitz's essential (and essentialist) premise to end in stereotypically feminine inarticulacy: "Self-expression is the first and last difficulty of my living." Not that Sayer's coinage, "woman pictures," is inarticulate: brilliant shorthand for Stieglitz's key idea, its linguistic antecedents are phrases like "woman suffrage" and "woman move-

ment," usages in 1916 just ceding to the term "feminist."[15] Yet this was more or less the last time that authentication was needed from any woman, let alone O'Keeffe, about the meaning of her work. (It would henceforth be up to the artist herself to seek out women's reactions to her art, as we shall see.) From this point on, the main lines in its interpretation had been set, the central link between art and woman forged. Once Stieglitz's enthusiastic formula had made the initial connection, O'Keeffe's art emerged as the unmediated translation of a woman's self into representation and onto paper: her every line was so feminine it could function as a surrogate for its maker: it could stand in for the woman herself.

Elsewhere—and nowhere more emphatically or famously than in a manuscript essay "Woman in Art," written in 1919 and apparently circulated to selected friends—Stieglitz made clear that he took the female persona to be both essentially different from the paradigm of male selfhood and specially dependent on bodily sensation. He wrote: "Woman *feels* the world *differently* than Man feels it. And one of the chief generating forces crystallizing into art is undoubtedly elemental feeling—Woman's and Man's are differentiated through the difference in their sex makeup. The Woman receives the World through her Womb. That is the seat of her deepest feeling. Mind comes second."[16] If we were to take this statement—it is vintage Stieglitz—and combine its logic with the notion of the "woman on paper," an inevitable conclusion would follow: O'Keeffe's art can be nothing other than the registry of the feelings arising in her womb. The result is the inevitable erasure of the artist herself. If she *is* the picture, then she cannot accordingly be thought to stand "behind her work," external to it, in the customary position of the author as rational producer. It is as if Stieglitz, at the very moment of his apparent discovery of O'Keeffe the artist, forecloses the possibility of her attaining that identity in the accustomed sense. (Here the notion of the death of the author takes on particularly regressive force.) The woman is her pictures, and both are her womb.

If after 1916 female informants were no longer invoked for the light they could shed on the new "woman pictures," this was because it was soon commonly claimed that O'Keeffe's work "spoke for itself." The gallery's early habit of avoiding numbers, labels, lists, and catalogues, as well as the artist's own aversion to using a visible signature, was taken as evidence to support that claim. Many critics, particularly those closest to Stieglitz, did not mind those

strategic omissions: by this time they were quite certain they knew just what O'Keeffe's paintings had to say. "The style is the woman," declared Henry Tyrrell, a commentator for the *Christian Science Monitor*. O'Keeffe, we learn from his 1917 review, "has found expression in delicately veiled symbolism for 'what every woman knows,' but what women heretofore have kept to themselves, either instinctively, or through a universal conspiracy of silence."[17] And Marsden Hartley, who like O'Keeffe also showed with Stieglitz, sometimes more or less literally alongside her, in the same exhibitions, announced in 1919: "With Georgia O'Keeffe one takes a far jump into volcanic crateral ethers and sees the world of a woman turned inside out and gaping with deep open eyes and fixed mouth at the rather trivial world of living people."[18] According to Paul Rosenfeld, a critic of both music and art and a frequent visitor at the Stieglitz farmhouse at Lake George, her painting stemmed

from the nature of woman, from an American girl's implicit trust in her senses, from an American girl's utter belief, not in masculinity nor in unsexedness, but in womanhood. O'Keeffe gives her perceptions utterly immediate, quivering, warm. She gives the world as it is known to woman. No man could feel as Georgia O'Keeffe and utter himself in precisely such curves and colors; for in those curves and spots and prismatic color there is the woman referring the universe to her own frame, her own balance, and rendering in her picture of things her body's subconscious knowledge of itself. The feeling of shapes in this painting is certainly one pushed from within. What men have always wanted to know, and women to hide, this girl sets forth. Essence of womanhood impregnates color and mass, giving proof of the truthfulness of a life.[19]

Rosenfeld's verdict was set out in his 1924 *Port of New York: Essays on Fourteen American Moderns*. Two years before, in *Vanity Fair*, he had written with similar lack of restraint:

It is female, this art, only as is the person of a woman when dense, quivering endless life is felt through her body, when long tresses exhale the aromatic warmth of unknown primeval submarine forests, and the dawn and the planets glint in the spaces between cheeks and brow. It speaks to one ever as do those high moments when the very stuff of external nature in mountain sides and full breasted clouds, in blue expanse of roving water and rolling treetops, seems en-

veloped, as by a membrane, by the mysterious brooding principle of woman's being; and never, not ever, as speak profaner others.[20]

One could continue almost indefinitely in this vein, piling citation upon citation, Pelion upon Ossa, and in so doing compile an ever more elaborately detailed picture of the enthusiasms and excesses characteristic of O'Keeffe's reputation. The curtain is rising on "The Myth of Georgia O'Keeffe." Like any good myth, it is meant to explain away certain anxieties, not least the worry provoked at just this moment in America by the specter of a woman become "masculine" or "unsexed." These are the 1920s code words for *feminist*: in an age of bobbed locks and severe tailoring, they conveyed something more than style of dress and cut of hair. To be seen as utterly feminine in the 1920s was one way of not being viewed as feminist. Yet the very existence of feminism, however embattled the movement in the years of backlash after the suffrage victory, did more than inflect responses to O'Keeffe's art. It also meant that a feminist dissent from the standard view inevitably emerged as part of the critical record—in one instance it was solicited, interestingly enough, by O'Keeffe herself (of which more later). Moreover, the various contemporary responses to feminism, pro and con, provide one main interpretative context for her work and one explanation for the fraught tenor of such interpretations. Yet no matter how many citations might be adduced in detailing those responses, the main lineaments of O'Keeffe's reputation would not change much from the bare outline these first quotations provide. The task seems all the more redundant given that most of the critical responses to O'Keeffe's work through 1929 have been reproduced verbatim in a remarkable study by Barbara Buhler Lynes.[21] Enough reason here to call a halt to this accumulation before it starts. While it is certainly necessary to cite representative opinions chapter and verse—this is because their ostensible content is, though familiar, nonetheless not negligible— it is also essential to assess them, to take the measure of the tone set by their characteristic style.

What these texts deliver—their hallmark, if you will—is their unchecked enthusiasm for the somatic metaphor: where would they be if phrases like "quivering sensations" and "warmly exhaling tresses" were ruled out of court? Each text is a narrative that leads the reader compulsively, inevitably, back and

FIGURE 10. *Gardner Rea, "The Man Who Understood Symbolism,"* New Yorker, *February 25, 1933 (Photograph: Bob Boni).*

back to a source, a secret, an interior, the place within: to the woman's body. The effect of such diction is to summon a fleshly embodiment for both painting and painter, conflating the two into one and in the process producing a kind of "sensationalist" aesthetics run amok. Such animating work is accomplished in a style of writing that is essentially additive. Sentences career along endlessly, breathlessly, thrilled by their own audacious enthusiasms. These are textual performances that make of the painter what the critic desires. The frisson is the more pleasurable because it is so novel: we learn again and again that this is the first time in history that a woman's art has spoken so frankly, revealed such secrets and provoked such raptures. Of course this writerly moment was in general a rather breathless one: the Stieglitz circle had read Gertrude Stein (Stieglitz had published her profiles of Matisse and Picasso in *Camera Work*, and Stein was herself a Stieglitz admirer),[22] and in their private correspondence they themselves wreak havoc on standard punctuation in the interests of the "personal" and the "immediate." Rosenfeld, moreover, was so roundly rebuked for

his public literary manner (his most virulent opponent, Gorham Munson, condemned it as "formless impressionism" and, even more pointedly, witheringly, as "premature ejaculations") that Lewis Mumford, for one, came to his defense with a phrase meant precisely to legitimize "formlessness" as feeling: "The test of a good style," he wrote, "is in the closeness of its conformity with the thought and passion behind it."[23] How to decide between thoughtful passion and premature ejaculation? It may be a matter of paying your money and taking your choice.[24]

If one document telegraphs how much this critical characterization of the femininity—read bodily truth telling—of O'Keeffe's art not only attained the status of critical doctrine but became something like a household word, it is a cartoon published in the *New Yorker* in 1933, just at the moment of the painter's annual winter exhibition (fig. 10). (The artist herself was in a nursing home, suffering from "psychoneurosis.") The cartoon shows a viewer in action: deep in a state of proper aesthetic reverie, this fellow can contemplate the bared curves of Susannas and Venuses, Godivas and Odalisques, without a blush. Show him a quasi-O'Keeffe, however—a work with strong analogies to several abstractions that had hung in her show the year before, paintings like the 1930 *Black and White*—and his sense of decency is deeply affronted. This is precisely because, to quote the cartoon's caption, he is "the man who understood symbolism." What our good burgher thinks he understands about this up-to-date language of curves and orbs and plunging diagonals is just what the critics insist on: its forms are to be taken as substitutes for the female body, and as such must be highly, disquietingly sexualized, in ways that leave the more explicit yet more familiar protocols of the traditional nude far behind.

It is easy to look back at these jokes and opinions simply as different forms, lurid and trivial, of the contemporary sexist burlesque. What has fallen away from them over the years—most particularly from the critics' responses—is the possibility of much credence in the validity of, or interest in, the "thought and passion" (to borrow Mumford's phrase) behind them. Besides the general writerly excess, there is a hyperbolic biological determinism and an adamant insistence on feminine mystery and otherness—an insistence no less problematic for all its familiarity. To quote Simone de Beauvoir—not an inappropriate voice if we want to try to understand the sexual politics of the 1920s: "Man seeks in woman the Other as Nature . . . but we know what ambivalent feeling Nature

inspires in Man."[25] Certainly the criticism I have quoted *is* ambivalent, though its authors—the Hartleys and Rosenfelds and the others—would never have admitted it, so close were their personal ties to O'Keeffe and Stieglitz, and so strong their desire to celebrate O'Keeffe's art as all feeling, all emotion. An intuitive female art could serve as one more armament in their struggle against materialism, American style—the profligate wastefulness of the culture of the Machine and the Businessman—which their version of modernism tried to keep at bay.[26] Little matter, according to this point of view, that in the process the creative woman is still barred from the traditionally male province of rational thought. Rationalism had itself become suspect. The bodily and the intuitive— Craven's "naive expression"—were championed as the necessary alternatives to materialism's deadening constraints. Such "intimacies" became Stieglitz's stock-in-trade—stock that the Intimate Gallery (inter alia) was organized to put on view. In the gallery world another order reigned, one shaped by studied disregard for some marketing techniques and calculated development of others. From inside its protecting walls Stieglitz viewed and photographed the city's modernizing changes, always at a safe remove. Inside those walls, O'Keeffe's work, by virtue of her womanhood, was the emblem of "intimacy."

It should be granted, however, that though these expressions of belief may have been self-serving, they were not therefore mere journalistic performances, aimed at the market and reserved for the regular column in the *Nation* or *Sun* or *Vanity Fair*. The O'Keeffe myth is not just journalism, or was not in the years between the wars. So much seems clear from two different sources, both more "personal" than a published review, each of which frankly attributes the writer's own most intimate sexual feeling to O'Keeffe's work. The first is a letter written to Stieglitz by a young man of his acquaintance, the twenty-one-year-old David Arkin. Arkin wrote Stieglitz (then sixty-three) from Paris in the summer of 1927; his great news was a liberating and passionate love affair with a girl who, as he tells it (at length), "taught me to be as free and as pagan as a he goat raphsodist [sic] in an amorous play. I was not absolutely a virgin, but I had had just enough of the sex act to be violently afraid of it. I forced myself to strip love and sex of all its melodramatic association and to become as artless and immediate as possible. I discarded the passionate gesture and the divine afflatus, and the embrace thru that became so sublime and powerful that we laughed aloud in pure joy." An initiate in love, Arkin wrote as a person newly

PLATE 1. *Georgia O'Keeffe, Special No. 4, 1915, charcoal on paper, 24½ × 18½ in. (62.2 × 47 cm.). © The Georgia O'Keeffe Foundation, Abiquiu, N.M. (Photograph © Malcolm Varon, New York, N.Y.).*

PLATE 2. *Georgia O'Keeffe, Special No. 5, 1915, charcoal on paper, 24½ × 18½ in. (62.2 × 47 cm.). © The Georgia O'Keeffe Foundation, Abiquiu, N.M. (Photograph © Malcolm Varon, New York, N.Y.).*

PLATE 3. *Georgia O'Keeffe, Red and Blue No. 1, 1916, watercolor on paper, 12 × 9 in. (30.5 × 22.9 cm.). Collection of Mr. and Mrs. Irving Brown, Brooklyn, N.Y. (Photograph © Steve Sloman, 1990).*

PLATE 4. *Georgia O'Keeffe, Portrait W-No. III, 1917–18, watercolor on paper, 12 × 9 in. (30.5 × 22.9 cm.). © The Georgia O'Keeffe Foundation, Abiquiu, N.M. (Photograph © Malcolm Varon, New York, N.Y.).*

PLATE 5. *Georgia O'Keeffe, Seated Nude X, 1917–18, watercolor on paper, 11⅞ × 8⅞ in. (30.2 × 22.5 cm.). The Metropolitan Museum of Art, New York, Van Day Truex Fund, 1981 (1981.324).*

PLATE 6. *Georgia O'Keeffe, Seated Nude XI, 1917–18, watercolor on paper, 11⅞ × 8⅞ in. (30.2 × 22.5 cm.). The Metropolitan Museum of Art, New York, purchase, Mr. and Mrs. Milton Petrie Gift, 1981 (1981.194).*

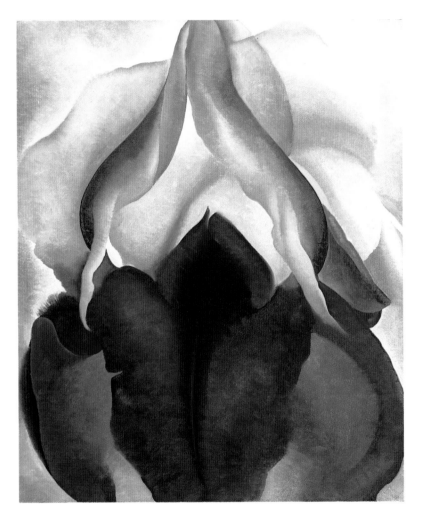

PLATE 7. *Georgia O'Keeffe, Black Iris III, 1926, oil on canvas, 36 × 29⅞ in. (91.4 ×* *75.9 cm.). The Metropolitan Museum of Art, New York, Alfred Stieglitz Collection, 1969* *(69.278.1).*

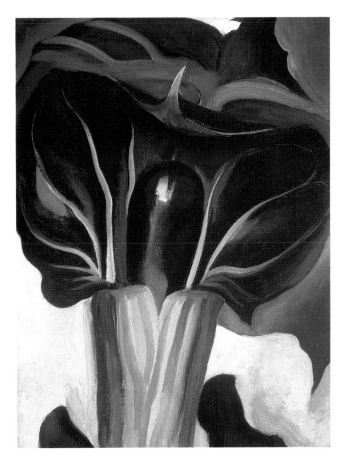

PLATE 8. *Georgia O'Keeffe, Jack-in-the-Pulpit I, 1930, oil on canvas, 12 × 9 in. (30.5 × 22.9 cm.). Private collection, courtesy Gerald Peters Gallery, Santa Fe, N.M.*

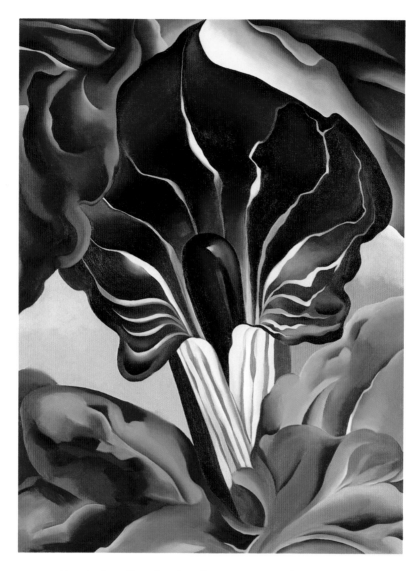

PLATE 9. *Georgia O'Keeffe,* Jack-in-the-Pulpit No. II, *1930, oil on canvas, 40 × 30 in. (101.6 × 76.2 cm.). National Gallery of Art, Washington, Alfred Stieglitz Collection, Bequest of Georgia O'Keeffe,* © *1996 Board of Trustees, National Gallery of Art, Washington.*

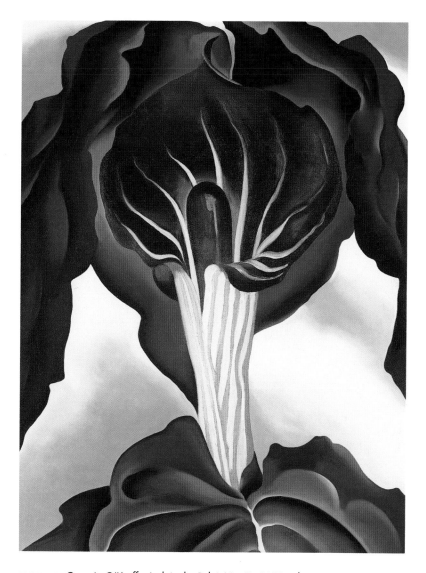

PLATE 10. *Georgia O'Keeffe, Jack-in-the-Pulpit No. III, 1930, oil on canvas, 40 × 30 in. (101.6 × 76.2 cm.). National Gallery of Art, Washington, Alfred Stieglitz Collection, Bequest of Georgia O'Keeffe, © 1996 Board of Trustees, National Gallery of Art, Washington.*

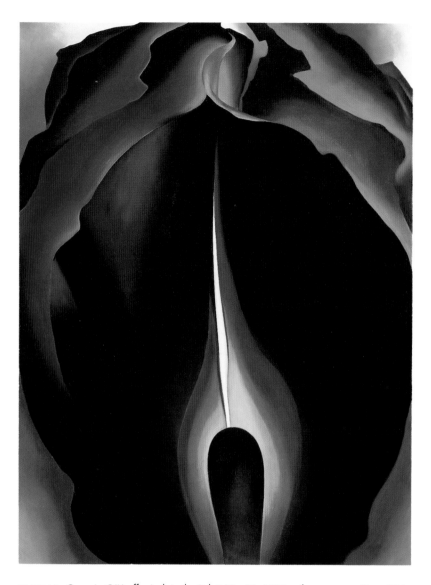

PLATE 11. *Georgia O'Keeffe, Jack-in-the-Pulpit No. IV, 1930, oil on canvas, 40 × 30 in. (101.6 × 76.2 cm.). National Gallery of Art, Washington, Alfred Stieglitz Collection, Bequest of Georgia O'Keeffe,* © *1996 Board of Trustees, National Gallery of Art, Washington.*

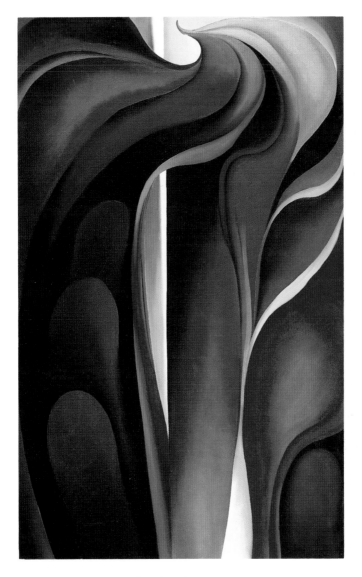

PLATE 12. *Georgia O'Keeffe, Jack-in-the-Pulpit No. V, 1930, oil on canvas, 48 × 30 in. (121.9 × 76.2 cm.). National Gallery of Art, Washington, Alfred Stieglitz Collection, Bequest of Georgia O'Keeffe, © 1996 Board of Trustees, National Gallery of Art, Washington.*

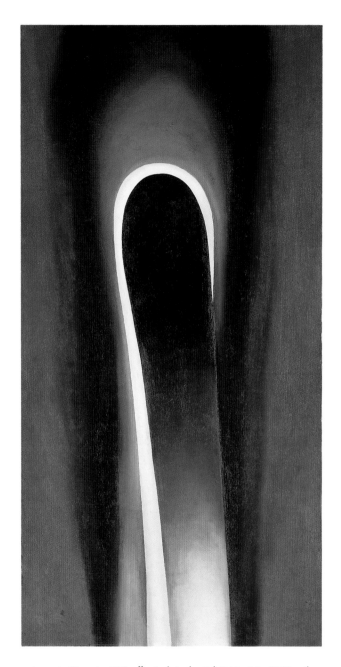

PLATE 13. *Georgia O'Keeffe, Jack-in-the-Pulpit No. VI, 1930, oil on canvas, 36 × 18 in. (91.4 × 45.7 cm.). National Gallery of Art, Washington, Alfred Stieglitz Collection, Bequest of Georgia O'Keeffe,* © *1996 Board of Trustees, National Gallery of Art, Washington.*

"capable of understanding the power and splendor of a reality which is simple and natural and single." From his new position, moreover, he understood himself and his former fear of sex: in particular he realized that "when I once told you that I was afraid of an O'Keeffe, it was not of the O'Keeffe I was afraid but of myself." [27] As if to make amends for that earlier projective response and come to terms with his own repressions, Arkin even enclosed in his letter an essay on O'Keeffe in which he tried "to be definite, not dogmatic"—to confront her work more directly, on its own terms rather than his. Now when he looks at her work, the body is banished from his thoughts, replaced by quasi-mathematical abstractions: "Never does O'Keeffe in any of her paintings speak of the luscious sensuous ooze and glow of things. With thin nervously patient fingers she takes the flowers and twists them into strange, gigantic multiples of themselves, takes fibre and pistil and stamen and leads as if she were demonstrating in floral calculus some infinitely compound progression."

Nothing in Arkin's letter suggests that he meant his missive ever to be published. The same cannot confidently be said of the second document, a letter written early in 1934 by no less than Lewis Mumford to his friend and lover, the writer and designer Catherine Bauer. (Anyone who publishes his own correspondence may be thought always to have written with one eye on posterity, yet Mumford's letter seems no less sincere for all that.) He had just seen, to his pleasure, the latest O'Keeffe exhibition, a retrospective: "The show is strong," he wrote: "one long, loud blast of sex, sex in youth, sex in adolescence, sex in maturity, sex as gaudy as 'Ten Nights in a Whore House,' and sex as pure as vigils of the vestal virgins, sex bulging, sex opening, sex tumescent, sex deflated." Of course Mumford too was projecting, though unlike Arkin, he clearly enjoyed the sensation of seeing sex in paintings. Like Arkin, by contrast, and perhaps speaking too as a self-avowed convert to psychoanalysis, he knew what he was doing; his letter continued, mixing honesty with more than a little boastfulness: "After this description, you'd better not visit the show: inevitably you'll be a *little* disappointed. For perhaps only half the sex is on the walls: the rest is probably in me." [28]

In the light of this various testimony, does it not seem safe to conclude that O'Keeffe's viewers are projecting, using her pictures as a catalyst and repository for their own attitudes—their desires and prohibitions—concerning women? As viewers of O'Keeffe, they invent a stance toward both the woman and her

art that thus seems to meet both personal and cultural needs. O'Keeffe's art, we might say, offers them a site in representation for the enthusiastic avowal of the sexualized scripts that direct their understanding of male and female identity. It is a site where fantasies of an unbridled feminine sexuality and the female orgasm can be enlisted to stand as surrogates for—no, as the vehicles of—an imaginary male experience of potency. Never mind O'Keeffe's own sexuality— or her feminism. Her art can nonetheless be made to play a role in the sexual aspirations and explorations of its culture, and in the 1920s holding action against the women's movement, in each instance mirroring to viewers both their beliefs about women and the urgings and strivings of their own sexualized selves. Such enlistments of her art of course continue: consider for a moment some recent appropriations of the painter. Nowadays she is no longer necessarily taken to represent the Eternal Feminine. Instead she is used to reflect our current national obsession with familial dysfunction and sexual abuse, and her life re- written to conform with that scenario. Hence we learn from Jeffrey Hogrefe, a recent toiler in the vineyard of O'Keeffe biography, that hers is a story marked by "repressed homosexuality, incest-induced rage, madness, coercion and de- ceit." We discover the dubious truth that "by the time she received a measure of success in her early thirties, she already bore the heavy armor of the seriously abused."[29]

This reads like biography for the age of Oprah, having more to do with sales and scandal than anything else. Yet I do not believe O'Keeffe's other critics can be so easily dismissed, despite their own transparent motives. There are several reasons I am prepared to think they deserve more serious treatment than a label and a shrug, chief among them being the peculiar passion of the writing, in both its public and private guises, and the uncanny agreement of these various opinions over the years. For the view of O'Keeffe's art as essentially feminine has proved to have remarkable staying power, surviving well into the 1980s and even beyond. It is gospel for a whole range of viewers whose opinions might otherwise be thought to have little or nothing in common. I find it hard to imagine, for example, two such disparate characters as Stieglitz and Judy Chicago agreeing about anything other than O'Keeffe; the one born in 1864, the other in 1939, they lived and worked at a real cultural remove. Yet they do concur, however improbably, in asserting the femininity of O'Keeffe's art. True, Chicago, writing in 1975, put the matter more baldly than Stieglitz; for her

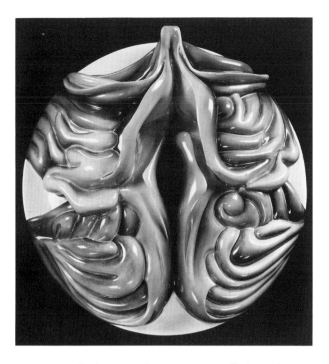

FIGURE 11. *Judy Chicago et al., "Georgia O'Keeffe Plate,"* The Dinner Party, *1979, mixed media. Photograph courtesy of Through the Flower,* © *Donald Woodman.*

this was a principle that needed no hyperbolic argument or special pleading, other, that is, than its confirmation in Chicago's own experience: "I felt that O'Keeffe made a similar connection between herself and her work. In her paintings the flower suggests her own femininity, through which the mysteries of life could be revealed." [30] Her visual rendition of this idea has something of the same literal quality—though with rather more surprising results. Even now Chicago's *Dinner Party* seems outrageous; each table setting—including the sumptuous, tumescent place laid for O'Keeffe, the only living artist so honored—defines a famous woman by a plate full of genitals from which we as viewers are invited to sup (fig. 11). It hardly needs saying that this formula is every bit as blatant about the bodily essence of O'Keeffe's art (let alone female achievement, or even women themselves) as the notion of a woman on paper: clearly the work's desires and pleasures, as well as its rhetoric, are lodged in this one idea. Chicago dissents from Stieglitz's opinion only in her understanding of where in O'Keeffe's work—in her imagery, not her abstraction; in the flower rather than

the line—her identity as a woman can best be grasped.[31]

By all accounts O'Keeffe herself had little sympathy with the enthusiasm of 1970s feminists for her art. She found them generally "undignified," turned Gloria Steinem away from her door, bouquet and all, and refused to allow Chicago to reproduce her paintings.[32] Can an antifeminist produce feminist art? Chicago does not hesitate to own up to this apparent contradiction, acknowledging flatly that O'Keeffe "resisted articulating her commitment to a female art, despite the fact that her work clearly reflects that commitment."[33] The refusal could be forgiven, however, since active collaboration was to Chicago's mind secondary to the greater achievements of O'Keeffe's career. Or, as Chicago put it, "The facts of her life and the strength of her images speak louder than do her fears of standing with other women."[34] Those "fears," however, were perhaps more selective and of more recent origin than Chicago was in a position to realize. In 1974 she could not have known of O'Keeffe's several efforts, fifty years earlier, to "stand with other women"—and to get them to stand with her—in order to adjust the terms of her reputation. O'Keeffe made little effort at the time to disguise her distaste for the rhetoric that first claimed her pictures as "woman pictures." Her letters, for example, are riddled with dismay at the journalists' interpretative stock-in-trade: "I don't like publicity—it embarrasses me— . . . one must be written about and talked about whether one likes it or not—It always seems they say such stupid things."[35] Or "Rosenfeld's articles have embarrassed me—I wanted to lose the one for the Hartley book when I had the only copy of it to read—so it couldn't be in the book. The things they write sound so strange and far removed from what I feel of myself."[36] Or "Every time I think of that page in *Vanity Fair* I just want to snort."[37] The page in question was a spread of photo vignettes of six artists, grouped above the inevitable title "The Female of the Species Achieves a New Deadliness." About O'Keeffe the copywriter rambled on happily: "Her work was undistinguished until she abandoned academic realism and discovered her own feminine self. Her more recent paintings seem to be a revelation of the very essence of woman as Life Giver." This must be where O'Keeffe stifled a snort: according to her there was only one line of type worth salvaging from the entire layout, the line at the bottom, which forsakes the patter about "the feminine self" for rather more professional diction. It reads, "Women painters of America whose work exhibits distinctiveness of style and marked individuality."[38]

It is tempting to conclude, on this basis, that in 1925, when O'Keeffe approached Mabel Dodge Luhan to write about her art, she was looking for something more along these lines—some greater attention to the "distinctiveness" and "individuality" of her work. At the time, however, O'Keeffe herself seems to have felt less than certain about the actual form a better criticism might take. She knew she was looking for someone—a woman—to "write something about me that the men cant [*sic*]." And she was ready to entertain the possibility that a more "personal" criticism, one drawn from a woman's life experience, might be as much an improvement as a treatment couched in a more professional tone. Her letter to Luhan expresses these various possibilities, albeit in a vague and halting way: "What I want written—I do not know—I have no definite idea of what it should be—but a woman who has lived many things and who sees lines and colors as an expression of living—might say something that a man cant—I feel there is something unexplored about women that only a woman can explore—men have done all they can do about it." [39]

The result of this vague invitation—Luhan's astonishing essay "The Art of Georgia O'Keeffe"—was never published. Nor is it clear that O'Keeffe ever read it; had she done so, it seems unlikely that her friendship with Luhan could have survived the shock of this particular "exploration" of O'Keeffe's work. Take, for example, the assertions with which the essay leads off: "The art of Georgia O'Keeffe is unconscious. It is the poignant speech of her living plasm talking while she sleeps, for her work is the production of a sleepwalker and one feels indelicate looking upon these canvases—for here are the utterances of one taken unawares; here indeed is made manifest the classical dream of walking naked on Broadway." [40] According to Luhan, O'Keeffe's painting is evidently something worse than simply natural; it is involuntary, somnolent, beyond reason, unconscious—and profoundly embarrassing by virtue of those qualities. They mean, moreover, that when her art is put in the service of Stieglitz the showman, it operates merely to titillate and confuse: both the unaware viewer and Stieglitz himself feel its arousing effects. Dripping with irony, the essay enjoins its readers to a more direct approach:

So take Georgia O'Keeffe, then, and look boldly at her work. It is there for you to see. Do not feel embarrassed. Quiver and flush as you look and you will delight the showman. (We cultivate sensitiveness here in this Intimate Gallery.) Speak of

feeling and of power, of woman, and of the soul. . . . The showman will burn a trifle warmer at your recognition of this woman's vibrant sex. But he will not know why he burns, nor why his eyes glow with a deeper, darker fire.

Oh no! We do not wish to *know* here; we wish *not* to know. So to keep more firmly sealed from life the fountains that rise about us. So to keep from transformations more challenging to our maturity these energies that may remain *ours* only so long as they do not transform.

This woman's sex, Stieglitz, it becomes yours upon these canvases. Sleeping, then, this woman is your thing. You are the showman, here boasting of her faculty. More—you are the watchman standing with a club before the fate of her life, guarding and prolonging so long as you may endure, the unconsciousness within her.

You have not harvested these fruits, Stieglitz, you have not transformed these fires into purer being. You were not able to do this. Now, then, you immure them in an "Intimate Gallery" and we others, we go to look at this filthy spectacle of frustration that you exalt and call by the name of *Art*. You are a *camera*-man, Stieglitz, and the essential objection to photography applies to you. You do not create. Endlessly you re-present. . . . You photo-graph.[41]

Does it need emphasizing that Luhan made outrageousness a specialty? Saying the unsayable seems to have come naturally. But the unsayable is often evocative: Luhan's essay demonstrates the utter pervasiveness of the sexualized interpretation of O'Keeffe's art. That it erupts so lethally here, like friendly fire on the battlefield, says as much about O'Keeffe's reputation as any published critique. Its terms and tenor even manage to give an already distasteful formula a newer, nastier twist: "O'Keeffe externalises the frustration of her true being out on to canvases, which, receiving her outpouring sexual juices, lost while in the sleep of Unconscious Art, permit her to walk the earth with the cleansed, purgated look of fulfilled life!" If a woman here answers the artist's hope that she would "say something a man cant," it can only be as a nightmare fulfills a wish, given the sheer extremism of Luhan's condemnation of both parties. One an exploiter, the other exploited, both are deluded by two corrupting allegiances. First there is the Cult of the Unconscious—Luhan calls it the "Stieglitz hobby." And there is Art. Now the vitriol really begins to flow:

There have always been those who favor catharsis: since the Greeks we look for this type of relief. The deposits of art, then, lie all about us, no more significant than the other deposited accretions and excrements of our organisms. Art purging us of our unused powers and of our energies, permits us to unload them on the ground, but they turn to poison in our blood.

Art *does not* transform raw energy into being—it runs it off onto canvas and paper, into stone and wood. Art is a safety valve and these materials are the non-conductors of cosmic fire. The art of today is the negation of being . . . the art in these "*Intimate*" galleries! It is well to call them intimate, for they are among the other "comfort stations" of our civilized communities.

It is difficult to account for this essay's utter extremism without pointing to its feminist and psychoanalytic polemic: the property of a villainous husband, O'Keeffe exists insensate, a mere tool or appendage. But given Luhan's opinion of art, O'Keeffe could never be otherwise while painting. This is because "being" is the optimum condition: creation saps the strength—it only means unloading into the cultural latrine. Stieglitz, as a photographer, is furthest away from life. But he is most culpable in his relations with O'Keeffe. He functions as a kind of antianalyst, not the helpful confessor other critics saw in him. Instead of therapy, he offers his cult of the unconscious as an end in itself, since an unconscious O'Keeffe is more firmly under his control.

Strong stuff. When O'Keeffe finally got the review she was looking for (or at least an acceptable substitute), it took less objectionable form. An essay by the critic and poet Blanche C. Matthias published in 1926 (the year after the letter to Luhan) in the *Chicago Evening Post Magazine of the Art World*, it was, according to O'Keeffe, "one of the best things that have been done about me."[42] The improvement, from her point of view, was not just that Stieglitz is returned to a more acceptable character: he is once again depicted as untiringly devoted to art; his efforts are again selfless. But a real effort is also made to reinvent O'Keeffe along with her husband. Granted, her work is still profoundly feminine; it is still the direct expression of the artist herself. Matthias even concedes that Paul Rosenfeld's elucubrations about "unbounded sensations" do have something to say about her work. But a few new elements have now crept, however tentatively, into the mix: O'Keeffe now has "the trained mind of an intuitive woman for a tool" (never mind, for the moment, that the concept is deeply

contradictory). She is hardworking and uncompromising and, wonder of wonders, she "reasons logically." Her work, if magical, is also "stimulatingly powerful." And her artistic project is finally claimed as feminist.

The terms in which Matthias makes that claim are worth investigating: they keep in play throughout the tactical illogic, the conceptual compromises, conveyed by her notion of a trained intuitive mind. On the one hand, O'Keeffe has produced a woman's art, a claim that provokes a mealymouthed excursus on the limits of female artistic achievement: "We haven't done much in art, we women, but we are not in despair. O'Keeffe's own words to me were pregnant with the humble place in which we find ourselves today, a place that we accept until we earn a better one. The way is slow because we are not militant, we are only trying to give freedom to an almost unused force that seeks conscious expression."[43] How strange to read in the wake of such conciliatory claims a more stirring declaration of the threat O'Keeffe and her ilk will someday present to the order of things: "Without hesitation I say that women like O'Keeffe are dangerous to this world of affairs, especially dangerous when they are artists. The purity of woman may indeed become a virtue when she learns to express herself fearlessly in art and action. Let her add wisdom to her capacity for love and face life with the courage which her sublimest ideals demand, then look sharp, you world, who see in flag-waving an excuse for murder, and in power, your privilege to abuse. The O'Keeffes are coming!"[44]

Despite Matthias's indecision as to the precise political meaning of O'Keeffe's work—is it militant or not?—and regardless of her efforts to blunt her own main political message—is it militant or not?—her essay still stands as the marker of just how far critics were willing or able to go to distance themselves from the enthusiasms of a Rosenfeld or Stieglitz. The distance is not great. Even in this context O'Keeffe's work is relentlessly equated with her person—indeed, it seems to have been impossible, at this particular moment and site in American letters, to think much differently about artists and the objects they produced. (If, that is, those artists and objects were rated a success. Dove's painting *was* Dove, and Marin's Marin, all the more indelibly the better Dove and Marin were thought to be.) Moreover, any suspension of the gender categories that came with those identities was unthinkable—even when the writer, a woman, wrote to express her own loyalty to her sex. O'Keeffe was always and ever Woman—though a special kind of woman, it is true.

That special status, it was generally agreed, was communicated by her self-presentation: it was signaled likewise by presenting the artist herself in the text—by describing her clothes and her hair, citing her words, and so on. To Blanche Matthias she declared, "Too much complaining and too little work," as if the phrase were a pragmatist's mantra, and then proclaimed her dislike of cults and isms. (She had been asked if she was an Expressionist.) These, according to Matthias, were the utterances of woman "as is"—and O'Keeffe physically looked the part. Unrouged, uncorseted, unconstrained, unimproved by any familiar "feminine" artifice: her simplicity ultimately stood as the guarantee and contrast to the impassioned femininity of her painting and helped to make it unconventional—helped to make it legible as avant-garde. On her personal simplicity and directness, or so her various supporters claimed, rested the paradoxical truth value of her art: its uncanny ability to register the very essence of feminine being.

O'Keeffe's Modernism

The first of two main lessons to be drawn concerning O'Keeffe's reputation emphasizes O'Keeffe's practical response to the media's treatment of her. If her chosen tactics fell short of outright suppression (after all, she *didn't* lose Hartley's text), they certainly included efforts to solicit an alternative account. From her letters it seems that before approaching Mabel Luhan, she thought of two other writers—Sherwood Anderson and Katherine Mansfield—as possible champions of her art.[45] Stieglitz himself, meanwhile, not only refused to surrender his belief in "woman pictures," but defended it whenever necessary. Witness his response to Samuel Kootz's *Modern American Painters* (1930). Kootz had dared to air his doubts on the key article of faith: "As a record . . . of highly personal womanhood," he wrote of O'Keeffe's images, "they may be good propaganda, but there they end." Faced with such apostasy, Stieglitz worriedly turned to Arthur Dove for advice and support, both promptly forthcoming.[46] Dove fired off a salvo aimed at a telltale contradiction in Kootz's position, his inconsistency in condemning male painters as pathetically sexless and O'Keeffe as hyperbolically oversexed. One or the other might do, but not both. Nor would he stand for Kootz's preference for the "more thoughtful," less sexualized language of her New Mexican work, which announced a future as a better painter, when her

talents as a woman will help and not hinder her progress."[47] Dove had no time for a vision of O'Keeffe's art sans sex; it would lose its tonic effect: "The bursting of a phallic symbol into white light may be the thing we all need. Otherwise it would not bother them so," he wrote by way of a reassuring conclusion to his commentary.[48] Avenged, Stieglitz sent Kootz Dove's analysis.

In the meantime, however, the excesses of O'Keeffe's reputation had long since provoked her to tactical actions of her own. That she took them, even though her circle stuck to its original views of her art, raises a still more interesting issue: how she responded in paint. There can be no doubt that her artistic practice was revised in the light of her reception: the change in subject matter that Kootz heralded is but one instance—and only the most obvious one—of her efforts to rework and transform it. In what follows I argue that O'Keeffe had already begun the process of revision and response years before: during the first two decades of her career, her work is deeply marked by painterly efforts to renegotiate the terms in which her art presented itself to its viewers. Interwoven with the argument, moreover, are reflections that proceed from the second inevitable lesson to be drawn about O'Keeffe's reputation, a lesson that derives from the criticism's peculiarly homogeneous tone. O'Keeffe's pictures seem consistently to have presented their audiences with an unprecedented experience of bodily sensation—they create a special illusion of embodiment, one able to spark a peculiar process of revelation and exposure in viewers' minds. And viewers in turn have gone to great lengths to spell out that process. The purple prose is about *something*: saying *what* is the challenge to feminist criticism. It is essential to recognize that the biases and limits of the terms used to describe O'Keeffe's art do not preclude a struggle on the part of its audiences to name a special experience—one only her work offers. Bound up in that experience, paradoxically enough, are both the very essence of her ambitions as a modernist and the most serious threat to her self-respect as an artist. O'Keeffe staked her claim as a modernist painter on her effort to rewrite the terms in which the body could be experienced in representation. That effort in turn was at the root of critical readings—and readings-in. She seems to have been forced to respond.

My purpose, then, is not to discount or debunk previous responses to O'Keeffe, however untoward they may seem; they have not been paraded here simply as a spectacle of the sexist excesses of the past. Nor can we extract the artist herself from the conditions and culture that gave them rise. Instead we

need first to recognize that the imperatives and limitations of criticism imposed conditions that the artist was forced to negotiate not just as a person but also in paint. Her consistent public claim that she painted "what she felt" was in her view not exactly the same as the public's claim that she "painted as a woman." There was evidently a functional lack of fit between the two states: "she" could not easily find herself in "woman," at least as that identity was currently defined. (The two categories remain distinctly separate in her mind even at the moments of her most vehement allegiance to the cause of women, as in her 1930 debate with the editor of *New Masses*. Witness her declaration on that occasion: "I am trying with all my skill to do painting that is all of a woman, as well as all of me.")[49] Yet taking criticism of O'Keeffe as problematic for, even downright inimical to, her sense of artistic selfhood in no way licenses us to assume that she could single-handedly exempt herself entirely from cultural definitions of the female, had this been her goal. Hers must be thought of as a career inevitably marked by instances of assertion and denial, conciliation and resistance.

The primary site of these negotiations was her art. One place to begin demonstrating this claim is an image of the kind Anita Pollitzer showed Stieglitz back in 1916, the fourth in the series of charcoals O'Keeffe called *Specials* (plate 1). This is not the beginning, of course, in anything other than a symbolic sense, and in some ways it is the end point of a protracted process: O'Keeffe began to draw as a girl and received formal art instruction on and off from 1903 to 1916; her professional education began in 1905 at the School of the Art Institute of Chicago and continued in New York at the Art Students League in 1907–8. Along the way she used her graphic skills to earn her living as a teacher and technical draftswoman, updating them as necessary in summer courses and the like. The *Specials* had behind them a decade of experience from which they can be seen to profit, but at the same time, they mark her emergence as an "artist" for the first time.

There is no body in *Special No. 4*, no woman or man on paper; yet the avoidance of explicit figuration does not necessarily prove her critics wrong in their central claim: this *is* an imagery that solicits a bodily reading, despite the absence of bodily form.[50] It is the nature of the reading that remains to be defined. It hinges on the soft curved form that takes shape along the upper edge of the paper; a slightly paler version shadows the darker image and lends it further substance. Both the puckers and folds within the shape and its sheer visual

weight and centrality invite us to make it over into a body part—perhaps an appendage become detached from an unknown creature, perhaps a creature with an anatomy both full and drooping, now bent yet apparently capable of lifting itself. Yet this invitation is soon enough retracted. The form fades and flattens, losing corporeality as it travels down the paper, leaving only charcoaled strokes. Their intensity varies without resolving into form. Any sense of bodily presence thus cedes promptly to absence, to an encounter with the marks that made it. And this contradictory experience of bodily presence is elsewhere even more directly contrasted with bodily failure, or *dis*embodiment: this occurs in the elusive entity just emergent on the left. A shallow crescent of charcoal bounded by a broken charcoal line, it mimics the main shape but lacks precisely its density—its bodiliness, if you will. Its presence forces the comparison between the means and sensations of embodiment and their opposite, and between the charcoal and the illusion it is used to create. Nor does the contrast offer any resolution. The image does not prefer one vocabulary to another: it does not indulge more fully in summoning the effects of embodiment than in exposing their means, or vice versa.

Special No. 4 demonstrates O'Keeffe's approach to the issue of embodiment in representation: the insistence that sensations of the bodily should be difficult, even irresolvable, from the standpoint of the attentive viewer. Just how difficult may be judged from the ways in which its terms and premises are underlined, through a kind of reversal, in the image that followed it, *Special No. 5* (plate 2). Once again the sensation of a peculiar—in this case, peculiarly hectic—bodily experience is at a premium, and once again the viewer is not in a position to resolve the various quandaries that experience presents. It is impossible, for example, to put this plethora of forms—the festoons and nodes and strands— back together into a whole, yet equally impossible to dissociate them entirely. The picture is too full of forms for us to deny an illusion of some kind of bodily presence, but the forms are so many and push so close to the picture's edges— to both its front and sides—that they are not easily imaginable as making a whole. We are too much within the picture—within a picture crammed with embodiments, embarrassed by them—to attribute to the image any bodily coherence, much less a gender, other or larger than the diverse sensations it provides. And those sensations—above all, the insistent oppositions of light versus

dark—eventually demonstrate how impossible it is to be sure of the substance and presence of any form we see. The picture's world refuses to be static; rather, it demands the constant renegotiation of its terms.

Had O'Keeffe gone on from this point to produce a wholly nonfigural art, it might be possible to claim that these two works inaugurate concerns that would then dominate an entire career. The effort both to invoke and to destabilize an illusion of bodily experience, and to do so in recognizably modernist, notably self-referential terms, could consequently be taken as characteristic of the whole of her art. And the specific disclaimer of the body in representation as legibly feminine that both these *Specials* advance (a disclaimer typical of all the drawings in the group) would thus prove to have been reiterated so often as to brook no contradiction. The *Specials* present a bodily fantasy of both inside and out, bodily part and bodily space, and they do so comparatively, as their status as a series declares. These works are "special" in more than their meaning for O'Keeffe: one gauge of their difference is the odd exploratory brand of modernism they espouse. Yet these conclusions are only part of the story. The fact is that O'Keeffe did produce a figural art—its existence surely has decisive implications for any claim for the modernism of her art as well for viewers' responses.

And what about the rubric *modernist?* Is it really justified at this stage of O'Keeffe's career, or merely evidence of wishful thinking on my part? These pictures are self-referential, it is true, in both imagery and execution. But given their overt, not to say rampant, biologism, they may seem more generically "modern," in quotes, than modernist: their curvilinear rhythms may read more like holdovers from a European Art Nouveau that by 1916 was mostly on the wane. O'Keeffe most likely knew the style from posters and reproductions in the art magazines, rather than any high art source.[51] At the same time the asymmetries of placement, the figure/ground reversals, and the interest in the edge have clear affinities with the simplified and orientalizing protocols urged in the teachings of Arthur Wesley Dow, in whose prestigious courses O'Keeffe had been enrolled to earn a certificate from Teachers College, Columbia. Their focus was likewise the language of modern graphic and interior design, not easel painting: its purpose, as Dow imparted it, was to instruct teachers in tasteful principles that would equip their (female) pupils—the housewives of tomorrow—to decorate their homes in an attractive and orderly way.

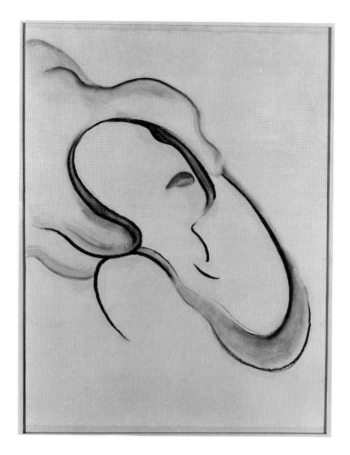

FIGURE 12. *Georgia O'Keeffe, Abstraction IX, 1916, charcoal on paper,
24¼ × 18¾ in. (62.2 × 47.6 cm.). The Metropolitan Museum of Art,
New York, Alfred Stieglitz Collection, 1969 (69.278.4).*

The result of these various influences from the "moderns" of taste and design
is a modernist pidgin, if you will—a representational language drawn from
diverse sources encountered in the decade or so that passed before O'Keeffe had
the chance and means to become a professional artist. For the viewer to fix on
any one language, however—to see these works as being most like Dow, for
example, or Art Nouveau—is to fail to grasp how much their chief quality is
their willful eclecticism. With no fixed allegiance to any particular system,
making and remaking her art as she went along, O'Keeffe seems to have felt
licensed to recombine and invent at will from the materials at her disposal. That
freedom had two main consequences: the departure of her imagery from any

FIGURE 13. *Alfred Stieglitz,* Exhibition of O'Keeffe Watercolors and Drawings at Gallery 291, April–May, 1917, *photograph. Courtesy of Virginia Zabriskie.*

particularly coherent or legible bodily form (she had absorbed no hard and fast allegiance to observation, despite her year at the Art Students League and apprenticeship with William Merritt Chase: even the Chase Still Life Scholarship had not done the trick) and the guiding confidence, from this time onward, that (distanced as she was from any one particular or identifiable artistic "source") she would use a cobbled-together language, one assimilated in fits and starts, to paint "what she felt." And she would do so to please herself.[52]

These various influences are very much in evidence in the charcoal she called *Abstraction IX* (fig. 12). The drawing was one of the first works she sent to Stieglitz, and he liked it enough to include it in the second of her New York shows, where it hung just to the left of *Blue Lines* (fig. 13). Given the surrounding abstractions, it seems worth asking not only what it was doing there but why it came to exist in the first place. In a literal sense, the answer is straightforward. O'Keeffe sent her drawing to Stieglitz, who hung it. Its function as part of the show, however, seems to me rather more rhetorically charged: it provided a sign of sufficient identity, a brake or safety valve against the generalities and instabilities of her more thoroughgoingly abstract works. In this context it could ensure, even insist, that O'Keeffe's work be seen "as that of a woman"—an assurance that perfectly suited Stieglitz's purposes in championing

this woman's art. We might even claim that the drawing was hung amid the bodily indeterminacies of her other works to figure the artist herself: to give her an identity in terms that the other works refused to supply.

The sheer *existence* of *Abstraction IX*, however, was contingent on rather different factors. Its counterparts are the *Specials*: it shores up their claim to that term. That is to say, it presumably came into being as the result of its maker's effort to engineer a comparison between the two repertoires of abstraction and figuration, and two versions of modernism as well. If the one kind of drawing takes the bodily as the unstable subject of representation, the other revokes precisely that instability by tying a heretofore indeterminate experience of bodily sensation back down to an aestheticized version of the female form. Its maker's effort here to equate the body with the marks that made it—to absorb it into those rhythms and curves—reverses, not the ethics of modernism, but the legibility of the formal protocols—the play of whole and part, presence and absence, inside and out—that organize the other works.

I see O'Keeffe's impulse toward themes and oppositions, her habit of testing and explaining her language by such juxtaposition, as a main motor of her art.[53] The practice was soon repeated in late 1917 and early 1918, for example, more or less directly in the wake of her second New York show. In this instance her medium was watercolor, not charcoal; for the most part using uniformly sized pieces of paper (all approximately nine by twelve inches, they may have been part of the same lot or packet), she undertook two series of works. One was a group of abstractions called *Portraits* (or sometimes simply *Abstractions*), the offspring of a sequence from 1916 titled *Red and Blue*. The other was a collection of seated female nudes—there are at least sixteen in all. (I have chosen four representative examples [plates 3–6] for illustration here.) Many of the nudes use the same colors as the portraits/abstractions; they all depart from Rodin's watercolors—works like those that O'Keeffe had admiringly encountered in the pages of *Camera Work*.[54] (She actually saw the Rodin show at 291 in January 1908, though her response to the genuine article was far from positive at the time.)[55]

To use Rodin so boldly is one way of demonstrating the aspiration, not just to master the task of depicting of the body—though since these seem to be O'Keeffe's first and only nudes outside the life class, that aim cannot be discounted—but to give it an up-to-the-minute inflection. To make Rodin's already

elliptical handling look fussy, maybe downright trivial, by your utter directness registers a still more ambitious goal. This is revisionism, not just mastery. Of this, more in a moment: the parallels of size and coloration between O'Keeffe's two series, the nudes and abstractions, are first of interest here.

They argue for again seeing the two groups of pictures as linked opposites, images whose meanings are generated primarily through the pattern of relations and contrasts between them. The questions posed seem urgent, and they are given particularly pungent form. What is the proper object of representation in modernist practice? Will the watery accidents and ellipses of this new abstract way of working provide access to some inchoate and movemented interior—to a space that might finally literalize the modernist notion of an inner world? Or is the business of modernism to render exterior forms—above all, the form of the woman? Might it not be discovered in practice that these two operations have more than a little in common, even while they struggle to declare their specificity, their different sense of what watercolor can do? Neither effort is ultimately more present or urgent than the other: the workings of the medium in both cases promote and then revoke confidence in the effects each makes its own. A limb puddles out into pigment: a puddle of pigment coheres just enough to suggest an appendage: watercolor may in one instance trace light and shadow on legs, but elsewhere it may simply make patterns that refer not at all to body parts. Black may grade to red so as to convey hair and profile, shoulders and belly—or then again, when used elsewhere, it may do nothing of the sort. By such devices the viewer is offered an experience of what we might term effects of interiority and exteriority: bodies and spaces are made uncannily alike. Yet the radical difference between the two kinds of imagery means that we will nonetheless never confuse them, even though it might be claimed that in a technical sense their component parts are essentially the same.

That O'Keeffe is evaluating and comparing the relative claims of abstraction and figuration is further confirmed by the special characteristics of these nudes as a category unto themselves; particularly those characteristics that put them at greatest distance from other nudes—from the figural drawing of Rodin, for example. I am thinking of the ways the artist uses water and color to neutralize the customary fiction of the nude as a presence or consciousness available both to receive and return the viewer's (self-interested) scrutiny. It is impossible, in other words, to attribute much personhood or identity to any of these nudes;

their bodily substance, though certainly considerable (their coloration makes them seem much less elusive than a Rodin nude), again and again shows itself to be merely a matter of medium. This impression—an implicit demystification of the nude's familiar codes—relies on a variety of tactics. Time and again, for a start, the nude lacks eyes—her face is merely a flat field of pigment. And if she once did have eyes, they have long since bled out into—or been consumed by—dark stains or pools of color. In both cases, the result is oddly the same: the figure seems blind—blind to both our presence and our demands. Though her body may be presented for our perusal, the person herself seems absent, and this distancing effect is further enhanced by the extreme deliberation of O'Keeffe's use of watercolor. These are pictures that, though they may look spontaneous, are actually the result of repeated returns to the page: with nearly every touch the brush bore a different hue; after each touch, work was not resumed till the paper had been allowed to dry.

Understanding this methodical procedure means acknowledging both its slow tempo and its visual result: this is a method that ultimately undermines any confidence that these works were painted from a living model, from another woman. A photograph seems more likely to have played that role, or memory, or even a mirror; in any event, they were painted under conditions that made the actual identity of the model seem secondary.[56] O'Keeffe seems to have been much more absorbed by the qualities of the picture taking shape on the page— many of them seem like puzzles fit together according to their own rules—than concerned to produce a visual equivalent of an individual's presence to the eye. The effect achieved is of bodily substances having been surrendered to the exigencies and erasures of the processes of their making; and while these might in some instances be highly allusive—I am thinking of the stain in the lap and between the legs of *Seated Nude X*, which has precisely the color of dried and clotted blood—such allusions are not invariable or inevitable. The body most often takes shape as a vivid formlessness—a palimpsest of stains and marks. The oxymoron helps to convey the pull of shape and color against the viewer's desire for knowledge of the body's forms. This effort to sever watercolor from simple bodily description, moreover, seems ultimately at least as powerful as the impulse toward embodiment, to make bodies that are vividly *there*. The result is disorienting: O'Keeffe's nudes manage to seem both present and absent—pres-

ent in or as absence—with both states the effect of her reconfiguration of abstract forms.

More than a little evidence suggests that O'Keeffe continued to think of abstraction and figuration very much along these lines—that is to say, as both powerfully, even structurally, related and also endlessly opposed. Some of that evidence is textual, as is often the case with O'Keeffe. There is, for example, a remarkable passage from her correspondence with the novelist Sherwood Anderson. The moment is 1924, as she prepared for a joint exhibition of her paintings and Stieglitz's photographs. The year before she had had her largest show to date: the critics' responses had left her shaken:

> I have had a cold—and have been shut up in my room since I knew the event was to take place—and nothing goes on in my head—His is the continuation of a long fight—Mine—My work this year is very much on the ground—There will be only two abstract things—or three at the most—all the rest is objective—as objective as I can make it—He has done with the sky something similar to what I had done with color before—as he says—proving my case—He has done consciously something I did mostly unconsciously—and it is amazing to see how he has done it out of the sky with the camera—.
>
> I suppose the reason I got down to an effort to be objective is that I didn't like the interpretations of my other things—so here I am with an array of alligator pears—about ten of them—calla lilies—four or six—leaves—summer green ones—ranging through yellow to the dark somber blackish purplish red—eight or ten—horrid yellow sunflowers—two new red cannas—some white birches with yellow leaves—only two that I have no name for and I don't know where they come from—[57]

This last phrase should be underlined: "two that I have no name for and I don't know where they come from." O'Keeffe is describing pictures that, unlike Stieglitz's, seem to their maker to have been done "unconsciously" (Luhan was right all the time!): pictures that, again unlike Stieglitz's, now strike her as entirely too open to misinterpretation. Hence the turn to objectivity—callas and sunflowers, avocados and cannas, dahlias and a whole spectrum of colored leaves; the change meant new subjects, certainly, but more important, it provided an evasive strategy.

FIGURE 14. *Alfred Stieglitz, Georgia O'Keeffe Exhibition, Anderson Galleries, 1923, platinum print. Manuscripts and Archives Section, New York Public Library, New York, Mitchell Kennerley Papers.*

Explicit as this letter is about presenting objectivity as both the alternative to abstraction and a guarantee against misreading, we should take care to understand it, not as a literal statement about the phases of O'Keeffe's development (along the lines of "first came abstraction and then objectivity"), but rather as the verbal expression of a confidence that the two practices could be significantly opposed. Yet a glance at one of the photographs documenting the 1923 show (fig. 14)—the show O'Keeffe seems to be recalling in her letter—makes it clear that she had already dispatched plenty of fruits and flowers into the public realm. It was not so much O'Keeffe's practice that underwent a change in 1924 as her sense of the need to negotiate the terms of her reception. She would try increasingly to influence the terms in which her work would be named, no longer offering up paintings she herself had "no name for." She could now say *canna* or *calla* or *horrid yellow sunflower*, and by using those words and

presenting those pictures could—and would—resolutely deny the always re-current, always sexualized interpretation of her art.

But do not pictures proverbially speak louder than words? In this case they certainly do: they bespeak above all the tenacity of O'Keeffe's notion that de-spite their differences, representation and abstraction could be developed as cognate means to explore a special notion of embodiment. If the two were es-sentially alike, then the absorbing and destabilizing effects and experiences achieved by her version of abstraction might conceivably be able to masquer-ade as the experience of objectivity. Take for example the terms in which the viewer is invited to consider the Metropolitan's great *Black Iris III* of 1926 (plate 7). In keeping with its maker's earlier resolution, there is no verbal claim for abstraction registered here. On the contrary, the title declares its interest in our achieving a properly botanical point of view. And it seems easy enough to oblige. How comfortable it feels at first, how confirming of our skills as viewers, to see in the picture the flower the title names. There are the three downward curving petals that botanists call the falls, and the rising petals known as standards; there is even a small section of bristling strokes we can—and should—read as the iris's beard. Yet we need not mount a very elaborate thought experiment to arrive at another view: "Imagine that you come from another planet, one where no irises grow." Even this is too complicated: how about simply thinking of the canvas as an abstract picture in masquerade? Such an imagining would put its stress on the elements of the picture that renege on the rhythms and regularities of natural form and erode the boundaries between substance and space. Take, for example, the two patches of greenish gray in the bottom corners. Based on their analogies with other areas of the image's mar-gins, they seem clearly to represent space or ground. But now look along the edge just a short distance to the right and left of each corner, to the two analo-gous gray patches flanking the central black shape. These patches must now be part of the iris itself: if not, they must interrupt its wholeness, opening twin voids at the core. Such moments are frequent in the picture: look for another example at the transparent gray membrane at the crest of the flower, reaching down from the upper edge. Why is it transparent? Where does it actually lie? Or what about the strangely crisp gray triangle edged in white and gray, just to the left of center? What manner of form is this? Does it recede or project? Is it part of the flower at all? Looking at the way shapes are painted brings no

resolution: each stroke is put on with a dry and evenhanded economy that re-fuses to perform or imitate. When such uncertainties occur, it is as if the viewer is asked to adjudicate among competing presences and absences, forms whose material status fluctuates increasingly the longer she allows herself to look. The picture represents an iris, yes, but with a difference: the difference of Cubism, its lessons learned but in the process naturalized. As Sheldon Cheney says, "There are few painters whose work would so well repay study for detection of the interrupted abstract element."[58] Or, to put the matter somewhat differ-ently, O'Keeffe has created an image that, for all its apparent intelligibility, is fraught with local unfamiliarities; she means the sheer strangeness of these painted phenomena to strike us and reorient our vision. How else should we account for the near hallucinatory myopia of the picture's point of view? It means that the flower is not simply an object to be looked at but a world to be lost in. This is how O'Keeffe "repays study": with interest, with the insistence that the familiar is essentially unknown.

What I am aiming to demonstrate is the continuity between objectivity and abstraction in O'Keeffe's practice—the evident relatedness, we might say again, of her treatment of flower and line. I want to make clear, moreover, that these connections remain intact even when we take representatives of the con-troversial abstractions of 1923 as the specimen pictures (figs. 15, 16). For all the evident clarity of their pictorial format—like flowers they seem to have their own anatomy—they induce the viewer to see the bodily in novel, unex-pected terms, and propose those revisions against the grain, as it were, of the overall form of the picture. Here is a language of centrality and symmetry, of fold and depth and core. Yet the apparent invitation to analogize such struc-tures—to make of their formal histrionics a specially female performance—is rescinded before too long. If one is provoked, for example, into thinking that the "core" of either picture, its central opening, is a space the imagination might comfortably or pleasurably inhabit, that fantasy is soon enough dashed. The viewer realizes, in the one instance, *Gray Line with Lavender and Yellow*, that the "mysterious center" is in painterly terms not one whit different from the gray and shifting ground of the object's surroundings: when this goal is reached, it fails to satisfy. And in the other case, *Gray Line with Black, Blue and Yellow*, the very symmetry of the folds eventually makes us realize the lack of reward the center provides. Once we are caught up in comparing the resemblance between

the two sides—there is no other narrative of growth, say, or generation to take precedence over such formal considerations, and no horticultural fantasy on parade—the center itself appears increasingly flat and detached, a mere lifeless lozenge of flat black paint. The body in the painting becomes the body *of* the painting: a prosaic demonstration of the terms that create its visual effects.

When I suggested, a few lines above, that O'Keeffe's flower pictures might be thought of as abstraction in masquerade, I used that term advisedly. I wanted to be able to call attention to what was evidently a strategic decision on the artist's part to seek a refuge for her art in the representation of natural objects—not just irises, of course, but a whole variety of other blossoms, as well as leaves and stones and shells. O'Keeffe sought allegiance, not so much with the natural world as a whole, as with its fragments and ephemera—bits and pieces she could capture, remove, and paint. Such an alliance, of course, was as unexceptionable as it was strategic; it forced the association (if any urging was necessary) between a painter who was a woman and that realm, Nature, insistently held to be woman's sphere. O'Keeffe sought shelter in that association; once it was in place in her viewers' minds, she could pursue a modernist protocol—the calculated destabilization of the visual field—without too much opposition. She could be confident that most viewers would see what she first asked them to see—orchids or pansies, poppies or larkspur or petunias—and be convinced that this was reality ("The Beauty of Nature") rather than some strange and urgent hallucination. Yet really looking at O'Keeffe's flowers means putting aside any confidence in the orderly verities of the natural world. Her pictures offer an experience that can rob viewers of familiar comforts: a stable vantage point in the world of objects, for example, and the assurance that objects and spaces observe the decencies—the conventions that normally insist on registering the former as present and substantial to the senses, and the latter as absences or voids. Color is similarly indecent—that is to say, its frequent shrillness and acidity can wreak lurid chemical havoc on the modulations of an organic blossom's hue. Such intensities point again to both the visionary and the modernist aspects of the work. Like the dissonances of modern music or poetry (Edmund Wilson made this point about O'Keeffe's color back in 1925, and Marya Mannes again in 1928) they seem to negotiate a certain distance from nature, and to compensate for it by refusing to pale in contrast to that abandoned world.[59]

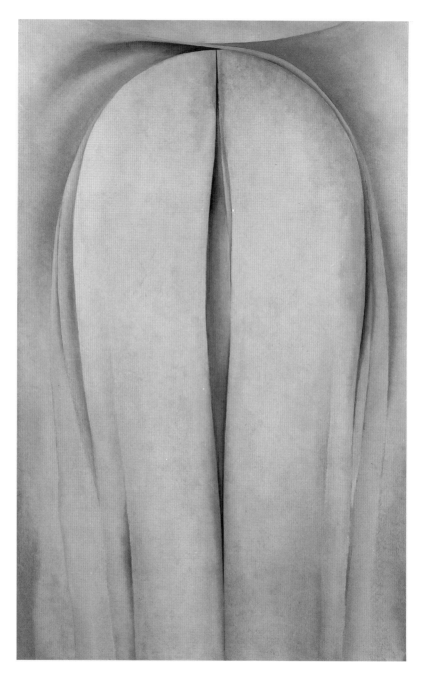

FIGURE 15. *Georgia O'Keeffe, Gray Line with Lavender and Yellow, ca. 1923, oil on canvas, 48 × 30 in. (121.9 × 76.2 cm.). The Metropolitan Museum of Art, New York, Alfred Stieglitz Collection, Bequest of Georgia O'Keeffe, 1986 (1987.377.1).*

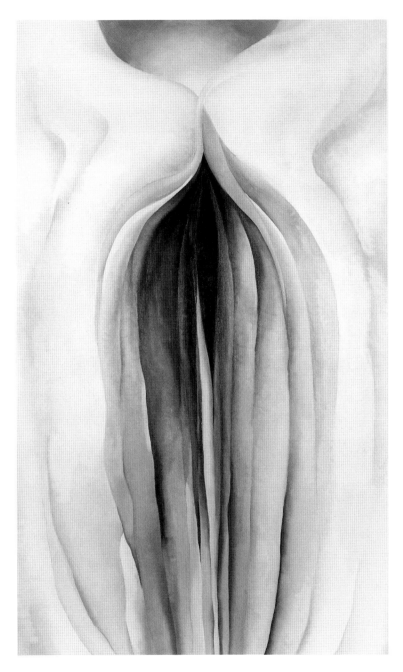

FIGURE 16. Georgia O'Keeffe, *Gray Line with Black, Blue and Yellow*, ca. 1923, oil on canvas, 48⅛ × 30³⁄₁₆ in. (122.2 × 76.7 cm.). The Museum of Fine Arts, Houston, museum purchase with funds provided by the Agnes Cullen Arnold Endowment Fund, 77.331.

I take as evidence in support of this reading of O'Keeffe's flowers her viewers' notable indecision about how "natural" her images actually are. Take for example the observations of two different visitors to her 1928 Intimate Gallery show. The exhibition ran for the better part of two months, a long time for gallery exhibitions of the day: hence it was both possible and relevant for *Creative Art* to print reviews in two successive issues. First, in January, came "Georgia O'Keeffe: A Woman in Painting," an essay by Louis Kalonyme, a critic much involved with 1920s avant-garde theater (he was a friend and supporter of Eugene O'Neill). In February the feminist essayist Marya Mannes took a turn. Their disagreements are simple: according to Kalonyme, "no one can paint the living quality of flowers and branches and leaves quite like O'Keeffe, nor can color be made more organic." Thence followed an enthusiastic enumeration of the pictures' alleged hues: the "cool fresh green of the sea's mountain of ice" and "the singing blue of sun drenched summer seas"; "the orange and red moment before the advent of late summer," and the "yellow and purple and white (she makes of white a new color) flowers," and so on. All this is prefatory to Kalonyme's grand, quasi-Nietzschean finale, in which O'Keeffe is said (once again) to reveal "woman as an elementary being, closer to the earth than man, suffering pain with passionate ecstasy, enjoying love with beyond good and evil delight [*sic*]."[60] No wonder Mannes went straight for the jugular. "Let us once and for all dismiss this talk of 'a woman's painting' and 'a man's painting.' Any good creative thing is neither aggressively virile nor aggressively feminine; it is a fusion of the best of both." The imperative where O'Keeffe is concerned is to talk, not about her gender, but about her painting: particularly, it must be said, about Mannes's reservations on that score. She admits to being "somehow repelled by the bodilessness of it." "If there is one quality her painting lacks more than anything, it is plain pumping blood—that kinship with the earth that even the greatest ecstasies must keep to sustain their flight." And the flowers are Mannes's case in point: "It is always a question whether the flowers in an opium dream are more beautiful than the flowers in the field; or the Garden of Eden than the first protoplasm."[61]

These two responses again make visible the central paradox: if O'Keeffe's flowers dream of an Eden where they might be free of their bodies, they also admit that it is only a dream, one that not all viewers will recognize or enter.

In fact they put their trust in the possibility of being seen as "the flowers in the field," able to convey the "living quality" of the things they represent. It is the essence of O'Keeffe's painterly interests—and in their interest—to reconcile two incompatible strategies: to make them lie down together, lion and lamb. Hence those aspects of her pictures that cannot be taken as "abstraction in masquerade"—those qualities that from the beginning have appealed to many of O'Keeffe's enthusiasts. They are nowhere more pertinent than in the case of the flower paintings, which after all represent structures whose principal function is to hold and frame their core of reproductive organs as "attractively" as possible. In making herself over into a flower painter—from some points of view the transformation might have seemed a suicidal move, so relentlessly was that painterly identity traditionally "that of a woman"—O'Keeffe seems to have been looking for the means to depict bodily effects, even erotic and sexual effects, with the impunity their apparently "natural" subject matter could confer.

If so, she succeeded: the flower paintings came to define her identity as a painter almost as decisively as did Stieglitz's infamous phrase. By the early 1930s, and even before, they had come to represent her art as a whole. For critics they were the bait used to hook readers into their opinions. A show was often measured by the yardstick of the flowers: were they present or absent? Were pictures of barns (or bones or the desert) to be prized more or less than paintings of blossoms? Were they too complicated for "average gallerygoers" or just complicated enough?[62] They could be used mockingly to make O'Keeffe a woman's painter—Henry McBride relished reporting on the party of old ladies who traveled all the way from Davenport, Iowa, to view the *Petunias*, only to be disappointed (silly old women! the show had closed)—and according to Lewis Mumford, they were what the O'Keeffe imitators copied "mechanically."[63] The report of a sale of a group of *Calla Lilies* for the fabulous sum of $20,000 helped make them the index of the market value of O'Keeffe's art.

For the artist too they became a kind of figure. They represented, I think it is safe to say, a whole range of difficulties and disjunctions: they measured the gap between life's routine and moments of attention, between attentive vision and painting, between painterly vision and public understanding. I base this reading on a well-known passage written by O'Keeffe to accompany her 1939 exhibition:

69

"Still—in a way—nobody sees a flower—really—it is so small—we haven't time—and to see takes time like to have a friend takes time. If I could paint the flower exactly as I see it no one would see what I see because I would paint it small like the flower is small.

So I said to myself—I'll paint what I see—what the flower is to me but I'll paint it big and they will be surprised into taking time to look at it—I will make even busy New Yorkers take time to see what I see of flowers.

Well—I made you take time to look at what I saw and when you took time to really notice my flower you hung all your own associations with flowers on my flower and you write about my flower as if I think and see what you think and see of the flower—and I don't.[64]

That this passage is retrospective makes its introspection possible. And despite the repetitive diction—"flower" and "see" each occur ten times in a few short lines—disjunction is its main motif. Flowers were still a fraught subject even in 1939, after the artist had mostly turned to other themes.

Exactly how fraught can best be measured in an extraordinary series of six canvases that ambitiously, self-consciously, worked and reworked the image of a resolutely phallic jack-in-the-pulpit (plates 8–13). Painted in 1930, the five largest were shown at the Intimate Gallery the following year.

Accounts of these pictures have always been divided, with O'Keeffe's, characteristically, the most prosaic of all: "In the woods near two large spring houses, wild Jack-in-the-pulpits grew—both the large dark ones and the small green ones. The year I painted them I had gone to the lake early in March. Remembering the art lessons of my high school days, I looked at the Jacks with great interest. I did a set of six paintings of them. The first painting was very realistic. The last one had only the Jack from the flower."[65] What could be more straightforward? Yet for all the simplicity of this narrative, more complex meaning cannot be kept entirely at bay. If realism supplied a rubric for the origins of the group, it was not all-containing: for the final canvas of the series, it would no longer do the trick. Little wonder: this was the same picture to which Arthur Dove referred in his letter to Stieglitz of December 1930: "The bursting of a phallic symbol into white light may be the thing we all need. Otherwise it would not bother them so." Dove is describing the last, most

outrageous picture in the series, *Jack-in-the-Pulpit No. VI* (plate 13), which features a domed stump of a shape, the jack, shown either stripped of its leafy surround or in magnified isolation within it. There are few clues to clarify the matter, and again O'Keeffe's description does not really help.

One thing is certain: O'Keeffe's numbering of these pictures claims for the series a certain totalizing status, gives it coherence and direction, and nominates this final canvas as the summa of the whole, the thing the others were working up to say. No, to show: up to this point, in the other variations on the theme, the jack is represented in varying states of presence or absence, framed or hidden or half revealed by the changing furl of its striped petal sheath. Those transformations are certainly deliberate, part of a process of exploration and revision that, though it began with a study from nature, left those origins far behind. The small scale of the first canvas indicates its private and preliminary purpose; at what point its maker understood its further potential is impossible to say. The change meant abandoning her initially unsuccessful effort to capture the flower's most characteristic form, the way the upright spadix is overhung by the curving spathe. The later canvases are devoid of such explanatory botanical forms. Instead, in looking from picture to picture, we are meant to move from one invented world to another, though all those worlds are as phallic as can be. The flower and its world may be shot with pink, deepening to red at the core— this is their treatment in *Jack-in-the-Pulpit No. II*; or, in *Jack-in-the-Pulpit No. III*, the same zone may be reduced to a tight series of closely executed stripes that, framed in green, float in cool isolation against a blue-and-white sky (plates 9, 10). In *No. IV* and *No. V*, by contrast, questions concerning the centrality, and hence the meaningfulness, of the jack's phallic shape are posed (plates 11, 12). In the first instance, this occurs because the familiar bulbous protuberance opposes a central stripe of pure white. Both stand out against the velvety black treatment of the flower's interior, but O'Keeffe's strategies prevent us from deciding exactly the position we should allot the stripe—is it presence or absence, in or outside the flower? Is it behind the jack, or part of it? Similar questions bedevil our understanding of *No. V*. The center of the picture is now neither phallus nor stripe, but a sturdy yet oddly amorphous pillar of brown. Its very nature is obscure, as is its relationship to the sharp edge of white that cuts through it and to the three timid jacks that lurk displaced at left, huddled within the petal's luxuriant furl. Note that this, the least phallic image, is

decisively the largest of the series. As if by a similar logic, *No. VI* is the small-
est. Phallic intensity is not here a function of size or scale.

These paintings form a series by virtue of their imagery, and likewise because
of the evident calculation—the absolute intentionality—of their painterly
technique. (The comparative and sequential format of the series supplies one
basis for this claim.) There is the sheer vulgarity of *No. II*, where color is as
bizarre and lurid as anything ever painted by the arch-vulgarian Thomas Hart
Benton: the green leaves encroach hectically from all four corners, the central
member (forgive me) has been given an oddly reflective surface that makes it
seem to glow, and the cotton-candy pink has escaped from fairground or music
hall. If the aim of the canvas is to go over the top, it succeeds. In comparison,
the execution of *No. VI* looks, in all its stark flatness, rigid with tension: the
phallus glows because of the careful gradations from black to white and through
the shades of gray. When seen against the uncanny, hectic vitalism of the others,
it radiates both irony and hostility in nearly equal measure.

Never, in short, has the phallic symbol been more decisively colonized in
paint. The series seems to mark the artist's achievement of a long-held ambition:
to avoid the beautiful at all costs and instead to present work so "magnificently
vulgar that all the people who have liked what I have been doing would stop
speaking to me."[66] Of course there are many ways to be vulgar. The *Jacks* at-
tempt several—comedy, irony, pornography—and in so doing help to clarify
what was on O'Keeffe's mind. This is the vulgarity that might occur, for ex-
ample, to readers of D. H. Lawrence, which O'Keeffe and her audience cer-
tainly were. No wonder that in an essay on her work published in 1924, Paul
Strand sees O'Keeffe as a quintessentially modern woman—for him it is as if
she is walking out of the pages of *Women in Love* to fulfill the potentiality of
Ursula and Gudrun Brangwen, "Ursula whose spirit alternates between ecstasy
and despair" and Gudrun, the artist. (Remember Gudrun in her classroom, giv-
ing lessons on the flower's reproductive anatomy, "the structure and the mean-
ing"; both she and O'Keeffe emerge as subscribers to a key Lawrentian dictum:
"Nature responds so beautifully."[67] This is one reason Lawrence's description of
Gudrun sketching water plants has so much resonance here: "She could feel
their turgid fleshy structure as in a sensuous vision, she *knew* how they rose out
of the mud, she *knew* how they thrust out from themselves, how they stood stiff
and succulent against the air.")[68] Yet unlike Gudrun, Strand claims, O'Keeffe

can profit from her knowledge, she can "envisage and use the frustration of her relationships, . . . her hatreds and resentments."[69] From these sources wells her creativity. (Strand seems to be saying that O'Keeffe's powers of sublimation fuel her painting—I see no reason to disagree.)

It is left only to consider the implications of this passionate vulgarity for the artist and her status as an author. The logic seems inexorable: if, as critics never tired of asserting, O'Keeffe is her art, then in the *Jack-in-the-Pulpit* series she is the phallus, no less—at least she can perform it. And although her own prior, biologically ratified, identity as a woman inevitably still had some standing in viewers' minds, might she not be said to demonstrate—at least in these pictures, if nowhere else—the will to exempt herself from the cultural implications of that gender status, perhaps even to achieve a kind of androgyny? Androgyny as performance, to be sure: this is a status knowingly, perhaps even bitterly, claimed.[70] The victory is Pyrrhic, and the achievement ultimately elusive, but O'Keeffe's ironic effort to adopt and employ the key male signifier still stands as the most extreme of her efforts to adjust the terms of her reception.[71] In the process, another adjustment was effected: the groundwork was now fully laid for the ultimate condemnation of her work as pseudo-modern, rather than modernist. She could be dismissed by Clement Greenberg, as she was on the occasion of her MoMA retrospective in 1946, for indulging in "private worship and the embellishment of private fetishes with secret and arbitrary meanings," and for bringing together into a single practice "the opposed streams of hygiene and scatology" usually identified with modern art.[72] Myself, I doubt that O'Keeffe's language is arcane or secret. Perhaps it seemed that way because she used it so disturbingly to imagine an impossible union—the passionate coupling of hygiene and scatology, the body and its absence. Perhaps Greenberg's embarrassment says more about the intelligibility of O'Keeffe's pictures than he cared to admit.

Yet Greenberg was not wrong to be concerned with O'Keeffe's meanings. How to name these pictures has always been the question, even for the artist herself. The issue is not just that she tried for a while to paint things that she had "no name for": this is a time-tested modernist goal. By these lights, Mumford's encomium comparing her images to "words achieved for the first time by a dumb or tongue-tied race" was real praise—until the inevitable moment, that is, when the comparison collapses, and O'Keeffe becomes that "dumb race."[73]

The problem concerns the inevitable accommodation between such depiction—the effort to communicate a pre- or extra-linguistic experience—and a representational economy whose principles are strictly enforced. Those principles are, among others, the polarities of gender; the pre-linguistic is not yet subject to such categories, but they necessarily structure the world of language, visual language included, and determine how its utterances are received.

How might the role of the unconscious be mapped and verified where a particular painting is concerned? What are its traces once the picture has been completed? While working, the artist may aim to chart a topography of the unconscious, tapping its particular residues of bodily and instinctual sensation, and mining its radical disregard for time and reality and doubt and certitude—for everything, that is, except pleasure and unpleasure. Yet those aims must also, must always, take intelligible visual form—if, that is, they are to be seen as art. That is to say, intelligibility and artistry result from technical procedures and observe formal principles not necessarily operative in unconscious terrain. It is hard to make a painting—let alone a good one—unconsciously. So much is obvious. Are we then justified in seeing the unconscious manifested in any and all works of art? Clearly not, yet it seems certain from some aspects of O'Keeffe's artistic practice that her unconscious *was* engaged there, as indeed she so often claimed. Its workings are evident not so much in imagery as in process: above all in the extreme repetitiveness of her procedures. O'Keeffe's pictures exist in multiple versions that reiterate a few key configurations. This occurs so often, and so many versions proliferate, as to point toward an "extra-artistic" explanation of the case. In making and remaking the visual structures and emphases that characterize her images, repeating them with minor or major variations, O'Keeffe seems to have been taking possession, not just of technical matters and mastery, but of the emotional content that her imagery screened, thus binding and controlling the pleasure and unpleasure from which the image first emerged.

Lest this all seem too abstract, let me try once more to make it relevant where the *Jack-in-the-Pulpits* are concerned. These six paintings select their symbol from a familiar lexicon; like callas, the chosen flower is among the *araceae* (and the calla, it was said, was made for O'Keeffe to paint).[74] The selection opened the way to a series of restagings of its main forms, as if they had a tale to tell. It is not a botanical one. At first the flowers float and hover, framed in baroque green

baldachinos: painting as bodily altar, betokening a near-ceremonial desire without fulfillment or transcendence. A change of tactic was the result. Retreating to a deep dark grotto, the jack is backlit by blinding light. Confidence in its presence is now undermined by a specially brilliant white slit: this new element (is it thing or cavity?) seems to take over the rhetorical lead. Only when sidelined by wavy patterns, as in the next picture of the group, does the jack surrender center stage. Yet now become a shadowy threesome, it is no stronger, though a replicant. In these stagings of presence and absence, the issue is bodily power, and the canvas a theater of bodily form. Male meets female in a play of difference, and the last picture of the series makes *male* the final unvarnished word. Unless, that is (it is my final suggestion), the jack should be seen as contained within a larger, encompassing void.

If pleasure and unpleasure are visible in O'Keeffe's imagery, they could be seen there only by virtue of the modernist artistic language she used to express them. Her art needed flat passages and shifting spaces, the push and pull of conflicting planes, the rhythms of line and pattern. Those choices, if they mark the moment of her departure from a purely unconscious realm, also register O'Keeffe's real spirit of inquiry where painting and meaning were concerned. Her imagery—hybrid, eclectic, willing to test and compare the limits and likenesses of abstraction and figuration—makes that case. So does the seriousness of her understanding that her inquiry would have to mine effects proper to modernist painting if it was to have any force at all. What she was not prepared for, in my judgment, is the extent to which "painting" was elided, in critics' minds, with painter. The modernism of the body of the painting all too promptly became a simple metaphor for the artist's self.

The two were elided—let me say it once again—because the artist was a woman. Their conflation might even be seen as a negative emblem of her creativity. Perhaps I can convey what I mean more clearly by recourse to an exchange between two characters in Susan Glaspell's 1922 play *The Verge*. They are speaking of the protagonist, Claire, a botanist whose passion is flowers—not just their cultivation, but their hybridization. She is working to coax forth an entirely new blossom, to be called the Breath of Life.

Harry: It would be all right if she'd just do what she did in the beginning—make the
flowers as good as possible of their kind. That's an awfully nice thing for a

woman to do—raise flowers. But there's something about this—changing things into other things—putting things together and making queer new things—this—

Dick: Creating?

Harry: Give it any name you want it to have—it's unsettling for a woman.[75]

Only if we think of the social positions of these creators, O'Keeffe and Claire and Glaspell herself, can we see in their hybrid imagery—their penchant for "changing things into other things"—metaphors for contemporary transformations of the female self. If their own selves are implicated in those changes, it is as examples of the new hybrid type.

O'Keeffe and Stieglitz

The decision to give O'Keeffe's relationship with Stieglitz its own separate place in this chapter needs explaining, though not because of the novelty of the idea. It should already be clear that O'Keeffe's life and art have long been understood as inseparable from the influence of her dealer and companion. Disagreement has arisen only about whether his influence worked for good or ill. Was O'Keeffe her husband's property and creation? Did he try to shape and limit the course her art would take? Were those efforts malign or supportive? Was their relationship collaboration or exploitation? And so on: these questions have been the inevitable consequence of the economic, legal, and affective ties between these two people, simply because they linked male and female persons: as encoded by the contemporary marriage institution, their bond demanded subordination and dependency on the part of the woman. Critics more recent than Mabel Luhan have argued that both were forthcoming. To quote one opinion: "Stieglitz's denial of his wife's wish to have a child was only one of the many ways he thwarted her in life as in her art. Though he is widely regarded as responsible for her success, the record now shows that Stieglitz's effect on O'Keeffe was more destructive than not, and that the efforts he made, supposedly on her behalf, were often self-serving"[76] Or later in the same essay: "It was Stieglitz who profited: he successfully marketed O'Keeffe's art as a kind of soft core pornography or as a sop to male fantasies by perverting her images of her

experiences of her body and her desire into reifications of male desire, of the pleasure men imagine themselves giving women."[77]

The most urgent question provoked by such commentary concerns not Stieglitz, but O'Keeffe. How did it happen, we might well ask, that O'Keeffe, who after all is depicted elsewhere as a strong-minded feminist, was so completely at the mercy of this "profiteer" as to become his puppet and his dupe? These passages, and the ones quoted earlier from Luhan's essay, imagine scenes from a marriage that would be meat and drink to the tabloids or the soaps. The problem, of course, is that in their scenarios, Stieglitz emerges little short of demonic, while O'Keeffe can always and only play the stock victim, the wife, rather than in any sense an agent of the conditions of her life. Yet such stock binaries and (soap) operatic stereotypes are not inevitable: "the record" can be read to other ends. O'Keeffe can, for example, be seen as a willing participant in her existence with Stieglitz; remember that she too stood to gain from it, and did. And the record can be seen as documenting an intense, pragmatic, companionate, evolving relationship—a marriage of its own particular sort— between two individuals who both were inevitably at least as neurotic as the rest of us, and whose relationship was likewise inevitably shaped by those neuroses, for the most part in ways not yet known. The marriage, though it was documented to an extent by the compendious correspondence the two artists kept up, nonetheless remains private; O'Keeffe's and Stieglitz's letters to each other will not be made available to scholars until the year 2021. (Note that despite the "frankness" and intimacy of their discussions of matters sexual, despite their knowing tone, the authors of the most sensationalist recent biographies were unable to circumvent that restriction.)[78] Until access is granted (and doubtless even then), authoritative comment on its intimate dynamic can only be a compendium of indirect (though certainly motivated) testimony: the memories of friends and family, the inferences and speculations of critics and biographers, and so on. It may be better not to trust such testimony completely. (Of course even the letters the couple exchanged should not be taken as "the truth.") I have decided to look in what follows, not only at verbal evidence, but also at visual practices: I am interested not in victims and victimizers, but in the ways that the circumstance of O'Keeffe's relationship with Stieglitz provided its own terms for the construction of her femininity.

O'Keeffe and Stieglitz collaborated in two main activities; both were deci-

sive for her reputation, and for his: the regular, more or less annual, exhibitions of her work and the sessions in which she sat as the model for his camera. In the end 329 photographs were designated as constituting his composite "Portrait of Georgia O'Keeffe." (An image is considered to belong to the "Portrait" if it exists in a mounted, "archival" print; the total number of photographs making up the whole is swelled by their maker's habit of printing the same negative using different processes—typically in palladium and gelatin silver prints—and his occasional cropping of a single negative in different ways. O'Keeffe was herself responsible for ordering the Stieglitz archive after his death and for placing his pictures at the National Gallery of Art.) While the exhibitions and portrait campaigns took place at different intervals and sites (the shows belonged to the winter and New York City, while the photographs were, after the first few years, normally made during summer sojourns at Lake George), they should nonetheless be thought of as contemporaneous activities, with the one proviso, of course, that O'Keeffe continued to exhibit under Stieglitz's auspices after he ceased to photograph in 1937. He was seventy-three.

O'Keeffe and Stieglitz shared fundamental beliefs about, and allegiances to, their art, so much so that outlays of time, energy, and understanding were often reciprocal, at least where photography and painting were concerned. This does not mean, however, that their work is best read to discover career-long counterpoints of interests and motifs, as the recent exhibition *Two Lives* has tried to suggest. If two artists represent the same shed and flagpole in images years distant in time; if they produce compositions that, despite their different subjects, both use a strong diagonal as a central, structuring motif, are we then entitled to conclude anything—or anything terribly interesting—about their artistic affiliation?[79] Are we licensed to infer that these parallels depend on personal circumstance in other than obvious historical ways? Why are the parallels in the art of this couple taken to be so much more interesting than the differences? (Might not differences have actually been more difficult to secure?) In partial answer to these questions, I would like to focus on a particular object, so as to argue that the creative affiliation between O'Keeffe and Stieglitz had as its mutual project the ongoing definition of that most volatile of concepts, O'Keeffe's femininity. Equally at issue for that project was the role modernism was to play within it. If O'Keeffe's paintings are one half of the story, as we have seen, Stieglitz's photographs are the other.

I have already suggested above, in pointing to the inclusion of *Abstraction IX* in O'Keeffe's second show, that her work was presented under circumstances meant to solicit responses to it as "that of a woman." Other such strategies include the habit of using the exhibition checklist (once such a document had been adopted) to cite snippets of earlier criticism—key phrases from Rosenfeld, say, or Hartley—as a means of introducing the show. That practice offered viewers—both the professionals and the public at large—a framing device (a critical Claude glass) with which to locate the pictures and to keep their maker's femininity well in mind. The composite Portrait was another such device: shown in the same spaces as O'Keeffe's canvases (and on one occasion, in 1923, in the same exhibition), its detailed presentation of O'Keeffe's face and body likewise insisted that the artist be understood as portrayed there: as a woman. In what follows I take Stieglitz's composite Portrait of O'Keeffe as the second main site of the enunciation of that concept, its importance equal in that regard—though significantly not identical—to the fervid criticism to which her exhibitions gave rise.

My argument can only proceed, however, from the acknowledgment that some of the most basic questions provoked by the Portrait are the most difficult to answer. It is impossible to be certain, for a start, exactly which of its photographs were actually exhibited publicly, and thus there can be no adequately informed speculation as to the principles of inclusion and exclusion motivating its presentation. It is certain that by early 1921, when some forty-five prints were first publicly exhibited at the Anderson Galleries, they represented only about a third of the photographs on which the two had thus far collaborated.[80] Yet—to put their production in a slightly different light—by 1921 nearly half the pictures that would eventually enter the master set had already been taken. Evidently enough work had been done to justify the first exhibition as representative of a project whose main lines were clear.

To be sure, there are some few scraps of information about the works that were eventually chosen for exhibition. Stieglitz made notations on the backs of some photographs—"Exhibition 1921 Anderson Galleries," "1923 Exhibition"—that document their public history. Others he simply labeled "A1," and thus it is not possible to be sure that these prime prints necessarily were the exhibited versions. And although he continued making such notes at least through 1932, his records were erratic at best. Nor do the responses of contem-

porary critics give much help with the problem. Their descriptions (typical for criticism of the day) focus, not on individual images, but on the particular tenor of the photographer's talent. Take for example this passage from a 1921 review by Paul Rosenfeld:

> He has based pictures not alone on faces and hands and backs of heads, on feet naked and feet stockinged and shod, on breasts and torsos, thighs and buttocks. He has based them on the navel, the *mons veneris*, the armpits, the bones underneath the skin of the neck and collar. He has brought the lens close to the epidermis in order to photograph, and shown us the life of the pores, of the hairs along the shin-bone, of the veining of the pulse and the liquid moisture on the upper lip.[81]

It is not that Rosenfeld has not seen Stieglitz's pictures: on the contrary, he has looked at them very closely indeed. Yet it would be impossible to tell, on the basis of his description, just exactly which of the prints he had had before his eyes, and whether, moreover (given his close relationship to Stieglitz), he had encountered them on the walls of the Anderson Galleries or in a private interview with the photographer. The second is a definite possibility, since it is certain that smaller groups of prints had been shown to friends and associates during the two years before.[82]

Hence the necessity of falling back on other views of the project—chief among them the publication on which (in cooperation with the Metropolitan Museum of Art) O'Keeffe herself collaborated in 1978.[83] Included are reproductions of fifty-one photographs, and again there is no way to be sure which might have been exhibited while their maker lived. They are prefaced by O'Keeffe's reminiscences of their origins many decades before: memories that are vivid and polished and particular. Yet for all their clarity, they insist on the distance between the writer and her image: she is struck by the differences among the images, and by their difference from the woman she has become. "There were nudes that might have been of several different people—sitting—standing—even standing upon the radiator against the window,"[84] she wrote; and similarly, "When I look over the photographs Stieglitz took of me—some of them more than sixty years ago—I wonder who that person is. It is as if in my one life I have lived many lives. If the person in the photographs were living

in the world today she would be quite a different person—but it doesn't matter—Stieglitz photographed her then."[85] Most striking of these statements are the closing sentences, in which the writer absents herself entirely from the portrait said to represent her: "I never knew him to make a trip anywhere to photograph. His eye was in him and he used it on anything that was nearby. Maybe that way he was always photographing himself."[86]

There are several reasons why O'Keeffe might have felt distant from these images. Among them, the most obvious may also be the best: they had been made a lifetime ago. In the meantime she had indeed become a different person, with that transformation the product not just of age, but also of her own purposeful reinvention as O'Keeffe the resolute desert elder, an apparently indomitable character who has moved beyond the mere trivialities of age and sex. Able to surrender the notion that the pictures might have anything much to do with this new personage, she seems specially alert to their discontinuities. Her response does more than pay lip service to Stieglitz's refusal of portraiture as a singular activity—a notion that she crisply, laconically, reports: "His idea of a portrait was not just one picture."[87] This is because a person has more than one self—at least when she is O'Keeffe. But O'Keeffe goes further than this: she concludes by suggesting that the selves in question belong to Stieglitz after all.

These remarks seem to me astute. They differ in tone, moreover, from the only other record we have of O'Keeffe's opinion of the images in question. This one dates from the epoch of their making; indirect testimony, it is given in a 1918 letter written by Stieglitz to Paul Strand: "Whenever she looks at the proofs [she] falls in love with herself—or rather her Selves—There are very many."[88] Despite their differences in content and speaker, those two documents are not self-canceling. On the contrary, each speaks to different aspects of its making and meaning. As the years went on, O'Keeffe could discover both herself and Stieglitz there, with both of those responses a function of the intention of the work. Its central purpose was its maker's claim to present a notion of the female person as multiple, profoundly different in her various guises—differing from moment to moment even at those instants when he is able to reveal her as ostensibly most herself—when she is unclothed.

Certainly the format of the Portrait is one main agent of these perceptions. This is a work that is intentionally incomplete—it could never be known as a whole, even by its maker, even when work on it had come to an end. Its incom-

pleteness, in other words, is not just the function of its additive format; it is determined by the scale of the work and the sheer impossibility of holding all its images completely in the mind. Even in a selection of prints like that shown at their first presentation, it is difficult to keep the subtleties of the imagery clearly sorted. A few images are singular, of course, with no other pictures in the series attempting to equal or repeat their setups. But Stieglitz's fascination with certain formats and body parts—O'Keeffe's hands, for example, or her head and torso silhouetted against the sky—lends the ensemble of images an oddly, almost compulsively, repetitive character. The viewer is challenged to recall how, if at all, this version of hands at rest or in action, say, might differ from the last one seen—to say nothing of the version before that.

The Portrait means to be an antiportrait: "For Stieglitz a portrait is not an acceptance of looking pleasant."[89] And its sheer ungraspability as a whole is its main material and conceptual feature—the great challenge it issues to the linked traditions of photography and art. Hence Stieglitz's use of it to stage his return to the photographic scene. While the whole 1921 exhibition was generally understood, in the words of one critic, "to question and affirm" the two disciplines,[90] the section titled "A Demonstration of Portraiture" was taken as specially declarative—the demonstration of the theory its author espoused. In it the images of O'Keeffe were key. Photography, the Portrait announces, need no longer deny its essence as a medium: repetition is now not only its defining condition, but also its main aesthetic resource.[91] Essential to that declaration are both Stieglitz's choice of subject, a woman, and the message he aims to convey. Photographic representation can now, through sheer repetition, suspend the utter familiarity of "woman" as the archetypal subject. A marvelous contradiction is the result: though presented as a kind of truth, a "demonstration," she becomes as unknowable as the hundreds of images pressed into service to represent her, and unknowability likewise becomes the chief condition of her imaging. The viewer may be given a multitude of individual moments of utter clarity, be endlessly confronted with the "life of the pores" and the "veining of the pulse," to borrow Rosenfeld's phrases once again—but those moments merge into the final impossibility of their retention in the mind's eye.

This is not to say, of course, that we walk away from the Portrait with no image of the sitter whatsoever. I am claiming rather that its viewers are inevitably engaged in a process of looking that argues against the conclusion that her

image has any one stable guise. Instead the Portrait shows Stieglitz at pains to offer an imagery of contradictions and differences and, moreover, to show those differences as more and other than simple cliché. No shallow attribute of her sex, they are part of her and are a matter of bodily being above all.[92] This effect likewise depends on the Portrait's multiplicity: while there are large patterns of resemblance within the work, any two images are likely to confront us with notable disjunctions in the aspect of the sitter. They are of course a matter of dress and setting—but they are profoundly somatic above all. There are contrasts in the sitter's presence before the camera, in the being and embodiment she allows herself and is allowed to have; she is alternately spare and ample, her expression blank and knowing, her aspect undone and impregnable, with my use of those last adjectives meant to suggest above all the ways her presence shuttles between the polar conventions of gendered identity. In prints of 1918, for example, she is shown in a camisole, sporting a straw hat in the shape of a derby; here she looks, I think, like a cabaret singer who affects a top hat, a performer whose "masculinity" is clearly an erotic disguise (fig. 17).[93] Yet in another image, a particularly somber palladium print of 1922, the erotic is entirely absent. Someone looking at the brooding visage may even be uncertain whether a woman, let alone the same one, is depicted at all (fig. 18).

This fascination with differences was characteristic of the Portrait from its inception. Begun in the wake of the 1917 exhibition—apparently even *in* the show—it uses drawing after drawing as backdrop and prop for a staging of selves. Already striking is the way Stieglitz works toward multiplicity from the consistent elements of the artist and her work. Although the drawings all have the same maker, they can cue not one identity, but several. And even the same drawing can spark different moods. Take O'Keeffe's various poses before *Number 15* in the series of *Specials*: the differences between any two plates may at first appear minimal, but they soon come to seem decisive (figs. 19–21). In one case the addition of hat and coat undermines the emphasis on the line of the throat and hides the forehead from view; thus interrupted, the woman's physiognomy is downplayed, or at least made less obvious a resource in the viewer's game of identification and response. Her visage is capped by the hat, while her complicated gesture with the button forces an analogy between its shape and the bubbling forms behind her. We are asked, I think, to consider the possible relationship of those hands and the forms behind them, and that solicitation is

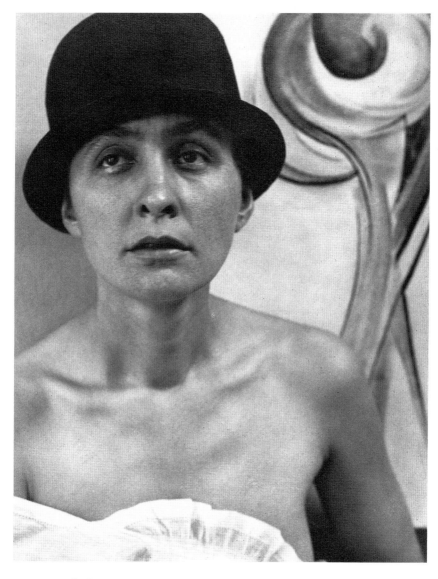

FIGURE 17. *Alfred Stieglitz, Georgia O'Keeffe: A Portrait, 1918, silver print, 9⅝ × 7⅝ in. (24.7 × 19.7 cm.). National Gallery of Art, Washington, Alfred Stieglitz Collection (1980.70.14).*

FIGURE 18. *Alfred Stieglitz, Georgia O'Keeffe: A Portrait, 1922, black palladium print, 8¹¹⁄₁₆ × 6⅝ in. (22.2 × 16.8 cm.). National Gallery of Art, Washington, Alfred Stieglitz Collection (1980.70.181).*

decisively different from the invitation issued by a third plate in the sequence, where gaze and gesture are both redefined, moving with the drawing in ways that seem to propose the possibility of entry into the chaos behind.

Such parallels between body and drawing are frequent during this phase of the Portrait's making. And when her drawings are included, the sitter's identity as an artist is specifically at issue as well. Again and again that second identity is likewise envisioned, not just as social fact, but as a matter of bodily being. Note two of the ways O'Keeffe is positioned in relation to a drawing from the *Blue* series: in the one image the drawing seems simply to provide an environment for an easy, socially legible identity; in the other its womblike shape stands like an icon, a form her hands rather tentatively explore (figs. 22, 23).

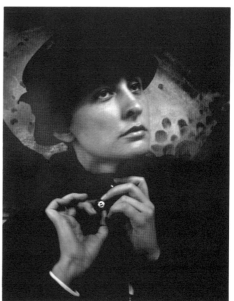

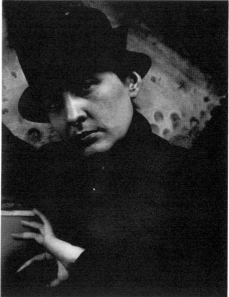

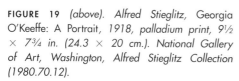

FIGURE 19 (above). Alfred Stieglitz, Georgia O'Keeffe: A Portrait, 1918, palladium print, 9½ × 7¾ in. (24.3 × 20 cm.). National Gallery of Art, Washington, Alfred Stieglitz Collection (1980.70.12).

FIGURE 20 (above, right). Alfred Stieglitz, Georgia O'Keeffe: A Portrait-Head, 1918, silver gelatin enveloped-out print, 9¾ × 7¹¹⁄₁₆ in. (24.3 × 19.5 cm.). National Gallery of Art, Washington, Alfred Stieglitz Collection (1980.70.6).

FIGURE 21 (right). Alfred Stieglitz, Georgia O'Keeffe: A Portrait, 1918, platinum print. National Gallery of Art, Washington, Alfred Stieglitz Collection (1980.70.67).

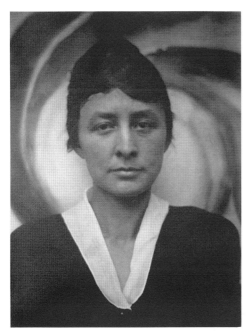 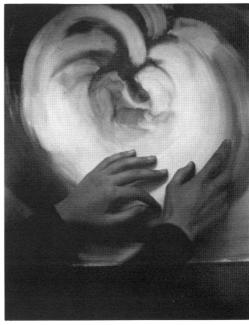

FIGURE 22 *(above left). Alfred Stieglitz, Georgia O'Keeffe: A Portrait: At 291, June 4, 1917, platinum print, 9 × 7 in. (24.3 × 19.4 cm.). National Gallery of Art, Washington, Alfred Stieglitz Collection (1980.70.2).* FIGURE 23. *Alfred Stieglitz, Georgia O'Keeffe: A Portrait: Hands and Watercolor, June 4, 1917, platinum print, 9⅝ × 7⅝ in. (24.6 × 19.5 cm.). National Gallery of Art, Washington, Alfred Stieglitz Collection (1980.70.3).*

These are not gestures of making, or even possession. Instead I would claim that the relationship between drawing and person posits a notion of parallelism or reiteration: by this means the artist and her body are identified as one and the same. Other highly calculated self-stagings with an exhibited drawing, in which the woman's hands carefully mime the drawn shapes, repeat this equation in markedly similar terms.

By these lights, it would seem that I am arguing for a view of the composite portrait as something like a visual fulfillment of Stieglitz's reading of O'Keeffe's work. (That the Portrait became an emblem of his understanding of his *own* work is equally likely. One of its images in particular [fig. 24] points to this conclusion: O'Keeffe is shown in Stieglitz's 1923 exhibition, flanked by paired and "equivalent" photographs, a plate from the Portrait series and the image of a tree.) This is not to say, however, that his "woman on paper" is a simple or

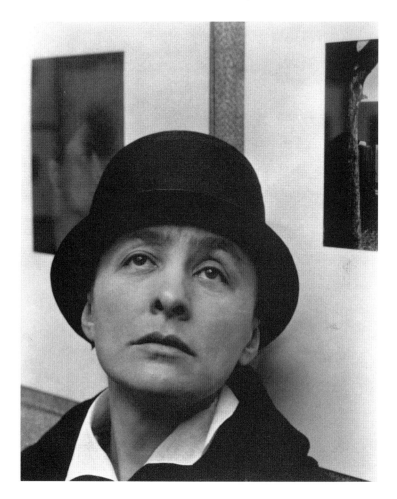

FIGURE 24. *Alfred Stieglitz,* Georgia O'Keeffe: A Portrait, Head, *1923, platinum print, 9⅝ × 7½ in. (24.7 × 19.3 cm.). National Gallery of Art, Washington, Alfred Stieglitz Collection (1980.70.189).*

reductive one. On the contrary, it evidently aims to describe a certain complexity as inherent in feminine identity, and to claim for that identity an unexpected novelty by virtue of its sheer inclusiveness and range: this woman is fertile and androgynous, open and self-contained, a creature of taut surfaces and cushiony ones. She can inhabit a whole range of psychic and social states, looking successively cheeky, domestic, proud, withdrawn, contemplative, seductive, submissive, and so on. And she is an artist, with that single social fact standing implicitly as the license and guarantee of the interest of the project as

a whole: it is essential that the sitter is so known, that these photographs por-
tray "Georgia O'Keeffe." The existence of that public person is the only valid
pretext for the work.[94] Yet we nowhere get the sense that O'Keeffe's identity
as an artist—or her existence in any of her other roles, for that matter—is
anything other than a bodily state. It is based, we learn in looking, on an abso-
lutely artificial yet nonetheless uncanny resemblance between the art and the
body in question.

We might say, trying to speak about the Portrait in a general way, that it was
Stieglitz's great concept to treat the body as if it were a visual guide or index
to the plurality of the female self: if that plurality coheres as a unity, it is only
graspable as a conceptual whole. This notion is at a real remove from the other
concept current at the time, which made the body and its manifestations the
ultimate evidence of female carnality and insufficiency. In and on it, in its organs
and orifices and social comportment, were lodged the traces of woman's many
weaknesses: her pleasures and diseases, her vices and her lack. It was the busi-
ness of the various regimes of description, the artistic and scientific included, to
give an account of the woman, each attending to her body with its own terms
and skills. Stieglitz's description, by contrast, goes about its business from a
radically different tack. For a start, it begins by admitting to the failure of its
project—it is determinedly, intentionally incomplete. And its sheer scale en-
sures that it will remain so, even once work has come to an end. Nor does his
attention to the body have as its purpose the will to demonstrate one single
ineluctable claim. The body can and will be shown in its carnality, to be sure;
this is flesh as a founding category. There is, for example, a series of photographs
in which the camera's vision variously frames O'Keeffe's breasts (fig. 25). Her
hands rest there, or sometimes squeeze and press them in gestures that seem
oddly like a proof or demonstration of the fleshly reality of the body on display.
The actions look less like onanism than simple self-possession, a testing and
affirmation of the bodily state. It is only as the gaze moves out from the breasts
to the picture's edges that the mood becomes more theatrical than existential.
O'Keeffe wore a wrapper or kimono when the photograph was taken; its edges
part like the curtains of a stage to reveal the small drama, the proof of female
existence that takes place within.[95]

To point to the differences between Stieglitz's project and the tradition of
representation with which he breaks is not thereby to separate the man and his

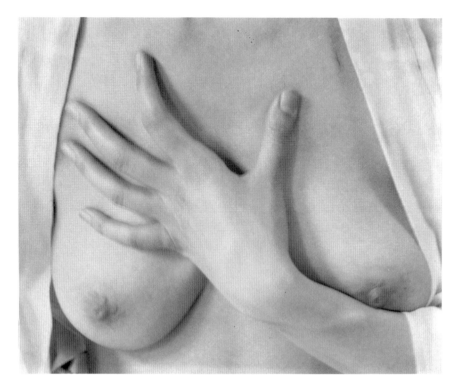

FIGURE 25. *Alfred Stieglitz, Georgia O'Keeffe: A Portrait, Hand and Breasts, 1918, platinum print, 7¾ × 9¾ in. (19.8 × 24.8 cm.). Collection of the J. Paul Getty Museum, Los Angeles, Calif., © Estate of Georgia O'Keeffe.*

art from any available context of belief about the female self. On the contrary, I want to argue that exactly those qualities of the photographs that are original in visual and conceptual terms mark the points of their identification with contemporary updatings of theories of female identity. By these lights, "differences" once again become "difference": the Portrait is one symptom of the profound reimagining undertaken in modern societies of the ways that notions of "body" and "person" intersect in the figure of Woman. Equally symptomatic and more influential was the direction taken by contemporary psychological science, particularly in the work of writers like G. H. Hall, Morton Prince, and William James. According to Ruth Leys, by 1910 or so analysts were preoccupied with the notion of the subliminal self—even selves—as a key attribute of the individual person, above all when that person was a woman.[96] A hidden self might

be revealed as the result of trauma, but it was also possible to call it forth less precipitately, if no less dramatically, by exercising powers of suggestion—hypnotic suggestion in particular. In the case of one Miss Beauchamp, which Morton Prince narrates, the effect was transforming. The characters who emerged differed markedly from the conventional female of the day, whose polite mask Miss Beauchamp wore. Normally she was conscientious, reticent, anxious, self-sacrificing, and pious. The person(s) who replaced her (according to Prince, Miss Beauchamp's several alter egos eventually settled into one dominant identity) was by turns playful, flirtatious, saucy, heartless, rebellious, and bold. She could be difficult to control, sometimes even downright dangerous (all these adjectives have been culled from Prince's account). This, we learn, is a character who at times resembles nothing so much as an unruly city mob; the vivacity that marks her as profoundly immature, however, is also the very quality that makes her the most attractive of the patient's selves.

The worry that this case and others like it provoked among analysts is revealing. They feared that the patient's other personalities had been created by her physician; called forth at his suggestion, they were "his" as much as "hers"— or more. It is curious in this context that Stieglitz was sometimes accused by critics of doubling as O'Keeffe's analyst, acting the part of a Freud manqué— at least where her canvases were concerned.[97] The comparison was usually meant to be degrading; his ministrations, we learn, were the catalyst that allowed her to confess herself in paint. The idea would be laughable were it not so mean-spirited. In the case of the photographs, however, Stieglitz's suggestions certainly must have catalyzed O'Keeffe's performances of various personae (though only in the most direct, straightforward sense: "Stand here," "Move your hand," seem like more plausible instructions than "Be mutable, be different!"). The images themselves make evident the complicated, ongoing exchange of observation and solicitation (hers as well as his), provocation and response (his as well as hers) from which they necessarily emerged. The elusiveness of such exchanges—they leave their residue only in the photographs that Stieglitz took—is one reason that he, rather than O'Keeffe, is conventionally credited with having first given the notion of female multiplicity adequate—even compelling—visual form.

It is tempting to understand the Portrait as marking a moment of progress, an improvement over the general run of representations of the female. More imme-

diately it seems like an explicit corrective to O'Keeffe's mistrust of being "written down" by men.[98] Its imagery may endeavor to make her physically present—explicitly, relentlessly so—but it simultaneously keeps her elusive. Yet that very lack of stasis demonstrates its conceptual relationship to another, less patently "progressive," discourse of the feminine—the medical discourse with which it coexisted. Their connection should be used, not to condemn the portrait—its beauties are too many and too unexpected—but to demonstrate once again a truth that, while obvious, still needs spelling out: that there is no space in which representation eludes ideology. To make images that are steeped in their refusal of one account of womanhood is not thereby to give no account at all. It is simply that Stieglitz, unlike the doctors, was unconcerned with its pathology.

I am not claiming, however, that all viewers at the time—the visitors on the occasion of its first exhibition—were necessarily aware of the Portrait's project and achievement. They saw photographs of Georgia O'Keeffe, lots of them. And though a notice at the gallery made it clear that Stieglitz had held back the most sexually explicit images (only, some say, at the urgings of friends and family), they certainly saw pictures of her naked body.[99] The main story she told late in life concerning the Portrait's exhibition both downplays and reaffirms its erotic significance: "Several men—after looking around awhile—asked Stieglitz if he would photograph their wives or girlfriends the way he photographed me. He was very amused and laughed about it. If they had known what a close relationship he would have needed to have to photograph their wives or girlfriends the way he photographed me—I think they wouldn't have been interested."[100] The anecdote may read like a simple, almost casual memory, but as so often with O'Keeffe, the impression of offhandedness is misleading. Notice how efficiently she conveys and evaluates two levels of understanding of the Portrait—how it can be read, and misread. There is the shallowness of the reaction of the casual male viewer, who, though attracted to its imagery after "looking around awhile," fails to grasp the profound intimacy that gave rise to it. The eroticism seems to him somehow normal, thus easily available for purchase and replication. A better reading of the work, one more genuinely interested, would be able to recognize the specialness—the irreproducibility—of the imagery and the circumstances of its making.[101]

This of course is only partly true. Several of the motifs used in the Portrait

became conventions both Stieglitz and the photographers around him (particularly Paul Strand) used to represent women, and not just their wives.[102] That O'Keeffe held fast, despite the passing of time and such reuses, to the memory of their origin in the closeness of her relationship with Stieglitz seems to me to suggest her attitude toward the Portrait better than most other attempts to explain it. Take for example the utter pall sometimes cast over the project: "Stieglitz represented O'Keeffe and her art in sexual terms from the first, however, introducing her to a wider viewing public (in 1921) not directly through her own work but through his many sensual photographs of her, where her pictures sometimes served as hazy backdrops to her voluptuous, nude or lightly clothed body. As far as we know she made no effort to stop him."[103] We are back once again with O'Keeffe as passive bystander: surely a more wholehearted acknowledgment of the reciprocity of their collaboration seems called for. How else to explain the most sexually explicit image from the series, a photograph taken in 1918 and included in the 1978 publication? It is difficult to think of O'Keeffe reacting passively to its making; indeed, it could not have been taken without her active collaboration. (How this attitude fits with the refusal of her current representative to allow publication here I leave to the reader to decide). She is perched on the edge of a stool. Only her torso is shown, and it occupies nearly the width of the frame: the upper edge of the image ends above the breasts, just above the point where they begin to swell out from the chest wall. In the center of the lower edge, a few inches of the seat of the stool can be made out, but her widespread legs obscure most of its length; they angle out to the two lower corners, losing focus as they near the camera, which was not far away. It may well have been placed on the twin to the stool, thus low enough to capture fully the view between her legs. It is odd, therefore, that while individual strands can be distinguished within the thick mat of her pubic hair, and the grain of her skin where legs meet torso can be read with equal clarity, the actual space between the legs reads only as a void. It is impossible to see the genitals, even though the camera inevitably did so, and registered that view. This is not because of any lack on O'Keeffe's part, but because of Stieglitz. It is clear from the photograph that once in the darkroom he took steps to make the image less explicit, over-exposing it between the legs, so as to burn into the surface a dark rounded absence where a presence had once been. His action—and O'Keeffe's—reminds me of a phrase in a letter Stieglitz sent

to Mitchell Kennerley, the director of the Anderson Galleries, where the Portrait was shown, and D. H. Lawrence's American publisher. The subject is *Lady Chatterley's Lover,* which both Stieglitz and O'Keeffe have just read. (Though the letter is undated, the year must be about 1928.) The issue is the book's scatology. Stieglitz writes:

> To really get the book one must read it all—and then I fear that for a while most people won't get "it." They'll be too repelled by "vulgar" words—Frankly and significantly used—very differently from the way Joyce uses them. Lawrence is "easy" reading—direct—Joyce isn't.
>
> O'Keeffe is much too innocent to have been shocked—I not so innocent, did have to get used to some of the language.
>
> There is something grand and barbaric about the book—
> And yet it's all very subtle—of today.[104]

I cite this letter, not as proof of O'Keeffe's supposed innocence, but as evidence of her matter-of-fact approach to matters sexual, her refusal again to be repelled by the vulgar (particularly the Lawrentian kind). Stieglitz could not match her in this, either as a reader or as an artist. When it came to pursuing the implications of their exploration of female presence to its furthest conclusion, it seems to have been Stieglitz who backed off, his vaunted clarity of vision ceding to propriety. Or perhaps he could not entirely surrender his well-documented allegiance to an imagery of feminine mystery and lack. Or both. Whatever his motivation, the existence of this photograph alone flies in the face of any argument that represents O'Keeffe as the unwilling victim of an exploitative Svengali. Her commitment to their mutual project seems to have been equal to his—perhaps even greater. She was willing to stare implacably at the camera—or to let her body do the staring—and to seek no refuge from its gaze. Yet if it was Stieglitz who flinched first, the lapse happened in the darkroom, once the camera had done its work.

Contrast the frank dialogue of the Portrait with Lewis Mumford's characterization of photographer and model in the standard *Camera Work* nude: "Sex must be disguised as art—that is, as artiness—before one may peep at it without blushing. Undisguised, the girl averts her face from the camera, so that the self-conscious and self-righteous face shall not acknowledge the powers of the body.

The efforts of these earlier photographers are not to be despised; but the tantalizing fear of sex, a fear of its heady realities, is written over their pictures, with their dutiful aversion, their prescribed degrees of dimness, their overarch poses.''[105] These are all tactics the Portrait was resolved to do without.

Although in the later years of the Portrait O'Keeffe mostly posed clothed, she nonetheless did model naked again, in 1932, for photographs in an extraordinary series that forms a reprise and subset within the whole.[106] Focused on her torso, or more often on buttocks and thighs, they are as eroticized as any of the earlier nudes, and as insistent in their attention to her bodily topography. She was by then forty-five years old, no Trilby or Doolittle. These images again bespeak collaboration as much as subordination: they demonstrate O'Keeffe's (continued) willingness to play the part of erotic object, to see the role as one she could identify with, and thus allow herself to adopt. I conclude that the pleasures of the role outweighed the risks—or perhaps, as so often when the erotic is concerned, pleasure and risk were one and the same.

Both were part of an act of communication perhaps now best understood as having two authors rather than one. It likewise has two objects. To speak of O'Keeffe as both object and author is to make of the Portrait a self-conscious and declarative act notable for its candor, both then and now. Its message is necessarily double-edged. It concerns O'Keeffe's possession of her body: to demonstrate publicly such bodily possession (remember that the Portrait is a "Demonstration") is to declare that one can be seen as an object, even while one aims to be seen as a subject. In the Portrait, O'Keeffe acknowledges embodiment—even sexual embodiment—as constitutive of her self. Stieglitz's role corresponds. Though the author of the Portrait (and conventionally more entitled to the role), he too is its object, as O'Keeffe came to understand: he was, as she said, "always photographing himself"—though always in absentia, to be sure. Ostensibly the master of the work's effects and of its sitter, he is a slave to his vision of both. In them he loses himself: he loses his body as constitutive of his self. The sheer concentration of the Portrait, to say nothing of its multiplicity and repetitions, its extremism and innovation, makes this abundantly clear. Such loss and possession figure in what we have come to understand as artistry. In the case of the Portrait they were not accomplished alone. Though the mutuality of Stieglitz's and O'Keeffe's roles in its making should not be overstated, neither should their collaboration be discounted. What they most shared, per

haps, was their fascination with the novel complexity—the modern contradic-
tions—of the female subject: O'Keeffe. And in understanding the painter's own
engagement with this project, we come to grasp the collaboration's implications
and limits from a feminist point of view. It helps to realize that it is much easier
to imagine O'Keeffe making this Portrait alone than taking comparable pictures
of Stieglitz. Neither seems to have contemplated such a thoroughgoing reversal of
roles. This realization is instructive: I think we would be right to conclude that
contemporary beliefs about masculinity, as well as femininity, stood in the way.

Femininity as a Masquerade

In suggesting above that O'Keeffe intended her pictures to masquerade as femi-
nine, I was aiming to map the terms she negotiated for artistic success and to
explicate their motivation. Moreover, I meant my analysis to resonate with an-
other study of feminine success, this one published, significantly enough, in
1929, at the close of the decade in which O'Keeffe's reputation crystallized.
Called "Womanliness as a Masquerade" and published in the *International Jour-
nal of Psychoanalysis*, it was the work of Joan Riviere, a British analyst and trans-
lator of Freud.[107] It does not surface in the context of this chapter to spark a
psychoanalytic reading of O'Keeffe's art, although her career unfolded at just
the moment when the therapeutic and explanatory powers of such interpreta-
tion first gained currency in the United States. We know that both the artist
and her public had read Freud; her reviewers sometimes even found it useful to
mention the doctor by name, though usually to mischievous ends. But Riviere's
essay interests me here for the particular social phenomenon it invokes, and for
the case history it takes as its centerpiece. Its general subject is a "particular
type of intellectual woman," who could no longer be seen as "overtly mascu-
line," unlike her nineteenth-century predecessor, "who made no secret of her
wish or claim to be a man."[108] Successful women in the 1920s, by contrast,
seemed able, as our pop psychologists might say, "to have it all"—or, to return
to a passage from Riviere introduced in the preceding chapter, to have achieved
"complete feminine development. They are excellent wives and mothers, ca-
pable housewives; they maintain social life and assist culture; they have no lack
of feminine interests, e.g. in their personal appearance, and when called upon
they can still find the time to play the part of devoted and disinterested mother-

substitutes among a wide circle of relatives and friends. At the same time they fulfill the duties of their profession at least as well as the average man. It is really a puzzle," Riviere concludes, "to know how to classify this type psychologically."[109]

The particular instances that most interest the analyst occur when the seams between the two identities, the feminine and the professional, seem to come unstuck enough to be visible. She reports at length on one such case, an American woman whose career demanded the delivery of frequent public lectures. The woman carried off those intellectual performances with impersonality and objectivity, yet oddly enough, afterward she inevitably became extraordinarily flirtatious, coquetting with the men in attendance as if seeking both approval and a sexualized response—as if to demonstrate that she was indeed a woman. Moreover, such behavior, Riviere believed, could frequently be observed in ordinary life. She cites a capable housewife of her acquaintance, "who can herself attend to typically masculine matters." But should she call in a workman, this same woman hides her knowledge and defers to him, "making her suggestions . . . as if they were lucky guesses."[110] Or there is the example of a university lecturer in an abstruse subject, who is also a wife and mother. When she addresses her (male) colleagues, she chooses particularly feminine clothes and behaves in a flippant and joking way, so much so as to cause "comment and rebuke."[111]

These are instances of women assuming "the mask of femininity." All women do so; according to Riviere, there is no difference between genuine womanliness and the masquerade. It sometimes happens, though, that such behavior emerges as discrepant, if not downright neurotic. We do not need to trace Riviere's investigation of the particular etiology of such neurosis to cite her analysis of its de facto purpose: "Womanliness therefore could be assumed and worn as a mask, both to hide the possession of masculinity [read power and authority] and to avert the reprisals expected if [the woman] was found to possess it."[112]

Let me clarify why Riviere's essay has cropped up in this context: not because I mean to suggest O'Keeffe might have read it, or because I think it would necessarily be relevant if she had. But I do think relevant this particular problematization of female public identity: its aim is to characterize, not just a psychic disorder, but a social phenomenon, one that the essay documents as much as describes. In other words, it is a particular *historical* circumstance, the actual

emergence of that new historical character, the successful professional female, that provokes the description of her characteristic neurosis: the excessive display of what is already compensatory behavior, that is, the enactment of the feminine role. So problematic is this new creature that it does not occur to her observers—Riviere was herself, ironically, a member of the new species and may have had her own case partly in mind—that her "neurotically" compensatory behavior might actually be justified, under the circumstances. As a successful artist, O'Keeffe enacted her own compensation in the realm of representation, as painting rather than personal conduct. I have no argument about the latter as specially "feminine," although it was certainly its own kind of performance. On the contrary, there is considerable evidence, including her self-presentation, to suggest that O'Keeffe was consciously critical of much ordinary "feminine" behavior. As a young woman she read feminist literature—works such as *Women as World Builders* by Floyd Dell—and on one occasion we know she heard a lecture by Helen Ring Robinson, Democratic state senator from Colorado. And confronted with a photograph of the 1946 award ceremony of the Women's National Press Club (fig. 26), where O'Keeffe in her sober black stands out amid the laces and orchids of the other distinguished honorees (Agnes de Mille and Dr. Lise Meitner are among them), we might remember that fifty years before, in 1916, she had read Charlotte Perkins Gilman's long essay "The Dress of Women" in the *Forerunner*. At the time she was enthusiastic; something lasting seems to have rubbed off.[113]

For O'Keeffe the masquerade functioned as the means, if not entirely to conceal, then at least to suppress, the evident ambition of her pictures: it operated so as to relegate to a visually subordinate role their engagement with the effort to invent a new order of bodily experience in representation. By such means she meant to elude the inimical opinions of those critics who ironically were among her most enthusiastic supporters. It is as if she reasoned that by confirming their dearest prejudices about her work—by offering, in the folds and swirls of her sweet peas and cactus flowers, the visual version of something like "You want feminine, I'll give you feminine"—she could silence them. Pictures like these literalize "femininity" by tying the concept down to botanical bodies and their transparent analogies; notions of womanliness are here simultaneously "objectified" (given material form) and fetishized (i.e. transferred to a material substitute), in something like classic instances of these terms. Yet all the while, of

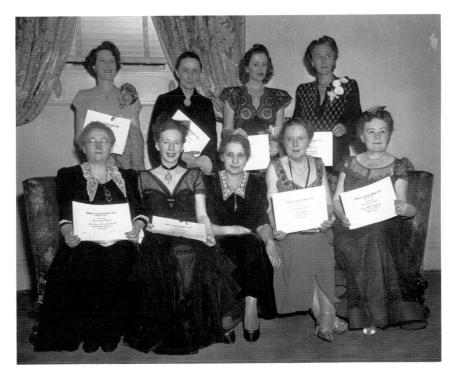

FIGURE 26. *O'Keeffe at the awards ceremony of the Women's National Press Club, February 1946. Photograph: UPI/CORBIS-BETTMANN.*

course, O'Keeffe is establishing the conditions for her own explicit and insistent denial of the sexual content of her art. For all her protests about objectivity, her work's utter sensuality and engagement with the bodily slackened only slowly over the years.

What did get put aside was the concerted attempt, initiated at the outset of her career, to distinguish anew between figuration and abstraction; to demonstrate the figurative suggestiveness of the abstract, and the abstractness of the figurative, in the hope of exposing both the differences and the dependency of those terms. It is impossible to be a viewer of O'Keeffe and to claim confidently that the old oppositions—body/abstraction, exterior/interior, objectivity/subjectivity—can lay claim to quite the clarity of meaning they seem to possess in other circumstances. If bodies can become fundamentally, structurally abstract, though all the while quick with life, and if abstractions, though evi-

dently only mere pigment, can take on a life of their own, then such transformations might make available the rudiments of a language in which a new set of generalizations about embodiment might also be proposed. Both the initial circumstances and visual terms of that proposal, moreover—the deliberate yoking together, in O'Keeffe's practice, of abstraction and figuration—seem to suggest that while O'Keeffe's art may well have arisen in part from her own experience of bodily sensation, of embodiment, she was resistant to an art that would seem to be about *her* sensations alone. She was intent, rather, on other effects: on throwing attention back onto the means by which bodily analogies could be generated, on demonstrating how effects of the bodily can be destabilized; on undermining assurances that the body in representation takes one stable, easily legible—even easily gendered—form.

O'Keeffe's art and career also serve to demonstrate that at least earlier in this century, for a woman to represent the body at all is to give herself over to her interpreters; to become hostage to their limited notion of a woman's world as simply and only an extension of her bodily feeling. For this reason, I think, she had recourse to what I have termed a "masquerade" of her ambitions, clothing them in an expectably figurative, expectably "feminine" guise, perhaps justifying that transformation in her own mind by insisting that it merely rephrased her old ambitions in different terms. I think she continued to see these new pictures as stemming from her long-standing effort to find a space both within and outside the body, and to conceive of a body both within and outside gender. Lest that body be seen as hers, she made it a flower. The new guise allowed the continuation, even the expansion, of some of her artistic goals, though in terms now made generally more difficult to see. But even that effort at conciliation could only ever be, as I say, partially successful. "When I gathered flowers, I knew it was myself plucking my own flowering": perhaps this line from Lawrence conveys the risk with greatest poignancy, though it suggests too a self-knowledge that, in my judgment, the artist failed to attain.[114] Hence it may be better to put the paradox of O'Keeffe's position in a slightly different light: "There is no outstripping of sexuality any more than there is any sexuality enclosed within itself. No one is saved, and no one is totally lost."[115] So wrote the philosopher Merleau-Ponty; it is a dictum that could easily serve as the résumé of O'Keeffe's artistic career.

To view O'Keeffe's success and failure as equally incomplete is to my mind a

way of acknowledging the strength of the interests that competed unsuccessfully to define her public self. I do not think this overstates the case. The fiction of O'Keeffe's femininity was upheld in two different quarters; each gave a different version of the tale. Neither can be thought of as securely preceding the other; both aim to negotiate the kinds of power and authority O'Keeffe's art will be said to have. One version was floated on the tide of critical response: it is exceptional in the annals of artistic reception for its urgency and its extremism because it had real work to do. It came at a signal moment when, in the wake of the disruptions of World War I and the achievement of female suffrage, avidity for, and hostility to, the notion of a particularly feminine art went hand in hand. Those circumstances fed the chief pretense of the critics—their overwhelming urge to attribute to O'Keeffe and her art a (false) totality. This is what was implied by the celebratory claim that her art was indeed "that of a woman," that it was nothing if not essentially feminine. The verdict underwrites the assurance that the work is utterly self-sufficient, completely bound up in its circuitry of female sensation and emotion. Relevant here is Mary Ann Doane's formulation of the social function of the essentialist position: "The entire elaboration of femininity as a closeness, a nearness, as present-to-itself is not the definition of an essence but the delineation of a place culturally assigned to the woman."[116] Now look back at the passages from Paul Rosenfeld cited above, this time to note the exceptional recursiveness of the text; it comes back and back to its key notion of feminine self-reference (the artist's aesthetic is so reflexive it can even refer "the universe to her own frame") in a way that seems to want to mimic textually the totalizations it attributes to O'Keeffe. Such strong claims made O'Keeffe's reputation: perhaps only strength—or overstatement—would do to register the arrival of a woman artist on the scene, and make it count. Yet their strength is also their chief disciplinary tool: O'Keeffe's stature is thereby contained. Again the logic seems inexorable: if O'Keeffe's painting is her self, it is only herself. Which is to say, it is excluded by definition from those other—those many—spheres of meaning and achievement that exist outside the female persona. It can have no truck with style or influence: it can exist in no particular relationship with history and can have only a nodding acquaintance with other moments and practices of innovation. Its possible relationship to contemporary politics or culture must be downplayed or derided or stamped out. At all costs, let there be no confident expression of positive

connections to feminism or psychoanalysis. This is what it means to celebrate an art as that of a woman, at least when the woman is O'Keeffe.

Yet the woman was also an artist, and she was ready to answer her critics in her own way. She did so, often strategically, sometimes emphatically—with the results in every case demonstrating her remarkable ambition, resilience, talent, and commitment to her practice as a painter. I do not know why she had these qualities—as always, such personal attributes do not lend themselves easily to explanation—but I am sure that she did. Otherwise I do not see how she could have made of her art such a powerful vehicle both to sustain and to contest her reputation. I come back to her ambition, as confessed to Waldo Frank, to achieve a vulgarity so magnificent—a magnificence so vulgar—"that all the people who have liked what I have been doing would stop speaking to me." What would it be like to overturn, by the sheer power of one's painting, the (un)comfortable decorum governing one's place in the world? To elect painting the site of the upset is to ensure that it occur in a space simultaneously public and personal; it is to make the upset an effect of fantasy, one's own and that of the viewer.

This, I think, is what O'Keeffe did again and again. Her pictures both instance and solicit fantasy, and do so simultaneously and to different ends. The viewer is sometimes allowed to claim a special somatic knowledge in response to their imagery: differentiating that knowledge as female is a special departure on his or her part, one licensed and enforced by the gendering of O'Keeffe's own place in the world. Her own fantasies, it seems, were rather different; they centered on the possibility of using her pictures to claim identity, power, and knowledge. Hers is a form of representation that aims to show the unshowable: the body in its absence, and without gender; the interior of the body, when no corresponding exterior can be imagined; the gender of the body, when no gender can be determined; the symbols of the body, when they can be made to differ and conflict. If we take seriously the various confusions of status and substance that O'Keeffe's images cultivate, then we must grant them their claim to exist in the space of the imagination. We must concede the many ways in which her imagery engenders odd hybrids, irreconcilable differences: solid voids, absent distances, and the like. This is, I think, the imagery of the phallic woman. I use the term advisedly, yet nonetheless hoping it will not erupt within my text, wanting it as a graphic figure for the notion of an O'Keeffe trying to

negotiate for herself the terms of her own special potency, her identity as a painter. Look back at the series of jack-in-the-pulpits, and look at them in conjunction with a definition of the phallic woman: "Woman endowed, in phantasy, with a phallus. This image has two main forms. The woman is represented either as having an external phallus or phallic attribute, or else as having preserved the man's phallus inside herself."[117]

The term is helpful if it can bring into focus the anomalies of O'Keeffe's work: above all the way she claims a particular language as "hers" yet refuses to let stabilize the gender implications contingent on that claim. Those anomalies, I contend, constitute her effort to renegotiate the gender boundaries of her art: to stake out a new position in her painterly practice while in many ways seeming to accept or even to defend the old. If the result is a peculiarly feminine syntax, then it is one that aims, however impossibly, to measure up to the complexities of Luce Irigaray's redefinition of the term: "In that syntax there would no longer be either subject or object, 'oneness' would no longer be privileged, there would no longer be proper meanings, proper names, 'proper' attributes. . . . Instead, that syntax would involve nearness, proximity, but in such an extreme form that it would preclude any distinction of identities, any establishment of ownership, thus any form of ownership."[118] These are the effects embodied in Georgia O'Keeffe's art.

Krasner's Fictions

When Cindy Nemser tried to summarize the complications involved in the interviews that became *Art Talk: Conversations with Twelve Women Artists* (1975), she kept the lid tactfully, securely clamped down: "Some people were more challenging than others," she wrote mildly. The code is not hard to crack: challenging usually means difficult when applied to people (or hiking trails); it certainly does here. Lee Krasner headed Nemser's brief list of problem subjects. She was "alternately ferocious and fearful, voicing heated indictments against art world powers one moment and editing them out the next."[1] Like the sessions with Audrey Flack (Nemser's other great challenge), those with Krasner provided an "intellectual adventure only hinted at in the finished conversations."

One remark that survived Krasner's relentless self-editing concerns the sources of her art: "I think my painting is so autobiographical if anyone can take the trouble to read it."[2] Not quite an invitation, this—or if it is, it is edged with the mixture of aggression and abnegation, bravado and aggrievedness typical of Krasner's conversational style. How much trouble, one cannot help wondering, might actually be involved? And what kind of trouble, exactly? Would the reward be worth it in the end? It seems to me that anyone who rises to the bait and launches an autobiographical reading of the painter's art finds her way blocked at every turn. Many of the barriers were consciously placed by Krasner herself; she erected them with real efficiency. Other obstructions, though not unique to her—they may arise when *any* painterly practice is seen as autobiographical—still get in the way. There is, for example, where Krasner is con-

cerned, a peculiar lack of self-documentary material other than paintings them-selves. We are after the autobiography of a person who, unlike O'Keeffe and Hesse, wrote very little. She apparently kept no journals. Personal letters are few, though more may exist than have so far come to light. This is a woman who lived and died within fifty miles of her Brooklyn birthplace, and though she traveled to Europe several times during her seventy-six years, those occa-sions gave rise to no great epistolary production. Eventually, by the 1960s, she used secretaries and lawyers to handle her correspondence. The paucity of writ-ten documents by Krasner cannot merely be the product of physical circum-stance: she was evidently not much nourished by written communication. By her own admission, she "ha[d] difficulty with titles"[3] and came to rely on the suggestions of author friends like Richard Howard and Sanford Friedman, who served her well. In a pinch she would settle for less professional advice, once mining the comments of her housecleaner's small daughter for phrases like "Flowering Limb," "Happy Lady," and "Eyes in the Weeds." Once in a great while a title simply popped into her head: its "automatic" appearance gave it a status akin to that of her figural imagery—the occasional bird or flower—which, she told Nemser, she simply "got." "I don't go around consciously think-ing these images up. They come through. So in that sense, it's archetypal."[4]

How should one go about reading as autobiographical an art in which visual imagery is the main narrative vehicle? How is the project complicated when, as in Krasner's case, the imagery is for the most part resolutely nonfigurative, steeped in those techniques of representation apparently best equipped to baffle a literal account, no matter how "personal" a picture might seem? This is an art to which verbal clues are notably lacking, or, at best, provided secondhand, an art, moreover, whose autobiographical standing is not claimed as the result of its maker's conscious intentions. Such legible imagery as it offers—not just the occasional bird or flower but also, presumably, those fragmented body parts that briefly enter her art in the later 1950s—emerges inadvertently and (at least according to its maker) offers clues only to the least "personal" of possible mean-ings, the "archetypes" into which the "personal" is routinely channeled, and thereby managed. If we are to respond to Krasner's hint that her self is inscribed in her paintings, then we shall have to devise a way to read her painting, for all its habitual abstraction, as a kind of writing able to register the personal in pictorial form. To aid in that process, moreover, we will need special tools,

materials other than the written documents in which the self is customarily
thought to be inscribed: I am thinking, for example, of Krasner's self-portraits,
particularly a canvas she painted about 1930 to gain entrance to the National
Academy of Design, as well as the various photographs for which she posed
throughout her life. In the absence of journals and letters, the many interviews
she gave from the 1960s until her death in 1984 should perhaps also be read as
autobiography, with the actual writing doled out to various subcontractors—
this even though on several occasions their ostensible subject was Jackson
Pollock, Krasner's husband. Although some (like the one Nemser published)
were carefully edited for publication, others exist exactly as transcribed, with
the many lacunae and elisions of Krasner's thoughts and speech intact. These are
the main issues of evidence, but there are also difficulties of interpretation to be
confronted—none more prompt or pressing, it seems to me, than the question
of just how "personal" her *visual* language actually is, as well as when and why
it might ask to be seen as such.

Though Krasner's invitation hints that interpretation will be difficult where
her art is concerned, it gives only a hint (perhaps it does not do to be too
discouraging when interviewers come to call). There is no whisper, for ex-
ample, of a problem at least as intractable as those just raised. Krasner's art may
be autobiographical—an act of self-inscription—but how can we be sure ex-
actly who that self was, in anything more than a literal sense? Of course there
is no genuine confusion about this matter: the person born in Brooklyn in 1908
was duly buried on Long Island in 1984 in the cemetery at Springs. The place
is marked by a rock made modest by the boulder resting on Jackson Pollock's
grave. In death Lee Krasner is positioned relative to her husband; in life this
was also the case. Her marriage to Pollock in 1945 created Mrs. Jackson Pollock,
an identity that legally and practically all but replaced the former Lee Krasner
for a good many years. When wife ceded to widow, Mrs. Pollock survived,
even flourished, while Krasner likewise began to come back into her own. But
Lee Krasner herself was something of a fiction; she had been born Lenore Krass-
ner and continued to use that name on official occasions, to sign her marriage
license, for example, and to witness Pollock's death certificate.[5] Making her
name literally less "krass" and more boyish, moreover, is only one of the varia-
tions she toyed with: there was the more elegant "Leonore" she occasionally
adopted and the romantic "Lena" and quasi-biblical "Leah" she used at Cooper

Union, as a teenager taking a stab at "being an artist" for the first time;[6] there was also the person who for years signed her paintings using only the initials "L.K."

These identities have overlapped and competed for attention whenever and wherever Krasner has entered the public realm. The roles of wife, widow, and painter, each with its attendant assumptions about womanliness and androgyny, dependence and autonomy, shaped this inchoate public self; none of them gained the upper hand. On the contrary, one identity has been used to mediate another at almost every juncture. Parentheses are usually enough to do the job: Mrs. Pollock is qualified as (the former Lee Krasner), Lee Krasner as (Mrs. Jackson Pollock). The brackets breed a hybrid, ego and alter ego, a strange composite creature who inevitably limps along like a contestant in a three-legged race. Pollock was the glue that fixed them in their mutual, inevitable dependency, and made the fusion a handicap. It may be that the "trouble" at which Krasner hinted involves the difficulty of peeling back the various wrappers that have come to surround her public—and private—selves. Were such an endeavor successful, we might well conclude, it would reveal another self entirely: the self as the artist described it—the self inscribed in the painting.

In what follows I argue for the usefulness of seeing the historical personage Lee Krasner primarily as a product of various fictions, her own included, concerning her public self and art. I am pessimistic, moreover, about the possibility of locating any self for the artist outside these various roles. Nonetheless, I think it helpful to submit those narratives to scrutiny because they seem not merely to typify, but also to give extreme and visible form to the pressures at work on the lives of American women, not least the artists among them. These pressures operated efficiently enough to foreclose the possibility of women's achieving anything like the artistic success offered to their male counterparts. By rights 1950 should have marked, if not Krasner's "artistic maturity" (I have never been sure what that phrase really means), then at least the firm establishment of a career whose roots and first successes date from the late 1930s and early 1940s. In retrospect it is a respectable history: at the time it must have seemed a positive augury of future success. Krasner was put on the federal payroll as an artist in 1934, when she signed up with the Public Works of Art Project. In 1940 she joined the American Abstract Artists and began to exhibit, successfully enough to be allotted, four years later, a full-page illustration in Sidney Janis's

Abstract and Surrealist Art in America. In 1950 Krasner was forty-two. Yet her first one-person show did not happen until the following year, and the next to be held in a New York gallery was delayed until 1955. The 1950s instead brought success to a significantly younger generation of painters, women like Helen Frankenthaler (b. 1928), Grace Hartigan (b. 1922), and Joan Brown (1938–1990), who entered the art world some two decades after Krasner first exhibited her work. When *Life* pronounced in 1957 that women artists were "in ascendance," there was no one over thirty-five in the photogenic group marshaled to illustrate that claim.[7] (A 1950 spread rounding up the country's best "younger" artists drew the line at thirty-six—still, of course, well below Krasner's age.)[8] Little wonder that when she did get her own show in 1951 she fudged the key number and gave her birth date as 1911. The three years she had shed were enough to bring her age down to just shy of forty, even though in the eyes of the media she would never be "younger" again.

Such strategies and small deceits—make no mistake about it—are the actions of an individual aware of the expectations and prejudices of the art world and aiming to thread her way around them, insofar as she was able. Late in her life she answered feminist regret at her checkered career with the insistence that she had decided her own course, rather than having it foisted upon her.[9] No doubt she believed this was the case. By then the cultural climate had changed enough to begin the public retooling that turned her back into Krasner again. She died in 1984, having been reclaimed as an artist in the late 1960s and 1970s, particularly by feminist art historians like Nemser who, unlike others in those days, were able to see her as more than the best living source of information about Pollock. Her rehabilitation, interestingly enough, was solidified by media attention as symptomatic of its day and age as the first journalistic responses to Pollock were of theirs. In 1949 *Life* asked the question, "Jackson Pollock: Is He the Greatest Living Painter in the United States?" In 1972 *Time* declared unequivocally that Krasner was "Out of the Shade." The light-and-dark metaphor soon began to show some mileage: in succeeding years, according to the headlines, Krasner variously "put Mrs. Jackson Pollock in the shade," "showed her true colors," became "an artist in her own right," "found her own voice," came "out of the shadows to gain recognition," moved "out of Pollock's shadow," and graduated "from disciple to individualist."

These phrases, with their pretensions to a heroics of Woman as Survivor,

evidence the invention of Lee Krasner in gendered terms as much as any of the details I have so far cited. They could hardly do otherwise, for gender, a less-than-stable social phenomenon, is always negotiated in social performance and representation, including the feminist kind. Yet this last persona, the Survivor, was only one of the several constituents of Lee Krasner's public identity—an identity that in its ramifications and manipulations inevitably escaped her control. Nor could she decide her options from an infinite array of possibilities. On the contrary, I argue that both her painterly and social selves were necessarily confected from the closed set of materials that surrounded her: they are inevitably marked by those historical limitations. To make these points, I route my argument along the path of least resistance—that is to say, I attend first to the more expectable materials of Krasner's biography and autobiography, trying to isolate and interpret the identities supplied her through these channels, and to spell out the terms of her participation in them. Only then do I turn to the ways her art might be said to play an autobiographical role: my reading confirms Krasner's sense of it as a self-accounting, and tries to understand the indirection of its terms. These two tactics have several points of contact; it will not always be easy to keep them prized apart. Yet the effort is worth making, since it offers a foundation secure enough to support my main interpretative task, that of fashioning a response to Krasner's backhanded invitation.

Painter, Wife, and Woman

Before the 1940s there is a relative dearth of the kinds of "supplementary" materials that could register Krasner's artistic identity with any force or clarity. I do not mean facts and dates: the month of her entry into Cooper Union, the names of her teachers, her place on the federal payroll—all these have been duly recorded. We know likewise of the professional associations and exhibitions into which she found her way with increasing frequency as the 1930s came to a close. The point is not that such facts lack interest: on the contrary, they document a career off to an auspicious start, at least according to the standards of the day. This was not an artistic moment or market given to meteoric rises and presold shows; one-person exhibitions were infrequent, particularly for an artist just starting out. Hence the absence of such events in Krasner's career is decidedly more typical than not. Yet the primary sources for a study of

identity—as well as for its initial elaboration—are generally more adjectival, materials that function more obviously as sites for self-description: at this stage in her career, Krasner evidently made greatest use of the genres of the self-portrait and the photographic portrait to elaborate a notion of her personhood.

Krasner's earliest surviving self-portrait (plate 14) was a student exercise, but it is no less a statement of selfhood for all that. It was painted, so the story goes, to gain admission to the life drawing class at the National Academy of Design; all candidates were evidently set the same task. The requirement seems both excessive and calculated: skill in painting from life is not a traditional precondition for instruction in drawing from life; perhaps bound up in the demand was the desire to see how effectively the aspirant could imagine herself in the painter's role, or, indeed, if she could do so at all. Krasner could; hers is an image of an artist on the job. Brushes and rag are in one hand. The other is completely hidden, at work behind the interjected corner of the canvas. The business side of the canvas is likewise hidden. Though it hangs at an angle that recalls the mirror Krasner claimed to have nailed to a tree so as to be able to paint out of doors, the only markings it shows are on the back, flat patches of gray and beige: they threaten to coalesce into a shadowy head, it is true, but ultimately fail in that attempt.

In other words, Krasner paints a canvas that is hidden from the canvas she is painting, and in so doing reiterates one of the standard contradictions of self-portraiture. Its other main complication—again one Krasner made much of in this picture—involves the erosion of boundaries between painter and spectator. Krasner both inspects and paints herself—as the record of that self-scrutiny her picture inevitably presses the viewer simultaneously into two roles, those of the artist and her mirror. In the act of painting she stares at her object—her self—and her picture urges its viewers to assume both that same stance and glance. Its first viewers, the committee of judges at the National Academy of Design, apparently had difficulties obeying the injunction. Her promotion to the life class was only conditional; questions were raised concerning the central conceit of the work: had it really been painted outdoors?[10] Did it really stand up to its claim to have been made in the full light of day? The questions persisted: to quote Krasner, "No amount of explanation helped."

If Krasner was forced to defend the truth claims of her portrait, then it may be productive to wonder what they actually entailed—whether they con-

cerned more than the simple demonstration of a talent for execution *en plein air*. I am thinking in particular of the light the picture casts on Krasner's contradictory conception of artistic identity. Being a painter, the picture mainly suggests, is a practical business; it is best undertaken in a spirit of directness; it demands a steady gaze, one level enough to meet any challenge from self or viewer. It means too an insistence on the relationship between the painter's means—the hot orange and blue on her rag and brushes—and her visage, which is put together using just those hues. But it also seems to involve neutralizing or obscuring the main signs of sexual identity. Krasner's hair is cropped, her shirt reminiscent of the workman's favorite denim, her apron a convenient device to downplay the curve of her breasts, her bared arms and hand forceful, even meaty. Though not exactly a portrait of the artist as a young man, the image edges close to that pretense. It certainly goes far enough to reveal Krasner's artistic directness as a matter of posture, not truth. And this sense is further shored up, in an oddly contradictory way, by the implications of the painter's disobedient decision to put her professional self to work in a wood. It is as if she meant to naturalize her claim to that identity through recourse to the realist tradition. The contradiction arises, however, when we realize that this reference to the Real—to Nature—places the mannish young painter in a conventionally "feminine" setting. The painter's stance and her setting are notably at odds.

That determined stance seems to have been Krasner's characteristic posture when she painted, at least through the early 1940s. It is echoed, for example, in a photograph of her before the easel in Hans Hofmann's studio, where she had begun to study in 1937 (fig. 27). On this occasion (the year is about 1939) the glance is again direct and the guise pragmatic; the arm and hand at her side again seem specially forceful, cocked at a slight angle from her body as if ready to take action should the need arise. In this portrait, however, her work is very much visible; as she looks away from it to confront the camera, her hand keeps its brush in steady parallel to a line on the canvas, as if it is about to return there and wants not to lose its place. And this new sense of reciprocity between bodily and pictorial postures is upheld in other ways: note, for example, how the hair-trigger tension of the circuitry outlined on the canvas seems to be restated in the sheer tension of the "tough" psyche enacted in gaze and pose.

These two portraits span a decade in which the allegiances of Krasner's pic-

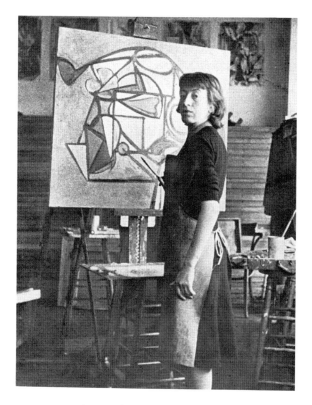

FIGURE 27. *Unknown photographer, Krasner painting in Hans Hofmann's studio, ca. 1939. Archives of American Art, Smithsonian Institution.*

tures changed considerably more than her posture before them; by the early 1940s, her way of painting had nothing to do with the standards and methods of the professors at the National Academy of Design. Working with Hofmann was a different kettle of fish—but not because he rejected the power and relevance of Nature. Witness the brief statement he submitted to Janis's *Abstract and Surrealist Art in America* (the text accompanied a color illustration of Hofmann's *Painting* of 1944): "I paint from nature. Nature stimulates in me the imaginative faculty to feel the potentialities of expression which serve to create pictorial life—a quality detached from nature to make possible, a 'pictorial reality.'"[11] Working from Hofmann's lessons presumably meant grasping the contradiction inherent in this statement: the painter's task means standing attentively before some object in nature—a still life was the textbook example in the Hofmann

school, but a human body could do just as well—and then *de*-naturing that experience insofar as one could. The objects of the natural world were to provide the impulse to leave the world behind. Yet they should do so only under the strictest controls; Hofmann granted no broad licenses for self-expression, though he conceded that self-expression would inevitably occur. This he spelled out in 1941, in an address delivered in conjunction with the Fifth Annual American Abstract Artists exhibition (Krasner's work was included in the show): "Abstract art is in my opinion the return to a professional consciousness—a consciousness which controls the emotional accumulations in the process of creation. Such a control is only possible within the limitation of the medium of expression. I think there cannot be doubt that every artist attempts to say what he has to say, and he will say it within the limitation of his personality. Every art expression is rooted fundamentally in the personality and in the temperament."[12] While Hofmann here is notably silent about the version of abstraction best able to promote professional consciousness, it is clear that fostering such a consciousness was a main goal of his teaching, however muddily expressed. It was the only means, so Hofmann claimed, by which the artist could hope to render that special province, "pictorial reality": with the self ("the personality and . . . temperament") kept carefully in check.

Hence, we might conclude, the disappearance from Krasner's practice of the genre of self-portraiture—or at least its disappearance in any self-evident form. From Hofmann Krasner learned the painterly "detachment" required in his studio: the art of translating forms into a springy armature of lines and planes and circles, working with and through their jumps in scale and color to equalize them all as marks on a planar surface. This is the language of *Blue Square* (plate 15), for example, and of the canvas on the easel in the studio photograph, and of *Composition* (plate 16), the painting that *she* had reproduced in Janis's survey. Unsigned, it faced John Graham's *Studio* in the section titled "American Abstract Painters."[13] (The present signature, "L. Krassner," is said to have been added by Pollock, so as to insist on an authorship the painter herself was—typically—reluctant to assert or reveal. How odd that the comma following her name turns it into an unfinished remark.) This context was a compliment, one echoed within the text: there Janis termed *Composition*'s structure "powerful," high praise at the time.[14] Yet any one of these three pictures might have deserved that label, even aimed to secure it: they all display a tense control of

their parts and objects and monitor their lines and edges to vigorous effect: "power" is evidently on display. If my descriptive language seems coded, it also has a purpose: any one of these pictures might have been the painting to which Hofmann awarded his highest palm, the greatest accolade a female student (working from the limitations of *her* personality) could then earn: "This is so good you would not know it was painted by a woman."[15] The comment is telling, and not just in obvious ways: it speaks to these works' overproduction of a still-life machinery, a structure that holds each part in strict control.[16] There are none of the ambiguous and subjective effects—the lines that vacillate and get rerouted—that mark Hofmann's canvases of a similar date, and none of the willful reductivism characteristic of Picasso, another point of comparison the pictures evoke. Such differences shed new light on the *lack* of difference of Krasner's work. Do they make it *in*-different, perhaps? They certainly are enough to suggest a new wording for Hofmann's encomium: "This is so aggressively controlled you would not think it was painted by a man." It is as if, for Krasner and Hofmann alike, a fantasy of "masculine painting" is offered as the aim—the achievement—of her art. The rubric does not reference style and ambition so much as it speaks to the cultural context in which both were to be viewed.

We know that Krasner recalled her teacher's tribute as "double-edged,"[17] and even a "cold shower."[18] She was eventually to repudiate the importance of his lessons about painting: the only ones that stayed with her (at least consciously) concerned the artist's comportment, not his art: "As I try to look back I would say that the most valid thing that came to me from Hofmann was his enthusiasm for painting and his seriousness and commitment to it. That is the most I got from Hofmann."[19] Perhaps these remarks mean that Krasner should be counted among the best of Hofmann's students—the most attentive to the essentials of a message whose main recommendations did involve the cultivation of a proper painter's demeanor. Yet we also know that Hofmann eventually elaborated his guidelines for artistic conduct, couching them in even more clearly gendered terms, and insisting even more explicitly that the artist's identity was prescriptively gendered: witness remarks he made one July 1949 evening in Provincetown. The theme of the discussion was "What is an artist?" "Well, I don't know what an artist is—but I know what makes him an artist: I do know that only the man equipped with creative instincts and a searching

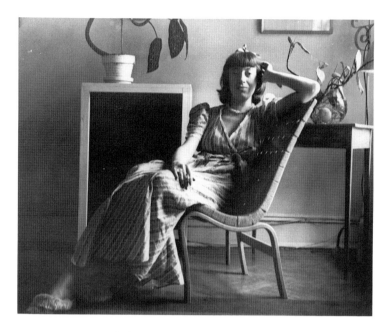

FIGURE 28. *Igor Pantuhoff (?), Lee Krasner, ca. 1938, photograph, Lee Krasner Papers, Archives of American Art, Smithsonian Insitution.*

mind is destined to become an artist. As an artist I do know that only the highest exaltation of the soul will enable the artist to transform the deepest and the weightiest of his experiences into a new dimension of the spirit that is art."[20] Of course we have to concede that Hofmann was operating within a linguistic system that functioned somewhat differently from our own; but if neologisms like "s/he" had yet to appear, neither had the constellation of beliefs and politics that has given them rise. Yet this was also Krasner's context: at this moment she represents herself—and is represented—as a painter determined to achieve a "professional consciousness." She aimed to stimulate in herself the special "imaginative faculty" that could leave nature behind, precisely to make possible a "pictorial reality" Hofmann could approve—a painting "so good you would not know it was painted by a woman."

These are the circumstances from which the first of Krasner's fictions emerged—we might call it the "myth of L.K." The phrase is meant to invoke both the artist's habitual neutered signature of the 1940s and 1950s—she used L.K. if indeed she signed at all—and the social and professional circumstances that led to the adoption of the particular selfhood signaled by her androgynous

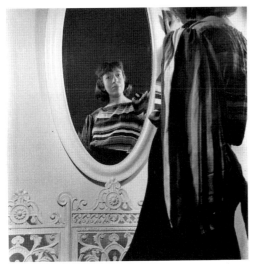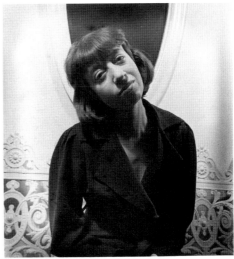

FIGURE 29 *(above, left). Igor Pantuhoff (?), Lee Krasner, ca. 1935, photograph, courtesy Robert Miller Gallery, New York.* **FIGURE 30.** *Igor Pantuhoff (?), Lee Krasner, ca. 1938, photograph, courtesy Robert Miller Gallery, New York.*

nom de guerre. Her pose seems the more self-conscious, moreover, when it is contrasted with the persona in another set of images. There she adopts another guise entirely. These are photographs that date from the mid and late 1930s: they may have been taken by the painter Igor Pantuhoff, with whom Krasner lived for eight years or so (the liaison was close enough, reports Ellen G. Landau, for the Krasner family to assume that a legal marriage had occurred).[21] On these occasions Krasner faced the camera with no pretense of artistic professionalism (figs. 28–30). Her postures seem compliant and her gaze indulgent— now she was acting the woman's role. It involved soft tailoring and long skirts, a winsome twist of the head and a glance from heavy-lidded eyes. In one photograph—it must date from about 1938—she arranges herself in a bentwood chair as if to echo the curves of the plants behind it; her cigarette stays unlit. The conceit here is relatively simple (*la vie de bohème* meets *House Beautiful*)—yet the result is not to be mistaken for a casual snap. In an image that is probably the earliest in this small sampling, the staging is even more elaborate. Krasner has turned her back on the viewer—her gaze reaches us only through its mirrored reflection: the setup is the perfect inverse of the painted self-portrait in

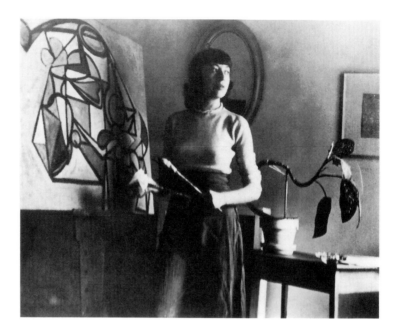

FIGURE 31. *Maurice Berezov, Lee Krasner painting at home, ca. 1939. Location unknown.*

the wood. The photograph's efforts at romantic distancing fall pretty flat—the game of denial and revelation contrasts oddly with the sheer weight of the prosaic details that crop up in the image—the folds and wrinkles in the blouse, the zipper of the skirt, the lettering on the wrought iron screen, the varnish on the nails. This *belle dame lointaine* turns out to be not very distant after all, and the viewer feels disillusioned (and reassured) by the way the camera's sharp focus (its attention to "nature") forestalls the workings of desire. She learns once again that when desire and its illusions have truck with specific material conditions, the latter may take the upper hand. When Krasner again poses before the mirror (fig. 30), it is notable that she confronts the camera, the coy tilt of her head now countered by the directness of her look. It is as if she means through her gaze to take greater charge of the terms of her representation and its encounters with the world.

The point of calling attention to these images is not to claim that any one of them depicts the "real" Krasner of the 1930s. On the contrary, each mines

different strategies of making and conventions of representation, in some in-
stances adopting the stance of self-scrutiny, in others showing the complicity
necessary to photographic collaboration. Nor am I arguing that the identities
they supply are necessarily incompatible. Yet they are distinctly different, so
much so that we are not tempted to confuse them. Nor is it immediately appar-
ent that they needed to be kept so carefully separate, at least in the context of
representation. I know of only one photograph of Krasner from this moment
where the role of painter is assumed with anything less than total concentration
(fig. 31). She is working at home on the selfsame canvas she was painting in the
portrait taken at Hofmann's studio; while the shutter is pressed, she wipes a
brush, studiously ignoring for once both her picture and the camera. Yet her air
of distraction in this case only serves to prove the rule that governs the other
images: there "painter" and "woman" are kept carefully apart.

Let me be the first to point out that my argument seems thus far to depend
on a singularly scanty body of evidence. Indeed, the very lack of other subjec-
tive sources nominates these few images as the key 1930s instances of self-
signification—instances in which, without benefit of hindsight, Krasner herself
deliberately registered her varying sense of her own persona. (There is plenty
of evidence, by contrast, to suggest that hindsight eventually came to play a
considerable role in her attitude toward this period of her life. Note, for ex-
ample, her singular reluctance to admit the extent of Pantuhoff's role in it to
later interviewers, as if she feared that revealing their former closeness would
impinge on her standing as Pollock's wife and widow. There is as well her own
eventual recognition, in retrospect, of the paucity of available documentation of
this phase of her career: when in the 1960s her own growing reputation made
it necessary to have more of a history, she enlisted Francis V. O'Connor to
supply her with data he had collected from the National Academy of Design,
the Federal Arts Project, and the like.)[22] The absence of contemporary verbal
texts with anything like the density of these visual ones likewise means that
later written descriptions of the young Lee Krasner are necessarily the product
of memory, her own memory above all. They expand our sense of Krasner's self-
invention in new and useful directions.

It was Krasner herself, for example, who made the best use of recollections
of the 1930s and early 1940s, not just to supply herself with a past, but to

emblematize the discomforts of her gender status as an artist. She told and re-
told the story of Hofmann's backhanded compliment, sometimes making a stab
at a Germanic accent ("Zis is so good . . .").[23] Another twice-told tale, her
account of a run-in with Peggy Guggenheim, telegraphs an awareness of how
much her signature initials risked becoming the figure for her lack of a name in
the art world. After Pollock had bungled the arrangements for one of Guggen-
heim's visits to his studio, the pair met her steaming down the stairs as they
came up. She was in a stew, muttering, "L.K., who is this L.K.? I didn't come
to see L.K.'s work." To which Krasner added the dour and phallic punch line,
"She damn well knew at that point who L.K. was and that was really like a
hard thrust."[24]

 This is a story with real didactic value. The issue, once Krasner's association
with Jackson Pollock had begun, *was* exactly "who L.K. was" where the art
world was concerned. Again the painter's responses to various interviewers in-
dicate her grasp of that key circumstance. They are usually notably circumspect,
even guarded—it is clear she recognizes just how much is at stake. Take for
example an occasion in 1960 when one Louise Rago went straight to the heart
of the matter: "Do you feel that you have lost your personal identity because
you happened to be the wife of Jackson Pollock?" Krasner replied levelly: "If
anything my identity has been enriched through knowing Pollock. Naturally I
would be influenced by as dynamic and powerful an artist as Pollock. I owe an
astonishing debt to him. It was a tremendous advantage to know him; however
I still paint as Lee Krasner."[25] Period. And when Barbara Rose tried to get her
talking during an interview for *Vogue* in 1972, her tone stayed similarly even,
or at least was edited to seem that way: "I don't know what I would have felt if
he'd said, 'I don't want you to paint,' or acted it out in some way. The issue, of
course, never arose; but it's inconceivable to me that I would have stopped
painting if my husband hadn't approved. Since Pollock was a turbulent man, life
with him was never very calm. But the question—should I paint—shouldn't I
paint—never arose. I didn't hang my paintings in a closet: they hung on the
wall next to his."[26] Even when an interviewer struck sparks, as Emily Wasser-
man did in 1968 and Cindy Nemser did again a few years later, the main point
of the story—Krasner's dogged maintenance of a separate painterly identity—
stayed the same. Here, verbatim, are the two exchanges:

EW: What was his reaction to your work when he first saw it?

LK: Very sympathetic.

EW: Did he in any way criticize what you were doing, or give you suggestions?

LK: No, he did not criticize. He simply did this, and I'll relate one episode here . . . and that is, he took a canvas—this is while I'm in my Ninth Street studio. . . . And I was out one afternoon, and I come in, and I found that the painting I had kept on the easel, that I was working, you know, and I said, "That's not my painting," and then the second reaction was, he had worked on it. And in a total rage I slashed the canvas . . . I wished to hell I had never done it, but . . . and I guess I didn't speak to him for some two months, and then we got through that.[27]

CN: Some critics have said that this series [the figural paintings completed after 1956] is the beginning of Lee Krasner as an independent painter. They feel that only after Pollock's death were you able to be yourself.

LK: Where have I not been Lee Krasner prior to that? I don't understand that point of view. It is an outside point of view and I am not in touch with it.

CN: It implies that you couldn't be free or yourself until you moved out from the orbit of Pollock's influence.

LK: Hogwash is my answer to that kind of thinking. Esthetically I am very much Lee Krasner. I am undergoing emotional, psychological, and artistic changes but I hold Lee Krasner right through.[28]

These snippets of testimony suggest that at least in retrospect Krasner tried hard, not just to be sanguine about the split between her social and painterly selves, but even to insist upon their separation—however difficult it sometimes was to find the right words: "It hasn't been easy going. But I'm still not clear . . . whether it has been because I'm a woman artist or because I am Mrs. Jackson Pollock so that I feel in that sense it's more than what's known as a double load. That is to say, if I were Lee Krasner but had never married Jackson Pollock would I have had the same experience I have being Mrs. Jackson Pollock?"[29] Yet even though statements like this one convey Krasner's sense of a kind of social schizophrenia—even mimic it, via their grammatical disarray— they rarely raise directly any problems that might follow in its wake. If complaints were in order, they were to be displaced onto the character "Mrs. Jackson Pollock"—and then only once she had been widowed. Witness another

remark to Rose: "Since his death, of course, being Mrs. Jackson Pollock has become something of a burden—an art world burden, that is. It was never that while Pollock was alive."[30] Or there is the deliberate ambiguity of a quip to Rago, "Unfortunately, it was most fortunate to know Jackson Pollock."[31] Sandwiched here between the contradictions of Krasner's identity, between fortune and misfortune, is one further displacement: the *it* that stands in for *I*, the speaker's self, and locates that self at a distance, yet fast in the grip of a patently contradictory fate.

Although these remarks ostensibly cancel any suggestion of trouble at Springs, they still reveal Krasner's predicament and the nature of her response. Thus I am willing to hazard the suggestion that the career implications of life with Pollock were actually more burdensome, less purely "fortunate," than his widow was later willing or able to admit outright. They certainly were not easy to control. I think, moreover, that both at the time and later Krasner and Mrs. Pollock were each aware that these identities were being forced into unhealthy conjunction. Both had to devise a response to the crossbreeding of their social and professional selves, even though neither could be sure that her response would be effective. Strategies could backfire or have unsought consequences. In retrospect, some of the choices made by Krasner in the wake of her marriage seem to fit that bill—for example, her decision about how to meet the press one summer's day in 1950. Burton Rouché, a Long Island neighbor and journalist, came to the door in search of material to use in a piece destined for the *New Yorker's* weekly column "Talk of the Town." Characterizing Pollock, that "uncommonly abstract abstractionist," was his main purpose, but along with the sketch of one partner came a vignette of the other: "Pollock, a bald, somewhat puzzled-looking man of thirty-eight, received us in the kitchen, where he was breakfasting on a cigarette and a cup of coffee and drowsily watching his wife, the former Lee Krasner, a slim, auburn-haired young woman who also is an artist, as she bent over a hot stove, making currant jelly." These familiar roles are maintained as the visit progresses; the puzzled, drowsy Pollock "shrugs" and "grunts" and "scowls reflectively" as the interviewer poses his questions; Mrs. Pollock "laughs merrily" and "smiles" as she obligingly remembers details her husband has forgotten about his art. ("'What's it called?' we asked. 'I've forgotten,' he said, and glanced inquiringly at his wife, who had followed us in. '"Number Two, 1949," I think,' she said. 'Jackson used to give

PLATE 14. *Lee Krasner, Self-Portrait, ca. 1930, oil on linen, 30⅛ × 25⅛ in. (76.5 × 63.8 cm.). Estate of Lee Krasner, courtesy Robert Miller Gallery, New York.*

PLATE 15. *Lee Krasner, Blue Square, ca. 1940–42, oil on canvas, 30 × 24 in. (76.2 × 60.9 cm.).* © The Equitable Life Assurance Society of the United States, courtesy Robert Miller Gallery, New York.

PLATE 16. *Lee Krasner, Composition, 1939– 43, oil on canvas, 30⅛ × 24¼ in. (76.5 × 61.6 cm.).* National Museum of American Art, Smithsonian Institution, Washington, museum purchase made possible by Mrs. Otto L. Spaeth, David S. Purvis, and anonymous donors and through the Director's Discretionary Fund.

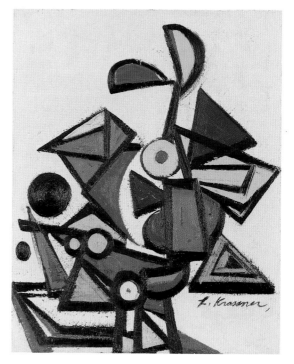

PLATE 17. *Lee Krasner, Untitled, 1949, oil on composition board, 48 × 37 in. (121.9 × 94 cm.). Collection, The Museum of Modern Art, New York, Gift of Alfonso A. Ossorio.*

PLATE 18. *Lee Krasner, Polar Stampede, 1960, oil on cotton duck. 93⅝ × 159¾ in. (237.8 × 405.8 cm.). Courtesy Robert Miller Gallery, New York.*

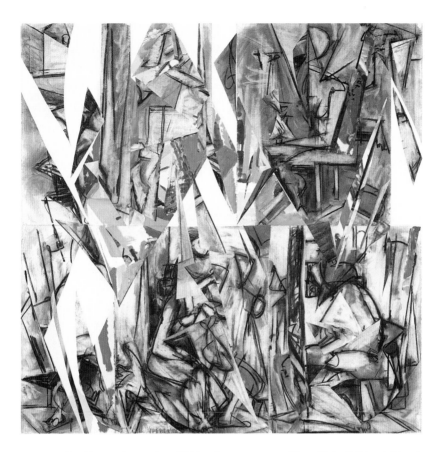

PLATE 19. *Lee Krasner,* Imperative, *1976, collage on canvas, 50 × 50 in. (127 × 127 cm.). National Gallery of Art, Washington, Gift of Mr. and Mrs. Eugene Victor Thaw in honor of the fiftieth anniversary of the National Gallery of Art.*

PLATE 20. *Lee Krasner, Bald Eagle, 1955, oil, paper, and canvas on linen, 77 × 51½ in. (195.6 × 130.8 cm.). Collection of Audrey and Sydney Irmas, courtesy Robert Miller Gallery, New York.*

PLATE 21. Lee Krasner, *Prophecy, 1956, oil on cotton duck, 58⅛ × 34 in. (147.6 × 86.4 cm.). Robert Miller Gallery, New York.*

PLATE 22. *Lee Krasner, Three in Two, 1956, oil on cotton duck, 78 × 57½ in. (198.1 × 147.3 cm.). Mr. and Mrs. Robert I. MacDonnell Collection, San Francisco, courtesy Robert Miller Gallery, New York.*

his pictures conventional titles—"Eyes in the Heat" and "The Blue Unconscious" and so on—but now he simply numbers them. Numbers are neutral. They make people look at a picture for what it is—pure painting.'")

I can think of few examples of writing that return a woman more relentlessly or routinely to her identity as wife. (I make this claim well aware that Krasner sometimes collaborated in that process.) This Mrs. Pollock emerges as chief cook and minder for an imperfectly socialized genius of a husband. The early riser of the pair, she is the one with the smile and the memory and the arguments concerning the interest of Pollock's art.[32] Actions and observations that might normally seem unexceptionable—for instance, making jelly on a sunny Saturday morning—are converted into stereotype when they become the "Talk of the Town." Photographers often created the same effects. There are, for example, the several notorious double portraits of Krasner and Pollock by Hans Namuth. Or take the photographic campaign conducted by Wilfred Zogbaum to portray the couple "at home" (figs. 32, 33). Though a sculptor by profession, Zogbaum shot two rolls of film with great aplomb; like performers in a mime of marriage, his sitters busied themselves in the garden, with shovels and dogs and daisies. The former Lee Krasner had been domesticated; so had Pollock. The year is 1950: the cheery normalcy of Cold War domesticity stands waiting in the wings.

Against such effortless havoc Krasner's later doings with the interviewers might seem merely an effort at damage control. Nor did her questioners ever really plumb her reactions to the critical erasure of L.K. by the Little Missus. How could they, when they relied on posers like "Do you feel that you have lost your personal identity because you happened to be the wife of Jackson Pollock?" This is not a question designed to be answered yes. An inquiry able to suggest some separation between public and private, media representation and response, might have earned a more self-searching reply. But most interviewers were less interested in ferreting out the complexities of Krasner's personal history than in supplying scripts for other dramas in which she might have played a part. What would she have said if asked about particular incidents in her own career? How might she have explained the change in her reputation? For example: how would she have responded to the fact that Janis's sense of the "power" of her compositions became a mere memory as the 1940s came to a close? Or maybe not even a memory. It was Janis himself, presumably, who

FIGURE 32. Wilfred Zogbaum, *The Pollocks at home, Springs, Long Island, 1950. Lee Krasner Papers, Archives of American Art, Smithsonian Institution.*

FIGURE 33. Wilfred Zogbaum, The Pollocks at home, Springs, Long Island, 1950. Lee Krasner Papers, Archives of American Art, Smithsonian Institution.

chose the Pollocks (along with the Delaunays, de Koonings, and Arps) for inclusion in his 1949 exhibition *Artists: Man and Wife*. Whatever confidence the two of them may have had in exposing, side by side, the complementarity and relatedness of their work must have evaporated when the reviews came out. Read *Art News* on their contribution: "There is also a tendency among some of these wives to 'tidy up' their husbands' styles. Lee Krasner (Mrs. Jackson Pollock) takes her husband's paints and enamels and changes his unrestrained, sweeping lines into neat little squares and triangles."[33]

Widow

We do not know Krasner's reaction to criticism like this because no one ever thought to ask her, and then press for a response. I think, moreover, that she did supply her reaction in paint—we will return to this in due course. The questions put to Krasner took a different direction because Pollock's death in 1956 catalyzed the emergence of a different process and persona: his will named her his sole executor and heir. These events were the necessary precondition to Krasner's entry into the special company of contemporary artists' widows (Action Widows, B. H. Friedman called them)[34] that the critic Harold Rosenberg classified in 1965 as a major art world force. "It is hard to think of anyone in the Establishment who exceeds the widow in the number of powers concentrated in the hands of a single person," Rosenberg jealously declared, and Mrs. Jackson Pollock was his case in point: she "is often credited with having almost single-handedly forced up prices for contemporary American abstract painting after the death of her husband."[35] Such critical treatment rankled with Krasner (and incidentally, with Friedman, who, having cited Rosenberg's verdict, made a point of insisting that in her "slow and regular" release of the paintings— they were sold even more slowly than friends had advised—she acted out of "love" rather than "power politics," let alone business acumen).[36] Krasner's own grievance took a different form; being a widow was too much like being a wife. "I was put together with the wives, and when Rosenberg wrote his article many years ago, that the widow has become the most powerful influence, I don't know, powerful something in the art world [sic]. To date, a lot of the widows are acting it out. He never acknowledged me as a painter, but as a widow, I was acknowledged. And, in fact, whenever he mentioned me at all following Pol-

lock's death, he would always say Lee Krasner, the widow of Jackson Pollock, as if I needed that handle." [37]

Krasner does seem always to have "needed the handle" of identification with Pollock and the domestic role; moreover, the labels wife and widow apparently made her more uncomfortable than she was sometimes willing to admit. She was at pains to spell out (in an interview conducted by Barbara Cavaliere in 1980) that her relationship with her husband did not conform to the pattern of most artistic marriages. Pollock was no Motherwell or Matta or David Hare, who "treated their women like something you dreamed up and put on exhibition. Well, I didn't fit into that . . . Pollock and I, the idea of Pollock picking a dress, you know, at most, first of all I don't even know if he saw what I was wearing, if he ever, ever said something like that's a nice blouse you've got on, it was, wow, big holiday." [38] Nor was Krasner able quietly to take a back seat, as other wives did: "Then you have the other wives, like Gottlieb's wife, Ester [*sic*], and Barney Newman's wife, Analee [*sic*], who never opened their mouths, You didn't know they had an opinion. They worked, they supported their husbands, they taught school and they kept their mouths absolutely closed tight. I don't know if they were instructed never to speak publicly. I don't know if they ever had a thought." (Remember, in this context, what Mark Rothko had to say to Newman on the subject of wives—the year is 1945: "I want both of us to have the most beautiful wives in captivity, both of us seeming to have an untenably romantic attitude about this shady business." [39] When it comes to wives, it doesn't sound as if Rothko and Krasner would fundamentally disagree.)

Krasner was not very charitable, nor was she very beautiful, but she had plenty of thoughts, and not a few of them concerned her husband's art. The fact that those musings were so frequently solicited after his death demonstrates the special privilege granted her, not simply because she was a widow, but because she was a widow who was a painter herself. The possibility that she might provide some special knowledge of Pollock's work (its sources, its meanings, its techniques) anointed her in the role of oracle and high priestess of the Pollock-ian mysteries. Krasner recognized that this status was exceptional—though she had difficulty expressing her sense of its implications. In an undated statement among her papers, for example, she examines her status as woman and wife but can find no means to come to grips conclusively with either:

The fact that I was a woman in the movement [Abstract Expressionism] is pretty complicated[.] I haven't resolved that. I'm asked that question a great deal. Certainly it has to do with the fact that I was a woman, and the fact that, to date, a great deal of noise is being made about the subject so that, in a sense, all of it is surfacing now. But in addition to that I was also Mrs. Jackson Pollock. I want to be very clear about this. That is not the same as a woman artist being married to a male artist. The name Jackson Pollock is not just another male artist. As such, it threw a difficult light on the role that I had to function in. I'm still preoccupied with where I was and why it hasn't been acknowledged fully.[40]

This statement would have been unthinkable without the women's movement of the 1970s, which was a main agent in the growth of Krasner's reputation. Yet however poignant, however historically enabled, the painter's wish to be "very clear" about her role as Mrs. Jackson Pollock, that wish bore no real fruit—in fact it is her *lack* of clarity about these matters that is actually most productive. "The name Jackson Pollock is not just another male artist," she declares. Yet in making Pollock a name, not a man or a painter, while in the same breath declaring he "is not just another," Krasner admits his special implications, not just for her social experience, but for her psychic economy. He is the Other (i.e. "not just another"); his name stands in the place of the Father and of the Law. And Krasner reveals her continuing preoccupation with her *own* location—with the place she is to be assigned in some (conscious and unconscious) drama of names. That it could be broached mostly via negation lends weight to an understanding of its powerful psychic role.

This preoccupation, to repeat, seems not to have been resolved before her death: the desired clarity was not forthcoming. Moreover, it sits uneasily and sometimes even clashes with her other postures and attitudes after Pollock's death—her loyalty to him, for example, and her hostility to other women, and her wish to devise a special framework in which to see her wifely role. All of these responses are often likewise at odds with those of critics and biographers. Let me try to separate the several strands that contribute to this particular widow's tale. The task of so doing is necessitated not just by their relevance as biographical circumstance—Krasner spent nearly thirty years as Pollock's widow, against eleven as his wife—but because Krasner's widowhood was shaped by social and economic conditions. The women's movement again was

one such circumstance—it opened the attractive yet threatening possibility that her interests as painter and widow might not be one and the same. Another was the mushrooming of the art market and the election of a Pollock-led school of American painting to world-historical stature, phenomena that likewise kept her interests as widow very much on the boil. Now add to these another, no less relevant phenomenon, the ongoing postwar merchandising of artistic identity in commodified mass-cultural terms: the Pollock-Krasner story was grade-A grist to this highly profitable mill. All of this goes to suggest that Krasner's situation did not simply settle into a reasonable facsimile of the widow's traditional "comfortable estate": "the only hope," as they sing in *The Beggar's Opera,* "that keeps up a wife's spirits."

Krasner's widowhood was comfortable, of course, from an economic point of view. Prices for Pollocks did indeed rise crisply after his death, too late to help him much, but not to ensure both his widow's livelihood, and the establishment of the Pollock-Krasner Foundation after her demise. The pace of change is inscribed in the insurance valuations assigned Krasner's loans to MoMA; although these are not to be confused with market prices, nonetheless the jump in the values assigned Pollocks between October 1956 and June 1957, when some of the same group of canvases were lent to the São Paulo Biennial, has them more or less doubling in worth. *Gothic* had been set at $9,600, and rose to $15,000; *Totem [Lesson] II,* once $9,600, rose to $20,000; the valuation of *Portrait and a Dream* climbed from $11,000 to $20,000; *Summertime* went from $12,000 to $25,000, and so on.[41] In 1960 a group of paintings from 1950 and 1951 were given valuations ranging from $45,000 to $60,000 when they were shipped to the Tate Gallery for possible purchase (they were refused as too expensive, and not representative of Pollock at his best).[42] By 1961, when Clement Greenberg wrote his essay "The Jackson Pollock Market Soars" for the *New York Times,* the price for one medium-sized picture (three by eight feet) had topped $100,000, and the really large-scale works could not be had for love or money. When in the 1970s the biggest pictures did begin to come back on the market—the watershed came in 1973, when *Blue Poles: Number 11, 1952* was sold to the Australian National Gallery, Canberra, for $2 million—the early prices began to look like spare change.[43]

Krasner's role in some of these events was surely decisive, and *pace* Friedman, perhaps even astute (note, however, that some of the largest pictures, like *Blue*

Poles and *Lavender Mist*, were not sold to the profit of the estate). Yet there is little to imply that she therefore operated as anything like the powerful schemer Harold Rosenberg wished to make of her. (Or if she was a schemer, she was hatching plans as much for the exposure of her own work as of Pollock's: in the space of seven years, between 1955 and 1962, she showed with three different dealers, breaking abruptly with each.)[44] Krasner did not sell Pollock's works so much as have them sold; the estate was handled by dealers, who tended to most routine matters of stewardship.[45] And it was left to the lawyers to handle her finances, lawsuits, and taxes, and to charge for their services. Yet Krasner's was not a passive role; she shifted her allegiances whenever she saw fit. The chief such instance was her departure from the Sidney Janis Gallery, with which Pollock had been associated at his death, to Marlborough Gallery in London; her aim, so it was said at the time, was to position the estate closer to the European market, and thus to escape the relentless ministrations of the American sellers of art. Yet there was certainly more to this than meets the eye, not least, as a letter from the Janis Gallery makes clear, her ambition to have the estate emerge as a separate entity, cited on an equal footing with the gallery in matters of photo credits and the like (no doubt a useful prospect, since some sort of foundation was already under discussion). What else should we expect? What else did Rosenberg expect? When his peculiar, resentful investment in the fiction of the Action Widow is set aside, Krasner actually seems to have functioned not only as widow/dealer, but also as widow/curator. (There is admittedly a gray area between them, as in cases where a work's authenticity was concerned.) It seems typical that she was interested enough in the prospect of a catalogue raisonné of Pollock's work that she had written into her 1957 contract with Janis a commitment to its publication. (This was a commitment about which Marlborough, by the way, subsequently had some misgivings before, in 1972, it finally decided to support the catalogue with a grant to Yale University Press.)[46] Her efforts, in other words, went toward establishing the physical conditions and legal terms under which Pollock's work would be encountered; she determined, insofar as she was able, the basis for its marketing, but also its preservation and care.

After all, Pollock could not do the job himself; his unavailability meant that Krasner legally made his interests her own. The point is not that he necessarily would have done so, had he lived; on the contrary, most writing about the two

FIGURE 34. *Unknown photographer, Lee Krasner being interviewed before* Blue Poles, *1973. Lee Krasner Papers, Archives of American Art, Smithsonian Institution.*

artists urges the reader toward quite opposite conclusions. Time and again Krasner emerges, Svengali-like, as the power behind the throne, the calculating and ambitious dealer/manager of an alternately inept and recalcitrant spouse. This Pollock, we are meant to understand, was both unable to confront the realities of daily life and resistant to the commodification of his person and his art. But this is also the Pollock who did not survive, if he ever existed.

The Problem of Pollock and Krasner

A photograph, apparently taken in 1973, shows Krasner being interviewed against a background of *Blue Poles* (fig. 34): its every detail—the interviewer's youth and Krasner's age, his deference and her curmudgeonliness—seems to confirm the Action Widow premise. Yet Pollock's death and Krasner's bereavement have had implications, not only for the market, but also for their reputations as a couple of painters. The presence of one and absence of the other have shaped interpretations of their artistic identities—they are a precondition of

the Pollock myth, and the Krasner who goes with it. This is the problem of Pollock and Krasner: their personal relationship has been harnessed to their artistic reputations, to mostly deleterious effect. As a result, I argue, their ties as man and woman, husband and wife, are now more or less beyond recovery as anything other than discursive effects, inventions endlessly fashioned and updated in the ongoing repackaging of both partners. The loss of any viable view of their union, in other words, results from various efforts, Krasner's among them (though by no means to the exclusion of more decisive attempts), to fill the void opened by Pollock's demise.

To see this process in action we need to return to the interviewers once again. We begin in medias res, in 1967, at the moment of the Pollock retrospective at the Museum of Modern Art. The show was the reason that Krasner was quizzed by the writers Francine du Plessix and Cleve Gray; the title given her responses—they came out as "Who Was Jackson Pollock?" in the May *Art in America*—suggests that reputation was the name of the game. Only a month before, *Arts Magazine* had run its own Pollock piece, some reflections on his stature by the sculptor Donald Judd, then aged thirty-nine and at something like the height of his creative powers and influence. The two articles could not be more different in their authors, but they are oddly similar in their urgent address to the issue at hand: Pollock's reputation. Krasner was taking the opportunity—one of many she mobilized—not just to set the record straight, but to fend off its worst excesses: Pollock was an alcoholic, yes, but one who never painted drunk; an alcoholic, yes, but one whose problems rested with his mother; an alcoholic, yes, but one whose violence never extended beyond words and objects to people. And he could bake a great apple pie.[47] The tenor of these reflections makes it clear they have a purpose; in delimiting Pollock's personal behavior they aim to counteract the particular excesses of the myth of "Jack the Dripper," the "bearded shock trooper of modern painting," a myth of whose existence Krasner was entirely aware and by which, as she told her interviewers, she was profoundly "bored." Judd's purpose was likewise to address Pollock's status: he wanted to go on record with one central claim: "I think Pollock's a greater artist than anyone working at the time or since."[48] But for a great artist, Pollock was, according to Judd, remarkably ill served by his epigones: "Not much has been written on Pollock's work and most of that is mediocre or bad. . . . Quotations and biographical information should be consid-

ered more carefully than they usually are. Dumb interviewers often get dumb answers."

In retrospect, such impatience with the simplifications and excesses of the Pollock myth may seem oversensitive or prescient, depending on one's point of view. Note, though, that Judd and Krasner were not alone in their efforts to resist sensationalism. Within only a few months of Pollock's death, Clement Greenberg, the painter's best critic in the 1940s (even the dissatisfied Judd had to admit, however grudgingly, that "Greenberg was beginning to think about the paintings; but he quit"), published a two-page piece on the artist in the *Evergreen Review*. It was an obituary, pure and simple—the facts, ma'am, just the facts. And when Greenberg learned that one or two of his facts were factitious—they were contested in personal letters from Peggy Guggenheim, the painter's dealer, and Charles, his brother—he immediately wrote the editors to correct them: "Not that I wish to magnify the importance of every detail of Jackson Pollock's life, but I would not like to see errors of fact, however unessential, become current because of their appearance in a note like mine, which was designed to give nothing but facts."[49] Such scrupulousness on Greenberg's part, moreover, still haunted him in 1961, when for the benefit of readers of the *New York Times Magazine* he attempted to explain why prices for Pollocks had soared. His explanation had little to do with market nuts and bolts, and everything to say about cultural priorities. What was being consumed at astronomical cost was not painting but a mythology that metastasized, as Pollock himself internalized it and assumed the provided identity of *artiste maudit*, into real suffering—suffering, however, that the public found entirely glamorous and consumable. "As one who was a friend of Pollock," Greenberg wrote, "I can only deplore this. Glamour is cast over a lot of wretchedness that in principle had little to do with art. And somehow the false glamour interferes with a recognition of the great and sophisticated qualities of his art itself."[50]

Matters have improved little in the past thirty years or so; on the contrary, it might be argued that they have gone sharply downhill. Judd's wariness of dumb questions, Greenberg's insistence on facts, not false glamour—these are mostly things of the past where the public Pollock is concerned. Consider the character of two of the most recent Pollock biographies, Jeffrey Potter's *To a Violent Grave: An Oral Biography of Jackson Pollock* (1985) and Steven Naifeh and Gregory White Smith's *Jackson Pollock: An American Saga* (1989). The first of these, as a

self-declared "oral biography," wears its use of interviews on its sleeve: in its 280 pages the testimony of scores of different named informants is cited; a handful of unnamed sources appears as well, sometimes under aliases—"First Neighbor (mechanic)," "Second Neighbor (bulldozer operator)"—that give their speeches a quasi-theatrical air. But the number of "witnesses" Potter consulted pales next to the thousands of hours of testimony that, we learn from the proud calculations of the authors, went into the manufacture of the Naifeh/Smith opus: upward of eight hundred different informants were consulted; their recollections run in transcription to more than eighteen thousand pages, which together bear a total of some ten million words. Apparently the reader is meant to marvel at these statistics—but it may make more sense to reserve your amazement, the better to wonder that thirty years after Pollock's death, so many people still had something interesting to say about him. Perhaps their memories had become more "interesting" over the years.

Given the extraordinary weight and confidence placed by these authors in the "spoken word," it would be foolish not to consider the ends to which these hours and volumes of speech are put. Their explicit purpose, of course, is to invent a Pollock; what needs emphasizing is the way that fiction depended on Krasner—on both the woman herself and the character she was assigned to play in the Pollock drama. First things first: for these authors there was the necessary initial task of negotiating a relationship to her in her guise as the official repository of Pollock's memory. Hence, I think, their shared choice of an oral technique. As a result of such a method, Krasner can become simply one of many witnesses, if a valued one; her word need not be taken as law. (Though from a legal point of view it seems to me no accident that both of these books appeared only after Krasner's death—*her* absence was in this instance the decisive factor.) And invoking such an authentic source, while circumventing her, is indeed the point. Potter's biography, for example, though dedicated to Krasner, is not a work in which she collaborated, although according to the author (like Pollock and Krasner a resident of East Hampton) it had been begun in 1971, when she was still alive and well. She was to have been Potter's last interviewee, "mainly for fact checking." Her death meant that this plan never came off.[51]

To Naifeh and Smith, Krasner, though in failing health, gave seven interviews and provided "many insights." However illuminating those might have

been—the authors fail to signal the remarks they found especially useful—they could never withstand the sheer weight of materials that supplement and supplant them. And they certainly could not resist the pull of interpretation to which the various events of both Pollock's and Krasner's lives have been submitted. Take for example Naifeh and Smith's opinion of Krasner's decision in 1932 to "withdraw from the field" (the phrase is Krasner's) and enroll in a teacher training course at City College: "It was more like a rout than a withdrawal. She not only left art, she retreated all the way back to the most traditional and secure aspiration a young Jewish woman could have: teaching. . . . Lee later tried to explain the sudden reversal as a financial necessity. . . . But no excuse could conceal the truth. Even Lee must have realized that at a critical moment in her career, her will had failed; that for all her style and rhetoric, her fire didn't burn hot enough."[52] Where to begin? With the sanctimoniousness of this opinion, or its sexism, or its doctrine of rampant individualism and free will, or its duplicitous notion of "the truth"? Or perhaps with that snide "even," which single-handedly, effortlessly turns Krasner into the most self-deluded of mortals, the last to recognize her motivations and her failures.

It is of course not simply the use of interviews that poses a problem for students of Pollock and Krasner, it is the *way* they are used. Which testimony does an author take to be most convincing? What criteria are established to evaluate the motivations—to say nothing of the truthfulness—of the informant, once testimony has been collected? When we read, for example, that the sculptor Harry Jackson (the former Mr. Grace Hartigan) thought that Lee had "asked for it" (physical abuse from Pollock),[53] or that "Lee had a goddam hold on him, terrific hold—right by the ying-yang, like a goddam kosher icicle,"[54] what confidence should we place in him as a source for knowledge about Pollock's attitude toward Krasner's painting? "He encouraged her, but he was disdainful. He had that 'little woman' attitude toward her. He took me up to look at her paintings and said something like 'That's Lee's little painting.' He wasted almost no time with her and considered almost everything he did in that area as sort of encouraging the little lady."[55] "Little lady"—even were we to give good ole Harry the benefit of the doubt and assume that, as a Wyomingite, he is just speaking some local (sexist, anti-Semitic) dialect, such a concession would not be enough to boost confidence in his dispassion as an art critic, let alone trust

in his skills as an analyst of personal motivation. Except, perhaps, for Naifeh and Smith, who side with Harry to opine that Pollock's encouragement of Krasner was "superficial" and his discouragement "strong, if subtle." [56]

Did these writers on Pollock and Krasner believe everything they were told about the pair, or just some things? Did they never wonder, as their sources spoke, "Why is this person telling me this?" or ask "What kind of person would say such a thing?" (Perhaps the sheer volume of interviews conducted put time for such reflections at a premium.) How much did their own tastes for the sordid and sensational guide their questions, as well as the ways they cut and pasted and tucked the reams of testimony they accumulated? What about their taste for commercial success? Ernst Kris and Otto Kurz demonstrated long ago (as we have noted) that traditionally artists' biographies, from antiquity through the Renaissance, were recounted so as to ensure that the lineaments of individual identity—the key events of a career, the means by which talent is recognized and celebrity won—conform in broad outline to recognizable patterns that supply their readers with certain expected satisfactions. [57] The Pollock biographies likewise offer contemporary readers a set of peculiar—and now predictable—narrative pleasures: the same pleasures Greenberg labeled "false glamour" and tried, however ineffectually, to fend off. Stories of *artistes maudits* attract because they are antiromances—first cousins and antitheses of the Harlequin genre, I mean. Their interest and marketability rest on their inversion of the romance formula: "plucky, independent woman wooed and won by dashing hero" becomes "creative, flawed hero/genius, his masculinity threatened by women-modernity-failure, tragically succumbs." It is essential to the experience of this second kind of story, like that of the romance, that the outcome is known in advance: victim and hero (henpecked and abusive), Pollock must and will go to his "violent grave" in due course, but meantime the oral format, with its reliance on opinion and pseudo-controversy, breathes life into the old clichés and lends texture and a certain suspense to the telling. The result is biography for the fin de siècle, quasi-docudrama, a genre whose immediacy, like that of its cinematic or television counterpart, is supplied by the contingent claims of the so-called eyewitness—actually post facto—account. The sampling of critical opinion on the cover of the 1989 paperback version of Potter's work only confirms this conclusion. From a *Newsweek* pundit we learn that "Pollock is like a character out of a Sam Shepard play." The *Guardian's* critic

declares, "It cannot be a long time now before there is a major Hollywood production." (The current crop of rumors from movieland suggests he was squarely on the mark.) And the reviewer for *Dan's Papers* writes that the book "reads as if it were a thriller."

Yet if Pollock's life is to be conceived of as "scripted," its lineaments should be understood as conforming to unities and conventions rather different from those recurrently invoked by the media as the stuff of thrills and entertainment. Pollock's life reads like a movie/novel/play not least because it has been written that way. It seems safe to assume, moreover, that the tools most useful to explain it differently are not in these, or perhaps any other, biographer's hands. Like their various informants, they are too profoundly engaged in fashioning a Pollock—and, it should be emphasized, a Krasner to go with him—that will satisfy their requirements for narrative and character. That they appeared in print only after Krasner's own disappearance from the scene seems to bear out the conclusion that her presence served as at least a partial brake against these fictionalizations. The brake removed, the biographers went to town. Tempting though it might be simply to dismiss the results as too tendentious to be taken seriously, such an impulse would be mistaken. This is not just because Naifeh and Smith won a Pulitzer Prize for their effort, though that fact should be noted. Remember that such works—and the institutional honors they re-ceive—help to legitimize the myth of artistic identity that fuels them.

The paradigm of an assertive and unstable Pollock—a character who is, need I say it, relentlessly made to conform to the familiar role of a freewheeling, handsome, inarticulate, white, Protestant, Western-born male genius, "born under Saturn," as the old phrase goes—is cemented when coupled with its complementary fiction, Krasner. She is urban, Eastern, Jewish, the daughter of immigrants, homely, capable, good with money, a wily bargainer and strategist, intellectually competent but lacking "inner fire"—in short, she is everything that Pollock is not, the antithesis that confirms the thesis concerning modern male identity sited in his person. The point, of course, is not to claim that Krasner was someone other than a nonpracticing Jew from Brooklyn, or Pollock a lapsed Protestant born in Cody, Wyoming—not, in other words, to dispute the relevance of particular biographical circumstance—but rather to recognize how and when the circumstantiality of any one account hardens into stereotype. This occurs in the case of Pollock and Krasner when the elements of biography

are used to suspend confidence either in the authenticity and depth of their relationship or in the validity of Krasner's purposes as a painter, or both. The result is yet another offering laid at the feet of that familiar cultural deity, the independent and superior male artist. Krasner made some efforts to moderate the worst excesses of the Pollock effect, as did Greenberg and Judd, yet they were mainly ineffectual, perhaps because all three (unlike Naifeh and Smith) believed too wholeheartedly in Pollock's stature as an artist—an attribute that his cult pretends to celebrate, but mercilessly commodifies.

Viewer

Nowadays it seems that the tools and methods of feminist criticism are most useful in contesting the kinds of fictions that have given Krasner and Pollock public selves. Armed with them, we might look again at material that has already served other purposes here. Take Greenberg's obituary in the *Evergreen Review*. Perhaps we should now note that it contained a few other errors of fact that neither Krasner nor any one else bothered to clear up. They concern the dates the two painters met and married. Greenberg put both too early: the former in 1940 rather than in 1942, and the latter in 1944 instead of 1945. Minor errors, of course, except when accuracy is the stated goal. I suspect the main reason Greenberg's slips went unnoticed, at least by Krasner, was that he described the artists' relationship in such positive terms: "She first met Pollock on this occasion [an exhibition at the McMillen Gallery to which they both contributed], and they were married in 1944, but even before their marriage her eye and judgment had become important to his art, and continued to remain so."[58] This was an opinion Greenberg did not renege on, even though his friendship with Krasner came to an embittered end in 1959. It offers a certain identity for Krasner within her marriage—that of Pollock's closest critic—an identity that apparently had for Greenberg, let it be said, something like the status of fact. It certainly functioned as such in the obituary, where facts were at issue. And it has been reinforced by Krasner's memory of the utterly basic questions Pollock used to ask her about his painting: "Should I cut it here?" "Should this be the bottom?" or, most famously, "Is this a painting?"[59] There are few questions more fundamental than these.

Now consider a brief episode from the notorious film of Pollock at work made

by Hans Namuth and Paul Falkenberg in 1950. It is an episode that seems to have remained more or less invisible—if not literally, then functionally—since the film was released. (It was first shown at a screening at the Museum of Modern Art, New York, and then made available for rental to colleges and universities.) Sandwiched between the film's two main parts, those canonical frames in which Pollock is seen painting first on canvas and then on glass, is footage that Namuth has described as follows: "In the next sequence, a long painting, 'Summertime,' is pulled slowly beneath the camera. The canvas appears to be floating past the viewer. Next, Pollock is seen tacking the same painting onto the walls of the Betty Parsons Gallery. There are other paintings in the Gallery, and a visitor (actually his wife)." [60] Namuth does not go on to add that the visitor, seen mostly from behind, enters the gallery space to stand lost in thought before the works on view. I take this gallery sequence to function as the film's explicitly affirmative answer to the implicit question, "Is this a painting?"—a question that others asked of Pollock's art even more frequently and suspiciously than he did himself. Yet while the film feels called upon to show Pollock's products *as art*, needs to make his canvases socially or contextually recognizable as such, it does not therefore "need" to posit a woman—"(actually his wife)"—as the figure of the ideal viewer, the arbiter of the status of Pollock's painting as art. That its makers chose to do so, it seems to me, suggests that Krasner was profoundly "in character" in the role—a suggestion only affirmed by a battered documentary photograph of the Parsons show, which has her, now facing the camera, standing happily in its midst (fig. 35). The image is a rarity, since Pollock installation shots are seldom peopled; its rarity is part of the point.

The character of viewer, moreover, was one that Krasner herself worked hard to keep hold of as the interviewers trooped through with their microphones and eager repetitive questions. She did not avoid them: her strategy was more active than that. It involved *not* serving, after the fact, as taste- or phrasemaker on behalf of the pictures—at least not in any specially forthcoming or articulate way. (In fact she seldom referred to specific canvases: the talent for titles and dates seems to have been mostly a journalistic effect.) On the contrary, her chosen role seems to have meant maintaining a dogged consistency, and even a peculiar scrupulousness concerning what she could or would say about her husband's art. Thus there were some stories she never tired of repeating; some of

FIGURE 35. *Unknown photographer, Lee Krasner at Jackson Pollock's 1951 Betty Parsons Show. Jackson Pollock Papers, Archives of American Art, Smithsonian Institution.*

Pollock's best lines in fact have come down to us as ventriloquized through her: "I am nature," for example, and "I choose to veil the imagery," and "Is this a painting?" and (about Picasso) "That bastard! He misses nothing."[61] This is the Pollock sutra, the aphorisms on which the core critical exegesis has been based. None contradict the key principles in Krasner's account of the roots of her own work. It is not a matter of her claiming to have influenced Pollock outright: when asked if she had shaped his art, she would at most own up to pointing him toward Matisse. At issue instead was a common aesthetic, a matter of shared principles: she too, we learn from her later interviews, chose "to veil the imagery."

In keeping with this posture, Krasner seems to have been consistently willing to declare her lack of answers to certain questions (and conversely, consistently able to remember points that backed up her own views). We might even say that she sometimes made a show of having forgotten just those morsels of information her questioners seem to prize most. Take the tenor of her answers to a set of questions put her by Barbara Rose. Krasner's notable taciturnity on this occasion cannot be laid at the door of reserve or hostility toward the inter-

viewer, as it might have been in other circumstances. On the contrary, the painter proved herself willing to cooperate with Rose several times over the years. (It was Rose, for example, who made the major film of Krasner and who organized her 1983 MoMA retrospective.)

BR: The first "drip" paintings were made in 1947. Do you think moving into the barn had anything to do with greater physical freedom?

LK: It would be very convenient to think along those lines, but I don't believe that was it. Pollock had a lot more space on 8th St. He wasn't confined to one tiny little room. I think the increase in size has more to do with the fundamental aspects of why he did what he did. He certainly needed the physical space to work as he did, but I think he would have found the physical space whenever he was ready to paint with large gestures.

BR: Do you remember how and why Pollock started the drip paintings? . . .

LK: I can't remember, that is the point. I am always rather astonished when I read of a given date. I actually cannot remember when I first saw them. . . .

BR: Do you have any idea why he had the drive to enlarge the gesture onto a physical scale?

LK: Why he did this I don't know.

BR: I have always believed that the installation of Monet's *Water Lilies* in the Museum of Modern Art had a big effect on Pollock. . . .

LK: I don't recall him looking at them, but that doesn't mean that he didn't. We didn't go to shows together necessarily. He would go when he wanted to, and I would go when I wanted to. Occasionally we went together, but not that much.[62]

Reading Krasner's stonewalling responses here and elsewhere, we encounter a witness who did not often claim to know *why* Pollock had done something; moreover, she could only sometimes say *how*. She seems resolutely skeptical toward the art-historical interest in influences, mechanics, and motivation and unwilling to play the historian's role—but she is never skeptical about the paintings themselves:

CN: What was it in Pollock's work that made you respond so profoundly?

LK: It was a force, a living force. . . . Once more I was hit that hard with what I saw.[63]

And this conviction, she makes absolutely clear, was decisive for her art:

BR: Aside from Mondrian, Picasso and Matisse, who were you most affected by?

LK: Pollock, of course. . . . In Pollock I felt a force that once more moved me as strongly as the impact of Matisse or Picasso.[64]

These phrases suggest what it is like when Krasner *does* remember. Each gap in her memory, by contrast, seems to function to hold open a place in which more "fundamental aspects" of meaning, in her terms, could be left understood, unstated. This was the proper reaction to interesting art, from her point of view: in fact neither Krasner nor Pollock seems to have considered responding to painting a particularly verbal experience.

Being a *viewer* of painting is not identical to being its critic or its keeper. As Pollock's viewer, Krasner said yes, no, or maybe—literally not much more than that—and then sooner or later returned to her studio to weigh what those verdicts might mean for her own art. She painted, in other words, without first having surrendered her status as Pollock's viewer (conversely, she looked as a painter), and with both those identities cohabiting with the woman and wife and (eventually) widow she also was. The first tangible result of their commingling was the group of pictures she produced from 1946 to 1949 and called *Little Images* (the selfsame pictures whose title Harry Jackson took as a slur). Of course to be "little" is to invoke a comparative frame of reference: not all pictures could provide the necessary scope and scale. The emphasis on size (or its lack) is one way that Pollock is brought to mind, and with him, questions concerning Krasner's voice and ambition.

In fact the signal achievement of this series is the way it views and reviews Pollock, profiting from and differing with his example in ways that are strategic and intentional. In Krasner's hands Pollock's techniques of the moment—including versions of his signature pours—are chastened, made antirhetorical, almost erased by devices imposed like a baffle before the pictures' surfaces. Lacking the absolute clarity of the grid, they seem like specimens from its prehistory. I am thinking of the black network webbing the surface of *Abstract #2* (fig. 36), and the static hum of the short radiating brushstrokes in *Continuum*, and the flickering overlay of strokes of white paint that gives *Night Light* (fig. 37) its manic nondescript repetitiveness. These elements move back and forth, back and forth, often working over and against a bottom layer, yet without getting any-

FIGURE 36. *Lee Krasner, Abstract #2, 1946–48, oil on canvas, 20½ × 23¼ in. (52 × 59 cm.). Instituto Valenciano de Arte Moderno Generalitat (IVAM Centro), Valencia, Spain.*

where much. Surfaces often seem thick, yet hectic, and their implicit extenda-bility as grid and repetition gets hopelessly bogged down. These effects look willfully contradictory: terms like continuous arhythmia and rhythmic discon-tinuity seem helpful here.

The *Little Images* use their means to real rhetorical purpose: they aim to negate any notion of "language" in painting, using ideas of silence—even a kind of visual repression—to do the job. The several ways these purposes are effected seem above all to try to still the graphic energy of the poured line. (Note that Krasner made many of these works on the floor or a table, using a "tiny" can.) Their technical devices function like prohibitions, with the result that the sur-face simply will not coalesce into imagery, not least the imagery of action. Its measure stays even-grained; its marks, though separable, are equivalents of each

FIGURE 37. *Lee Krasner,* Night Light, *1949, oil on linen, 40¼ × 27 in. (102.2 × 68.6 cm.). Greenville County Museum of Art, Greenville, S.C., Gift of the Maremont Foundation (by exchange).*

other; they seem, if not exactly anxious *not* to mean, then at least reluctant to do so in the ways that by this time Pollock had made his own. This is not to say that they are not involved with ideas of order, or often, as in *Untitled* of 1949 (plate 17), with tantalizing suggestions of writing, messages the attentive viewer might just be able to decode. Yet these promises—their flirtations with meaningful unity, with unified meanings—are refused, deflected into signs left just at the edge of resolution. Meaning remains at the level of a resemblance approached, then skirted once and for all.

These were not fleeting concerns for Krasner; they surface time and again in canvases of the late 1940s, though they take a variety of guises there. The *Little*

FIGURE 38. *Lee Krasner, Untitled (Little Image Painting), ca. 1947, oil on canvas, 21¾ × 15¾ in. (55.8 × 40.5 cm.). Collection of Mr. and Mrs. Eugene V. Thaw, New York.*

Images approach and back away from legibility, but they do so without ever surrendering their main difference from Pollock's own peculiar script. In Pollock's paintings from this time "writing" consistently means apparently improvised signs; his marks seem to be made up anew in each instance and situation, as if entirely dependent on context. Even poured black paint is a presence, seemingly able to signify differently wherever and however it falls. In Krasner's paintings, by contrast—in the Thaw Collection *Little Image*, for example (fig. 38)—black is a negation that puts pressure on communication: the poured tracery and flickering color must be read under and against the absences it imposes. The black-on-black effect makes that negative function doubly clear,

since the upper layer so clearly blocks the lower one. In this and other instances, the (anti)writerly effect is tied in with regularity and prefabrication, with the grid and an overall equality of touch: these familiar procedures here read like rationalisms with nothing to say.

These various effects mean that Krasner's vision seems in retrospect tougher and more pessimistic than Pollock's in the sense it gives of containment, even constraint, by laws that a formal system provides. Her paintings of this moment harbor no illusions about polyvalence or pluralism; though she sometimes called them hieroglyphs, they hold out no hopes of posing as a mythic new language. I am thinking of their contrast with the exuberant eclecticism of Adolph Gottlieb's pictographs, for example (he saves them from portentousness only by brilliant design), or the emotional "subtlety and directness" of Mark Tobey's "white writing" (the quoted phrases are Greenberg's).[65] Krasner's symbols, by contrast, steer clear of both portentousness and delicacy. They take another track (the "lost track"), keeping language at a distance, as a dim, indecipherable memory. I think, in this context, of the comparison Krasner herself later found for these works: they were a "throwback" to the Hebrew she learned in childhood, "which is, you know, for me indeed today a foreign language. I can neither read it today nor can I write. I lost track of it."[66]

"Nor can I write." If the phrase can stand as an epithet for the *Little Images*, it can also do as an assessment of their pessimistic achievement. They name, not Krasner's own inarticulacy (to see these pictures as inarticulate makes them symptomatic of a stereotype, the classic feminine condition), but what her pictures manage to communicate: their refusal to be taken "literally," taken as the letters of a new language. This is the promise they manage to undermine. They revert instead to abstraction, at just the moment when they might be hoped or expected to cohere.

What the *Little Images* patently do *not* do, by contrast, is aim to find some kind of direct visual equivalent to the verbal terms in which Krasner named her initial response to Pollock's art: "It was a force, a living force. . . . I was hit that hard with what I saw." Even if we take these phrases as describing a literal first encounter, naming not Pollock's drip paintings, but the very first work by him that Krasner knew—it was *Birth* (fig. 39), the canvas he showed at the 1942 McMillen Gallery exhibition, which she kept until her death—the implications of the message are unchanged. Yet viewing a hard-hitting art did not at first mean producing one; on the contrary, it meant painting pictures that adhere

FIGURE 39. *Jackson Pollock,* Birth, *ca. 1938–41, oil on canvas mounted on plywood, 46 × 21¼ in. (116.8 × 54 cm.). Tate Gallery, London/Art Resource.*

decisively to a set of central principles that offer their own special description—their fiction—of Pollock's achievement. The point for Krasner, we might say, was to retrieve from his work—and in the case of the *Little Images* her inspiration was particularly his poured paintings of 1947–49, works like *Full Fathom Five* (fig. 40)—a set of agreed principles whose logic she would absorb, but whose overall rhetoric she could then negate. Krasner agrees with Pollock at this moment that painting should be resolutely severed from its familiar func-

FIGURE 40. *Jackson Pollock,* Full Fathom Five, *1947–49, oil on canvas with nails, tack, buttons, key, coins, cigarettes, matches, etc., 50 × 30⅛ in. (127 × 76.5 cm.). Collection, The Museum of Modern Art, New York, Gift of Peggy Guggenheim.*

tions and allegiances. References to bodies and objects in the real world are to be banished; traces of the artist's hand are visible but will not add up to "paint handling" in the old sense. Yet while Pollock worked these principles to erode, complicate, and restructure notions of artistic unity and presence—and manipu-lated them to do so in a dramatically high-risk way—Krasner's procedures de-liberately act to take the rhetoric of risk and presence out of the equation. She

invented such techniques because, I believe, Pollock's operations are too easily read as self-risk, as the Pollock myth exists to demonstrate; Krasner's technique, by contrast, resolutely keeps the self, as both subject and performance, at bay. It does so, moreover, at the moment in her career when that "self" was the most easily returnable to the identity of Mrs. Jackson Pollock. The *Little Images* offer a painted answer—hard-won, intellectually rigorous—to the most difficult problem Krasner faced: establishing an otherness to Pollock that would not be seen as the otherness of Woman. Its urgency was only heightened by social circumstance—by being a wife.

We can take Krasner's revision of the rhetoric of Pollock's painting as a paradigm for the study of the ways gender has shaped twentieth-century painting. In her effort not to be Pollock, while profiting from her view of his art, she seems to point directly to those qualities of his work that were tactically impossible for her, as a painter, woman, and wife, to emulate. She avoided exactly those effects easiest to identify as probable catalysts for her violent and forceful response to his art. She could not reproduce in her own work, it seems, what meant most to her about Pollock's—at least until after he died. Instead his art served to inspire pictures whose imagery leaves behind the boundaries of domestic dialogue: their taciturnity has more to say than that.

Krasner's direction after 1956 offers the clearest possible corroboration of her earlier refusal. Painting after painting from the decade following Pollock's death—from her own *Birth*, say, through *The Gate*, *Polar Stampede*, and *Primeval Resurgence* (figs. 41–43; plate 18) and on through the works of the mid-1960s—aims to sort out a different relationship to Pollock's art. Works from all stages of his career from the late 1930s onward are now rewritten in her terms. And those terms have undergone a terrific change. Most often they put into operation a roiling, circular energy that seems to wheel across the canvas: no wonder Vivian Raynor said she felt "physically thumped."[67] The circle, first used as an organic shape (often an eye—of which more later), soon becomes the driving principle of this phase of Krasner's art. The result, or so I thought when I first saw such pictures in 1989, seems "more Pollock than Pollock": I jotted this phrase in my notebook, but then nervously retreated from such a verdict, unwilling to return Krasner once again to the old comparison. Yet I think the analogy needs exploring, not least since the artist seems once again to have invited it; both the enormous scale and the explosive gestures of these works

FIGURE 41. *Lee Krasner, Birth, 1956, oil on cotton duck, 82½ ×
48 in. (209.6 × 121.9 cm.). Collection of Barbara B. Millhouse.*

issue the request. Now she paints as if reacting to the lifting of an old prohibi-
tion, and doing so with a vengeance, to work out of Pollock more thoroughly,
more concertedly than any other painter of the day.

The result is again a fiction. What is most like Pollock, perhaps, is the sheer
control of the language of uncontrol, the achievement of the effect of unbridled
energy, and the turning of those technical innovations into a painting.[68] Not

FIGURE 42. *Lee Krasner, The Gate, 1959–60, oil on canvas, 92¾ × 144½ in. (235.6 × 367 cm.). Courtesy Robert Miller Gallery, New York.*

poured so much as thrown (Krasner now worked on the wall, not the floor), these images can be called neither tidy nor neat. They are anything but pretty, and usually enormous. Very often painted in umber or an excremental brown, shot with explosive streaks and gashes and splatters of white, sometimes mixing in a jarring magenta, they have a voluble nihilism more or less the opposite of the taciturn intransigence of the *Little Images*. Yet in this same wild volubility they leave Pollock far behind and thus require the viewer at some point to assess how his art is being rewritten. That is to say: "Jack the Dripper" is back in this new version of Pollock's art—the persona, if not the technique. For Krasner has dispensed with Pollock's characteristic ways of undercutting the apparent violence of his art: the multiple effects of space and overlay, of paints threaded and woven, of continuities inflected by chance.

I once felt certain that of these two painterly modes, the *Little Images* were decidedly superior; I was ready to underline (if not actually to savor) the irony that the "better" works were the products of the peculiarly cramped social and

FIGURE 43. *Lee Krasner,* Primeval Resurgence, *1961, oil on cotton duck, 77 × 57¼ in. (195.6 × 145.4 cm.). Collection of Gordon F. Hampton, Los Angeles, courtesy Robert Miller Gallery, New York.*

psychic circumstances in which they were produced. (As has often been noted, Krasner painted in a converted bedroom upstairs at Springs, while Pollock had the barn. Yet given her remarks to Barbara Rose, she might have been prepared to deny that the size of her studio was decisive for her pictures.) As Krasner reworked her painterly identity in Pollock's absence, I thought, she operated as

FIGURE 44. *Lee Krasner, Untitled, ca. 1962, oil on canvas, 96 × 127 in. (243.8 × 322.6 cm.). Pollock-Krasner House and Study Center, East Hampton, N.Y. Photograph © Noel Rowe.*

if now licensed to embrace and expand, rather than negate, his legacy. And by taking up Pollock's inheritance, she could transform what was once "personal" about his art into the elements of a pictorial practice or language in which she shared. The result was a set of pictures that, exactly because they emerged from these purposes, might be said to come too close for comfort to their sources, or to fail to leave them far enough behind. But my verdict has failed to hold up. Whose comfort? How close is too close, anyway, and according to whom? In whose interests are such judgments? Is not discomfort one main point of these works' chosen effects? In this rain of questions, one thing is certain: these pictures' response to Pollock is incontrovertible, and the status of that response is as complicated as it is declarative.

Such a view seems justified, not simply by the works themselves, but also by a peculiar action on Krasner's part. In 1974 she discovered a painting, folded and in ruinous condition, in an outbuilding on her property at Springs, a work that to most eyes closely resembles her paintings of the early 1960s (fig. 44).

Not according to Krasner, however. She took it for an "unresolved" Pollock of circa 1950–53; so as not entirely to contradict her, the canvas was catalogued among Pollock's works as a "Problem for Study." The "Problem" has been solved: Ellen G. Landau has recently used its dimensions and an old photograph to demonstrate conclusively that it is indeed a canvas by Krasner, one worked on in two different campaigns, in 1957 and again in the early 1960s.[69]

It is difficult to take this occurrence at face value as a "simple" loss of memory; nor is it probable that a painting in such bad condition could have been attributed to Pollock in order to be put on the market. The most likely explanation—though it can only be a hypothesis—is that, consciously or not, Krasner was supplying her own recent work with a highly specific precedent in Pollock's practice—a precedent that, just because it could be claimed to come from Pollock (thus to have that special art-historical pedigree) might avoid the "personal" (i.e. gendered) readings that had dogged her art. Such a complex stratagem invites interpretation, though the invitation is issued in the customary backhanded way. It returns us to Krasner's oblique declaration, cited at the beginning of this chapter: "I think my painting is so autobiographical if anyone can take the trouble to read it."

Painting as Autobiography

I am not the first writer to single out this statement for special attention. Ellen G. Landau, for example, took it as the epigraph for a two-part article whose purpose and achievement were the mapping of Krasner's early life and career.[70] Let me thus make clear that in citing this remark, I wish (unlike Landau) to use it in ways that the speaker might not have anticipated and probably did not intend. It seems evident from the context that Krasner meant to equate her practice with autobiography in the simplest and most uncomplicated sense; she meant something like "My art and life are inextricably intertwined," or perhaps "I paint what I feel." Her declaration was sparked by her interviewer's mention of a 1961 canvas called *Assault on the Solar Plexus*: "For me that is an embarrassingly realistic title. I experienced it. I had had the blow-up with Greenberg, my mother died shortly before, the Pollock Estate was pulled out of the Sidney Janis Gallery and frozen. I didn't know how to deal with Pollock. It was a rough life."[71] Here follows the sentence that concerns me.

Pace Krasner, I do not think that actually producing an autobiographical painting is quite as simple a business as the notion "painting what one feels" would imply. Feeling is one thing, painting another: painting is a means of expression deeply enough rooted, at any particular moment, in material practices and conventions of signification as to require that the autobiographical impulse submit to physical and practical constraints. Then how else might autobiographical painting be understood, if not as the product of a *direct* equation between painting and personal feeling? And how is an autobiographical painting to be undertaken at all when its chosen vehicle is abstraction? The answers I give to these questions are admittedly tentative, and perhaps may seem to be argued too much through a process of elimination: here nonetheless is their substance.

Autobiographical painting should not be thought of simply as an artistic genre—its main lines are by no means so neatly drawn. The self-portrait, in other words, is not the only site at which self-inscription can occur or subjectivity be claimed. Nor, however, is the field impossibly open: autobiography in painting is not the mere residue of any encounter between paint, brush, canvas, and the agent who brings them into contact to make a work of art. Were this the case, all painting would be autobiographical, and the term would be bereft of any utility as a description of kinds of pictures or of particular painterly means and effects.

Because nonfigurative art lies mostly (if not entirely) outside the conventions of the traditional genres, and because its representational terms invite interpretation as metaphor, it has been viewed as a prime means for self-inscription. These have been the assumptions of twentieth-century art and criticism, not least because they have seemed to carry explanatory weight and force. Yet painterly autobiography can occur only if and when the viewer is provided the pictorial means to suspect (indeed, to be convinced) that some such communication is at issue. Perhaps the formulation "painting in the first person" will suffice as an initial description of the necessary autobiographical effect.[72] For such painting to occur, the particular conventions of depiction must be laced with the means to convey the directness and immediacy and idiosyncrasy that have come to be associated with the self. There is a range of such devices, certainly—the revealing symbol, the gesture that looks speedy or impassioned or indecisive or manically repeated. The whole rhetoric of spontaneity can be said—indeed has

been said—to be a vehicle for the self, though if this were the only means the painter could mobilize for self-inscription, then the autobiographical content of painting would prove to be, if not precisely impoverished, then nonetheless mainly ontological in scope, confined mainly to the claim to being or existence. This list of procedures is not exhaustive, but it is long enough to convey the paradox involved. On the one hand, this is a lexicon of effects that can stand for something as "basic" or "real" as the artist's self. They are able to do so, on the other hand, only because they are conventional—because they seem to be in accord with an ideology of the self and of self-expression.[73] Conversely, the devices taken over from mathematics—here I am mostly thinking of the conventions and regularities of geometry—would seem able to index the selfhood of the painter only with difficulty, if at all; they could do so only in relation to the idiosyncrasy or waywardness of her inflection of the governing formulas.

These few provisos are straightforward enough, but they have not yet gotten us very far. We have not broached the possibility that painting may operate in respect to autobiography with some of the complexity of its written counterpart. It need not use the first person, for a start. Here the analogy to autobiographical writing is specially helpful. In a text "there can be identity of narrator and principal character without the first person being used";[74] in other words, "he" or "she" can replace "I." "I" can speak of or to the self as "her" or "him." In such a case, while the author is both the narrator and the principal character in the narrative, those relations are established indirectly and are kept from center stage by the author's pronominal choice. Imagine a painterly practice that tells its story by similarly delegating the main role to a third person—to an invented "him" or "her." This, I want to argue, is how Krasner's painting operates. Indeed it strains the relations between author, narrator, and principal character to a real extreme. My account views her art as consigning its narrative prerogative to designated stand-ins—sometimes to a fictive "him," sometimes to "her," and sometimes even to "Pollock." Hers is autobiography that rarely if ever says "I." Her painting is nonetheless autobiographical, I think—in other words, an account of "Krasner" *is* concerned—because through it, however backhandedly, its author time and again declares herself the subject of her own understanding (and misunderstanding) as painter, as woman, as wife.[75]

Krasner's chief autobiographical strategy is rooted in the special terms of her engagement with the modernist idiom; the charged nature of her artistic choices

FIGURE 45. *Lee Krasner, Untitled (Still Life, Gray Ground), ca. 1940–43, oil on canvas, 29¾ × 24 in. (75.6 × 61 cm.). Private collection, courtesy Jason McCoy, Inc.*

means that being a modernist was for her not a matter of style in any superficial sense. Her style had real structuring force where identity was concerned. Hofmann got it right when he said you would not know her work was painted by a woman—his was, I think, an understandable response to both the intention and achievement of her art in the 1930s and 1940s. Her canvases from this moment—look again at *Blue Square* (see plate 15) and *Composition* (see plate 16) and consider *Untitled (Still Life, Gray Ground)* (fig. 45)—seem like declarations of affiliation, or claims of belonging to a club. These pictures repeat like a pledge

of allegiance their inwardness with a particular painterly dialect of the day. Barbara Rose has called this language abstract Cubism, but of course this is a very general term. I take the idiom to be rather more limited and particular in its range of reference.[76] To make these canvases Krasner drew much on works by Arshile Gorky of the mid 1930s, paintings like *Composition with Head, Enigmatic Combat,* and *Portrait* (figs. 46–48), all pictures of the kind and date featured in Gorky's first one-person show in New York (it was held at the Boyer Gallery in 1938). These are the selfsame works that won for Gorky the rudiments of a reputation, one of a dubious sort: he was termed a mere copyist, a servile imitator, an eclectic. He was the "Picasso of Washington Square."[77] Speaking with considerably more sympathy, his dealer Julien Levy was to call him a "very camouflaged man."[78] In his study of the painter, Harold Rosenberg came closest to making Gorky's eclecticism over into something other than mere inadequacy. "Those eager to claim early originality for Gorky contradict Gorky's values. At twenty-five he had grasped the basic premise of the art of his time, and had grasped it with the energy and curiosity of one who has no heritage he can take for granted and to whom all knowledge is consequently brand new. This premise he re-stated in its most dramatic form: *the deliberate rejection of originality.*"[79]

The biographical connection between Krasner and Gorky is easy enough to demonstrate: no need for chirpy assertions claiming that Krasner "must have seen the Boyer show," when there is no firm indication one way or the other. (She must have seen it, but no document confirms her attendance.) Gorky crops up in person in Krasner's reminiscences of the 1930s, where true to form he is seen proposing, to six or seven generally uncomprehending artists, the execution of a group painting (the group included Krasner, though that she remembered the story suggests she got the point).[80] John Graham furnishes an artistic link between the two; his importance to both is a matter of record: Krasner by all accounts found his support and teaching liberating after Hofmann's, and Gorky too, according to David Smith, was for a time intent on painting by Graham's rules.[81] But for my purposes the relevant connections are to be found in the pictures and what they share; look, for example, at the relations between Gorky's *Portrait* and Krasner's *Composition.* There is the same predilection for an additive armature of shapes more or less loosely tacked together at the joints. And the shapes in turn fit more or less geometrical molds, though they run the gamut of size and scale and are sometimes interlocked. Sometimes the shapes

FIGURE 46 *(top, left). Arshile Gorky, Composition with Head, ca. 1934–36, oil on canvas, 78 × 62½ in. (198.1 × 158.7 cm.). Private collection.* FIGURE 47 *(above). Arshile Gorky, Enigmatic Combat, ca. 1936, oil on canvas, 35¾ × 48 in. (90.8 × 121.9 cm.). San Francisco Museum of Modern Art, Gift of Jeanne Raynal.* FIGURE 48 *(top, right). Arshile Gorky, Portrait, ca. 1938, oil on canvas, 31 × 24⅝ in. (78.7 × 62.5 cm.). Private collection.*

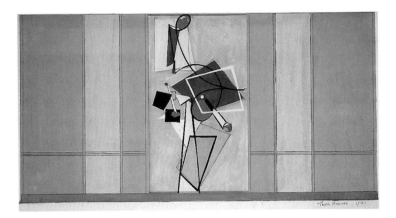

FIGURE 49. *Lee Krasner, Mural Study for WNYC, Studio A, 1941, gouache on paper, 19½ × 29 in. (49.5 × 73.7 cm.). Estate of Lee Krasner, courtesy of Robert Miller Gallery, New York.*

verge more on anatomy than geometry. The surface is rough and uniformly belabored, as if to circumvent, by a literal insistence on material unity, the impression of disjointedness that otherwise might rule the day. The parts each uses were picked up from Picasso and made over into the building blocks of a language whose salient characteristic was its declaration of allegiance. Of course there are differences: Gorky's painting looks more improvised, Krasner's more crisply workmanlike (*sic*): broad directional brushwork turns each shape into a physical statement (each circle and square is performed in paint), and makes her forms seem sturdy and serviceable in comparison with the whimsical and rickety linkages Gorky gets away with. There is in Krasner a sense of decisive, even insistent, management of means quite foreign to Gorky's art—evidence, as we have noted, of what she took painterly performance to be. (Though when Krasner actually envisioned putting these devices to use as decorative painting—they provided the language of her 1941 designs for a quartet of unexecuted murals meant to grace Studio A at WNYC [fig. 49]—the forms join more easily and have greater bounce and spring.) And though Gorky's general way with the composition in *Composition with Head* was like an open book to Krasner, her works of this moment never risked the inclusion of heads.

I think that like Gorky, if for rather different reasons, Krasner "had no heritage she could take for granted." (Again the similarity of their biographical circumstances—both had immigrant parents, his Armenian, hers Russian Jews;

both reinvented their given names to suit their tastes—underlines the relevance of the comparison.) If modernism was the goal, she did not find it in American painting by artists of either sex, despite a brief flirtation with the urban themes of 1930s painting—her *Gansevoort I* and *II* are the chief examples. (She even, believe it or not, began the decade with an awkward canvas of a bunch of calla lilies stuck in a vase, a novice's homage to Georgia O'Keeffe.) Her solution to this circumstance was, like Gorky's, to take refuge in a notion of artistic practice whose signature status would rest, however contradictorily, in its "deliberate refusal of originality." This was the practice, let us remember, that won Krasner professional notice and membership; it had the distinct advantage of being able to index a painterly identity without revealing a painterly self. It is easy to see why Gorky was the ideal confederate—perhaps the only possible one—to reach that oblique goal.

Another thing you would not be able to know from Krasner's painting itself is how she got from one phase of her practice to the next. Hers is not a career that lends itself easily to discussions of gradual development and step-by-step transformation. Instead there are stops and starts and abrupt changes of tactic. Krasner's own language in describing these processes makes them notably unplanned, even disruptive; she sees her imagery "emerging" and "breaking" of its own volition. Take this brief exchange with Cindy Nemser:

CN: When you say your work has broken what do you mean?

LK: Just like when I had a gray-out for a period of time and then the "Little Image" emerged. It went along until about '49 and once more the work started to change. I can't tell why this happened. This process has continued right up until today. I go for a certain length of time and the image breaks again.[82]

Such a description releases her work from the sway of immediate personal circumstance: this is painting with a mind and will inscrutably its own. Yet I want to argue against the grain of Krasner's remarks and claim that the motivating logic of her art can indeed be explained: that logic concerns the issue of authorial voice (and thus is by no means separable from the author's life). "Breaks" in Krasner's work do not simply boil down to matters of style. The changes involve self-positioning, advancing another pronominal voice—still another "him" or "her"—as the vehicle for the painter's self.

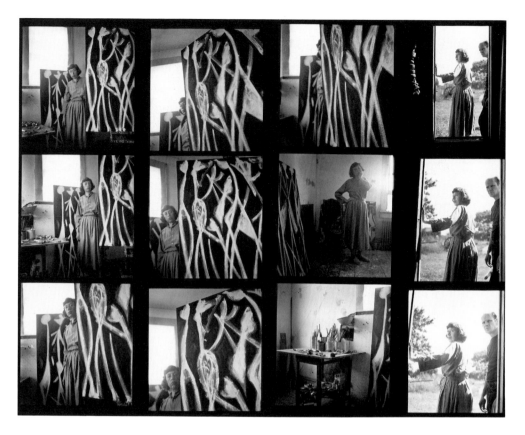

FIGURE 50. *Hans Namuth, Lee Krasner in her studio at Springs, 1950, contact sheet. Estate of Hans Namuth, New York.*

This thesis gives us a further means to understand the extraordinary transformations Krasner's work undergoes in the years 1947–51 (to say nothing of the gulf in that practice opened between 1943 and 1947, when she had her "gray-out"). The changes involved Pollock, as we know: taken together, they represent an extended effort to understand and express what Pollock might be made to mean to her art. The *Little Images*, to repeat, are a statement of one such possible meaning. Their strongest claim is their translation of Pollock's language into an idiom that can serve Krasner's own purposes; their major metaphor is the sign—the letter, the glyph, the grid, and the graph—and the work they do with that metaphor takes it to the edge of nonmeaning. The refusal of articulate utterance is the very essence of their communication; and it is this refusal, repeated again and again, that paradoxically makes these paintings so very au-

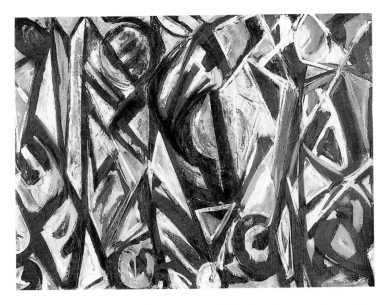

FIGURE 51. *Lee Krasner, Gothic Frieze, ca. 1950, oil on Masonite, 36 × 48 in. (91.4 × 121.9 cm.). Collection of Gordon F. Hampton, Los Angeles.*

tobiographical, so very eloquent. This is the case even though the rudiments of their language have been appropriated from Pollock: they are adopted only to be undermined. Or to put the case in slightly different terms, it is the exactness—the niceness—of their distance from Pollock that gives these paintings their autobiographical force and purpose.

When the *Little Images* "broke," Krasner's art went in a direction that puts their achievement in a rather different light. She next worked up and then abandoned a group of large-scale figure paintings; though they never saw public exhibition, they were recorded by Hans Namuth in Krasner's studio (fig. 50). Their closest surviving counterpart is *Gothic Frieze* (fig. 51), though in this picture the white shapes that once read as a parade of interlinked stick figures have been broadened and filled out into planar forms. It is pictures like these that by rights ought to have been presented at Krasner's first solo show, the exhibition staged at Betty Parsons in October 1951; they seem at any rate to have been the works on view in the artist's studio when Parsons committed herself to mounting it. By the time it came off, however, Krasner's style (I am tempted to say

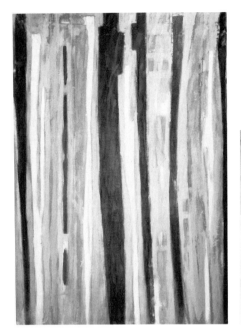

FIGURE 52 *(above, left). Lee Krasner, Untitled, 1951, oil on canvas, 82½ × 55⅞ in. (209.5 × 141.9 cm.). Collection, The Museum of Modern Art, New York, Mrs. Ruth Dunbar Cushing Fund.* FIGURE 53. *Lee Krasner, Number 2, 1951, oil on canvas, 92½ × 132 in. (235 × 335.3 cm.). Courtesy Robert Miller Gallery, New York.*

"voice") had broken once again: instead, she presented a suite of fourteen canvases that are in no sense figural. Theirs is a language of squares and stripes and rectangles, and they were at best a temporary venture. As it happened, all but two were destroyed or reused once the show had closed. (One of the larger works entered the collection of the Museum of Modern Art in 1969; the largest of the group also survives, the property of the Robert Miller Gallery, New York [figs. 52, 53]. Photographs of two others—numbers 4 and 12 on the price list—are its only other visual traces [figs. 54, 55]). Not much to go on, certainly, but enough to recognize that the issue of artistic identity and self-exposure was uppermost in the artist's mind. The autobiographical claim now boils down to a simple disclaimer: "I am not Pollock," these works seem to declare; they made that assertion, moreover, in the selfsame rooms where Pollock's own show was to open twenty-three days later.

FIGURE 54 *(above, left). Lee Krasner, Number 12, 1951, dimensions unknown, painted over. Photograph from Betty Parsons Papers, Archives of American Art, Smithsonian Institution.* **FIGURE 55.** *Lee Krasner, Number 4, 1951, dimensions unknown, destroyed. Photograph from Betty Parsons Papers, Archives of American Art, Smithsonian Institution.*

In one sense (though only a limited one), Krasner's painterly strategy was successful, in that this time reviewers kept their minds on Krasner. They made it clear that all fourteen canvases manipulated finely adjusted planes of colors—muted yellows, grays, and mauves, they say, though the MoMA canvas also uses buff and red and blue—in ways that read as "quiet," "discreet," "harmonious," "restrained and pacific," "majestic and thoughtful," "quietly innocuous," "sweetly cultivated," and, yes, "worked out with feminine acuteness."[83] Krasner herself remembered as "astonishing" Stuart Preston's remark in the *New York Times* that the show issued a "call to order,"[84] though the phrase seems to me an adequate response to the pictures' studied measurement and calm, their refusal of Pollock and all he stood for. If we could strike "quietly innocuous" and "sweetly cultivated," it would be easy to imagine a worse string of adjectives: it seems clear from the surviving paintings that the works were out to

solicit some such response, one in which Pollock could be made to figure not at all. By these lights the strategy was successful, in that for once reviewers made no mention of her marital status or marriage partner.

Another way of naming the artist's authorial voice, at least on the basis of these pictures, is to say that the painter here is "she"; moreover, I see the critical responses as for the most part substantiating that claim. But as my mother was fond of saying, "'She' is the cat's mother, and nobody knows who 'she' is." The maternal injunction was meant as a grammatical corrective: one was to make clear about whom one spoke. It is not very clear who Krasner's "she" was, either; Krasner seems to be inventing a new and different, yet still oddly distanced, identity—and to be doing so, let it be said, in this most crucial of professional contexts, the artist's first one-person show. Defining that identity any further—though it still seems to me unshakeably "she"—means looking at a few other paintings made in the wake of the 1951 exhibition. *Equilibrium* (fig. 56) follows it more or less directly. I take this picture as a clarification of the meaning for Krasner of her new way of working. Like the canvases exhibited in 1951, *Equilibrium* rings the changes on a geometrical format that observes the laws of gravity; yet compared with the earlier works, it seems even more to sound the call to order. Rectangles with crisp edges and sharp corners float against a ground and occasionally overlap: sometimes they are combined to make doublets or triplets, à la Newman. These regularities are quite strictly maintained, despite the occasional softening of an edge by a dribble of paint, yet that regularity is simultaneously undercut by the workings and scrapings that move across the pictures' surfaces so as to cut through both figure and ground. "Aha!" we might exclaim. "Geometry!" "Mondrian!" "Krasner is bespeaking her affiliation with a modernist master whose legacy she never repudiated." But these are made-up voices; let me cite Barbara Rose instead: "They are the logical outcome of her continuing dialogue with Mondrian." [85]

Perhaps. But how about another exclamation: "I. Rice-Pereira!" Hardly a household name these days, I realize—yet she was one of only three women in MoMA's *Fourteen Americans* show of 1946, and one of only seven whose painting was included in its sweeping 1951 survey *Abstract Painting and Sculpture in America*. (The other painters were Katherine Dreier, Gertrude Greene, Evas Model, Georgia O'Keeffe, Jeanne Reynal, and Anne Ryan.) Rice-Pereira, not Krasner, is the female painter who later crops up in Hesse's notebooks, albeit as

a negative example cited by Ad Reinhardt, no less, in the course of a public lecture Hesse attended. (Reinhardt was clearly rounding on a competing geo-metrist. Greenberg was equally hostile: to him her abstraction was "faked.")[86] Yet Rice-Pereira's brand of geometric abstraction shows real points of contact with Krasner's version all the same; take for example *Composition in White* (fig. 57), a work included in both the 1946 and 1951 exhibitions. Krasner's canvases are a trifle looser, it is true, and more open to accident; they spread their elements out more evenly across the surface so as to invoke a more generic relation to Bauhaus rhythms and oppositions. But Rice-Pereira's dynamism— the optical pulse she gets from the contrasts between a picture's parts and from the various textures of their surfaces—is not lost on Krasner; nor is the distance she has traveled from her European roots. The relationship between the two artists strikes me as not unlike Krasner's earlier posture toward Gorky; again it amounts to self-inscription through the use of a stand-in. In each case Krasner identifies her art with that of a painter whose work can function as a special token or representation of artistic identity or selfhood. The affiliation with Gorky seems to have brought with it the possibility of producing a male-coded modernism unburdened by links to a notion of male selfhood. The invocation of Rice-Pereira registered a brief allegiance to a more conventionally "female" practice, a version of abstraction that had won real professional standing (it offered a route back to the idiom of the American Abstract Artists group). And it could not have been further from Pollock's art.

In thinking of Krasner's "breaks" as advancing new and sometimes contradic-tory claims concerning the artist's self-identity, I do not want to overlook their central feature. After 1942 Krasner's work did not merely "break"; it broke "from." There is only one object for that dangling preposition: it is Pollock once again. And another preposition follows immediately: "to." In alternately devel-oping and abandoning a painterly relation to Pollock, Krasner's art elaborates, then retracts, its chief autobiographical fiction. The central figure of that fic-tion, perhaps even its most creative idea, can be named by the term *prosopopoeia*: that is, "the fiction of an apostrophe to an absent, deceased, or voiceless entity, which posits the possibility of the latter's reply and confers upon it the power of speech."[87] This definition is borrowed from Paul de Man: some explanation is needed to clarify its relevance to the *Little Images* and later work. After all, they are pictures whose metaphoric voicelessness has usually been taken as ap-

FIGURE 56. *Lee Krasner, Equilibrium, 1951–53, oil on canvas, 46 × 58 in. (116.8 × 147.3 cm.). Courtesy Robert Miller Gallery, New York.*

plying to Krasner herself; my own stress has fallen not on the pictures' voicelessness so much as on the special restraint of their tone. I hold to that analysis. Yet what if we were now to imagine the pictures as offering an image of Pollock, not Krasner? By these lights the *Little Images* would seem autobiographical, not because they fulfill the conditions of first-person narrative ("I speak to myself and my self speaks back"), but because they farm out their narrative to Pollock. Thus their claim becomes something like "I speak to Pollock, and Pollock speaks back"—but he can respond only in the idiom Krasner herself provides. Her Pollock plays the role that she has written. And this is still the case when the pictures in question are the most Pollockian of her career: a 1958–62 series, large and vehement canvases now usually called the umber paintings.

De Man's phrase defining prosopopoeia seems equally helpful here: works like *The Gate* (see fig. 42), and *Polar Stampede* (see plate 18), and *Assault on the Solar*

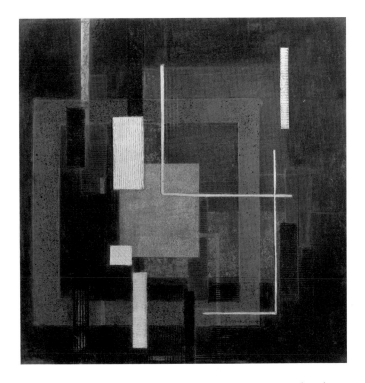

FIGURE 57. *I. Rice-Pereira,* Composition in White, *1942, mixed media on parchment. 18 × 18 in. (45.7 × 45.7 cm.). Collection of The Newark Museum, Newark, N.J., purchase 1944, Sophronia Anderson Bequest Fund.*

Plexus do nothing if they do not keep up the pretense of a dialogue with a departed Pollock: a Pollock now literally an "absent, deceased, or voiceless entity." When the works were first shown, Richard Howard remembered, Pollock was seen to be speaking directly, uncannily, through Krasner: "People said you were being influenced by Jackson from beyond the grave, and that these paintings were very much dictated by the spirit of late Pollock work."[88] Again the notion of autobiography gives this assumption a less predictable yet more plausible twist. If in these works it is *Krasner* who apostrophizes a Pollock who is *in* rather than beyond the grave, she is addressing him with a vehemence his own art never found, almost as if thereby to conjure him and his art once more into life (though again on her own terms). This idea puts in a new light her discovery at Springs in 1974 of that "Pollock"—the work she herself had actually painted sometime along about 1962. A whole new canvas makes Pollock

"undead"—he is a creature who is still being summoned into life by Krasner's art.

As with the *Little Images*, the umber paintings actively rely on the viewer to make the connection with Pollock and to understand the special tone of their address to him. They invite, I am claiming, an autobiographical reading, though not the one they have most commonly received. The strain and contortions of the painter's voice insist that the viewer take special trouble in formulating a response. Again a citation from de Man may help to explain why. "The autobiographical moment," de Man claims, "happens as an alignment between the two subjects involved in the process of reading in which they determine each other by mutual reflexive substitution."[89] The alignment of which de Man speaks—the special relationship he terms a "mutual reflexive substitution"—is for him the "autobiographical pact." By this he means the implicit two-way agreement between writer and reader that is constitutive of the genre—it happens unavoidably in writing through the agency of the "I." In painting the agent is most often the "eye"—that is to say, the pact occurs through the twinning of gazes that self-portraiture allows. In abstract painting the alignment occurs in different ways, as I have claimed above—but that it can indeed occur is a prime assumption of the art of Krasner's moment, and of the culture in which it is retailed.

Yet Krasner's art places special demands on its viewer: assuming Krasner's position means encountering it behind the mask or screen of identity—"he," "she," "Pollock"—it inevitably assumes; seeing through her eyes means seeing into the complexity of an oblique self-understanding, and attending to the complexity of its relationship to Pollock. Krasner invariably attributes to her viewer a tenacity and tolerance in looking that she has only rarely received. The prejudices of gender have meant that Krasner's assumptions about her viewers have often been betrayed, while the complexities of gender have meant that Krasner's intricate, embattled position has been difficult for viewers to adopt, or even decipher. Autobiography emerges from her practice with the pretense of a possible mutual alignment between two subjects, maker and viewer, significantly impaired, and for good reason. Krasner's painting offers fictions of the self at the very place where the truth is "supposed" to be laid bare. Yet in these same misleading and contradictory claims, her work *is* most like autobiography—this is the story of the self her work is able to tell.

For the viewer to strike a different pact with the umber paintings, to enter into a different relationship with their autobiographical claims, requires greater pessimism than some may be prepared to supply. To stand before these pictures in the guise of their maker means registering the bluntness—the brutality—of their account of Pollock, and of painting. In *Polar Stampede* (see plate 18), for example, the viewer encounters a representation of a process of making that apparently renders it an activity without delicacy, an action without refinement. Each mark seems almost to punch or strike the canvas; even when a line is made, as sometimes occurs when dark brown paint is used, the sensation of violence seems essentially unchanged. It does not seem so much to progress or unfold, like the trace of an action made over time, as to have been deposited at once, all in one go, as the result of a shot or an explosion. What force could get paint onto canvas in this way? How fast does it have to travel to break down on impact into a halo of radiating spray? What body—what person—do we imagine making such marks? That such questions are solicited by the work is part of its vehement achievement. Yet if like all such questions, they are answered by analogy or assumption or through prior experience, the body suggested is not Krasner's but Pollock's. A fictional Pollock, once again: he seems to speak, in this picture, in a voice denied subtlety and elusiveness; he is made to be present but appears in a disfigured state. "Autobiography," claims de Man, "reveals a defacement of the mind of which it is itself the cause." [90]

I want to make two further points concerning the autobiographical content of Krasner's art. The first addresses her use of collage, a technique to which she turned at two different junctures. From 1953 to 1955 most of her pictures were made from paper of various kinds (old drawings, both hers and Pollock's, among them) and a range of fabrics, including discarded canvases: both cloth and paper were cut and/or torn, and then applied to a canvas support along with oil paint. Again in the mid 1970s collage was used to put pictures together, though in this later campaign (for example in *Imperative*, plate 19) their main elements were drawings. Because collage almost always manipulates recycled materials, it is a medium that in most instances seems calculated to put seekers for the artist's self well and truly off the scent. In Krasner's case, however, the collaged materials are very often bits and pieces of her own work that have been scissored and ripped into fragments, and then recombined. Her account of her discovery of the process preserves a sense of the moment of its origins as an act of destruction,

one charged with real emotional freight: "My studio was hung with a series of black and white drawings I had done. I hated them and started to pull them off the wall and tear them and throw them on the floor and pretty soon the whole floor was covered with them. Then another morning I walked in and saw a lot of things there that began to interest me. I began picking up torn pieces of my own drawings and re-glueing them. Then I started cutting up some of my oil paintings. I got something going there and I start [*sic*] pulling out a lot of raw canvas and slashing it as well."[91] A process had been launched, and though the active hatred that had sparked it presumably subsided, Krasner's collages continued to begin with a preliminary round of destruction. Collage was the fate of most of the pictures from the Parsons show, for example, and a whole slew of drawings done under Hofmann's auspices went into the works of the seventies. To quote Krasner again on the process, "It is dangerous for me to have any of my early work around because I tend to always want to go back into it at some point—so the less around the better."[92]

But she could not stay away from trouble; despite the danger she kept "going back into it." In fact the technique eventually became something of an artistic signature, so much so that one visitor to her studio in February 1976, just when *Imperative* was being made, shot a series of photographs showing her hands at work with the scissors, reducing the lines and planes of a Hofmann-period drawing to a pile of triangular shards (fig. 58). Subjected to such uses, collage has double-edged implications for artistic identity. It insists that though the past may live on in the present, its materials can be brought under control and reworked as the present sees fit. (This is the gist of a statement concerning the motivation behind *Imperative* reported by John Bernard Myers: "I experienced the need not just to examine these drawings but a peremptory desire to change them, a command as it were, to make them new.")[93] At the same time, however, the new artistic present has an oddly fictional status, as a result of the exercise of "peremptory desire": it courts a certain loss of authenticity, however personal its materials may appear. At just the moment when Krasner's art might seem to have overturned the conventions of collage to be at its most autobiographical— most literally constituted out of the maker's artistic self—it has insisted on its characteristic distancing procedures. The images of the past are robbed of any sense they once had as representational wholes, yet the coherence and independence of the collaged result is itself made oddly contingent and incomplete,

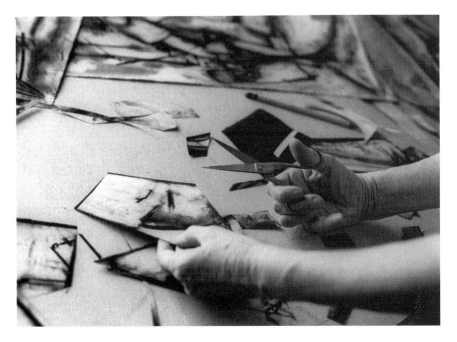

FIGURE 58. *Charles Eames, Krasner's hands at work cutting pieces for a collage, photograph, February 8, 1976. Lee Krasner Papers, Archives of American Art, Smithsonian Institution.*

because it relies so utterly on bits and pieces willfully rendered incoherent. This is a tactic marked by a bravado that owns up to its past, yet is haunted by the fear of artistic impotence, of having nothing more than the past to make images about.

Its autobiographical claim—for such a claim is certainly implicit—accordingly should be read as something like "I am myself, but my self is mere medium, a fragment utterly at my own disposal." The painter's self here becomes speakable only by being treated as Other—torn up and redeployed, as if in tacit recognition that the artist's self is always already assembled and constructed out of another language—even out of the language of the Other. It is striking that, even splintered into fragments, the collaged pieces in the 1970s work are still patently Hofmannesque: note their resemblance to the anonymous student drawings tacked to the wall in the photograph of Krasner in Hofmann's studio (see fig. 27). And in other poignant instances—take for example *Bald Eagle*, a collage of 1955 (plate 20)—some of the pieces are cut from canvases by Pollock. Here

both "Krasner" and "Pollock" are incorporated as the artist's work. The artist disposes of both.

These, of course, are ideas and words I am supplying to Krasner's collages. I am well aware that they make use of other languages as well: their comfort with New York abstraction is perfectly clear. Yet despite years of experience translating such visual effects into the idiom of formalist criticism, even a critic like Bryan Robertson (who staged Krasner's first retrospective at the Whitechapel Gallery, London, in 1965) finds that their autobiographical reverberations cannot be denied, however disconcerting the result. "The strange density and presence of these works," he writes in a general introduction to Krasner's collage practice, "comes principally from their color, design, and fresh use of space, but they have a different resonance because of their odd function as repositories of experience and second thoughts." They "give out the illusion, inevitably, of buried references, exhumed and reformed, of an artist's personal history disrupted and pulled together again at another altitude and in a fresh light."[94] Like Robertson, I think of the collages as giving (further) evidence of an artistic self or identity being subjected to revision and reordering. And Krasner's special thematics in titling these works points up how willful, how determined that process was. Borrowing from the grammarian's glossary terms like *Imperative* and *Past Conditional, Present Perfect,* and *Past Perfect Subjunctive,* she assigned them to her collages, as if thereby to predicate a new syntax for the past, one in which the maker can dictate its tense and mood, and thus control its parsing as she sees fit.

Eye and Body

When Lee Krasner took her first European vacation, in July 1956, she left behind in her studio a canvas that has come to be called *Prophecy* (plate 21). It is not clear if the picture had been assigned its mantic title before her departure — presumably not, since it is said to have been named by Alfonso Ossorio, its eventual owner — but titled or not, it was apparently close enough to being finished for her to have shown it to Pollock before she left. "I asked Jackson to come and look at this painting and he did and said I needn't be nervous about it. He thought it was a good painting and the only thing that he objected to

was this image in the upper right hand which I had scratched in with the back of a brush. It made a kind of an eye form. He advised me to take it out. I said that I didn't agree with him and left it in."[95]

Prophecy was still on the easel when Krasner returned as a widow to Springs. It first surfaced publicly to preside over her 1958 Martha Jackson show: again installed on an easel, it seemed to turn the back room into a kind of inner sanctum toward which Krasner herself, on hand to talk to the critics, gestured dramatically as she explained her art. What *Prophecy* announced, as its maker pointed out, was three years or so in which she explored the possibilities of a figuration based not just on its main forms and palette but also on its chief compositional principles.[96] *Birth* (see fig. 41), *Three in Two* (plate 22), *Four, Sun Woman I*—these are only some of the pictures derived from this particular source. In *Prophecy*, arcs and ovals make up body parts: a dense, hammy knee and calf; the orb of a face with its features extruded like fat phallic sausages, left and right; twin, migrating buttocks—or are they breasts?—in either case they flank an oval void. The allusion to the body is cemented by the use of a pale buff pink laced with reddish patches. Here the parts are put together with considerable urgency as well as restraint: the springy boundary of the various forms looks more energetic than casual, perhaps because it has been allowed to bleed and drip; the figure or figures crouch close to the viewer, squatting on the picture's lower edge so as to dominate its field. And this sense of urgency is redoubled in the other works: they become almost cluttered with parts, although, as in *Three in Two*, their proliferation is controlled, swept up by the energies of the whole. Great diagonal vectors cut through all these compositions—I am thinking, in the case of *Prophecy*, of the lemon yellow crescent, which seems somehow to underpin the forms it interrupts. Its task is to undermine whatever elusive impression of bodily unity might otherwise prevail, to insist on a contrast between the particular—the individual oval telegraphing eye or mouth, the pocket of shadow registering hair or void, the irregular patches of thin, blood-colored paint—and the more general mandates of an abstract compositional practice. The whole, in other words, is made over into fragments that are multiplied, even made redundant, according to the artist's purpose, but the picture is nonetheless kept unified by the great sweep of its overall structure. This is a set of principles that already in *Prophecy* shows real potential; it will be further elaborated, made more clotted and vehement, in

other canvases, and then, in the umber paintings, taken in new and different directions.

Yet while this description attends to how *Prophecy* and its progeny are made, it does not say enough about how they have been or might be seen. Cindy Nemser called their imagery monstrous, but Krasner immediately rejected that verdict as if it offered too much of an interpretative threat: "You use the word monstrous as though it were relegated to a realm other than man. I would call it basic."[97] Certainly the figures are anthropomorphic in a "basic" sense—or at least they seem to be fitted together out of quite rudimentary parts—and, *pace* Krasner, perhaps might even seem "monstrous" to some viewers if the "realm other than man" means woman. But if they do suggest the female body, even though phallically, still it is easy to see how that body's clearly hybrid quality might conjure androgyny, as it does for Barbara Rose.[98] For Bryan Robertson, the instabilities extend in a different direction—they are as much a matter of brute substance as of sex: "An eye can look like a seed and something like a vulva can look like the cross section of an apple."[99] Such shifts of bodily matter and meaning find their ultimate emblem (where else?) in Krasner's signature. At times her twisting script is easily mistaken for the curved and fluted feet of her strange figures, and vice versa: the incipient equation of author and image also threatens the erasure of author *by* image. That is to say, Krasner seems both to sign these bodies as their maker, and, in so doing, to risk losing herself (her name) in their forms. Perhaps this conflation helped license Parker Tyler's interpretation. He wrote of *Prophecy* in particular as a picture that takes hold of Pollock's last subjects ("sex and the woman" and "flesh and fecundity," as he explored them in *Easter and the Totem*) and repeats them "in a palette which oddly suggests off-pink cosmetics and fuchsia lipstick as well as flower petal, plant life, and the void."[100] Is *this* the "monstrous" aspect of the picture? Perhaps— the more so when we realize that Tyler's woman is a standard fantasy.

For all their elusiveness and ambiguity, these are figures (and pictures) that nonetheless mean quite urgently to be looked at; they mean to urge their presence (thus their ambiguities and voids) on the viewer. Could it be otherwise? Pictures are meant to be looked at, certainly, but nonetheless they take different approaches to that destiny. (Think back to the *Little Images* for an example, in Krasner's art, of a very different way to solicit the viewer's attention.) Krasner's decision (one not repeated before or after) to root her figures in the picture's

lower edge—they have a solid footing there—is the clearest possible declaration of their confrontational stance. And they likewise build this posture on—even *in*—the artist's signature, to similar effect. Their scale, moreover—at 58½ inches high, *Prophecy* is the smallest of the group—urges a parity between the viewer's body and the painted one. This is not, however, an equation sustained in the process of looking: the unity or centeredness familiar to the bodily experience of the self is the figural characteristic that Krasner's canvases most resolutely withhold. Her figures have parts—sometimes too many of them—and there is sometimes no telling where one leaves off and another begins.

Krasner was *Prophecy*'s first viewer. She called up reinforcements in the shape of Pollock yet did not take his advice—this even though they seem rather seldom to have disagreed about visual matters. His objection, she recalled, concerned one small yet crucial passage—the eye scratched into the upper right corner of the work. He pointed nervously to this key juncture—the moment at which technical and conceptual coherence were simultaneously surrendered, to powerful effect. Paint is scratched away—this eye is a graffito in something like the classic meaning of the term—rather than stroked on within an outlined scaffolding. It is a mark with multiple uses: it activates its black background into something more than merely ground, for example; the black becomes a void in which a claim to sight is lodged. The eye seems as well an instance of willful primitivism, particularly when one makes the inevitable contrast with the bland simplicity of the orb just to the left, near the midpoint of the upper edge. I suspect that the graffito eye was the last mark Krasner made on the canvas, a declaration scratched in lieu of the signature the figure's feet here only mime. In fact it seems that the eye, *pace* Pollock, was meant as a sign of making and maker: it is hard not to wonder if his objection came from the recognition that the handprints in *Number 1, 1948* and *Lavender Mist* play a similar role.

The separability and relatedness of eyes and bodies in this group of pictures is one main guide to the purposes of its imagery. Thus it seems worth asking not only what the eye was doing in *Prophecy*, and why Krasner allowed it to remain, but also why she painted a whole set of other versions, for example in the upper right corner of *Three in Two*.[101] This particular variant is the inversion of the first scheme: flat graffito becomes plastic illusion, complete with the obligatory wedge of white across the eye's dark center. Whose eyes are these? Certainly not those of the paintings' figures—they are each too much detached from the

formal language of the whole to allow this to be the case. The question is urgent enough to have tempted Irving Sandler to make a stab at an answer. Reviewing Krasner's 1960 show, he rattled off a whole string of possibilities—"the eye of God, the evil eye, the eye of the hurricane, the artist's eye, the inner eye" [102]— there are so many as to suggest that he conceives of criticism in additive rather than subtractive terms. Surely some of these identifications are more plausible than others. And what of a possibility Sandler does not consider? Might the motif not function as the eye of the paintings themselves? By which I mean that I take the eyes to serve as figures of the relation between picture and viewer that these works urge. I think they thematize a special, wishful notion of paint-ing and the gaze. Let me explain: in these two instances—in *Prophecy* and *Three in Two*—Krasner seems to have fastened on an odd and artificial means for her pictures to negotiate the viewer's look. The presence of the eyes demonstrates the urgency with which she imagined that interchange: it was urgent enough to split eye from body, and to make it a device. The eye is a figure of to-be-looked-at-ness, we might say, or of presence; it seems conscious of this burden in ways the bodies shirk. At the same time, it occurs as a protective device, warding off, in true apotropaic fashion, any unfriendly glances that just might happen to come its way. This talismanic role is secured by the patent disjunction between eye and body—between the representational languages of the eyes and the abstracting idiom governing the odd bodies over which they stand guard.

There is no doubt that the eye emerges as a motif in Krasner's work only when she starts to paint the figure, although she does not always continue to use it at this site and in this specially coded way. Like the figure itself, the form by 1959 is subsumed into a different effort, that of reviving a Pollockian art—the effort from which the umber paintings will emerge. The brief conjunction of eye and body in the three years preceding accordingly takes on special focus and force. Let me offer two further readings of their possible meanings for Krasner's art, and for its autobiographical purposes above all.

First, there can be little doubt that these pictures were meant as revisions of Willem de Kooning's "Paintings on the Theme of the Woman" (this is the phrase he used to title their first public showing at the Sidney Janis Gallery in March 1953).[103] Their imagery rankled with Krasner for years. This puts the case mildly, as the relevant citation makes clear: "With regard to his series on *Women*, I reject them one hundred per cent; I find them offensive in every pos-

sible sense; they offend every aspect of me as a woman, as a female." [104] Adamant in her hostility, she was unmollified even by the claim that the woman in question was an aspect of the artist's own psychic makeup: "Whether the female as he projects it there is the outside female or whether it's the female within himself make no difference to me at all. It's the hatred and hostility toward the female; whether it be within himself or be really the outside female doesn't change my attitude toward what I'm confronted with." [105] (It is interesting that she knew of the argument that the Woman was de Kooning's inner femininity—it was apparently first advanced by the artist himself in a 1956 interview.)

Granted that Krasner is speaking so passionately in 1972, two decades after she first saw de Kooning's pictures—plenty of time, in other words, for the offense to take deep root. She will have no truck with this image of her sex, even if it is really an image of his. Although there is no verbal document of her reaction any closer in date to the *Woman* series, her own figure paintings clearly serve as the vehicle of the earlier response. And they put it in a rather different light. Krasner may have been offended, but she was also inspired to make the terms of the injury clear. She too places her figure(s) foursquare within the canvas, and their various eyes, whether vapid or graffitied or illusionistic, preserve the memory of the Woman's manic glance. And it is likewise notable that *Three in Two* and *Woman I* have almost exactly the same dimensions, 198.1 × 147.3 cm. versus 192.8 × 147.3 cm. These various moves urge the comparison and place it on level terrain—the better to let differences take the field. Where de Kooning's figures hunker rather unsteadily within their canvases, held in place by the vehement welter of brushwork that surrounds them, Krasner's are solidly rooted. Their parts take over the space, each element moving free of the bodily coherence that makes traditional "figures" of the Women. The latter are ruled by an anatomical grammar that, whether anxiously and/or dictatorially enforced, does not relax its grip. Krasner's figures have slipped those bonds, to submit instead to a different order. Bodies in pieces, they have been reordered as abstractions. Unlike the Women, they seem to accept their fate.

What fate? And why should they accept it? If the fate is a threatened castration, as there is every reason to believe, then the body in Krasner's images might be thought of as simultaneously expressing and avoiding that anxiety—rejecting in particular its embodiment as "the Woman"—by preemptively accepting, even engineering, its own dismemberment. Thus her images can be remade on

different principles: breasts and buttocks, vagina and mouth, can be brought into new, more tolerable, relationships, even if those relationships are still mainly phallic and phantasmatic ones. Thus dis-organized, in other words, they can establish the illusion that they produce and inflect their own bodily dispo-sition: an illusion conveyed in these pictures, I think, by the coherent, rhythmic abstraction of their forms. This is the condition of their claim to mastery. De Kooning's marks, by contrast, look rough and arbitrary; in color and texture they seem both willful and subjective. Krasner here achieves her own expres-sive ends in a different, characteristically indirect, way. They are the function of her predicament as a painter: "This is what I'm talking about. I'm a product of this civilization, and, you might say that the whole civilization and culture is macho."[106] What Krasner is talking about is de Kooning's Women, osten-sibly, but the topic leads back to herself as an object or product—to the con-fusions and contradictions of her position in a masculine world she cannot say she has fully escaped, and to which she has lodged a claim.

This argument brings me, finally, to my last point about autobiography. If, as Krasner would have us believe, one main resonance of her work is its auto-biographical meaning, then I think we are obliged to see these particular de-vices, eyes and bodies, as having something to do with that claim. And auto-biographical painting again emerges, at least where Krasner is concerned, as taking a peculiarly oblique, even negative, direction. Eye and body can operate in two separate fields of reference. Which has more authenticity? To which should we give greater credence? Which should we say belongs more com-pletely to the painter, is more directly "hers"? Krasner's decision, in these few paintings, to link two figural languages (the languages of eye and body) effec-tively makes these questions unanswerable in any satisfactory way. Instead these languages perform a kind of autobiographical splitting (again), effectively sepa-rating the I who signs from the Eye who looks. The one is identical with what it paints (or writes)—or at least pretends to be; the other is at an absolute distance, looking back at both picture and viewer from a kind of void. Or, to put the problem somewhat differently: if Krasner's sense of self is inscribed in this impacted field of body parts, then how are we to see the eye, if not as filling a separate minatory role? But if the opposite is the case—if the eye is as much "hers" as it is the paintings', or more—then what of the body (or bodies)? In this case the gulf between the two languages makes it impossible to read the bodies as "hers." This is a difficulty that forces the viewer to back away from

autobiographical interpretation in any pure and simple form (as my proffering of two separate readings argues, in a rather different way). Only by doing so, I am suggesting, will we encounter autobiography as Krasner practiced it, with admission and denial traveling more or less hand in hand. The autobiographical is couched in a distance repeatedly taken from revelations of the self—a distance that inevitably has far-reaching implications for the tone of one's artistic voice.

Sport of Destiny

I imagine that Arthur C. Danto was quite pleased when he hit upon the central conceit of his review of Krasner's 1983 retrospective. Why not compare her to Domenichino? The comparison may or may not have been apt (this is clearly a matter of opinion), but it was erudite, and it allowed him the pleasure of quoting at length from Henry James. James did not like Domenichino, nor did he think his art lived up to the celebrated role that history (with various guidebooks and critics, including the great Poussin himself, acting as its agents) had assigned him. So inflated was his reputation that to James he presented something of a cautionary tale. "And yet this sport of destiny is an interesting case, in default of being an interesting painter, and I would take a moderate walk, in most moods, to see one of his pictures." The reward for the "moderate walk," according to James, was something like total immersion in an experience of academic art: "He is so supremely good an example of effort detached from inspiration, and school merit divorced from spontaneity . . . an artist whose development was a negation." While Domenichino (James conceded) possessed talent, he lacked charm, and his imagination "went about trying this and that, concocting cold pictures after cold receipts, dealing in the second hand, in the ready-made, and putting into its performances a little of everything but itself." [107] By rights a Domenichino ought to hang in every drawing school to demonstrate by negative example how an artist ought not to paint.

Exeunt James and Domenichino, enter Danto and Krasner, with the stage set for some good old-fashioned attention to the "quality" of the latter's art. No one will be surprised to learn that Krasner too turns out to be "more interesting as a case than as a painter," insofar, that is, as her case is intelligible at all. "It is difficult," Danto complains, "to respond to her save as a shadow of artists

greater than her—her teacher, Hans Hofmann, her husband, Jackson Pollock, and her luminous contemporaries of the New York School." And his critical quandary, he makes clear, is no fleeting or circumstantial predicament: it arises from something more profound than the aseptic installation in which MoMA presented her work. Nor did it have anything to do with gender, "with Krasner being a woman or a wife." The issue, needless to say, was genius, first of all as it was manifest in Pollock rather than his spouse: "Pollock's least effort had a life and energy Krasner never touched. He had the indispensable gift of being able to stand aside and allow paint to burst into life, as though he were there only to enable the miracle to take place." And then there was the matter of all those other geniuses: "I was struck by how little would be left of Krasner's work if one could succeed in driving all the shadows away: those of Matisse, Hofmann, Mondrian, de Kooning, the Cubists and the rest."

Myself, I am struck by the predictability of Danto's notion of artistic creativity: by these lights, a genius like Pollock is to be understood as a conduit or medium for a parthenogenesis of a truly miraculous sort. To make great art, he must work in something like total isolation, keeping himself untouched by the influence of other artists, no matter from what time or place. (Or perhaps only *she* need meet this requirement: note that Danto fails to wonder what Pollock's art would have been like deprived of these same shadows.) These are not new requirements, let me hasten to say, but they are nonetheless not negligible. They carry an ideological charge that for sheer arbitrary prescriptiveness outstrips James's brief aesthetic formula (musing about Domenichino, he declares, "The great thing in art is charm, and the great thing in charm is spontaneity") the way a *pneumatique* is made quaint by a fax.

Danto's opinions would hardly be interesting, however, had he not made the effort to say more specifically what he found lacking in Krasner's art. Let me quote him at some length:

> A great artist is fully present in each of his or her works, however various the styles. No one went through more styles than Picasso, but every Picasso is unmistakably his. There is no recurrent touch, or whatever may be the pictorial equivalent of voice, in Krasner's canvases. There are only the shadows of other selves, the echoes of other voices. Hofmann once said Krasner was one of his best students but "She gave in all the time. She was very feminine." We may discount

his ascription of gender to a quality of Krasner's artistic personality, but that quality is nevertheless patent. The little set of abstractions with which the exhibition begins could, if one did not know otherwise, be a group show of minor abstractionists. The whole exhibition is a series of surrenders to artistic personalities stronger than her own, and those surrenders are what enabled her to paint. Even though huge and bold, Krasner's work has something of the art school exercise about it.

There is much here to disagree with. One might take issue, for a start, with the sheer platitudinousness of Danto's view of Picasso's utter individuality (what about the little problem of analytic Cubism, for example?) or with the thoughtlessness of his readiness to discount the relationship between gender and Hofmann's point of view. Does Danto believe that the master's judgment of a female student stressed her femininity for some merely accidental reason? Is it possible to claim of a female practitioner that she "gave in all the time"—as Danto himself wishes to be able to do—without that claim seeming steeped in gendered assumptions? Yet these deep-seated limitations do not blind Danto to the key issue of Krasner's art: the way it configures "the pictorial equivalent of voice." His conceptual framework—his notion of genius above all—simply makes it impossible for him to respond to that issue in anything other than a hierarchical way. How far up—or rather down—on the genius ladder should Krasner be placed? We can only conclude that like James, Danto has learned little from the example of Domenichino, and thus can understand little about Krasner.

What James might have learned (and taught to Danto) concerns the contingency of historical judgments of taste. For him Domenichino's champions—all of them, from Poussin to the guidebook writers—are simply wrong. It does not occur to him that they might actually have functioned as another, *better,* audience for Domenichino's art—one versed in its language, attuned to its special voice. He is not provoked by the divorce between his own sentiments and those of past viewers into the effort to imagine responses to art that would place less of a premium on "charm" and "spontaneity." He does not care to inquire how or why such responses came to be: which of Domenichino's qualities they answer, what cultural needs they nourish. Nor is Danto able to learn from James's failure. On the contrary, he is compelled to repeat the same mistake. Danto does

not suspect that a different audience for Krasner's art might also come to exist, that, like Domenichino, she might find her Poussin: perhaps such an imaginative feat is difficult because those new viewers would necessarily exclude Danto himself, since he has proven himself unwilling to take the trouble to think about her art.

Included, presumably, would be viewers nurtured on a rather different notion of artistic achievement: they would have been weaned from the diet of geniuses and greatness that is Danto's steady fare and would be able to begin the act of interpretation where he leaves off. Danto's only idea about Krasner is that her "surrenders" enabled her to paint; his last few sentences declare: "Lee Krasner is what she is. Or, perhaps more accurately, she is what she isn't." By which he means not Pollock, not Hofmann, not Matisse, not Mondrian . . . and so on. Were he able to view Krasner herself as something more or other than absence, he might be able to see the negations of her art as strategic, and leave his own strategy, the sexualized notion of "surrender," behind. He might be able to see those negations, finally, as the repository of the artist's peculiarly consistent voice.

Krasner's destiny was to inhabit a present in which such acts of critical vision were notably infrequent—a present, moreover, whose main prejudices out-lasted the transitions in her social status inevitably brought about through time. They lived on, for example, as wife was supplanted by widow, and as the widow became the grande dame. They survived the efforts of American femi-nists in the 1970s to destabilize the status quo, perhaps because those efforts too often took the form of a simple reversal. Though Danto's review belongs to the last phase of Krasner's life, it is nonetheless part of a continuing set of cir-cumstances that played their part in informing Krasner just what (just how little) her continuing presence in the art world might be said to mean. While this chapter has already gone to some lengths to describe them, there are plenty of other examples I might cite. To add further details at this stage in the argu-ment, as its conclusion approaches, is to convey by accumulation how deeply ingrained in her personal and social circumstances these prejudices were.

So let me conclude with two final examples, drawn this time from fiction, rather than criticism. (We will not, however, be leaving Danto far behind.) In 1962 the novelist and critic B. H. Friedman, a New York real estate executive turned author (the champion of both Pollock and Krasner, he wrote a Pollock

biography, *Energy Made Visible,* and owned examples of their work), published his first novel, *Circles.* He gave Krasner a copy. It was not exactly a roman à clef, though set in New York and East Hampton. There is no pseudo-Pollock or Krasner among the dramatis personae, even if the artist in the book, Stanley (Spike) Ross, who drinks a lot and "paints" by riddling canvases with bullets sprayed by machine gun, is inconceivable without Pollock and his myth. Yet the immediate point for Krasner was presumably the representation of female artists in the book. There was only one, a painter known simply, condescendingly, by the nickname Virginia Wolfe. Her sole function in the story is to be wounded by Spike's machine gun (note symbolism) as he jettisons it in Long Island Sound, having decided to go back to painting *real* pictures, using ordinary oil on canvas. Exit the bleeding Virginia, to be carted off to the hospital.

So much for female creativity. Now add to this brief synopsis one more scenario, that of a 1968 short story, "Small Change," published by May Natalie Tabak in the *Kenyon Review.*[108] It follows the flowering of a fantasy that consumes Cecily Lake, wife of the painter Cob Lake, until it becomes a full-fledged neurosis. She vividly and repeatedly imagines he is dead and sometimes cannot tell her fantasy from reality. Thus prematurely obsessed, she is becoming—yes—an Action Widow (Tabak's husband was Harold Rosenberg). The story closes as Cecily worries there won't be room for Cob in the cemetery at Springs. "Who had said that the plots were all sold out? Perhaps she could get Jackson's widow to let Cob share his. It was too large for one man anyhow." Finis: finally this feeble little parable has gotten to its point.

These are not examples of great fiction, but nonetheless they are relevant here. They are a part of the same cultural circumstances that gave rise to Danto's views: they emerge precisely, moreover, from the specific context in which Pollock and Krasner lived out their lives and careers. Both authors would surely have been able consciously to analyze and to deplore the distortions and excesses of the Pollock myth, as well as its impact on Krasner. (Indeed, Friedman did so in his biography of Pollock.) Yet those abilities and sympathies, we must conclude, are evidently put into abeyance when it comes to imagining a painter's life and times. Friedman's novel takes for granted the relative positions of Spike and Virginia Wolfe as antihero and victim; it cannot imagine any other order of things. And although Tabak, in aiming at social satire, is necessarily dependent on picking a plausible and recognizable target (her *Art News* review of Fried-

man's novel condemns its lack of social resemblance), she seems to have swallowed the notion of the Action Widow hook, line, and sinker. In the wings of her story stands Krasner, forever tending Pollock's grave.

If these are the attitudes and beliefs of Krasner's immediate circle, was there much hope of her gaining the acknowledgment—let alone the separate identity—to which she aspired? That hope is endlessly documented in her personal papers, with her efforts to create a persona for herself taking a variety of forms: much of that evidence has been presented here. Hence she had Pollock's studio renovated for her own use and commissioned photographs to show herself ensconced and working there. (It was clear that the old photographs of her with Pollock, taken by Namuth and the like, would no longer do the trick.) And so on.

I take all these moves as meant to fly in the face of the Action Widow persona, to counter it by establishing another, independent, painter's self; I have tried to show that they were only—could only ever have been—partly successful. Explaining their lack of success means demonstrating the near seamless overlap among the various identities Krasner—and Pollock—were asked to assume. There was no prizing them apart—no social space in which "artist" was separable from "woman," "wife," or "widow," or, for that matter, from "man" (though of course it must be noted that among these categories, those of "husband" or "widower" are not at issue). But perhaps the best way to represent the inseparability of these identities is to have recourse to two sets of photographs: those contact sheets by Wilfred Zogbaum showing Krasner and Pollock working in the garden (see figs. 32, 33)—the year, remember, seems to be about 1950—and a second photographic campaign undertaken in the 1960s by the East Hampton photographer John Reed (fig. 59). His subject was Krasner alone. What is striking about both sets of images is the vivid sense each projects of role playing, of performing for the camera. In the double portrait, several poses are assumed, using dog and watering can and shovel as props. Then, holding flowers, the happy couple is silhouetted against the sky. Years later, in Reed's shots, a carefully dressed Krasner arranges and rearranges herself in an armchair, each time fixing the camera with a commanding gaze. Here is the letter Reed sent with the proofs: "Dear Lee, These being the kind of pictures they are—character studies? neo-realist sociology? Vogue at-homes?—I should appreciate credit lines when they are used."[109] A brief enough missive.

FIGURE 59. *John Reed, Lee Krasner at home in Springs, ca. 1965, photograph. Lee Krasner Papers, Archives of American Art, Smithsonian Institution.*

What is nonetheless notable is the letter's tacit admission that no one of these phrases achieves a proper description of the portrait; on the contrary, it is the *play* of possible descriptions that is important here. We might think that the task of achieving realism or psychological penetration or high style in portraiture would call for quite different kinds of imagery, yet this is apparently not the case. Instead Reed could pin all three genres to a single photo, could *see* them there—isn't it because the precise genre of his photos seems undecidable that he wants credit as their author?

I suspect that these three terms were put into circulation around the photos precisely because Krasner is occupying, as usual, something like three identities

at once: she is legible simultaneously, at least according to Reed, as an individual, as the representative of a social category, and as a media fiction—all the while remaining "herself." My sense is that a similar play of identities and genres circulates in Zogbaum's photographic efforts, as both painters enact social selves before the camera, making public the privacy of marriage as an image of domestic bliss. That such a theatrical moment was worth recording hinges, not on bliss, but on painterly reputation—and, in 1950, on Pollock's reputation above all.

It might be comforting to conclude by pulling a rabbit out of a hat, so to speak, and claiming that the practice of painting offered Krasner the means to escape just this circuitry of social identities through which shuttled her public self. Or perhaps some kind of magic might be worked to bring off a similar claim concerning her ability to elude the roles and constraints that personal circumstance provided. Either thesis, however, would go squarely against the grain of my argument—to say nothing of Krasner's own experiences. Let me state that argument once again: I have claimed that the painter's identity—above all, when she is a woman, and *because* she is a woman—cannot be prized apart from the other roles she is customarily asked to play. And though for Krasner those various roles coexisted uneasily, even paradoxically, they could not be eluded. They took a toll measurable in the terms in which her life has been represented and her art received; neither the genuine interest of her painting nor feminist efforts to understand her career (including my own) can or will change that history.

Nonetheless, it should be granted that Krasner herself seems to have operated with certain powerful illusions about her practice as an artist. She seems to have thought of painting in particular as offering a space separable from social identity; I think she trusted, not so much that painting was an entirely private endeavor, as many of her contemporaries would have alleged, but rather that it was an activity in which a gendered notion of the self—or even selves—might be held at bay, above all by means of a tactical deployment of the techniques and vocabulary of the modernist idiom in its most advanced—i.e. Pollockian—form. This vision of a gender-blind modernism could serve as a screen behind which the self could then stage its terse and convoluted statements, and lay claim to its (pessimistic) notion of artistic identity, writing and rewriting its

relationship to its own past, to Pollock, and to painting. This is how Krasner composed her autobiography, from the various artistic materials at her disposal. It gives the measure of her ambition to negate or transcend her identity as a woman even as those same negations document what her culture took a woman to be. This is the paradox of Krasner's career: her painterly ambitions demanded she come to terms with European modernism and with Pollock, while social circumstance made those encounters, if not impossible, then at least fraught and encoded from several points of view. Not least the critic's, as I have shown. Yet it must also be conceded, if only to underline the paradox still further, that this cherished fiction—her confidence in painting as a practice in which female difference could be challenged and managed and assimilated and exorcised and so laid to rest—was what enabled her to keep on painting. She needed her fictions; they had their uses. They are what help most people get from day to day.

At the end of her career, when she sought verbal terms for her personal and painterly predicament, she found it (typically) hard to name: "I'm a product of this civilization, and, you might say that the whole civilization and culture is macho." We wait in vain for her to take this formulation to its logical terminus, the inevitable Ergo with which a syllogism should conclude. But the conclusion stays implicit: no "I am macho" is offered as the final term. Krasner leaves unstated what her paintings also wish to convey by implication. They often succeed: which means that their modes are those of the suggestion, the qualification, the negation, the citation. Sometimes they fragment, exaggerate, or ventriloquize. Whatever the mode, these terms seem to echo and magnify the resonance of one key element in her unspoken proposition. In English, the macho is always performative and artificial, a means of putting masculinity on exhibition. Its intensities are always meant as modes of display. This observation leads us to one further conclusion. Although Krasner's art is "that of a woman," the autobiography it inscribes invents its subject (its "self") as the bearer of a fictional masculinity. Or at least this is what Krasner hoped to imply. The invention is strategic, meant to master the feminine, since for Krasner femininity was the more complex and threatening term. In trying to circumvent that oppressive fiction, she embraced its opposite as a kind of antidote to a social condition— she did not realize that no mode or style of painting can play that role. I cannot be sure that her "incurable womanhood" is the reason her invocations of "the

masculine" emerged as misreadings. But I am sure that those misreadings are productive, since they help to demonstrate the artificiality of the term they hold most dear. In this the parameters of Krasner's autobiography transcend her fictions of self. "I think my painting is so autobiographical if anyone can take the trouble to read it." If reading Krasner's painting has proved troublesome, our reward is what we learn from the story it has to tell.

Another Hesse

Three "Portraits" of Eva Hesse

Mel Bochner, Portrait of Eva Hesse, *1966 (fig. 60):*

wrap-up. secrete. cloak. bury. obscure. vanish. ensconce. disguise. conceal.

camouflage. confine. limit. entomb. ensack. bag. conceal. hide.

hedge-in. circumcincture. skin. crust. encirclement. cincture. ringed.

casing. veneer. shell. hull. shell. cover-up. facing. blanket.

tape. mummify. coat. chinch. tie-up. bind. interlock.

splice. gird. girt. belt. band. strap. lace. wire. cable. chain.

string. cord. rope. lace. tie. bind. tie. truss. lash. leash.

enwrap. coil. twine. intertwine. bundle-up.

shroud. bandage. sheath. swaddle.

envelope. surround. swathe.

enwrap. cover. wrap.

wrap.

FIGURE 60. Mel Bochner, Portrait of Eva Hesse, 1966, pen and ink on graph paper, 7½ × 7½ in. (19 × 19 cm.). Allen Memorial Art Museum, Oberlin College, Oberlin, Ohio, Gift of Helen Hesse Charash.

FIGURE 61. *Unknown photographer, Eva Hesse at the opening of her exhibition in Kettwig-am-Ruhr, May 1965. Allen Memorial Art Museum, Oberlin College, Oberlin, Ohio, Eva Hesse Archives.*

Hesse in Kettwig-am-Ruhr, 1965 (fig. 61):

The guests and the artworks are a bit of a blur, as befits the scene of an opening, but Eva Hesse stands out in sharp focus. Her hair is a sleek beehive, and her cigarette freshly lit. Her tulips have only just begun to droop, but those that have fallen have done so en masse. They yearn toward the string bag that hangs ladylike from her arm. For now a purse, before long it will become a sculpture.

FIGURE 62. *H. Landshoff, The table in Hesse's Bowery studio, November–December 1968, photo-graph. Courtesy Robert Miller Gallery, New York.*

A photograph of the table in Hesse's studio, 1968 (fig. 62):

The table top is gridded as if to anchor the objects upon it: an ashtray from "Persia," a kaleidoscope, a pencil, a thick-headed metal spike, a small pitcher and matching cup, each with some small object tucked inside. There is a roll of paper secured with a paper clip, and a small paper box, and a flip-book by Robert Breer, and two squarish pieces of plastic—one of these is clear. Nearly invisible is a bristle of clear plastic tubing, standing up like a porcupine's spines. There is a bowl with wrapped candies, and a pile of books and sketchbooks, and a compartmentalized plastic box, its twenty-four hoppers filled with Canal Street trove—nails and washers and grommets and the like. There is another gridded lucite box, all order rather than diversity: a potlatch gift like the table itself, this is a work by Sol LeWitt. In and around and on top of these objects are bits of material that Hesse has put to the test: folded and poured and pinned and wrapped and skewered, fourteen such objects in all. Sandwiched between the grid and the things upon it is one further layer: words and pictures, each one chosen as if to stand for still other stages in the transformation from thing

to art. There is a typewritten list of titles for sculpture and a copy of the periodic table—an elemental listing of the starting place of form. This is no impersonal inclusion; it is a handwritten object, signed and dedicated from Carl Andre to Eva Hesse. Is its strictly squared presence why the word "Anti-Form" is nearby, legible though dimmed by a sheet of tracing paper? Next to it, even closer to the elements, is a photograph of an art work—*Repetition Nineteen I*—as it was printed up to be used as the invitation to its maker's first solo exhibition. Meanwhile, the reproduction on another invitation stands in for its subject, the sculptor Ruth Vollmer, while playing a game of resemblance with the real works next to it. There are two clippings, one from the *Times*, one from the *Village Voice*. They are reviews of Hesse's show; John Perreault's column, "The Materiality of Matter," is still half legible, but Hilton Kramer's response has been wholly obscured by a vomit-like screen of plastic—"Anti-Form" seems to be having its say.

Three Self-Portraits by Eva Hesse

Hesse was no longer a student when in 1960 she began to paint self-portraits: the three reproduced here are among at least seven such works (plates 23–25). The practice had nothing to do with a curriculum, though the economy and sheer convenience involved in taking one's self as a model might well have played a role in their inception. Yet while these are self-portraits, they were not made with a mirror; if the artist's self was at issue, then that quantity was evidently not to be understood as a matter or effect of external appearances. But though Hesse did not consult her own image while painting, we are not justified in concluding that the process was any less intense or laborious than if she had. In fact there is much about these three pictures to suggest a protracted and deliberate process of execution: surfaces are almost uniformly belabored, paint pushed around the canvas with considerable purposefulness, colors brushed into and atop and through each other in ways that intensify their sobriety rather than relieve it. Design is an issue: the figures push close to the edges, intersect with them, are limited by them. These are faces and bodies made up of parts: blocky units, small geometries that do their duty as eyes or nose or mouth or brow. But the hat in one picture and hair ornament in another are anything but geometrical, and alike in nothing save their main rhetorical purpose: each em-

phasizes the part of the figure that stands for its mind or intellect: in the case of the ornament (it could be a bow or a flower), a piece angles out as if to point to the forehead, the blank expanse that is the central third of the picture. The hat, for its part, does not point to the forehead so much as replace it with a great, top-heavy, unbalanced shape. Seamed with red and orange and yellow, it looks more a part of the body than external to it; this is because of the similarity in its coloration to the core of the figure revealed through the gap in its breast.

Art and Life

Twenty years separate the two retrospective exhibitions of Eva Hesse's work to have been held in the United States.[1] The first, *Eva Hesse: A Memorial Exhibition,* was mounted in 1972 by the Solomon R. Guggenheim Museum. It left New York on a tour of four American cities, closing in Berkeley only in early 1974. The 1992 show, by contrast, began in New Haven and ended in Washington, D.C., without stopping in New York or anywhere else on the way. This limited itinerary cannot be explained solely by the fragility of Hesse's sculpture, even though it has begun to disintegrate over the years—or at least that explanation seems insufficient once it is noted that a number of the same pieces presented in New Haven and Washington turned up in Europe in 1993, part of a third retrospective making stops in Paris and Valencia. Nor does the close proximity of East Coast cities to each other offer enough of a reason. New York's lack of interest seems instead like business as usual: if "political correctness" really does rule the art world, why are there still so few shows of art by women, and why are the New York museums still so impervious to them? These questions linger, though their origin can be dated more or less precisely to the moment of the first Hesse show.

Much else has changed in politics and culture (and cultural politics) since 1972. The changes are profound enough that it is surprising to compare the terms in which the organizers of each show conclude their prefatory acknowledgments. Here is Linda Shearer, then a research fellow at the Guggenheim, writing in the earlier catalogue: "I only regret that I did not know Eva Hesse personally, even though I feel I know her through her work. The exhibition and accompanying catalogue will, I hope, stand as a fitting tribute to her memory." Now compare the comments of Helen A. Cooper, who as curator of American

paintings and sculpture put together Yale's impressive exhibition. "Organizing this exhibition has been a privilege. My only regret is that I never knew Eva Hesse personally. I can only hope that this catalogue and exhibition honor her memory as well as do justice to her art." What strikes me is not that each writer wishes her efforts to measure up to her subject's stature and memory: that goal seems unexceptionable—why else undertake an exhibition, we might reasonably ask. More notable is the regret each expresses, in nearly identical terms, at not having known Hesse personally: it is a desire that has survived the twenty-odd years since her death seemingly more or less intact.

The wish to know Hesse is profoundly nostalgic: it voices the desire for a return to the past to recover the Hesse who disappeared there, the woman who in 1970 died of a brain tumor at the age of thirty-four. She is the only Hesse we have, after all: she is the person preserved in a finite number of photographs and on a few feet of film; she is the author of a finite body of work and words. When we import her into our present, she appears there unchanged; she does not emerge, like some returnee from Shangri-La, only to age instantly and assume the guise of the woman she would have become had she lived. Hesse in late middle age, I feel certain, would have been a considerably less attractive cultural commodity (though no less interesting an artist, I wager) than the Hesse fate has provided. It is her (un)timely death that has meant that she has survived to play a special cultural role: forever under thirty-five, she answers a hunger for youthful, tragic death. She is the "dead girl," the beautiful corpse who counts for so much in so many cultural narratives. ("What had such works, I wondered, to do with this tragic doomed girl who stood before me calmly pronouncing her own death sentence?")[2]

Much of the writing about the artist cannot resist taking advantage of the free mileage it gets from Hesse's early death. When it is harnessed to her troubled life, so called, an irresistible package results. "Heartache amid Abstraction," "Fragile Artist's Agonized Life," "A Portrait of the Artist: Tortured and Talented," "The James Dean of Art," "Eva Hesse: A 'Girl Being a Sculpture,'" "Growing Up Absurd"—this brief digest of titles culled from both ends of the Hesse literature, the popular and the scholarly, is enough to suggest what I mean.[3] And while some titles fit less easily into this (or any) category—take Newsweek's obscure "Cockroach or Queen"[4]—the attitudes they vent make use of the same self-indulgent mix of sentiments: Hesse is endlessly gorgeous,

girlish, incomplete, immature, melancholic, a symptom of the pathology of the female condition. Even when a writer makes an effort to argue against the Hesse myth, as does Arthur C. Danto in "Growing Up Absurd," he ends up feeding it as if against his will. "Hesse appears to have been a happy person," he pleads, trying to get her off the tragedy rap: "The tumor was just a sad external fact, an unearned pathology, a fatal meaninglessness."[5] Danto is right, of course, and his enthusiasm for Hesse's art genuine. Why then did he take his epigraph from *Finnegans Wake*: "Die eve, little eve die! We see that wonder in your eye."[6] He was after irony, presumably, but taste deserted him halfway; no amount of wishing can leach the cruelty from Joyce's injunction once it has been linked with the "sad fact" of Hesse's death.

Perhaps it would be easier to make one's peace with this particular martyrology if its pace did not seem to be quickening over the years. Or, to put the matter more precisely, if the notion of "Hesse as wound" did not seem to have taken such firm root in recent academic writing about the artist: two of the five contributions to the Yale catalogue make that notion their theme, arming themselves with the requisite citations—Barthes and Cixous, Deleuze and Guattari—to urge the case.[7] It involves a double insistence: first, that the artist herself was literally wounded, as the victim all her life of bodily and psychic ill health, and, second, that as an artist who was a woman, she embodied and bespoke the wound as the principle of female being. Next to these passionate claims the earlier insistences on the "tragedy" of the artist's life and death seem merely to be lip-synching each other's banalities: I am thinking of sentences like this one, art gabble delivered undiluted: "The most poignant fact about the late Eva Hesse is that she died of a brain tumor at thirty-four, a beautiful courageous young woman who had, within five short years, produced one of the most impressively original *oeuvres* in recent American sculpture."[8]

The most important decision for Hesse's reputation was taken soon after her death by her older sister and executor, Helen Hesse Charash (b. 1933). She gave two critics, Robert Pincus-Witten and Lucy R. Lippard, access to the notebooks Hesse had kept from childhood and to the other manuscripts among her papers.[9] Both writers used their first gleanings in articles published before the end of 1971, and both went on to work further on Hesse. Pincus-Witten contributed a revised and corrected version of his 1971 essay to the Guggenheim catalogue (the first effort was riddled with errors, major and minor) and

also transcribed and introduced, in the pages of *Artforum*, a brief, intense series of texts in which, near the end of her life, the artist made the effort "to go back to the beginning" of her illness and set down her understanding of its course.[10] (Both at the time and in retrospect, his efforts struck some readers as excessive: to the critic for the *Village Voice*, they were "morbid disclosures" to which, like a virus, readers had been exposed.[11] In 1991 the sculptor Walter Erlebacher remembered Pincus-Witten's interest as nothing short of "necrophiliac": "Those of us that knew the lady, wondered what was with him.")[12]

Lippard, for her part, published *Eva Hesse* in 1976 to considerably more widespread acclaim; the fundamental study of the artist and her work, it was reprinted in 1993. In this case, interestingly enough, the worry was not that the author had come uncomfortably close to her subject's person: on the contrary, Hilton Kramer feared that Lippard, for all her intimate knowledge of her subject (acquainted since 1963, the two women had been friends and collaborators since 1965), had not come close enough. Whether from sensitivity—Lippard was well aware that a Hesse myth was in the making and did her best to deflate it—or because of an odd absence of curiosity, her treatment of the life seems somehow incomplete in Kramer's eyes. It lacked any real connection to her art, despite discussions of the work that are otherwise full of detail concerning "the thinking that went into [it], the ideas that passed from one artist to another, the ventures into new materials, and the new images that resulted."[13] But Kramer's worries about absent connections take us ahead of the story. In the case of the monograph, Charash contributed more than the free hand she allowed its author: she aided the book's production with financial support.[14] Once it was safely published, moreover, in 1977, Charash made a gift of the archival materials on which it was based to the Allen Memorial Art Museum at Oberlin College; the papers were microfilmed by the Archives of American Art that same year and so definitively entered the public realm.[15]

These two channels made available the main textual underpinnings of the view that has borne its sad fruit in the notion of Hesse as wound. Indeed, their sheer importance to the artist's reputation relates paradoxically to another main claim concerning her art: that it delivers, as Rosalind Krauss has put it, "the message of privacy, of a retreat from language, of a withdrawal into those extremely personal reaches of experience which are beyond, or beneath speech."[16] This view notwithstanding, the one further element necessary to the formation

of Hesse's reputation is as textual as those just cited: that is the transcript of an interview conducted by Cindy Nemser a few months before Hesse died. Like the Krasner interview, it would be included in *Art Talk* (1975), but its impact had been felt years earlier: an excerpt had appeared in *Artforum* in the last weeks of Hesse's life (it was rushed into print), and thus at her death was available to serve as a source for the first wave of commentary on her life and achievement.[17] It offered the first statement of the principle for which the artist's notebooks are customarily taken as documentation: the artist seems to declare in plain English (more or less) her belief in the utter connectedness between her art and life. Let me quote the relevant passage; it follows on the heels of Hesse's explanation of the emotional terms of her reaction to Carl Andre's work. "It does something to my insides," she says. "His metal plates were the concentration camp for me." To which Nemser replies, "If Carl knew your response to his work what would be his reaction?"

> I don't know! Maybe it would be repellent to him that I would say such a thing about his art. He says you can't confuse life and art. But I think art is a total thing. A total person giving a contribution. It is an essence, a soul, and that's what it's about . . . In my inner soul art and life are inseparable. It becomes more absurd and less absurd to isolate a basically intuitive idea and then work up some calculated system and follow it through—that supposedly being the more intellectual approach—than giving precedence to soul or presence or whatever you want to call it . . . I am interested in solving an unknown factor of art and an unknown factor of life. For me it's a total image that has to do with me and life. It can't be divorced as an idea or composition or form. I don't believe art can be based on that. In fact my idea now is to counteract everything I've ever learned or been taught about those things—to find something that is inevitable that is my life, my feeling, my thoughts. This year, not knowing whether I would survive or not was connected with not knowing whether I would ever do art again. One of my first visions when I woke up from my operation was that I didn't have to be an artist to justify my existence, that I had a right to live without being one.[18]

Here and at another juncture in the interview, when Hesse declares she wants to be like Andy Warhol in the sense that "he and his work are the same," are set out the foundation and future prop for the argument that Hesse's art and life

are likewise inextricable. When in *Eva Hesse* Lippard introduces that concept—
as the justification for her view that a psychological reading of the artist's work
is necessary, it is advanced (*pace* Kramer) as the first thesis of the book—she
builds her case from the Nemser interview, which she consulted in "very rough
transcript." As a result her version differs in some details from Nemser's (the
Artforum version of the interview is entirely a cut-and-paste job, which strings
together and reorders phrases culled from some ninety pages of transcript). Lip-
pard's is the one to include the two brief phrases, "My life and art have not
been separated. They have been together," to which the main premise of many
responses to Hesse's art can be reduced.[19] It is a simplification with real conse-
quences for her critical history: her work emerges from surgery less complicated
and contradictory than was the case.

How personal *is* the idea of the unity of art and life? When Hesse yokes them
together, as when she says, "I am interested in solving an unknown factor of art
and an unknown factor of life," she is not inventing new ideas. Her phrase has
close parallels. Think, for one example, of Robert Rauschenberg's declaration,
early in his career, of his resolve to work "in the gap between art and life." Seen
in this context, or placed next to Claes Oldenburg's notion of an art "that
grows up not knowing it is art at all," Hesse's statement seems less a move
toward self-revelation than a professional self-identification, one that is well
informed and reasonably up-to-date, if by no means universally shared (as the
reference to Andre was meant to attest).[20] Thus in the third transcription of the
same interview, the one published in *Art Talk*, Nemser's Andre question leads
Hesse to ventriloquize the reaction she would expect from him to the distinctly
non-Minimalist associations she brought to his art: in this walk-on part, she has
him pronouncing his key line as a prohibition: "You can't combine art and life."
But Hesse continues to speak; she admits unprompted that her own position
catches her in a conceptual snare. Her life and her art may be one, but even she
(like Andre) wants to set strict limits on what her art can be said to mean. Her
interdict proscribes anything smacking of "romanticism," as do pretty pictures
and sculptures and "nice parallel lines." All well and good, until Hesse starts
speaking of meaning herself: "then I talk about soul and presence and guts in
art. It's a contradiction."[21] The contradiction concerns meaning: it arises from
Hesse's wish to control the play of reference and gender when her own work is
concerned. God forbid her work should be called pretty, when to her it con-

FIGURE 63. *Eva Hesse, Project for an installation at the Whitney Museum, 1969, ink on paper. Allen Memorial Art Museum, Oberlin College, Oberlin, Ohio.*

cerns "soul and presence and guts." If this is Hesse's account of her art, it is also—or should be—the story of her life. But then what about sickness and wound?

Now a slight change of direction: among Hesse's papers is a drawing that, though undated, was probably done in 1969 (fig. 63). On it are a rough spatial plotting (perhaps a layout of pictures and lines of type) and the words "build wall," "Whitney," "Process; . . . means as end (title)," and "catalogue. film process." Cryptic notations, certainly, but enough to suggest that the sheet stems from a stage in her preparations for the Whitney's 1969 exhibition, *Anti-Illusion: Procedures/Materials,* to which she sent two works (in the end she did not use the ideas she was turning over here).[22] The drawing crops up in the context of this chapter, however, because of the reminder that Hesse scrawled along its lower edge: "my responsibility to know as I am being categorized in a way that's detrimental to my work." Appearances to the contrary, I am not proposing to exercise responsibility on Hesse's behalf, but rather on my own account. I am mistrustful of the assumptions and reductions at the heart of Hesse's reputation, and fearful that they may indeed be detrimental, if not to her

PLATE 23. *Eva Hesse, Untitled, 1960, oil on canvas, 18 × 16 in. (45.7 × 40.6 cm.).
Galerie Sophie Ungers, Cologne.*

PLATE 24. *Eva Hesse, Untitled, 1960, oil on canvas, 18 × 15 in. (45.7 × 38.1 cm.). The Museum of Modern Art, New York, Gift of Mr. and Mrs. Murray Charash.*

PLATE 25. *Eva Hesse, Untitled, 1960, oil on canvas, 36 × 36 in. (91.4 × 91.4 cm.). The Estate of Eva Hesse, courtesy Robert Miller Gallery.*

PLATE 26. *Eva Hesse, Contingent, 1969, reinforced fiberglass and latex over cheesecloth, 114–168 in. × 36–48 in. (289.6–426.7 cm. × 91.4–121.9 cm.). National Gallery of Australia, Canberra.*

PLATE 27. *Eva Hesse, Hang Up, 1965–66, acrylic on cloth over wood and steel, 72 × 84 × 78 in. (182.9 × 213.4 × 198.1 cm.). Through prior gift of Arthur Keating and Mr. and Mrs. Edward Morris, 1988.130. Photograph © 1994, The Art Institute of Chicago, all rights reserved.*

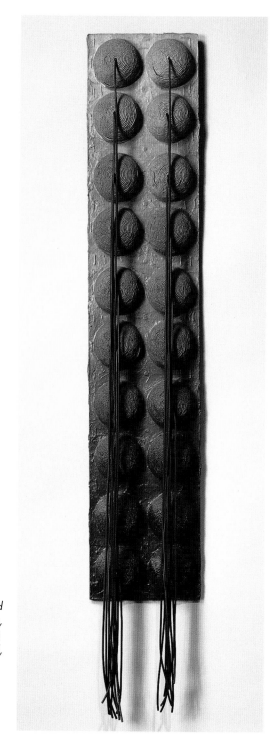

PLATE 28. *Eva Hesse, Ishtar, 1965, cotton and plastic cord, paper, wood, staples, nails, gesso, and acrylic paint, 36 × 17½ × 2½ in. (91.4 × 44.5 × 6.4 cm.). JNN Collection, Switzerland, courtesy Robert Miller Gallery, New York.*

PLATE 29. *Eva Hesse, Untitled, 1969, gouache, watercolor, pencil, and silver paint, 23 ×
17¾ in. (58.8 × 45.1 cm.). Private collection, courtesy Robert Miller Gallery, New York.*

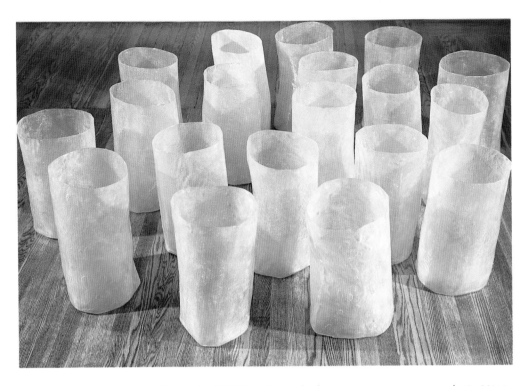

PLATE 30. *Eva Hesse*, Repetition Nineteen III, *1968, fiberglass and polyester resin, nineteen units, each 19–20¼ in. (48.3–51.4 cm.) high, 11–12¾ in. (27.9–32.4 cm.) in diameter. Collection, The Museum of Modern Art, Gift of Charles and Anita Blatt.*

work (it seems able to take care of itself, in every sense but the physical), then to our understanding of it. Equally at issue is the continuing argument concerning what it means to be female and to make art. This is an argument that migrates from artist to artist and will continue to do so until women's achievements are no longer seen as "exceptional." When it takes up residence in Hesse's person, however, the case for collapsing the artist into her art, and vice versa, takes on special glamour and persuasiveness. It has seemed unavoidable, so strong are identifications with the artist and so powerful the desire for a beautiful martyr. How could it be otherwise, we might wonder, when the artist herself linked art and life so directly, and left behind materials, in the form of her writings, that can be used to support that case. Hesse, we read, had a "near-obsession with autobiography":[23] she produced a set of pages that "allow a remarkably candid glimpse into the complex connections between her life and art." Hence the decision, by Helen Cooper, the organizer of the Yale retrospective, to allow Hesse's words to narrate her life: the detailed chronology is laced with excerpts from the diaries and mixes them with recollections taken from the Nemser interview. Cooper does not claim that the verbal picture which emerges is in itself sufficient; on the contrary, she warns that "language alone, no matter how intimate, never completely reveals the self."[24] That self is to be found elsewhere, she concludes, though not far away: "The fabric of Hesse's identity is a tight weave of intertwined threads of words and art."[25] Though a necessary caveat, it is not one that takes us very far: it enacts its own exclusions concerning the nature of the artist's self.

I want to argue in what follows that Hesse's own belief in the unity of her art and life is as much a cultural artifact as any other. It is not a belief, accordingly, that her interpreters are themselves honor-bound to embrace; on the contrary, it would be better to analyze its sources and implications, and to inquire about the kinds of understanding of art and identity it perforce leaves out. It would likewise be more useful to consider her speech and journals, not as providing the truth of Hesse's art or self, but as themselves the product of acts of representation undertaken with their own means and goals. Finally, it would seem helpful to surrender, at least for a while, confidence in the uniqueness of the artist's particular circumstances. To see them as profoundly social—as socially determined—is to understand better how her art might better be understood "as that of a woman."

These goals are best met, I think, not simply by cultivating a deep sense of identification with the artist, but by trying to measure with some accuracy the terms of her cultural and historical difference from ourselves. The wish to know Hesse could conceivably be formed from other impulses than the desire to see reflected in her one's own certainties concerning the female self.[26] In what follows I aim to keep alive a sense of her distance from ourselves. Yet I would nonetheless be the first to admit that I do so in order to find the terms of her relation to the present; I am simply prepared to accept that these meanings may lie in difference, not identity. Hesse—and above all, Hesse's art—may be able to show us what we are not, remind us of things we have forgotten. Attending to the terms and contexts of Hesse's life and art may be one way to learn those lessons: they involve an examination of a whole range of factors and experiences constitutive of her identity: her class and familial background, her education and marriage (to the sculptor Tom Doyle, b. 1928), her journals, her encounters with the psychoanalytic establishment of the 1950s and 1960s: there are many points of connection among all these. The task of interpretation finally circles back to her art, there to take up again the topic that inevitably concerns me as well as so many of my fellow critics, the subject even so astute an observer as Lippard left oddly incomplete (I agree with Kramer here): how to understand the connection between Hesse's art and life. My ultimate purpose, however, is parallel to that of others who have written about her. I too want to find a way to express and explain my sense of Hesse's stature as an artist, and to argue for the interest of her work.

Not Plath

Joyce Purnick, 1972:
Eva's friends talk warmly and openly about her with a lack of sentimentality. It is her art that they emphasize and they resent the linking of the Hesse name to Plath and Arbus in magazine articles and among young women artists.[27]

Douglas Davis, 1973:
It is no exaggeration to say that Eva Hesse is by now the Sylvia Plath figure in art—an embattled sculptress theoretically felled by disease, melancholy, male prejudice and misunderstanding. This is an easy mistake to make, given the morbid circumstances of her early death and her life.[28]

Peter Schjeldahl, 1973:

It is impossible, thank goodness, to see Eva Hesse as a martyr to anything. Comparisons to poor, embittered Sylvia Plath are wrong-headed: a more proper literary parallel is Frank O'Hara.[29]

Lucy Lippard, 1976:

Unfortunately, by the time the Guggenheim Museum's exhibition of Hesse's work opened in December, 1972, she had become a stereotype, or myth, the art world's answer to Sylvia Plath and Diane Arbus. That she did not commit suicide and had, on the contrary, an immensely strong will to live and to work, was ignored.[30]

Hank Burchard, 1992:

Hesse's works are so physically fragile they can hardly be shown, and so conceptually fragile that she seems likely to be soon forgotten unless feminist focus on her life rather than her work turns Hesse into an icon like Sylvia Plath.[31]

The tactic of identifying Eva Hesse with Sylvia Plath clings to life, even though it has long been emphasized—whether in protest or as a grudging admission—that the analogy has little to say about Hesse, who was not the author of her own demise. It survives, not as a tenet of feminist criticism, but as the figure, in the press, of the outlandishness of the feminist point of view. In fact, as Lippard demonstrated long ago, the feminist press, as energetically embodied by *Ms.* magazine in its salad days, was entirely able to provide an analysis of the significance for *artistic* standing in particular of the appetite for a tragic Hesse and Plath: "By implication, any woman who carries her art to heights that subordinate her personal life is bound to die tragically, probably by her own hand. It's a punishing sort of recognition, carrying with it the suggestion that without super suffering the art couldn't have happened; that no woman artist can be truly great in a public sense unless she has so mucked up her personal life that she can't possibly be getting any satisfaction out of it."[32]

In my view, this analysis grabs Hesse criticism by the jugular: I am thinking, for one example, of Robert Pincus-Witten's certainty that the creative watershed for Hesse—the event that kept her art from muddling on as a merely "derivative affair"—was her state of emotional misery in 1966. "The terror and isolation provoked by the death of the artist's father and the withdrawal of her husband from her—instead of forcing an incipient madness—provoked the

crystal lucidity of original creation."[33] This formula fits the *Ms.* description precisely. "Terror and isolation" have no trouble qualifying as "super suffering": note that they are given an uncomfortably sexual savor by Pincus-Witten's odd, quasi-biblical turn of phrase, "the withdrawal of her husband from her." The image is of bodily appetites forcibly denied satisfaction; only then could real art emerge.

But Pincus-Witten is also the only author I have consulted who has had a slight suspicion that there might be other, less sheerly exploitative, ways to connect Plath and Hesse as examples of artistic achievement, though he did not himself attempt them. It is only a suspicion, and it is very slight: it is to be located in his recollection of a "curious coincidence." As young women both Hesse and Plath won prizes and attention from magazines aimed at a readership of their semblables. Both had work appear in the "It's All Yours" section of *Seventeen.* Hesse was featured in the Gala Birthday Issue (alongside "Fall Clothes in New Flattering Colors," "Paris Designs for You, Too!" "Posture Pointers to Make You Prettier!") and was even employed by the magazine for a time.[34] Plath, for her part, published poems and stories in its pages—and was paid for them—after her spot in "It's All Yours." Then in the summer of 1954 she spent an ill-fated month in New York as a guest editor of *Mademoiselle;* this is the experience that supplied the setting for the first half of her novel, *The Bell Jar.* The overlap between the two biographies is a coincidence, but not a *mere* coincidence. Rituals of initiation into the female culture of the day, that "glittery Woman's House of fashion and domesticity,"[35] these experiences transport us back into the odd mores of the 1950s. They offer the means to begin the reconstruction of the circumstances in which young women like Plath and Hesse fashioned a sense of public (and private) self.

Those circumstances are by no means identical in their details. Born in 1932, Plath was Hesse's senior by three and a half years—just about Helen Hesse's age, she was also the firstborn (her brother Warren was born in 1935). Like the Hesses, she was the offspring of German-speaking parents, but they were parents whose arrival in the United States had preceded the shattering circumstances of the Jewish Diaspora and the Holocaust.[36] Nor were her parents Jews. Her father, Otto Plath, was distant, authoritarian, and dead by 1940: it is clear even from the carefully guarded account of Sylvia's childhood given by her mother, Aurelia Schober Plath, that their marriage was a difficult one. "I real-

ized that if I wanted a peaceful home—and I did—I would simply have to become more submissive." [37] Hesse's parents, by contrast, fled Hamburg in 1938 and had settled in Washington Heights, New York, by mid-1939. Wilhelm Hesse abandoned his career as a criminal lawyer and retrained as an insurance broker. After the arrival in New York, his marriage to Hesse's mother, born Ruth Marcus, began to deteriorate (she was by this time severely depressed and occasionally hospitalized). In 1945 they divorced. Wilhelm Hesse remarried in November 1946; his children lived with him and his second wife (also named Eva). Ruth Marcus Hesse killed herself in January 1946. She jumped from a window. Soon after Otto's death, Sylvia Plath extracted a promise from her mother that she would never marry again: Eva Hesse grew up skirmishing with her stepmother and often, by extension, her father. She kept photographs of her mother showing her laughing in some vague and sunny past in a prewar Germany; Plath's photograph of her father, a university teacher and writer, shows him in 1930, standing at a blackboard with chalk in hand.

These are biographies in which parental discord, early loss, familial instability and its restructuring all play their roles. So does the heritage of "Germanitude," Jewishness, and (for Plath) its lack. They are also circumstances that Europeans are comfortable calling petty bourgeois; Americans usually settle for (lower) middle class. Those terms mean, in these cases, a single woman (Plath's widowed mother, a teacher) and a re-skilled man (Hesse's father, the lawyer turned insurance agent) finding the means of support for their families, often in relatively low-paying white-collar jobs. (Plath's mother, it is recorded, was annually earning about $3,700 during Plath's high school years.) [38] Higher education for children in such circumstances is a familiar ambition, especially in immigrant families, but in both these cases it could be realized only by means of outside support, through scholarships. (For Hesse, help came from the Educational Foundation for Jewish Girls; for Plath the $1,600 cost of a year at Smith College was met by a private patron, the writer Olive Higgins Prouty, and the Wellesley Smith Club.) These are the circumstances that helped foster in both a complicated attitude toward achievement: a cocktail of ambition, conscientiousness, compulsion, and fears of inadequacy and failure. And in these circumstances both were quite certain that they faced a choice between social life (for which, in the 1950s, read marriage as an ever-present, inevitable goal) and personal success. For Plath that choice was initially met by dissembling:

her grades and ambitions and successes were concealed, says her mother, behind a facade, a purpose-built screen of "light hearted wit." [39] When her doubts about the future emerged, they were consigned to the pages of her journal—as, for example, in November 1952. She was twenty-one.

> If only I knew how high I could set my goals, my requirements for my life! I am in the position of a blind girl playing with a slide rule of values. I am now at the nadir of my calculating powers.
>
> The future? God—will it get worse and worse? Will I never travel, never integrate my life, never have purpose, meaning? Never have time—long stretches, to investigate ideas, philosophy—to articulate the vague seething desires in me? Will I be a secretary—a self-rationalizing uninspired housewife, secretly jealous of my husband's ability to grow intellectually and professionally while I am impeded? [40]

The passage is impassioned, and performs its passions with a writerly pleasure typical of Plath's journal; but though you can sense her relishing her imagery—embroidering her notion of a "blind girl playing with a slide rule of values," for example—her pleasure does not stop her from imagining an "impeded" future, a future that for many young women became reality.

This is one reason the same choices and questions were on Hesse's mind, though she was somewhat younger at the time. In her case they gave rise to a letter addressed to her father—the year again seems (coincidentally) to be 1952.

> I had wanted always to be someone big, important, but I've always been afraid I didn't have anything on my own merits to do this—thus I would seek the impor-tant things through marriage. . . . I've learned I guess one of the most necessary truths there is to make a success of one's existence. That is it's what one has in one's head and not in one's pocket that is important. That if I want to be an artist a real artist I must give myself, my mind and heart to study, not a few hours a day but always. Living on Park Ave. a wife of a doctor or lawyer then one must play the part of the "Doctor's Wife."
>
> I want to study and learn to understand this mixed up world and all about these people who make it thus.

Here Hesse must interrupt the letter to go for the wash (note irony), and so begins again to outline her sense of purpose and identity:

> I've got to try for myself. To live a life I will set up for myself, to become an individual. I want to experience all that life has to offer and I have to do this for myself.
>
> . . .
>
> I am an artist. I guess I will always feel and want to be a little different from most people. That is why we're called artists. More sensitive and appreciative to nature.
>
> Daddy I want to do more than just exist, to live happily and contented with a home, children, to do the same chores every day.
>
> If I fail, I want to start, I have to rely on my own judgement, not on others.[41]

"Daddy, I want. . . ." At sixteen Hesse petitioned her father for release from a future he seems not only to have described but also to represent: the doctor or lawyer, payer of bills and maker of decisions. He is the order to which Hesse wants not to conform, but also, in the absence of a journal (hers was begun in 1954), ironically the authority to whom she refers her (first?) subversive idea: if it's what "one has in one's head and not in one's pocket" (whether money or a Mae Westian pickle) that counts, Hesse will be an artist. Her mind is made up.

The urgency of these various reflections notwithstanding, Plath was not to marry for four years, when her choice fell on the poet Ted Hughes. Hesse's wedding to Doyle came nearly ten years after her letter, in November 1961. Both marriages ended in separation, Plath's dissolving in October 1962, Hesse's in December 1965. None of these events (as might be suspected) was to come about without many more—and more rigorous—spiritual exercises and self-examinations concerning the nature of marriage: the bargains it imposes, the price it exacts. Hence Plath on November 7, 1959: "Dangerous to be so close to Ted day in day out. I have no life separate from his, am likely to become a mere accessory. Important to take German lessons, go out on my own, think, work on my own. Lead separate lives. I must have a life that supports me inside."[42] Now Hesse, writing on July 14, 1964: "Am wondering if my reasons for working are all wrong. The need for recognition, praise, is so excessive a need it causes an impossible pressure to live with. My feelings of inadequacy

are so great that I oppose this with an equally extreme need for outside recognition to find some equilibrium. I think it is in everything but greatest in art. Tom can achieve both in the right way, that is he can find himself in his work and then and therefore achieve recognition. With this I then compete, and find no success. No wonder I get anxious."

The reader is referred to Plath's journals for further instances of her inquiry into the psychic and social results of what she called her "inescapable femininity":[43] they are there for the finding, precisely because the journals' pages, dominated as they are by the "twin thrusts of sex and vocation,"[44] were integral to Plath's negotiation of that identity. And when the matter of marriage erupted into poetry, as in "The Applicant," for example, it emerged suffused with particularly brutal irony about the debasement of the wedded state, at least from the wife's point of view:

> A living doll, everywhere you look.
> It can sew, it can cook,
> It can talk, talk, talk.
>
> It works, there is nothing wrong with it.
> You have a hole, it's a poultice.
> You have an eye, it's an image.
> My boy, it's your last resort.
> Will you marry it, marry it, marry it.[45]

To be poultice and image is the wife-toy's function: set against the poetic brilliance of this bleak and jaded picture, the young Plath's fears of becoming "a self-rationalizing uninspired housewife" seem unfounded, but also sadly innocent, a voice light years away.

As for Hesse, further discussion of her journals and marriage comes later in this chapter, yet I give nothing away by saying now that I do not claim Hesse's art was "about" marriage in anything like the way Plath's was—her choice for abstraction worked precisely to short-circuit such a possibility. The point of the comparison at this juncture is its usefulness in the task of de-pathologizing the conception of both authors. It yields a mounting sense of the overlap of their passions and impatience and anxieties, their almost equally exacting demands of themselves and their worlds—a sense that helps to make the sources of those

emotions seem decidedly more objective, less "personal" in kind (even though Hesse's or Plath's responses often seem personal indeed). The privacy and idiosyncrasy of their individual voices, in other words, do nothing to undermine their connectedness to what Betty Friedan, after a decade interviewing young women, would in 1963 call "the crisis in woman's identity." We could crosscut the worried testimony Friedan collected from young women of Plath's and Hesse's age (she did a round of interviews at Smith, Plath's—and Friedan's—alma mater) with the passages above; the two artists-to-be would emerge voicing the concerns of the female half of their generation. These young women recognize their choices as no choice at all; at seventeen, they confess their desire never to grow up. Hence the observations made by Hesse in a note of 1951: "I don't understand life. I'm afraid to die (Helen says everyone is) to get older. I don't know what I want to do when I finish school. I want to be an actress but don't know whether I have the talent." Now a seventeen-year-old girl to whom Friedan spoke in the course of her researches: "I don't want to think of growing up. If I had children I'd want them to stay the same age. If I had to watch them grow up, I'd see myself growing older, and I wouldn't want to. . . . I can't see myself as being married and having children. It's as if I wouldn't have any personality myself."[46] Stopping the clock at seventeen means that the future and its choices can be avoided, and one's mother's mistakes will thus be neither repeated nor corrected.

Marriage, of course, offers a young woman both a threat and a promise: surely she can do better than her mother did, can avoid her errors and her miseries—but if she does not, what then? Both Plath and Hesse were preoccupied (to put it mildly) with what they saw as their mothers' fatal mistakes and failures, and the injuries that had been left in their wake. "What do you do with your hate for . . . all mother figures?" Plath asked in her journal, generalizing for a moment an emotion she usually experienced and expressed with infinitely greater directness: one mother, her own, was her usual concern.[47] With Hesse the terror lay in over-identification, not its opposite: "Mother died, father rejected me and took a competent cold woman. Therefore I feel I am helpless and incompetent—so I am like my mother who was dependent, feminine and . . . sick" (1966). While I will not claim that these emotions are the *result* of the class positions of the four women involved, the responses they aroused, in both cases, were exactly contingent on class. Both Plath and Hesse entered psychiatric

treatment relatively young and stayed in therapy for most of the rest of their lives. They were part of a culture that had long since developed the means to deal with "troubled" young women—or in Plath's apt phrase, "passionate, fragmentary girl[s]." "The psychiatrist is the god of our age," Plath wrote in her journal. "But they cost money."[48] In the case of both Hesse and Plath, the resources were found to provide them with therapy. Olive Higgins Prouty again came to Plath's aid after her suicide attempt in the summer of 1953; she was subsequently treated free of charge at McLean's Hospital because she presented such an "interesting" case. Hesse's care began in January 1954, when she began work with a New York psychiatrist, Dr. Helene Papanek; it was her father, evidently, who picked up the tab. (Later, through an arrangement with her second psychiatrist, Dr. Samuel Dunkell, her therapy was at least partially paid for by the state of New York.)

Papanek's documentation of Hesse's case has come to rest in the Oberlin archive; it communicates in the language with which the psychiatric profession laid hold of Hesse's case, and spells out the terms found to diagnose and treat her. There is, for example, the report Papanek received, early in her dealings with Hesse, from a psychologist, Gertrude A. Brenner. Here is Brenner's assessment verbatim: "Obviously disturbed with what seems at first glance to somewhat schizophrenic [*sic*], has elements which may make for a less negative diagnosis. 'Selective inattention' and elements of the adolescent poseur who frequents the Modern Museum, suggest also terrific anxiety, 'exhibitionism' and the compulsiveness of the brilliant adolescent. There was no withdrawal from communication but she has restricted a good bit of it to 'sending' and not 'receiving.' However she is very enthusiastic about sharing it with the 'silent audience.'"[49] In keeping with her role in her patient's life (and perhaps with the results of her treatment), Papanek would "normalize" this report considerably when in 1956 she recommended Hesse for a scholarship to the Educational Foundation for Jewish Girls. She described a person whose problems added up to mild academic maladjustment: "mentally blocked by anxieties, in spite of high intelligence and a conscientious desire to work and an unusual talent for painting, she has difficulty studying." These were not difficulties, according to Papanek (correctly, as it happened), that stood in the way of Hesse's future: the "prognosis for complete rehabilitation was favorable," the doctor reported.

"She shows insight into her problems and is well motivated for change. She is gifted and ambitious." [50]

Plath's psychiatrist, Dr. Ruth Barnhouse, also wrote a letter of recommendation for her patient at about this time, one that is equally sanguine (though sadly, in hindsight, with less cause) about her chances for recovery from the "state of mental turmoil" that had led to her hospitalization. "She has a great sense of responsibility not only to others who may depend on her, but also to herself and to her integrity. She is extremely quick and sensitive in her relationships with others, and this, combined with her natural intelligent curiosity, leads her to seek experience almost for its own sake. In my opinion she is perfectly capable of handling the difficult situations into which these attitudes sometimes lead her." [51]

By pointing to the measure of similarity in these two cases, I do not mean to override the real differences between them, or to suggest that a clinical review of their psychiatric histories would produce anything like identical results. Yet it is hard to escape the sense, in both instances, of psychiatry as a kind of "social grease." [52] The profession—in the guise of its authorized representatives—is called in to help negotiate the difficult intersection between the young woman and her future: repairing rifts, mending fences, and otherwise making clear that a measure of maladjustment (even sometimes a large measure) is the inevitable offshoot of a lot of talent. The process is routinized, the procedures available, though sometimes harrowing (I am thinking of Plath's painful and inept treatment by electroshock therapy). And not only is the psychiatrist prepared to speak, but the schools and foundations listen. This is a culture in which the psychiatric voice is both familiar and reassuring, working not to keep young "madwomen" in the attic, but to get them the grants and scholarships for which they are otherwise well suited.

Of course that maladjustment finds its own expression in each case, leaving its marks in different actions and texts. Unlike Plath, for example, Hesse was suicidal only briefly, if at all. [53] And as a less practiced and less proficient writer, she was less able than Plath to use the medium to amplify and dramatize her state of mind. Writing is not the sheer source of pleasure to her that it is to Plath: because she turns words to her ends with greater difficulty, though with no loss of clarity, she cannot use them so easily as the means and repository of

fantasy. This is not to say that Hesse's journals, unlike Plath's, represent the incontrovertible *truth* of her world. On the contrary, both represent an experience of a world particularly intractable, even hostile, where issues of gender were concerned, and spell out their urgent need to negotiate its inequities.

Other differences between Plath and Hesse, like the similarities, are a matter of class and ethnicity. Hesse's early schooling—she was sent to the School of Industrial Art—is one of them. Walter Erlebacher, her contemporary at the school, described the rationale behind his attendance there; I have no doubt that it has some relevance for hers. "At the time it was called School of Industrial Art, and it was sort of—I guess more vocationally oriented than fine arts oriented. The theory—like a lot of families, particularly immigrant families—you ought to at least have something you can 'fall back on' in case you don't make it. So I studied advertising design, but I didn't want to become an advertising designer. But I succumbed to that reasoning. It made sense to me."[54] Hesse, for her part, studied window dressing, one of eleven girls among the twenty-four students enrolled in the course. (There were, by contrast, nineteen girls among the 101 students in Advertising Arts, Erlebacher's course.) Then, like Erlebacher, she went on to Pratt, but did not stay. In his view she "couldn't take that kind of discipline," but it seems much more likely that, as the "American Bauhaus," with "no bona fide Fine Arts department" (this is Erlebacher again), the place simply did not "make sense" to her. This certainly fits with the terms of her account to Cindy Nemser years later ("At Pratt they didn't stress painting at all"),[55] and it also coincides with her discovery at about this time in her life that she was an artist. She did not realize, as some other people do, that she wanted *to be* an artist, but rather that she *was* one. The difference is not a mere grammatical quibble. Hesse found both an identity and a name for her difference. "I am an artist," is what she wrote to her father. "I guess I will always feel and want to be a little different from most people. That is why we're called artists."

Hesse had fastened onto one crux of her identity and would hold tight to it until the moment when, threatened by her illness, she realized that she did not have to justify her identity by being an artist. (This idea crops up, remember, in the course of the Nemser interview. To cite the key text again: "One of my first visions when I woke up from my operation was that I didn't have to be an artist to justify my existence, that I had a right to live without being one.")

Another piece of writing—an "autobiographical sketch of a nobody," it dates from about 1954—elaborates the key identification at length. My citation picks up after two introductory paragraphs exploring the writer's sense of the ways her "pretty" exterior belies her interior state:

Furthermore, the nature of experiences in this young life have, as I have recently been made aware of, been extremely out of the ordinary. Now it is said that what befalls a youngster in his earlier states of development moulds and effects [sic] his development from then on. He is aware of being different and at one stage might even enjoy this fate and dwell on his special characteristics. He might confuse this "differentness" with something very special in a positive or negative sense. By comparing himself with others he might attempt to distinguish qualities of his own with those of others. Occasionally they allude to his feeling superior or inferior, very seldom to a feeling of just contentment and satisfaction and with it understanding.

To complicate the matter some, for the last year our friend has shown and developed talent as a painter, a good one at that. Here she confronted herself with the universal questions regarding the artist and his "special temperament." Was it in her being and feeling estranged and different that she could claim the title of "painter." The rebellion presently is a direct outcome of what for the time being she has accepted as the answer. That is that the artist in society, the true artist is paradoxically also the true personal misfit. It is by his very nature of being different that he first finds himself having the desire to create a piece of prose or a musical composition. Now is not the time to discuss the question of the similarities or differences of the arts nor the philosophical or aesthetic questions involved. My view regarding this would admit musical composition and poetry but not the writer of prose or non fiction. Briefly the reasons being that the former are involved with the same abstractions, the same unreal universals only indirectly affecting life and very far removed from actual experience for the creator. That is they are removed from the realities of life he would have to face as being a part of the majority of society. The word majority cannot here be stressed enough.

There was a relatively short period of contentment or adjustment while said person was fully engrossed in his small contained world of paints and canvas. Artistically speaking this is the greater world, the world outside and above daily routine, the ideal world. Extending into the illusionary world of fantasy and dream, enveloped into colors and forms selectively chosen by the master. He too

is not alone in that world but find [*sic*] companionship among the "select" few who also find their worlds among the smell of pigments and turpentine. Some are fortunate enough to maintain and sustain themselves a lifetime within this small and isolated society. They although expected to be the spokesmen, the communicators of reality to the majority, never do they claim this role for themselves. They do attempt communication among themselves but secretly deny and reject the world of their compatriots.

It would presumably be helpful to identify the main ingredients in this thick stew of ideas, what Hesse had been reading in the weeks and months before she wrote out her disquisition. Her ideas have sources; Hesse did not think them up, however well digested they may seem. In her case (unlike Krasner's), the use of notebooks means that we have a few scraps of information along those lines. They are furnished in the form of one of the first book lists she made—the later journals will be full of such jottings, which served both as reminders and as periodic reckonings of the account she kept with herself. This early list is as follows (its date too seems ca. 1954): "Letters to [*sic*] Van Gogh, Gaughin [*sic*] Noa Noa; Leonardo da Vinci diary; Delacroix diary; Museum without Walls, André Malraux; Guy de Maupassant; The Life of Benvenuto Cellini."

With the exception of Malraux and Maupassant, this is a list that dishes up some obvious sources, all required reading for the notion of the artist as misfit/ outsider. Hesse apparently (thankfully) encountered the myth at its origins, imbibing direct the musings of her fellow artists, in keeping with her notion of isolated beings attempting "communication among themselves." But even if these notes had not survived, it would not be difficult to provide her idea of the artist with its contemporary intellectual underpinnings. Hesse is writing, after all, in America at mid-century, a country whose key imagery endlessly opposed the idea of the rebellious individual and the conformist crowd, the action painter and the organization man. This is the moment when, according to Lionel Trilling in *The Liberal Imagination* (1950), "Edmund Wilson in his striking phrase has formulated for our time the idea of the characteristic sickness of the artist, which he represents by the figure of Philoctetes, the Greek warrior who was forced to live in isolation because of the disgusting odor of a suppurating wound and who yet had to be sought out by his countrymen because they had need of the magically unerring bow he possessed."[56] Now look back at

Hesse's vision of the artist's breed: "They although expected to be the spokesmen, the communicators of reality to the majority, never do they claim this role for themselves. They . . . secretly deny and reject the world of their compatriots."

Trilling, it should be said, was well aware of the mythic status of the concept of the neurotic artist; indeed his essay was written to argue against the wholesale acceptance of the term. Yet he conceded that the myth might have its uses—particularly for the artist himself. "By means of his belief in his own sickness, the artist may the more easily fulfill his chosen, and assigned, function of putting himself into connection with the forces of spirituality and morality; the artist sees as insane the 'normal' and 'healthy' ways of established society, while aberration and illness appear as spiritual and moral health if only because they controvert the ways of respectable society."[57] Hesse, it is clear, certainly believed in her own difference—and sometimes, indeed, in her sickness. That belief, I am claiming, was one requisite—if not, indeed, a prerequisite—of her adoption of the artist's identity.

There was little that Hesse encountered during the three years she spent at Yale to change her opinion. The lists of books grew longer and more varied—Gide, Dostoyevsky and Joyce, Austen, McCarthy, and McCullers—and now there were lists of words and definitions to accompany the names and titles: "profligate, inveterate, agrarian, attrition, rabid, obsequious, autistic."[58] She took aesthetics with Suzanne Langer and began her study of art history with the Renaissance: "I felt I would start firstly with western art since I am from the west, this is my culture and a source from which my work will grow. There is I believe a continuity and form of logical sequence in art."[59] Her papers in the history of art—she also took Ancient Art with Vincent Scully, and began, though seems to have dropped, a course taught by Robert L. Herbert—won high marks, but only with a struggle: "I work hard and try hard in other courses; but the constant doubts, fears and frustrations concerning the history of art courses persistently haunt me."[60] With this remark one can only sympathize.

At the points where one can see Hesse entering more deeply into her studies, a more detailed picture emerges. Even the titles of her papers transport us to a quite specific milieu: "Comparison of Two Greek Vases and Other Works of Art from the Point of View of Silence," "The Function of Form, Line, and

Color, As Seen in Giotto and Simone Martini," "Humanism As Seen in the Figures of Donatello, Masaccio, and Fra Filippo Lippi." At some point she had a long session with Robert Goldwater's *Artists on Art* and ended up copying out a page and a half of quotations. She was most drawn to Picasso's pronouncements—they read like articles of faith.

> Through art we express our conception of what nature is not.
>
> Whenever I had something to say I have said it in the manner in which I felt it ought to be said. Different motives inevitably require different methods of expression.
>
> An idea in painting must be translated into form and when a form is realized it is then to live its own life. Interpretations are literary, blind people with theories. An art form (cubism) must keep within the limits and limitations of painting, never pretending to go beyond it.
>
> In the old days pictures went forward to completion by stages. Every day brought something new, a sum of additions, for me today it is a sum of destructions. What I took away from one place turns up somewhere else.
>
> Not stages but metamorphoses of a picture.
>
> There is no abstract art. You must always start with something.
>
> There is no figurative and non-figurative art. Everything appears to us in the guise of a "figure." Ideas even in metaphysics are expressed by means of symbolic "figures."
>
> One is not conscious nor intends to invent. One simply "expresses what is in us."
>
> A painter paints to unload himself of feelings and visions.

Inner feeling and vision and the symbolic "figure" and self-expression: add to these key dicta a few parallel adages from Braque ("Nobility grows out of contained emotion"; "Emotion is the seed, the work the flower") and two or three precepts borrowed from Maillol and Matisse, and we can say with some confidence that the outlines of a intellectual biography have begun to emerge. Years later, jotting down a bon mot cooked up by her friend Sol LeWitt, "Art failure is heart failure," Hesse remained true to these same assumptions concerning the artist's self and art. This is not to say, however, that she disputed none of the assertions with which she was faced. She read Bernard Berenson's *Italian Painters of the Renaissance* and in this case coupled her transcriptions with her objections.

For example, when Berenson declares, "An object to be life enhancing must be one with which we can not only identify ourselves, but identify ourselves more easily, completely and happily than we do in normal conditions," Hesse responded with tart and decisive rejection: "I feel this is narrow, dated, and probably more than dated—it never really was so. Sounds like a soap opera." And to another piece of vintage Berenson, "Art is ideated sensation, not actuality," she put the slightly muddled question, "Why cannot this idea be carried into the realm of imagined images as well as from reality?" Despite its lack of clarity, this is a question that asked Berenson to consider the case of images that depart solely from the mind, rather than the real, come from fantasy, rather than observation; this is a task he was notably loath to take on.

Hesse's main quarrels with Yale doctrine, however, concerned not its liberal humanism—on the contrary, that was her meat and drink—but the ways she felt those notions were not sustained by the system of painting taught at the school. She was, as she told the story, Josef Albers's "little color studyist."[61] A fellow student at Yale, Mark Strand, was later "immediately" able to bring to mind, according to Rosalind Krauss, "the air she often had of an obedient schoolgirl, the one that had made her a star in Josef Albers's class, far and away his favorite pupil."[62] Yet Albers "couldn't stand" her painting—this is Hesse again—nor she his. This was because, as she later said, her obedience was belied in practice: she "had the Abstract Expressionist approach"—her shorthand (and that of the culture) for the constellation of beliefs we have been discussing. While still at Yale, she outlined the issues at greater length (the context, significantly, is a letter to her psychiatrist):

I procrastinate and worry. I am anxious. Partly I am never at ease due to the nature of my artistic work. I am not rebelling in painting against the ideology of the school but I search or what may be called drift from one quest to another. I can't take what to me is the easy way, since I believe it almost requires a formula, practiced by the so-called Yale proficient painters.

They don't approve of experimentation, search, freedom, or any form of expression. "Painting is from the mind, not the hand," this is Yale Law. You are to develop one way, perfect one idea; and experience this idea with slight variations on a theme. It is an academy as was those that all modern painters of an older generation than myself complain of, as for example that they drew plaster casts

and then progressed to plaster casts [*sic*]. Discipline I approve of but it is difficult to accept when it is imposed by one person, himself a painter who has come to believe fanatically in his own interpretation of what makes art, via a highly individualized, pure, theoretical art.

I can't continue discussing this now. . . .

I feel next year to be a challenge, as I face the mighty king in person, Joseph Albers. On the other hand I feel I should not come back at all.[63]

She did go back to Yale, and duly received one of the thirty-five Bachelor of Fine Arts degrees awarded in June 1959.[64] Twelve went to women that year, but there were only four women among the crop of twenty-three new M.F.A.s. (As will surprise no one familiar with the architectural profession, there were no women at all in either the B.Arch. or M.Arch. programs.) To let Hesse be swallowed up in these few figures, at least for a moment, is to see her career in the context of the classic "pyramid effect," as that concept traditionally describes the experience of women in higher education, where the pinnacle of success—in this case, teaching at Yale—is reserved for a disproportionately small percentage of those starting out. And while we might say that Hesse, who taught at the School of Visual Arts in New York during the last two years of her life (she also lectured at Oberlin and the Boston Museum School), got close to the top of the heap (that is, if her annual salary, $4,608 in 1969, did not make that term seem like a joke), acknowledging her eventual success in no way restricts my claims concerning the context and content of her schooling.

Was it a good education? "In retrospect," said Hesse, "I don't think I should have stayed." She did stay, even though sticking it out meant inhabiting a paradox on a more or less daily basis. Still a very young woman—Hesse turned twenty during her first year at Yale—she was engaged in the process of sorting out her identity as a female and a professional, a process that, once seriously begun, does not usually come to a definitive end (at least this was the case in the 1950s). At Yale Hesse kept asking horrible, inescapable questions: "Am I a woman? Are my needs for developing artistically and intellectually incompatible? Am I incapable of satisfying a man's need of supremacy? Must I take an actor's prompting from a director? Is my role to be there when a man wants me? Why am I a masochist and Bob a sadist? Why is he so domineering and need the spotlight on him all the time? Why is he so critical, cutting and arguing all

the time about my behavior? If he is so sick, why is he, or how can he be so well at the same time? Also his view is not isolated or unique, must the man then be an artist?"[65] These are all good questions to ask, even if they have no very good answers: the fact that she asked them in the context of her relationship with her psychiatrist—the passage is taken from a letter to Dr. Papanek—suggests that Yale was a place where it was easy for the sensation of difference to masquerade as neurosis. But it is also a measure of the usefulness of psychiatry to Hesse—of which more later—that it provided her the means to begin to separate the objective from the neurotic, above all where Yale and men were concerned. Hence one further passage from a letter to Papanek, this one written a month after the passage just cited: "For some strange reason I find myself really afraid of the men here at school, in general, not any specific male. Some of the feelings I have seem logical to me, not neurotic, as they have strange attitudes to the few women that are around school. In a sense they take great advantage of the women, and this feeling [this realization] is new for me."[66]

A Yale education meant learning to state, if not to solve, one's problems as a woman: the paradox comes when we realize that these skills were not exactly part of the curriculum. At Yale there was practically no such thing as a woman artist—except those enrolled in the classes, that is. If they were *becoming* artists (big *if*), they certainly had not yet arrived. Women did not crop up anywhere among the scores of painters quoted in Goldwater (even though the manuscript was scrutinized by Louise Bourgeois "from the point of view of the contemporary artist"), or in Berenson, or in John Canaday's *Mainstreams of Modern Art*—or, from what I can see, in any of the other reading Hesse did at the time. They did not figure in the lectures of Scully and Herbert and the rest. There was no woman mentioned as teaching in the studio, and no woman on the list of sculptors (she called them "sculptures") Hesse drew up in a notebook; Hans Uhlmann, Reginald Butler, Alexander Calder, Naum Gabo, Alberto Giacometti, Julio González, David Smith.[67] Not a bad list, all in all, though it certainly also seems a document of period taste. The point is not just that Hesse had readily available no models and identifications (I do not expect this circumstance to strike readers as a revelation), but rather that the examples on offer caught her in a contradiction from which there was no exit. It is a moot point whether Plath's effort to make sense of the suicides of Virginia Woolf and Sara Teasdale and "the other brilliant women" should be seen as a better or worse route to

artistic identity than Hesse's. For the one—Hesse—there was no plot to learn or character to get up, except in travesty; for the other, there was all too much plot, and a stock ending to boot. The only thing Plath seems *not* to have learned at an early age about Woolf is that she had had stones in her pockets when she waded into the River Ouse. (This was not a precaution Plath thought to take when as a teenager she failed in an attempt at death by drowning.)

For Hesse the possibility of identification with another female artist came only as the result of fieldwork, we might say—as one offshoot of the extended practicum that began belatedly once she left Yale for New York, and then recommenced when she returned to New York from Germany. And what she learned and reacted to about the women she encountered concerned the details of their practice above all. She came away from visits to the studios of Lee Bontecou and Marisol amazed at what each could *do*. About Bontecou she wrote "The work involved is what impressed me so. The artistic result I have seen and know. This was the unveiling to me of what can be done, what I must learn, what there is to do. The complexity of her structures, what is involved, absolutely floored me" (December 1965). Her response to Marisol, though less enthusiastic (she criticized the work as too much on the surface, and thus without mystery), has a similar cast: "Marisol does all her work herself. She will try anything. Experiment with any media, incorporating all things" (late 1965).

Yet if what interested Hesse about Bontecou and Marisol was the actuality of their practice—almost as if she was verifying their labor as a bodily fact—those observations could nonetheless be affirmed without anything else that she knew about art or artists demanding the least adjustment. Why change her views? Like Plath, she kept her identities as artist and woman at arm's length as she began her career: the trick was to be both. Nothing about either their ambitions or social and cultural experiences, moreover, particularly encouraged the resolution or unification of those roles. Those changes would have to wait for a later phase of their experiences; even then the two identities would not be entirely resolved.

How to Read Hesse's Journals

An honest answer to the question of how to read Hesse's journals must first admit that it is exceedingly difficult to do so. They have not yet been published

(though an edition is planned) and so must be consulted on aging microfilm; concern for their conservation means that reading them in person is necessarily a privilege granted relatively few. The project of seeing them into print, moreover, will encounter the stumbling block of their physical character: Hesse's handwriting varied wildly from day to day and year to year, and the results are sometimes enough to try the patience of the most resolute paleographer. The question of which notebooks ought to be published will also have to be faced, since a selection will inevitably have to be made. This is because Hesse's ways of using her notebooks were just about as variable as her penmanship: some books have the character of appointment diaries, lists and reminders that are only occasionally interspersed with more extensive comments. Others—particularly the notebooks written between 1964 and 1966—functioned as much more substantive repositories of Hesse's responses to her daily life. The appointment books certainly communicate just how busy Hesse was for much of the time—the days that went by during her illnesses are poignant in their very blankness—but they do not make fascinating reading.

All this means that the diaries are now known to most readers only in excerpt. Thus the issue of *how* they have been excerpted necessarily raises its head. What kind of work, exactly, have the diaries been asked to do in the making of the public Hesse? The question of course demands its complement: What tasks have been left undone? Or perhaps better stated, have elements of Hesse's work and persona been left unnoticed as a result of the process of selection? Does their absence make any difference to an understanding of her art or life?

Hesse's journals have been read closely and excerpted for public consumption on three principal occasions; in each instance, they have been used to similar ends. Lucy R. Lippard in her 1976 book, Ellen H. Johnson in a 1983 article (a kind of spin-off from work on Hesse for a 1982 drawing show), and Helen A. Cooper in the Yale catalogue each mined the journals for mainly biographical purposes. Each used them to map growth and insecurity, to document friendships and experiences and reading, to conjure into being the person Johnson and Lippard had known, and Cooper wished to have known. And as befits a case where "art and life" are held to be one, the resulting biographies are meant to bolster interpretation of Hesse's art—even to determine it. They have done so.

Of the three writers, Lippard seems most aware of the potential dangers in the overlap between criticism and biography. She is careful to refute biographi-

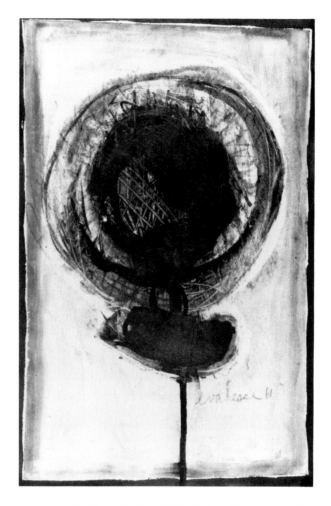

FIGURE 64. *Eva Hesse, Untitled, 1961, black and brown ink washes, gouache, crayon, and pencil, 9 × 6 in. (22.9 × 15.2 cm.). Ellen H. Johnson Collection, on loan to the Allen Memorial Art Museum, Oberlin College, Oberlin, Ohio.*

cal criticism as the sole and necessary response to Hesse's art, and equally careful to admit that she herself, as Hesse's friend for several years, was not in a position to provide anything else. Yet oddly enough, her scruples do not really keep her readings from becoming reading in. The issue comes to a head early in the book, around the group of drawings Hesse made in 1960 and 1961—works like the sheet illustrated here as figure 64. Lippard calls these pictures "ominous, al-

most gothic in their character, though frequently leavened by a particular humor." [68] This terminology packs enough of a punch to give Lippard pause, to prompt her to justify its use as inevitable: "It is impossible not to write about these works in anthropomorphic, sometimes surrealizing terms; they are inherent in the work as well as in my sense of the character of their maker. Because of Hesse's total absorption of herself in her work, one reads the work as one read the person, not in a gossipy or personally associative so much as in an archetypal manner; in that sense this interpretation could be arrived at by someone who did not know the artist at all. In fact, those who had no personal contact with Hesse know more about her than they realize, for to reach out to her work or to be reached by it is to be in touch with her most profound aspirations." [69]

So the work is the person, the person the work: anyone would see and say the same. There is only one fly in this ointment: it is a problem raised by the responses of Donald Judd and Brian O'Doherty to just such images. Each reviewed Hesse's first show, a selection of drawings hung in April 1961 at the John Heller Gallery. Not knowing the artist, Judd called her pictures "capersome," and O'Doherty declared she had a "gnomic capacity"; neither apparently felt prepared to hazard a further opinion as to what her drawings' capers and aphorisms might be about.

Hesse's journals and their uses have meant that it is no longer possible for viewers "not to know the artist"—or at least, not to *feel* they know her, and to prepare themselves accordingly when looking at her art. But knowing her means knowing a version of her: the one the excerpts present. Inevitably this will be a story made up of extremes: moments of exaltation and depression and frustration and doubt, occasions and emotions worth writing about, and worth quoting, the aspects of a life deemed adequate to its representation. What else would we expect? Yet it is hard to escape a sense of a certain teleology at work in these readings, as for example, when Ellen Johnson comments, following a recital of the most harrowing facts of the artist's life: "The Eva Hesse revealed in her diaries is as psychologically disturbed as one might expect from such a biography." [70] Just exactly how disturbed is that? one cannot help wondering. And when selections have to be made and a passage trimmed for reasons of economy, some principle of editing needs to be adopted. Often in the case of Hesse it is a principle that privileges a notion of a life lived on a sharp emotional

edge. Let me cite for example an entry in Cooper's chronology that presents such an edited passage; I include both the introductory comment and the journal entry that follows:

> September 1958: returns to Yale on a scholarship, but continues to find painting difficult in an academic environment, and social pressures distracting.
>
> Sept. 9: "People are returning constantly and show up in the apt. and I meet them in the streets and school. There is eagerness and apprehension . . . I can't seem to feel comfortable enough at the studio to paint . . . I hope I will be able to refrain from the competitive involvements, the exhibitions, prizes and so forth. the less pressures and strains that personally effect me the more relaxed and thoughtful can my powers be directed to thoughtful meaningful work. Too bad I need any of this type [of] attention to sustain ego. I will try hard to abstain from these needs." [71]

Now the same passage, with the two omissions restored:

> People are returning constantly and show up in the apt. and I meet them in the streets and school. There is eagerness and apprehension in what they say and generally excitement flows from them. I can't seem to feel comfortable enough in the studio to paint, since I will have to move to where I will be assigned next week.

There is, I realize, a difference of only twenty-four words between these two passages, but the implications of those words are significant. Reading the diary uncut, we can see that the "eagerness and apprehension" are those of Hesse's unnamed visitors, and that she finds their company tonic. And as for her discomfort in painting, the problem is not so much the "academic environment" as the more purely pragmatic difficulty of getting down to business with a change of studio just over the horizon.

Am I splitting hairs? My aim is to demonstrate, not malice aforethought, but the way in which the choices made in letting Hesse "speak for herself" can privilege an image of psychic distress. What gets left out, as in this instance, is context and explanatory detail—the kinds of information that might be used to ground and justify emotional response. Likewise there are whole categories of

writing that are always excluded: notes about finances, for example, or the projects Hesse drew up for use teaching art to children, one way she paid her bills. These were sometimes elaborated in detail in the journals—we have even inherited the nitty-gritty of her lesson plans as vetted by her supervisor. Is it inevitably less interesting to encounter Hesse holding down a job or worrying about money—doing the numbers, totting up her expectations from this source or that—than it is to meet her fuming about the inequities of marriage or acknowledging that she does not want to sleep with Sol LeWitt because he reminds her of her father? No doubt—but both kinds of information have something to say. Hesse may have fumed and worried, but she kept her life afloat.

These nips and tucks in the diary are not, let me hasten to say, omissions on a par with the surgery performed on Plath's journals (the comparison will not go away) by its editors, Frances McCullough and Ted Hughes: "excessive" violence and politics and bodily illness and sexuality were all cut out of that text, as were simple expressions of well-being and ability to cope. The result quiets ambiguities of motive and meaning, at the expense of Plath's character and to Hughes's benefit.[72] In Hesse's case there are no such direct interests to be served; Doyle, though never legally divorced from Hesse, apparently gave up his rights to her estate in April 1969, when she first became ill. (Doyle's position was thus importantly unlike that of Hughes, who became Plath's heir and executor at her death since she left no will.)

Hesse's journals have been read by friends and would-be friends, who have taken from them the story that, by their lights, most needed telling. And like most editors they have stripped that story down to its most dramatic and decisive lineaments. I do not question that the journals are a repository of Hesse's anxieties. On the contrary, this was their main purpose, though not the only one. But I believe that certain consequences follow from this recognition. We are not required to subtract from the journals their status as writing, to make them the transparent registry of Hesse's anxious state of mind. As writing they are more purposeful than transparent; they have work to do, and an audience— indeed, more than one—in mind.

Hesse's notebooks imagine two audiences. Initially there is the writer herself, a person most often named directly as "I" but sometimes also addressed as "you" or "Eva"; sometimes the book itself is figured as "you," with the ambiguity that results serving the writer's purpose. For example, as she begins her first journal:

"I open my new book. What will you tell for the next year." Or: "I very much want certain things from my life and am willing to work hard and struggle much to get them. I want happiness. I must define these terms as Eva uses them." The second person singular is of course the tool of self-assessment; the distance it imposes opens the way to self-accusation, though one that rarely reaches the depths of Plath's berating of herself: "you are crucified," "you are wallowing," "you are not sure."[73] "Eva," by contrast, is a term with a positive meaning, a whole identity: "Eva" is the person herself, at her best, in full control.[74] (For Hesse completeness is a term of value when applied to women; its opposite is "nothing" or "zero" or even "total zero." In these instances absence is an absolute negative, a usage that makes specially poignant her eventual use of "nothing" to name her artistic aspirations.)

Hesse's address to these various selves is the product of the essentially therapeutic project of the journals—a project that becomes even more explicit once the artist enters therapy. When this occurs—indeed, there is reason to believe that the journals are begun, or at least continued, at her therapist's instigation— Hesse begins to understand the therapist, Dr. Helene Papanek, as her diary's second audience. This is an understanding, moreover, that eventually puts her view of the journals—above all, their inclusions and exclusions—in its own particular light. Here is a passage written on September 9, 1958: "I wrote to my doctor today. It's hard to relate anything of the letter or content, since indirectly anything written here is addressed to her. You see anything I could feel or think was to be spoken of with Dr. Papanek." There is no need to discuss her therapy with Dr. Papanek, Hesse is suggesting, because to do so would only mean wasted effort: anything in the journal is already destined for her ears, by virtue of its appearance there.

Understanding the journals as part of a therapeutic project helps to explain their contents even further. This function applies to more than the transcriptions of dream scenarios and the list made before and after the session ("Doctor said: 1. . . . 2. . . ."). I am thinking particularly of the kinds of writing they do *not* contain: they are above all not descriptive of things in the world. There are no landscapes or artworks or stupendous meals that get recorded; Hesse does not use her words to store visual information or bodily sensation for future use or scrutiny. And if she weaves a narrative—telling the story of her father's fu-

neral, for example, or the opening in Kettwig, or a visit to a museum—she seldom records a direct encounter with objects in the world. A rare exception was her father's coffin: "We saw the limousine. My father was in a coffin. There was burlap covering a huge crate. long. a box in a box. looked like a Christo without ropes. A Indiana stencilled on burlap. 'Riverside Chapel' NYC" (August 1966). And she does describe a Lucas Samaras seen at the Whitney: "The Samaras I loved was a box covered with pins, cover slightly ajar with bird's head forcing its way out from under cover. Old cords and rope dropping out from under cover. The piece sits in a plexiglass case" (spring 1966). These descriptions may be notable for their content (the references to the coffin "as art" impose a useful distance on the sight, while the response to Samaras involves identification or likeness), but they may be more remarkable for their sheer rarity (I shall not invoke Plath yet again for comparison, but will urge readers to think of other journals they may know). Hesse's writerly focus almost never shifts from the self at the center of her perceptions; there are few objects in this view and only one main subject. When Hesse came back to these pages, which she certainly did, numbering them retrospectively and occasionally adding comments, it was to find in them the record of her responses and resolutions over time.

To see the journals as the record of an ongoing process of self-scrutiny, however, is as yet to say little about their tone. For example, they are often written in the present tense, in brief staccato bursts: "Today is problem day again. Everything has been upsetting" (May 5, 1959); "I must win over my troubled self" (also May 5, 1959); "You are an adult, do as you see right" (early 1960); "Feel better. Why are my emotions so unpredictable, changeable, and so exaggerated in importance?" (January 19, 1960). The sense is of someone frequently taking her emotional temperature and recording the results as assiduously as any nurse—albeit a sometimes skeptical one: hence the question "Why are my emotions . . . so exaggerated in importance?" Or again, following the observation "I seem to need therapy more and more" comes the wry sentence: "I am not thoroughly convinced that I am as confused about my emotions as I claim to be." When the mood shifts, it is toward the future and the conditional, as the artist makes plans to re-form herself: "I will abandon restrictions and curbs imposed on myself. Not physical ones, but those restrictive tabs on my inner being. I

will paint against every rule I or others have invisibly placed. . . . I should like to achieve free, spontaneous painting delineating a powerful, strong structured image" (October 28, 1960).

One way to describe Hesse's journals—and so to see their function—is to focus on this evidence of their immediacy. It is an index of purposefulness. The notebooks seem to act as a tool or device to which Hesse has prompt recourse as she experiences and diagnoses her reactions: when in 1967 Sol LeWitt gave her a ledger-sized volume, she could not use it comfortably because it was too big to be taken "into the field." (She preferred cardboard covers with a spring binding.) Employed under these conditions, pen and paper become the repository and vehicle of feelings that grip the writer *as she writes*, and hence may change even while she is tracking them: the journals thus seem to have functioned as a means of managing, as much as investigating, the self. They are artifacts of an individual more than usually obsessed with the conditions of her personhood: measuring adequacy or weakness, evaluating relationships, laying plans, issuing directives. Here Robert Smithson's view of Hesse comes to mind: "She had no external notion of a world outside of hers. I saw her as a very interior person making psychic models."[75] One way to understand his phrase is, I think, in relation to Hesse's work with her notebooks: there the "psychic models" were built and periodically (frequently) retooled. And as a result, Hesse could get on with the business of her life.

One kind of writing in the journals has not yet been discussed: the notes Hesse made to keep track of her reading. These rarely go further than to list author and title, although in the case of a movie seen or a play attended a brief judgment is sometimes appended; it often involves noting which of the characters she most identified with—Lenore in *Fidelio*, Andromache in *Tiger at the Gate*, Cathérine in *Jules et Jim*, and so on. (Hesse seems to have fed herself on a diet of middle- to highbrow culture. In the late 1950s a friend had to explain to her who Elvis was—was she the last to know?) In all cases, though, her lists' long columns seem to mimic the layout of an accountant's ledger, and the sense of a tally being reckoned is very strong. Hence, while their content is cryptic and their form terse, the lists do not seem fundamentally different from the other writing in the journals. Hesse, that is to say, seems to tack back and forth between two different kinds of stocktaking, measuring her adequacy on two different fronts. And it seems significant that at just the moment when her reading

notes are at their most discursive—while she is in Germany, she copies out passages from Simone de Beauvoir's *Second Sex*, Mark Twain's *Innocents Abroad*, *Cinema Magazine*, and Alexander Trocchi's *Cain's Book*—she is also using the journal to keep closest tabs on her emotional state. Self-education and introspection: these two fundamental aspects of Hesse's personhood, that is to say, are bound together in lockstep. They form two phases of a single process.

Hesse writes so much in her journals between 1964 and 1966 because she is unhappy; their project through these months is accordingly at its most intensely therapeutic. The pages track her view of her marriage and artistic identity once those two quantities have been transplanted to an unfamiliar context, the floors of the Kettwig factory loaned the couple by Doyle's patron, F. A. Scheidt, where they lived and worked. Formal therapy having been left behind in New York (Hesse was by this time working with Dr. Samuel Dunkell), the journal was its stand-in, a writing rather than talking cure: "I must write, my sanity is involved. I cry and cry, the pages are wet. I have no one, to go to and the edge of hysteria and insanity is not far apart" (October 19, 1964). The limit of its efficacy is reached in the course of the time abroad—Hesse eventually declares that she must go back into therapy ("I have no choice left but to seek help. I can not longer make it without")—yet by that very declaration seems to confirm the journal's role as its surrogate. She acknowledges, for example, that she writes about Tom "when I am forced to by hostility I can not exhibit outwardly"—as she would have done in the context of a therapeutic relationship. Hence, in keeping with their purpose, these pages in particular are filled with still other lists: "Possible Fears. Fears of desertion, death, sickness, poverty. but these are universal. it is more personal like the daily fears of—being a lost small nothing without abilities, without courage, without distinction, without—. The fear of 'Big Daddy' saying 'no' you are wrong, you are bad. But nothing I can account for can account for what I constantly go through" (March 7, 1965). Or again: "My gripes against Tom. Indecisive, mishandles practical problems. or rather doesn't handle them at all, refuses to plan, when alone completely so non communicative—when with others a 'show-off,' unpredictable where others are concerned. disorganized—refusing to handle ordinary necessary living problems. leaving me with a constant fear of things going wrong, not knowing from day to day. A contradiction to this is his ability to be 100% responsible in his jobs, to his sculpture and to his books. He gives

of himself to these things, but totally" (March 7, 1965). In each of these last two cases it is possible to pinpoint the moment when, while writing, Hesse assumes the role of the therapist who interjects a question to solicit, on the one hand, fewer generalizations, and on the other, a more balanced picture.

The instances of intense self-scrutiny, moreover, often seem to be accompanied by their opposite, in the form of more purely "informational" notes: they are followed or preceded by discoveries—of the great qualities of plaster as a medium, for example, or the insightfulness of de Beauvoir—which could serve, if not entirely to cancel anxiety and dismay, then at least to relieve them. Take for example the jump in tone and mood of these two entries, written only hours apart, on February 19, 1965. First comes a lament: "No longer know what to do, or I never have. I tried to hold my own for Tom's sake, and naturally my own. However I mostly feel for myself I would be better off if I *gave in*." The mood could hardly seem more desperate. Yet following directly on the heels of this entry is a long quotation from *Innocents Abroad* that Hesse transcribed later that same day: what is remarkable is not the appearance of a literary passage at this juncture (even though it demonstrates that she has not yet "given in"), or her interest in Twain, but the vast gulf between Twain's exuberance and the utter despair of a few hours before:

> "What is it that confers the noblest delight? What is that which swells a man's breast with pride above that which any other experience can bring to him? Discovery! To know that you are walking where none others have walked; that you are beholding what human eye has not seen before; that you are breathing a virgin atmosphere. To give birth to an idea—to discover a great thought—an intellectual nugget, right under the dust of a field what many a brain plow had gone over before. To find a new plant, to invent a new hinge, to find the way to make the lightnings carry your messages. To be the *first*—that is the idea. To do something, say something, see something before *anybody* else—these are the things that confer pleasure compared with which the pleasures are tame and commonplace, other ecstasies cheap and trivial."

I do not wish to seem to be claiming one aspect of Hesse's personality as somehow more authentic than another, nor do I mean to imply that her moods

were less than genuine because they were changeable. My argument aims to explain why she paid those moods such relentless attention: to explain, in other words, the purpose of her journals. I have tried to show that the notebooks were tools in a process of self-scrutiny that for Hesse seems to have been commensurate with the business of being a person. Emotions, motivations, responses: all were to be endlessly assessed, while other records were kept to register growth in different areas. (Hesse, by these lights, fits the art critic Gene R. Swenson's 1966 definition of the typical character from Godard and Truffaut: these are people who were "more likely to know why they are doing something than what they are doing."[76] Both directors, let it be said, were among Hesse's favorites; Swenson likewise was among the critics whose interest Hesse most appreciated.) The notebooks were about functioning, rather than dysfunction, the work of a person to whom taking stock and keeping count were ways of keeping going. And facing despair evidently brought its own pleasure: exuberance could follow promptly in its wake.

Two inventories in the journals give these concerns their most graphic illustration. One is a reckoning of Hesse's waking hours tabulated in spring 1965: this list is titled "A day," with these two words fenced off in a tidy little box (fig. 65). Beneath the heading the time is counted off, as if to grasp the logic of its passage: "8–9 dishes wash; 9–10 shop; 10–11 letters; 11–1 studio; 1–2 lunch; 2–6 studio; 6–8 dinner, etc.; 8–12 reading, letters." Then the total, "(16 hrs)," and in another box, "for myself 10 hrs." And a final question: "I should make it on that! no?" The second list is even more literally graphic (fig. 66): it adds up seven months' work in sculpture, from September 1965 through March 1966. Though drawn on a page of a German-made planner, it counts only work done after Hesse's return to the United States: there are eleven pieces in all. Each one is summoned by its drawn image, a symbol that betokens its literal existence and the way she has spent her time.

In offering these two lists as emblems of the purpose of Hesse's journals, I am proposing them as images of the kinds of exercises performed there. They are calculations of identity, personal and artistic, by an individual constantly taking stock of her claim to selfhood and artistic success. If the persistent anxieties bound up in this process are here boiled down to the question "I should make it on that! no?" they are present nonetheless. Lodged in the quick shift of mood

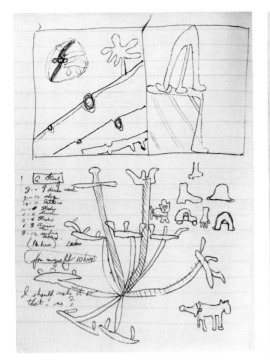
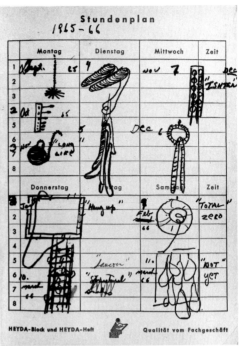

FIGURE 65 *(above, left). Eva Hesse, Page from a notebook used in spring 1965, pen and ink on lined paper, 8¼ × 5⅞ in. (20.9 × 14.9 cm.). Allen Memorial Art Museum, Oberlin College, Oberlin, Ohio.* FIGURE 66. *Eva Hesse, Stundenplan, page from a notebook used in 1965–66, pen and ink. Allen Memorial Art Museum, Oberlin College, Oberlin, Ohio, gift of Helen Hesse Charash, 1977.*

between injunction ("I should make it on that!") and question ("no?") are the inevitable worries about the trade-off between artistic engagement (what she does "for herself") and wifely commitments. The second list, however, can be read as answering "yes" to the "no?"—as does all of Hesse's work. The journals, we might say, safeguard Hesse's ability to work. As time passes, work more or less replaces them. The claim, therefore that their contents provide a complete or adequate image of Hesse's life is an assertion unseated by an analysis of their function. They image, not the self, but how the self was worked on—two different things entirely.

Several pieces of evidence, moreover, suggest that Hesse grew rather comfortable with an image of her tragic life and history: it may have become more image than experience. It is certainly the case that she considered her background one

source of her strength as a person, the catalyst of an ability to get on with things. By the time of the interview with Nemser, she even had enough distance from "tragedy" to glamorize the past, as well as to exaggerate it. "I think my family is like the Kennedys," she said; "I mean we didn't have that extreme wealth or fortune but it has all been extremes."[77] The door is here left wide open for us to attribute to the Hesses some Kennedy-like style and success to go with their disasters. And likewise, the absolute extremity of the statement "There is nothing normal in my life" invites us not to take it at face value. By this point, Hesse is manipulating "tragedy" rather than living it. (I say this well aware that she was soon to have the last of three operations for her cancerous tumor. That Hesse's death was tragic was not for her to say.)

Earlier in her life, even as she was going through one of the most difficult periods of self-evaluation, in 1966, there is evidence to suggest that Hesse consciously preferred—even found psychically necessary—her anxious experiences of life. It comes in the form of a reflection on the differences between her and her "healthy" sister:

> Truly incredible! Even though I am and know I am unhappy, I can and must evaluate at times and make value judgements. What I witnessed, saw, heard, and observed I can't admit exists, and it is my sister. [Hesse had just spent some time at her sister's house in New Jersey.] I come from same environment that she did. I dare say we took different roads in which to be miserable. They just don't know the miserable lives they built. They really don't know. It's the most total believable lie [sic] in which they bury themselves with things and buying + food + clothes + dogs + sports + cleanliness. Keep the exterior clean and phoney and you never never have to look inside or around at the ugly dirty world outside.[78]

Hesse's self-scrutiny, we learn once again, is a means of coping with "environment"—with the inheritance of the past. But it is also the measure—even the proud badge—of her "difference," the difference, we remember, of being an artist. Hesse needed her anxiety, we might say, to keep her insides clean. It was more constitutive than tragic: it was the guarantee of her artistic self. Seen in this way, Hesse's journals have everything to say about identity, and considerably less to say about art.

A Marriage in the Sixties

One small measure of the distance American women traveled in the years after the Second World War is the gradual disappearance of the obligatory tag, in an article or review, giving an artist's married name. Even though Eva Hesse was checked into the hospital during her final illness as Eva Doyle, she was not referred to publicly by that name, or as Mrs. Thomas Doyle. (The one exception was in Germany, where she was sometimes called Hesse-Doyle.) This does not mean, of course, that the tested rule of marriage between artists was not here observed as a condition of female advancement. It had its advantages, as did O'Keeffe's union with Stieglitz: remember that Hesse's first one-person show happened at Doyle's gallery, Allan Stone, in 1963, and that she met Lucy Lippard, one of the first critics interested in her work, through Doyle as well. (This was back in the days of the Bowery Boys, as Lippard dubbed their group of friends; she remembers taking the name at face value and thinking of herself and Hesse as "one of the boys.")[79] The stay in Germany that was to prove so productive for Hesse's art was made possible by patronage extended to Doyle and, through him, to his wife. Hans Haacke, a frequent visitor to the Kettwig studio, has recalled Doyle's scrupulousness in showing Hesse's work to his studio visitors, as if trying to give her equal time: one result was German showings and sales.[80] And so on: all of these circumstances conform point by point to the familiar twentieth-century pattern, and demonstrate once again (if anyone has forgotten) that marriage is traditionally an economic relation (hence Hesse's careful division, in the Kettwig notebook, of her day and her labor, using the standard formula, *me* versus *us*).

The marriage broke up late in 1965, and Hesse had begun to accept that the break was definitive toward the end of the following year. Few people have argued that the union ultimately made much difference to the direction her art was to take, though most tacitly agree with her own view that its initial influence was regressive: "I think there was a time, when I met the man that I married, I shouldn't say [I] went backwards but I did because he was a more mature artist and was developed and I would unconsciously be somewhat influenced and he would push me in his direction and of course when I met him I already had a drawing show which was much, much more me."[81] This judgment offers what has now become the standard interpretation, correctly in my view: that

the works shown in her 1961 exhibition—the drawings Judd called capersome, O'Doherty gnomic, and Lippard ominous—connect in feel and in technique with the drawings of the last two years of Hesse's life. (Whether regression was involved is of course a more loaded issue, though like Hesse, I myself believe it was.)

Why then should we not treat Hesse's marriage as a mere footnote to the artist's biography—something to be passed over with a brief entry in a chronology and nothing more? That their reputations have turned out to be set (at least for the moment) on opposite courses only seems to encourage such a response. By these lights the independence of Hesse's identity from that of her husband would seem to signal a more general phenomenon: the change in mores that by the early 1970s began to flood the art world with new assumptions concerning gender. Hesse and Doyle's story is an instance in that history as much as anything else. Yet to launch that hypothesis I need to argue it: with so much at stake, we can do with some particulars. One thing that needs to be said about the interaction between Hesse and Doyle concerns their individual success and failure in negotiating the gendered roles that marriage assigned them: one demonstrable source of conflict was the incompatibility, in both their minds, of the identities "wife" and "artist." Yet they did agree on what an artist was. The paradox is only apparent: nor is it difficult to demonstrate this claim. The other topic that needs exploration is more elusive. It concerns the artistic collaboration that their marriage facilitated—a collaboration that seems to have marked for each a kind of artistic misdirection. In the different routes they took away from their practice of the mid-1960s are to be plotted some of the coordinates of their differing reputations: these too, I will claim, are equally rooted in the contemporary regendering of art and the artist's role.

Hesse's notebooks are full of her difficulties in negotiating her experience of marriage: in many ways her teenaged fears were entirely fulfilled. The problem, to repeat, concerned her identity as it appeared in her own eyes and those of the world at large. Was female personhood a stable, viable condition? Marriage made the question unavoidable, and she looked it in the eye on several occasions, yet could not resolve it. "In competing with Tom I must be unconsciously competing with my alter ego. In his achievements I see my failures. Thusly when I watch him reading I witness my own inner fears of stupidity. Resentments enter, most precisely if I need be cooking, washing or doing dishes while

he sits King of the Roost reading" (November 21, 1965). Or again, on January 4, 1964: "I cannot be so many things. I cannot be something for everyone. . . . Woman, beautiful, artist, wife, housekeeper, cook, saleslady all these things. I cannot even be myself, nor know what I am. I must find something clear, stable and peaceful within myself within which I can feel and find some comfort and satisfaction." The questions were relentless in these years, as were worries about the direction of her art, and Hesse did not keep them to herself. Anxiety and advice shuttled back and forth between Germany and New York: as it happened, Hesse's correspondents had concrete suggestions to make on these and other matters. Sol LeWitt's cure for artistic insecurities boiled down to "Get on with it," said better and funnier and at great incantatory length: his key word is DO.[82] Ethelyn Honig, with whom Doyle and Hesse shared a studio for a time, had this to offer. "Hell Eva, you're in Europe for a short time. Let chaos reign & you get down to work. You're just as entitled as Tom & its the lousy woman role that bogs you down. I just finished reading a book called "The Feminine Mystique." You can tell? TO HELL WITH LIFE IN A NEST—WE WOMEN'S IS PEOPLE TOO, LET THE MEN WRITE THEIR OWN GODDAM LETTERS. Am I about to incite riot? What a riot. What? A riot?"[83] This letter is undated, but it necessarily arrived in Kettwig within months of Hesse's own first feminist reading, de Beauvoir's *Second Sex*. (If only it could be claimed that riots always followed feminist readings. Sometimes they have.)

All this is evidence of Hesse's trying to devise a way to be married; once the marriage was over, she seems to have gone through a considerable effort to understand and explain its failure. It took time to accept that the rupture was final. But acceptance also involved trying to understand the relationship between the break and her status as an artist. The evidence here is scattered. I present it, to paraphrase Lippard, not for "gossipy or personal" reasons but for the light it may shed on this business of artistic selfhood. Hesse, it seems, began to see her difficulties with Doyle as having involved (among other things) the rivalry between the two *as artists*. She was supported in this belief by friends like LeWitt—or at least this is the case in Hesse's account. "Sol said, 'I am too much competition for TJD. Too much of a person'" (March 5, 1966). A letter from another friend, John Taylor Burris, written late in 1965, offers a similar interpretation. "Another problem naturally is this masculinity thing. . . . I feel that Tom resents competing with you artistically. You could probably burn all

your brushes, paints and other parochial implements, and cure that problem, but then where would your satisfaction come from—." [84] If we add back into this mix the various contemporary journal references to the problem of women being artists, a still clearer sense of the ramifications of her conflict emerges. April 14, 1966: "Is my hang up now why men believe females can't make it as 'great' important artists? They are right in that it is too much preoccupation." Spring 1966: "Tuesday—The conflict now of woman and artist does exist— why because I feel I must try harder because of failure in marriage." These remarks are hedged all around by other references that offer their own picture of Hesse's mood during these months: the passages she transcribed from *Cain's Book* are pointed in their messages. ("To move is not difficult. The problem is: from what position? The question of posture, of original attitude: to get at its structure one must temporarily get out of it. Drugs provide one alternative attitude." "Knowing again that nothing is ending and certainly not this.") So perhaps is a reminder to make sure she listens to "Paint It Black." She has caught crabs from Doyle. And she reads Saul Bellow's *Dangling Man* and Robbe-Grillet's *The Erasers*.

Locating Doyle's attitude toward, and position in, the marriage is both more and less difficult than tracking Hesse through that territory. That Hesse's journals and letters are one main source of evidence for this phase of his life only contributes to the problem: they are not exactly an example of balanced reporting, although it is consistent with Hesse's generally scrupulous efforts at honesty that she owned up to her hostility and bias, and even set herself the task of writing a character sketch deliberately exempted from those taints. Here is the result:

He is a very complex person although his happy disposition screens this from himself and from the world. Happy disposition is not enough to explain an incredible ability to feel free and at peace and therefore always happy. It is a most praiseworthy attribute since he does not possess this temperament sitting back making the easy life. God he works hard. But for him it's not really hard. That is, he is always busy, but he is so at one with himself any preoccupation is given his entire very beautiful self. I must give a flimsy outline of a typical day. He arises in the best frame of mind, jovial, sweet, loving, tender and very eager for the new day. Even to the most anti-psychological minded person this is clearly a good

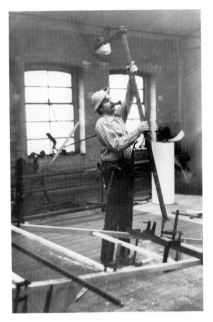

FIGURE 67 (above, left). Unknown photographer, Tom Doyle in his studio at Kettwig, ca. 1965. Allen Memorial Art Museum, Oberlin College, Oberlin, Ohio, © The Estate of Eva Hesse. Reprinted by permission. All rights reserved. FIGURE 68. Unknown photographer, Tom Doyle, Eva Hesse, and an unidentified man, ca. 1965. Allen Memorial Art Museum, Oberlin College, Oberlin, Ohio, © The Estate of Eva Hesse. Reprinted by permission. All rights reserved.

sign. He is a ritualist. The reading in the john the very first and very last of each day. It's practically foolproof. Many times admittedly it's just a solitary reading place. The big healthy breakfast, with the "breakfast place," the particular cup. (In America there is one self engraved with the Doyle trademark Irish Uncels [uncials] each more telling the tale.

Here she stopped: the rest of the page was left blank, presumably in the expectation—a vain one, as it happened—that the sketch would be completed another time. She never went back to it.

Thus Doyle survives in Hesse's papers (I think this is a fair statement about the papers, if not about Doyle) mainly as a catalyst of pain and insecurity: "I think my hang-ups now are almost all related to Tom" (winter 1965–66). He wears the guise of a man who misbehaves with drink and other women (and subsequently acknowledged that characterization to some extent deserved). Yet

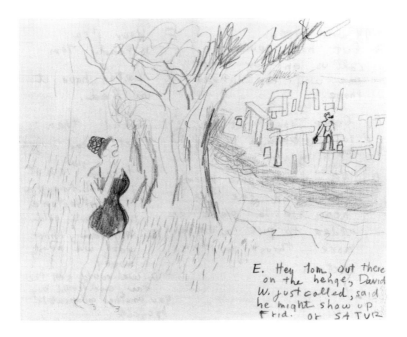

FIGURE 69. *Stanley Landsman (?), Caricature of Eva Hesse and Tom Doyle, 1961, pencil on white paper. Allen Memorial Art Museum, Oberlin College, Oberlin, Ohio, © The Estate of Eva Hesse. Reprinted by permission. All rights reserved.*

this conduct left no traces in the visual documents of the marriage: he appears in photographs and movies looking attractive, impervious, and unperturbed: smoking a pipe, mounting a construction, playing a trumpet, examining a sculpture with Hesse and another man, walking into an exhibition (figs. 67, 68). In one or two instances the tone is more playful: there is the cartoon Hesse held onto from the early days of the relationship—according to Doyle, it was probably the work of a friend privy to the jokes and roles and erotics the relationship involved (fig. 69). In this view of the marriage Doyle the sculptor is at work improving the "thrust" of Stonehenge, when a curvacious Hesse calls him to tea. They talk of art and Joyce and bed and money, with each playing "wife" or "husband" to the hilt.[85] In what is probably the last picture "of" the marriage, the roles have shifted once more (fig. 70). Though both partners are present, one is an image, the other an artist; Hesse stands in her studio flanked by a poster of a fellow in fisherman's oils; it is Doyle, out of character, posing in an

FIGURE 70. *Unknown photographer, Hesse in her Bowery studio, ca. 1966. © The Estate of Eva Hesse, courtesy Robert Miller Gallery, New York.*

ad for the Friday fish fry at Schraft's—if he is still part of Hesse's studio furniture, he masquerades there, in seafaring travesty. The string between them might as well be a wall.[86]

These are Hesse's marital mementos. Among the papers that Doyle deposited in the Archives of American Art in 1983, by contrast, are few traces of their life together: the list of women's clothing sizes scrawled on the outside cover of a sketchbook used in 1960–61 may possibly refer to her ("skirt 10–12; dress 8; blouse 10 fit, 8 loose"); the drawings inside the book occasionally juxtapose designs for sculpture with studies of a naked woman (figs. 71, 72), but there is

FIGURE 71 *(above, left). Tom Doyle, Nude, page from a sketchbook used in 1960. Tom Doyle Papers, Archives of American Art, Smithsonian Institution.* **FIGURE 72.** *Tom Doyle, Sculpture, page from a sketchbook used in 1960. Tom Doyle Papers, Archives of American Art, Smithsonian Institution.*

no particular reason to think that she is Hesse. The association of the sculpted body and the female one is long-standing, even when the sculpture in question is ostensibly nonrepresentational: think of the notebooks of Doyle's mentor David Smith for a relevant example.[87] It is tempting to see as apposite a brief notation, entirely unpunctuated, inside the cover of another sketchbook used in 1964–65: "perhaps some people go back too far to get where we are we have been through it and must go on." The drawings in this book are only of sculpture and seem to test out the various ways the wings of a sculpture can be built out from a central armature (figs. 73, 74): their closest point of reference is to a few pages in one of Hesse's sketchbooks, a resemblance that seems to confirm that the latter are likewise by Doyle (fig. 75).[88]

All this is not much to go on, but it is all the contemporary evidence publicly available in documentary form; it fleshes out the memories that friends have transcribed, and acts as a leaven to the bitterness the breakup caused. Yet locat-

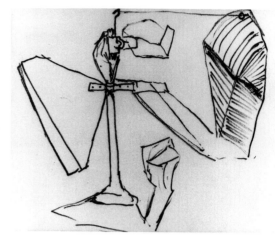

FIGURE 73 (right). Tom Doyle, Sculpture, page from a sketchbook used ca. 1964. Tom Doyle Papers, Archives of American Art, Smithsonian Institution.

FIGURE 74 (below, right). Tom Doyle, Sculpture, page from a sketchbook used ca. 1964. Tom Doyle Papers, Archives of American Art, Smithsonian Institution.

FIGURE 75 (bottom of page). Tom Doyle, Drawing in a notebook belonging to Hesse, ca. 1965. Allen Memorial Art Museum, Oberlin College, Oberlin, Ohio, © The Estate of Eva Hesse. Reprinted by permission. All rights reserved.

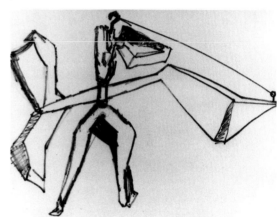

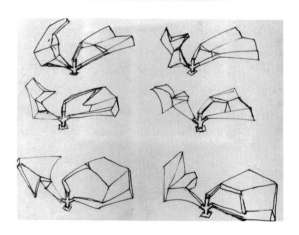

ing Doyle is in some ways easier than pinning down Hesse because his expla-
nation of the marriage's dissolution has been consistent, if consistently terse.
The problem, in his view, was that this was a marriage between artists: as he
told an interviewer in 1975, "There is probably too much ego for artists to be
married to each other."[89] The interviewer in question, Joyce Wadler, was not
entirely sympathetic to this view of things, as is clear from her treatment of the
division of labor in Doyle's third marriage, to Jane Miller. She is first introduced
as "a beautiful, young wife, who seems to adore him" and figures at the top of
a list of the sculptor's main assets, along with a $15,000 job at Queens College,
at $300-a-month loft on the Bowery, an $8,000 farm in Pennsylvania. Later
Wadler asks, "What does Jane do?" "'She takes care of me,' he said." Then Jane
cooks a vegetarian dinner in their "very tidy loft: fresh flowers on the table, the
black and white linoleum floor shining."

These details are offered for the *Post* readers' delectation and served up with
satirical sauce: not quite the *New Yorker* or "Lifestyles of the Rich and Famous,"
Wadler's column is kissing cousin to both. "Next Saturday: Trisha Brown, Cho-
reographer." Perhaps Doyle was misquoted; at any rate the interviewer seems
to have called most of the shots. Yet the implied contrast between kinds and
conditions of marriage, specifically Doyle's preferences in both, comes through
loud and clear, and conforms in broad outline to other versions of the case.
Wives and artists, in Doyle's lexicon, are apparently not the same kind of folk;
they need different skills and interests to fill their roles. What does a wife do?
"She takes care of me." This is the role Hesse found toughest to play.

To introduce Doyle's ideas about sculpture, I can again quote him directly, or
nearly so: the context is a 1964 letter to Lucy Lippard, which she transcribed
and later mined for an article on Doyle's work, citing a section on the benefits
of abstraction as the language of monuments: "When sculpture moves away from
reality the more grand it can become. . . . With abstraction we can do it, it's
not a man, a building, an object, but a spiritual thing that one can pass through
and be affected by."[90] The quotation stops here, perhaps because the letter
shifted its tone as Doyle began to expound his view of the stature of the sculp-
tor and the status of his product. His language is heartfelt, perhaps even confes-
sional; its fragments read as if jotted just as they came to mind. His words recall
ideas we have already heard from Hesse in different form:

I cannot join object makers. It's like joining Mad. Ave. Be a man, sell out. Perhaps I may be an anachronism, Old sentimentality whatever. But I want more goddam it. I may be building dinosaurs, but I have to follow my own evolution. Sometimes I feel like I don't know anything. I can only find out by trying it. Try to discover. When I was a kid I wanted to be an inventor, a hero, my own Man. Sometimes I think I picked the Last Brass Ring. Clutched may be the word.

Otherwise I have two pieces finished. Two waiting paint and a base, and two giants in the works. One is against all my principles of asymmetry and four sided Monolithic god figure sculpture. It always seems that whenever I scream loudest it means I'm about to do exactly what I am talking against. With the exclusion of joining in above mentioned. Anyway it is exciting to prove oneself wrong. But I was born wrong and have been embarrassing myself ever since.

I cite this passage for several reasons, but above all for the comparison it offers with the terms in which Hesse embraced the artist's identity. The yardsticks they use to measure artistic success and human failure (and their opposites) have radically different markings: the irony of Doyle's "Be a man, sell out" is something like the opposite of Hesse's wistful "Do I have a right . . . to womanliness?" The one can devalue manhood when it is the Madison Avenue kind; the other yearns after womanhood precisely because its characteristics seem so far from the reality she has experienced and achieved. But both agree that the artist's way is solitary, that it involves following one's own direction: in both their minds the artist is different, "born wrong," as Doyle puts it. Or, to cite Hesse once again, artists both "feel and want to be a little different from most people." *Feel* and *want*: each verb in this phrase should be given equal weight if its meaning is to be adequately understood. The phrase speaks of inward sensations and outward desires; it describes an experience of difference with both a personal and a social dimension. On this Hesse and Doyle agree.

But equally significant about this passage is Doyle's self-image as "building dinosaurs," and so evolving toward his own extinction. In retrospect, the phrase seems poignant. Not, however, that Doyle gave up sculpture; he continued to exhibit and win commissions pretty regularly through the 1970s and, indeed, still works and exhibits regularly today. His work found its niche in sculpture's "expanded field," and the move out of the gallery into open air meant changes that answered the criticism he had encountered in the 1960s. The main

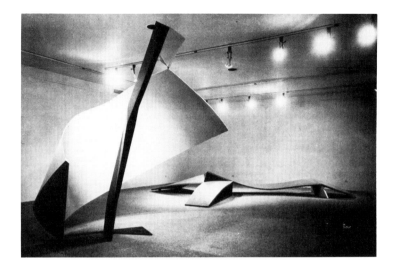

FIGURE 76. *Installation shot of Tom Doyle's exhibition at the Dwan Gallery, 1966. Foreground:* La Vergne; *background:* Over Owl's Creek *(Photograph: John D. Schiff).*

issues were raised at his first exhibition in New York after the German stay: it was held at the Dwan Gallery in April 1966. Two pieces, *La Vergne* and *Over Owl's Creek,* made up the show (fig. 76; they are reproduced here as photographed on that occasion). The keys to Doyle, said the critics, were his color and his technique. The first was "arbitrary, though handsome," they stated (or at least Dennis Adrian did, in his *Artforum* review).[91] It helps to know, in this context, that *Over Owl's Creek* has three colors "defining . . . the three components: surface (brick orange), support (midnight blue) and brief halt, or planar accent (yellow)." *La Vergne's* combination of dark green with "cosmetic pink, chosen arbitrarily from a color chart of available shades, stresses all of the voluptuous expansiveness and magnetism of its mammoth embrace."[92]

I cite Lucy Lippard on Doyle's color because his work is difficult to see first-hand; I know these pieces only in reproduction. And Lippard is a favorable guide: she was trying to carve out a place for her friend within the rigors and reductivism of the current sculptural scene. The leader for her essay gives the gist of her argument: "A romantic largesse of gesture and stance—the essence of his style—asserts itself within a tough formalism."[93] It is this same contemporary sculptural context that made Hilton Kramer find Doyle's work "almost

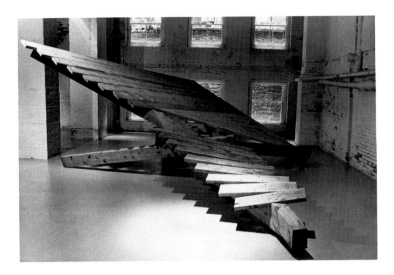

FIGURE 77. *Tom Doyle, Tullahoma, 1977, red oak and white pine, 7 ft. 11 in. ×*
20 ft. 22 in. (2.4 × 6.6 m.). Collection of the artist (Photograph: Jane Doyle).

Baroque, compared with the geometric severity of some recent efforts."[94] What
worried Kramer, however, was Doyle's "rather paltry sense of technique." That
technique is relatively complicated: it brings together three materials in one
work, painted wood, steel, and masonite for *La Vergne* and wood, steel, and
linoleum in *Over Owl's Creek*. For Kramer their linkage exhibits—horrors—"vis-
ible crudities," and he exhorts the artist "to improve his technical hold over
his sculptural materials."

That Doyle's technique was at issue in 1966 is conveyed by the efforts of
other critics—notably Adrian in *Artforum*—to refute these charges: Adrian saw
"immaculate technique" and "refinement of execution" where Kramer encoun-
tered crudity. The context, to repeat, was one that took a sculptor's response to
the issue of manufacture as the badge of belonging or the refusal to join the
current debate. As Doyle later recalled of "this minimalist sort of thing": "I fit
into [it] sort of like the bastard at the family reunion." His lack of fit meant that
he left Dwan in 1968 and did not show again in New York until 1971. His
return seemed to demonstrate, the critics claimed, "that his sculpture was never
really involved with Minimalism."[95] Defining what it *was* involved with be-
came the issue to settle and went on for nearly ten years. "This near cliché of
post-Minimalism" was the label Robert Pincus-Witten chose in response to the

1971 show.[96] By 1974, the year of *Tullahoma* (fig. 77), as color cooled and receded and wood, steel, and iron began to predominate, his talent seemed more sui generis, his stance "odd and American . . . at once nostalgic and vital."[97] By 1979 this view had taken secure root. In an essay entitled "Tom Doyle: Things Patriotic and Union Blue," Pincus-Witten was ready to apologize in print for his earlier mistreatment: "I recognize now that I was punishing Doyle when I reviewed his exhibition . . . despite my fine formalist phrases, for what I mistakenly construed to be his negative role in [Hesse's] life. This essay is partly intended to rectify whatever dislocation, if any, I may have caused in Doyle's career."[98] The Doyle Pincus-Witten discovered this time around worked entirely in wood, hammering and jointing structures of poplar and pine and red oak. Like *Over Owl's Creek* ten years earlier, the work of the mid-1970s traveled through space like a bridge or ramp and often took its name from a Civil War battle site. Its rough-hewn craftsmanship, however, meant that its formalism— for the work was still formalist—could now be assimilated to a particular characterization of tradition and personal identity, one with which the artist's biography was readily aligned. Pincus-Witten begins the new essay, "Tom Doyle comes from tobacco-plug dirt poor Irish-Catholics who reached Pennsylvania and Ohio perhaps as early as the eighteenth century. Doyle, now in his early fifties, embroiders on his people's eccentricities—amazing salt and pepper free-associative recitations just bordering on blarney."[99] This is a far cry from the same critic's leadoff sentence in his offending essay, when Doyle's jocularity was proposed as the source of his artistic confusion (so called): "A characterological feature of Tom Doyle's mind, his bonhomie, has consistently allowed him to confuse the weathervane with the wind. He tends to lock modes together rather than isolate particularities."[100]

What Pincus-Witten had now gotten straight, with assistance from the artist and his work, was a notion of what kind of person went along with this kind of art. It helped not a little that Doyle's habitual exhibition announcement in the 1970s was a portrait of sculptor with work and dog (fig. 78). It should be noticed that the stabilization of the meanings that could be attached to Doyle's work—his authentication as an American male—traveled in something like an opposite direction from that taken by Hesse's reputation, which has increasingly focused on what could be said to be female about her art.

It might be argued that the transformations of Doyle's work after the mid-

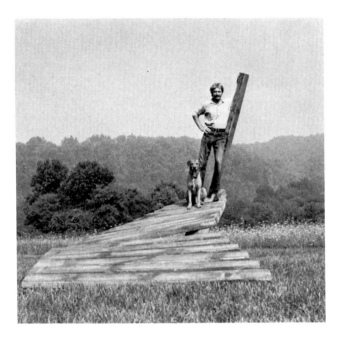

FIGURE 78. *Tom Doyle and his dog, standing on* Chattanooga Flying Bridge, *1974, oak, 14 ft. × 13 ft. 10 in. × 10 ft. 1 in. × 9 ft. 9 in. (4.66 × 4.61 × 3.36 × 3.25 m.) (Photograph: Jane Doyle).*

1960s were parallel in conception to the direction taken by Hesse's art after her stay in Germany, although they were accomplished at different rates. Both abandoned, first of all, arbitrary color relationships, and then gave up any added color at all. The bringing together of a variety of materials in a single work (for Hesse, this meant typically plaster, cord, paint, and found metal or wooden parts) gave way to works whose physical properties were more discretely those of the material that is their main component: wood for Doyle, fiberglass or latex for Hesse. The result, in both instances, is a practice that gives up any truck with the commodity, or at least surrenders any emulation of its forms. (This means that Hesse gave up what we might see as Pop about her German reliefs; Doyle turned his back on "minimalism.") Yet these similarities are outweighed by the great differences between them, above all that Doyle never let go of the category of sculpture as he had inherited it. Nor did he mean to. Doyle's purpose was the construction of places of passage in the natural world. For Hesse, by contrast, the category of sculpture seems to have meant relatively little—

remember how slow she was to sort out the difference between the key terms. *Sculptor* could be *sculpture*, in her lexicon: the confusion led to her curious question, "Is it right for a girl to be a sculpture?" Reading product for producer— not bothering to monitor which is which—declares one's dissociation from a profession as much as it proclaims identity with its products.[101] Professional sculptors sometimes agree: you cannot get much more professional—or more traditional—than her erstwhile friend Walter Erlebacher, the author of Philadelphia's statue of Rocky. Here is Erlebacher speaking of Hesse: "She was not a sculptor. You realize that. She was trying to be a painter. . . . She had no sense of materials. All of her work seems to be falling apart. She did have a kind of vision though. . . . She can be read as a precursor for non-art art . . . you could trace through her, the younger generation of twig artists."[102]

With "twig artists" Erlebacher starts to get nasty, but his concern with professional boundaries and standards still has something to say. It can shed light on the difference between Hesse and Doyle—on the difference in their reputations above all. It involves the implications, for interpretation, of their maintenance and/or suspension of sculptural definitions and conventions—of sculpture's roles as object, body, bridge, thing, picture, gesture, place. In the practices and reputations of both artists, the gender of the maker is clearly at issue: it is bound up in what they are prepared to let the sculpture *be*, as well as in the ways their works have been said to signify. In Hesse's case a lack of professional allegiance—a lack of allegiance to the profession of sculptor— helped: it was a way of achieving an art caught up in a negational task. Speaking of "non-art art," did Erlebacher remember the closest thing to a manifesto Hesse ever wrote? It was the statement composed in 1969 to accompany the exhibition of *Contingent* (plate 26): "I remember I wanted to get into non art, nonconnotive [*sic*], non anthropomorphic, non geometric, non, nothing, everything, but of another kind, vision, sort, from a total other reference point."[103] From "nothing" to "everything": this transvaluation is the core of Hesse's art. Doyle's practice, by contrast, involved not only the refusal to destabilize certain sculptural conventions, but also their increasing conflation, as the 1970s wore on, with certain masculine ones. It is as if his response to the voice saying, "Be a man, sell out," was to locate another manhood, one rooted in familiar values: carpentry, tools, dogs, forebears, and the battles of the Civil War. On it was based an art of place, passage, and connection. The choice is an understandable one; yet one

risk of linking sculpture to this particular tradition is that the innovations of its effects may well be overshadowed and obscured.

The Wound and the Window

What does Hesse's art look like? The question seems simple—it sits docilely enough on the page—but answers to it obey more complex laws than might be assumed. Disagreement begins with description, yet criticism cannot do without the effort to characterize. Does *Contingent* look like "a ghastly array of giant soiled bandages, or worse yet, like so many flayed, human skins (distantly evocative of the Nazis' notorious use of human flesh to make lampshades")?[104] Or is the following passage a more helpful description of the piece: "At once more detached and less associatable than most of Hesse's work, [*Contingent*] transcend[s] the whimsical to make a statement that is grand simply in its existence, and at the same time, is as profoundly personal or intimate as a work of art can be. It incorporates the qualities and texture of the new and the old, of the battered and the beautiful. With the opaque weight concentrated in the middle of the piece, it seems from some angles to hover in mid air, or to disintegrate at both ends."[105]

My question may be simple, but it is not trivial. These two specimen answers summon, in double-quick time, a sense of what is at stake when Hesse's art gets described. A work that for one viewer is notably detached from figural associations is for another the catalyst of sensationally grisly comparisons. For one there is no body in the work, for the other, there is only the body, as represented in its abject remains. For Lippard (it is time to give these authors names) the pleasure and interest of *Contingent*—and of Hesse's work in general—are its ability to conjure opposites and make them cohabit within discrete material form. For Chave interest and pleasure lie in her conception of a body (often Hesse's body) speaking through art of the repressed truth of female experience—its "inheritance of pain"—so as to enact "a kind of self-mutilation" in her art.

With one important exception, Lippard's main ideas about Hesse's art came to her in the 1960s, in the context of articles and reviews: she first put forth the notion of a dialectical Hesse in the press release for the artist's first solo sculpture show: "The core of Eva Hesse's art lies in a forthright confrontation of incongruous physical and formal attributes: hardness/softness, roughness/

smoothness, precision/chance, geometry/free form, toughness/vulnerability, 'natural' surface/industrial construction."[106] The terms of Chave's analysis of Hesse, by contrast, are unthinkable without the artist's death and the subsequent uses made of her life and art; unthinkable likewise without the multiple stresses on the bodily imaginary effected in the age of AIDS: the stresses exerted not only by consciousness of a tragic epidemic, but by the commodification of horror and violence as the dominant cultural imagery of the day. Consider the special tenor of the following declarations: "Evocations of disease are rife in Hesse's art, with its pervasive suggestions not only of mottled and yellowing skin and of extruded and exposed female anatomy—the internal externalized as it is in surgery, or due to gruesome accidents, or acts of violence—but of medical paraphernalia, such as surgical hose, bandages, restraints, and blood-pressure cuffs."[107] Or "in *Tori* of 1969 the nine scattered, slit, cylindrical units fabricated of a loosely flesh-like fiberglass create an effect as of dismembered, squashed, and discarded female genitalia."[108] Or "What was specifically inscribed on Hesse's body, and what she inscribed in her art, were above all the debilitating effects of tyranny, whether sociopolitical, sexual, or physical, as in the tyranny of disease."[109]

The polemical urgency and extremism of these statements struck me when I first read them in 1993; several years later, my sense that they represent a particular moment and ideology within feminist thinking is unchanged.[110] They also involve a polemical rewriting of the ambitions, effects, and meanings of Hesse's art. Thus the main issue is not that I disagree with Chave's descriptions, though that is the case: I do not see Hesse as an artist who "reports effectively on women's misery."[111] The tone of her work is, I believe, infinitely more metaphoric than illustrative, more purposeful than plaintive, more ironic than abject. Of greater concern are the histories that must be erased or elided to secure such a specialized account of the meanings of Hesse's work.

What histories? One relevant category might be that of the reception of Hesse's art during her lifetime, not because it is to be expected that contemporary critics "get it right" (no more is it necessarily to be assumed they "get it wrong"), but for the simple reason that the difference between what they wrote and what is or might be written nowadays may well be instructive. One volatile issue concerns how the body might be said to be present in Hesse's art. It was also demonstrably present back in 1966, when Hesse first exhibited sculpture

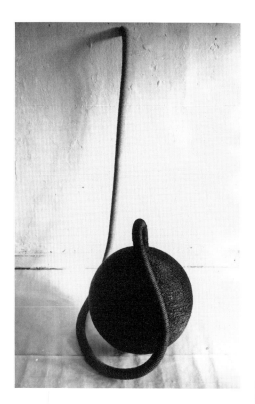

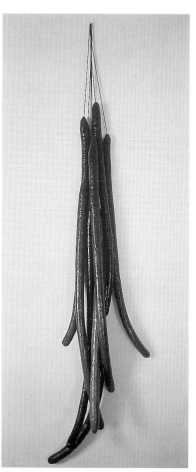

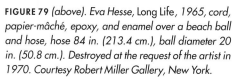

FIGURE 79 (above). Eva Hesse, Long Life, 1965, cord, papier-mâché, epoxy, and enamel over a beach ball and hose, hose 84 in. (213.4 cm.), ball diameter 20 in. (50.8 cm.). Destroyed at the request of the artist in 1970. Courtesy Robert Miller Gallery, New York.

FIGURE 80 (above, right). Eva Hesse, Several, 1965, acrylic paint, papier-mâché over balloon with rubber cords, 84 × 11 × 7 (213.4 × 27.9 × 17.8 cm.). Thomas Amman, Zurich, courtesy the Estate of Eva Hesse.

FIGURE 81 (right). Eva Hesse, Ingeminate, 1965, surgical hose, papier-mâché, cord, and sprayed enamel over balloons, hose 144 in. (365.8 cm.), each element 22 × 4½ in. (55.9 × 11.4 cm.). Private collection, courtesy the Estate of Eva Hesse.

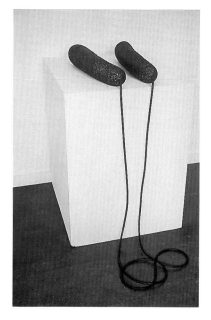

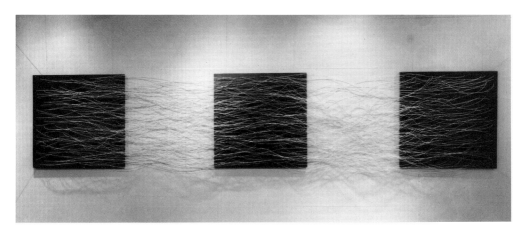

FIGURE 82. *Eva Hesse,* Metronomic Irregularity II, *1966, painted wood, Sculp-Metal, and cotton-covered wire, 4 × 20 ft. (1.2 × 6.1 m.), installed. Destroyed.*

in New York, in two historic shows, at the Graham Gallery's *Abstract Inflationism and Stuffed Expressionism* and Fischbach Gallery's *Eccentric Abstraction* shows (*Hang Up, Ishtar,* and *Long Life* were in the first, *Several, Ingeminate,* and *Metronomic Irregularity II* in the second; plates 27, 28; figs. 79–82). Here are the terms in which Hesse's sculpted body was ushered into print. I cite first Lucy Lippard: "Hesse's self-contained but tentative quality re-occurs in *Long Life,* a black wrapped sphere set on the floor and attached to the wall by a graded 'lifeline.' It takes little imagination to perceive the body 'ego' that went into this work, but it adds the curiously withdrawn objectified subjectivity of 'Swenson's new sexuality,' in which matter of fact understatement of ideas usually overstated is paramount."[112] These are observations that take some unpacking, though Lippard's references are not, as it turns out, all that obscure. Nor were they meant to be: she was making use of some recent reading, first of all, a January 1966 essay by a Yale psychologist, Gilbert J. Rose, that advances the notion of body ego, which Lippard defines as naming the idea that "symbolic thinking has a bridging function. Every symbol refers simultaneously to the body and the outside."[113] "Swenson's new sexuality" signals the idea of sexuality in art advanced by Gene R. Swenson in the catalogue of a show held, once again, early in 1966 (January 27–March 7, to be precise) at the Institute of Contemporary Art in Philadelphia. Presented under the prescient title "The Other Tradition," his essay is one of the first—if not the first—pieces of writing to propose an alter-

native to modernist criticism. Swenson's new sexuality is post-Freudian; it is explicit, perhaps even arousing, but never "hot" or pornographic; it has nothing to do with "love or tragedy"; it may be fetishistic. It is, claims Swenson, a symptom of "the deep and basic revolution now taking place in the realm of sexual awareness."[114]

A bit later in 1966 Mel Bochner reviewed the *Eccentric Abstraction* show for *Arts*. He had this to say about the appearance of the body in Hesse's art—though he said it, let it be noted, only after he had relished the absolute disembodiment of the mind-boggling totality that is *Metronomic Irregularity II* (see fig. 82): "not chaos but a structured order in itself yet unavailable to comprehension. . . . It is a fabrication of entanglement, a logical fiction. Regular, remote, and lifeless." Now the body: "Her other pieces—atrophied organs and private parts—are not garish or horrifying. The lacerated shiny surfaces have a detached presence which is real. Hesse's work has an awkwardness similar to that of reality which is equally empty of inherent meaning or simplistic contrasts. Her work and sensibility is [sic] in advance of the various categories it has been placed in."[115]

Sometimes criticism is discounted because it is written by the artist's friends, but in this case the close relations between artist and critics are all the more reason to take it seriously. Bochner and Lippard then occupied—and still occupy—rather different positions as viewers of art, but they nonetheless agreed in 1966 on how to describe the ways the body is summoned by Hesse's art: it seems likely that the artist herself would have concurred. (We know that she was energized and gratified by critics' interest in her work and counted Bochner and Lippard, as well as Swenson, among those whose opinions she most valued.) These writers breathe no suspicion of disease, suggest no ghoulishness, hint at no scenarios of dismemberment. Nor do they deny these scenarios—or urge their own—with such vehemence as to make us suspect that a cover-up is afoot. They seem convinced—and want to convince the reader—that what is compelling about this art is the sheer mundanity of its symbols, its matter-of-fact way of being personal about the body: no exaggeration, just understatement; no meanings outside substance, no horror other than that of the real. In other words, those features of Hesse's art now seen as determinant of its meaning were more or less invisible thirty years ago. It was a time when it was possible to begin to imagine a body with which a woman could have her way in representation almost as a matter of course. She could claim the body as real, and

personal, and symbolic, with no wounds being opened, and without that claim seeming to involve her alleged lack. This is, I think, an idea to be savored and a possibility to be regretted: we might wish to inquire as to why it seems so far away.

Hesse, I am arguing, represents that rare bird in the history of artists who are women: a practitioner to whom is attributed a special possession of her means of representation.[116] Not only is she able to control recalcitrant materials (I am speaking of her imagery, not her techniques), but she is able to strip those materials of any lingering affect: the taint of sensationalism or sentiment or a subjectivism run amok. To Hesse, we might say, is attributed the power of truth telling about the contemporary experience of the body: unlike O'Keeffe, however, who decades before was credited with similar powers, the body of which she speaks was *not* first seen as "hers." Its terms were more general—thus more ambiguous—than the fixities of a more familiar sexuality locked into love and tragedy. While it might be possible to doubt that the new sexuality ever really existed, men and women certainly thought it did, and took Hesse as giving it objective (though not reductive) form. "It isn't a question of liking these pieces or of being amused by them. They are not amusing. It is a question of finding them interesting and difficult as opposed to finding them pleasant. . . . [They] are odd and disturbing and elude simple definitions or descriptions. . . . [They] are completely abstract and resist any kind of single-leveled interpretation or response."[117]

By these lights it might be better to think of Hesse not as wound, but as its opposite. I can explain better what I mean by having recourse to an essay by Theodor W. Adorno, "Heine the Wound"; it was written in 1956 for delivery as a radio talk commemorating the poet a century after his death, and was published later that year. It is the Nazi misuse of the Jewish Heine that concerns Adorno: "Anyone who wants to make a serious contribution to remembering Heine . . . will have to speak about a wound; about what in Heine and his relationship to the German tradition causes us pain and what has been repressed."[118] Heine's wound is his poetry, its "fluency and self-evidence." These are the characteristics that allowed its transformation by the Nazis into spurious folk song: they betray the commodity character of his art. They ultimately stem, claims Adorno, from "the failure of Jewish emancipation" as that failure was manifest in Heine's acculturation; they are "the opposite of a native sense of

being at home in language. Only someone who is not actually inside language can manipulate it like an instrument. If the language were really his own, he would allow the dialectic between his own words and words that are pregiven to take place, and the smooth linguistic structure would disintegrate. But for the person who uses language like a book that is out of print, language itself is alien."[119]

Anyone who wants to make a serious contribution to remembering Hesse will likewise have to speak about a wound—not, in this instance, as the chief characteristic of her art, but as the emblem of its transformations in print. For what is striking about Hesse's art is its utter inwardness with artistic languages of the day; her imagery and effects are *not* learned by rote, only to be parroted back more or less unchanged. On the contrary, she is at home with the ways and concepts of Pop and Minimalism; she seems to possess them effortlessly and reconfigure them immediately. The machine? The grid? The cube? Repetition? Industrial processes? These are Hesse's meat and drink, or, to paraphrase Adorno once again, the words that come to her pregiven. But the patent inadequacy of any of these terms even to begin to offer an adequate description of a work like *Accession II*, say (fig. 83), even though they can all be applied to it, is one measure of the ways in which her work interrupts such smooth descriptions. There is something more and other to be experienced in the sculpture than *any* of these words can account for. The work concerns the senses and sparks desire with an immediacy that is anything but pregiven, and in ways that are not explained by a mere inventory of its materials or conceptual points of departure. The physical history of the three versions of the work offers its own record of those desires: when first shown, it was damaged by people climbing into it; to this day children are still lowered inside by indulgent parents and museum guards alike. Hesse herself was filmed bending over to stick her head inside and photographed with her hands poised in the bristling interior (fig. 84). As if in answer to these same desires, a photographer documented the interior soon after its completion (in so doing reframing the industrialized real of the minimalist object as the surreal of incomplete sexualized form). Whether in the wake or in advance of this photograph, Hesse likewise made a drawing of the inside that sees it from the camera's point of view (figs. 85, 86), but relaxes its linearity, as if to recast its affect as more purely random, less the result of visual geometry.

Looking at Hesse's work, I am claiming, involves recognizing in its operations

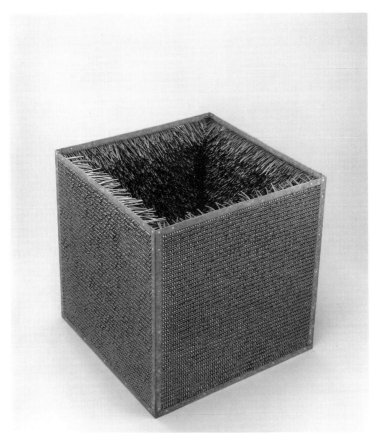

FIGURE 83. *Eva Hesse,* Accession II, *1967, galvanized steel and rubber tubing, 30¾ × 30¾ × 30¾ in. (78.1 × 78.1 × 78.1 cm.). Detroit Institute of Arts, Founders Society Purchase, Friends of Modern Art Fund and Miscellaneous Gifts Fund.*

a process akin to what Adorno describes as characteristic of the language of the native poet. She allows the dialectic between her own forms and forms that are pregiven to take place, and a smooth artistic structure thus disintegrates. These phrases are a way of pointing to Hesse's confident use of structuring conventions and forms, but of never allowing an experience of her work to be reducible to mere system. Yet, conversely, a structuring system is never absent, even when, in *Untitled ("Rope Piece")* (fig. 87), it becomes nearly vestigial, reduced to the finite set of hooks from which the piece must be suspended in order to be seen. (Some of the tenuous effect is captured by the attenuated grammar of Hesse's description of the piece: "With its own rationale even it looks chaotic.")[120]

FIGURE 84 (top, left). Hesse with Accession II, 1968, Fischbach Gallery Papers, Archives of American Art, Smithsonian Institution. FIGURE 85 (top, right). Accession II, detail of interior, 1968. Fischbach Gallery Papers, Archives of American Art, Smithsonian Institution. FIGURE 86 (above). View of the Hesse exhibition, Fischbach Gallery, 1968. Fischbach Gallery Papers, Archives of American Art, Smithsonian Institution.

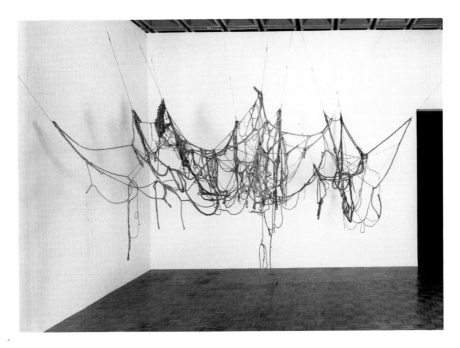

FIGURE 87. *Eva Hesse, Untitled ("Rope Piece"), 1970, latex over rope, wire, and string, three units 144, 126, 90 in. (3.6, 3.2, 2.3 m.) high, width varies with installation. Whitney Museum of American Art, New York.*

These conditions make possible a symbolic reading of Hesse's art, but they are also meant to contain, even to chasten, such readings before they get out of hand. Hesse did not intend her art to be reducible to her body alone—nor would it have been, I wager, had death not intervened.

Perhaps the measure of the complexity of her intentions is given by the title used for her first sculpture show in 1968. It was called *Chain Polymers*—not "modular mess" or "messy neatness" or "pathetic objects" or "object objects" or "anxious objects," or any of the other phrases the critics tried out in their reviews (no, not "abject objects" either). If the name she used does not make you get up and dance, the reason for the choice may justify that failure. The phrase signals its allegiance to certain artistic concerns of 1968: to process, to "natural law" and organic system. Remember the copy of the periodic table on display in Hesse's living room, the gift of Carl Andre; remember her friendship with Robert Smithson, with whom she exchanged works in 1967. Yet the chosen phrase is not a Smithsonian "crystalline structures" or "ordered elements."

"Chain Polymers" signals to the initiate the notion of a compound made up of elements that do indeed occur in a highly ordered fashion—the component elements have the same proportions, and proportionately the same molecular weights—but out of such structures of identity comes difference: the compound that results has physical properties entirely different from those of the structuring elements. The term, of course, is a metaphor for the workings of Hesse's art: it is a way to name a whole that is conceptually incommensurate with the physical reality of its parts, even while it adheres to their ordering principles.

From this interpretation the reader may well infer—rightly—my sympathy with the main force of Lippard's approach to Hesse's art: her effort to keep interpretation alive to the ways opposites join forces in a disquieting and unstable union. I do not think that this occurs, however, because Hesse's "art and life are one." On the contrary, I would attribute it to the depth and vigor of the artist's understanding of the representational issues of her day, and her ability to make those issues over in her own terms. These are matters to which I take Hesse's journals to be largely irrelevant, or at best tangential. Hesse sometimes wrote interestingly; she almost always wrote with feeling and with purpose: but her best ideas are in her art. Her work leaves her words far behind.

If Hesse's life did enter her art, it did so by a process that I do not think Hesse herself was in a position to describe, however hard she struggled to put names to her motivations and her fears. In this sense too she conforms to Swenson's definition of the post-Freudian self: by these lights, remember, she can be seen as one of those many late-century people who are "more likely to know why they are doing something than what they are doing." If we were to address what Hesse did not know that she was doing in her art, we would be attending to the ways it was marked by her unconscious—marked in something like a strictly Freudian sense. We would be looking for the ways it repeatedly configured, around the edges of a legibly artistic protocol, an imagery that was the repository of desires, prohibitions, and fears. I think such an imagery exists in Hesse's art, and I take it to concern the artist's feelings toward her mother above all.

I am not speaking here of Hesse's sustained efforts to make a conscious settlement with her mother's illness and suicide, even though it is important to remember that those efforts were intense and engaged her in defending herself against the threat that identification with her mother (identification with her

as a woman) presented. Her journals served, not surprisingly, as the registry of that process, which was (again not surprisingly) at its height during the years of her marriage and in its immediate wake. They are peppered with remarks like these: "I do now think that I am just like my mother was and have the same sickness and will die as she did. I always felt this" (spring 1966). "My father and mother got divorced, she was sick. he let her go off by herself—without us her children—she killed herself" (March 6, 1966). Or "Shame of height is shame of incest—an obvious seen shame covering for a hidden shame. Tom's desertion was planned as thought [*sic*] father's desertion of mother for me. I [*sic*] shame for this must therefore repeat and lose. punished for being bad. therefore my use of bad, 'Eva is bad again' (= Eva is sick again. I was sick and bad and therefore got father. helen smart and good, not sick, lost. so if sick and helpless have father, for which I then must punish myself" (fall 1966). These notes have such a disconnected character—they differ in that regard from other writing in the journals—because they were made in the aftermath of a psychiatric session. They convey what Hesse was able to understand about her fears concerning her mother—fears that centered on the multiple risks she ran of reenacting her mother's death as the inevitable result of her relationships with her husband and her father. The fear of incest could involve not just a fear of the daughter's having caused her mother's suicide by seducing the father; if she takes her mother's place with her father, she may thus confirm her destiny as the heir of her mother's sickness, as well as her man. And similarly, for Hesse to admit the failure of her marriage was to admit her likeness to her mother and thus to catalyze the inevitable fearful result.

In the same context Hesse speaks of her wish to be a child;[121] it was a scenario that recurred both sleeping and awake. I think that this wish expresses both a desire and a prohibition concerning her mother's death. As a child, with the clock turned back to the age of eight, the last time Hesse was happy (about the time of her mother's departure from the home), she might find it possible to avert disaster: "I never wanted to let go of what is past, the child and the trauma—to regain them maybe to have my mother and father and relive it" (January 10, 1961).[122] "It" does not stand for the experience of the Jewish Diaspora, as has been claimed, but the loss and destruction that followed in its wake. Hesse's desire conjures up a second chance that would restore the family and even keep it whole. Its complementary prohibition likewise follows from

childishness: if she is forever a girl, then she can refuse all resemblance to her mother, that ultimate intimate figure of pain, dysfunction, and death. Both wish and prohibition, moreover, are the expression of a necessary ambivalence to a person who had inflicted pain as well as experienced it. (Hesse seems to have worked to master that ambivalence—in a note in her diary she repeats her lesson, "my mother did not reject me. she rejected herself"—and she was likewise quick to censure her own behavior when she though it hurtful to her friends.)

But these are Hesse's conscious thoughts. To approach unconscious motivation we will have to take a different tack. Among Hesse's drawings there occurs a motif that was varied and repeated often enough to have earned both a name and status as a separate category within her graphic work. Ellen H. Johnson, author of the only study of the drawings, called it the "window motif." No more complicated terminology was needed because the appearance in Hesse's art of framed fields, sometimes regularly divided into compartments with "panes" and mullions and moldings drawn in, is self-evident. According to Johnson the artist herself called these images windows. While Johnson grants their roots in her drawings of 1960–61, she argues that their return to Hesse's art in 1968 may have had more immediate causes: "It is not impossible that the image . . . was suggested by her own windows that looked across the Bowery to Tom Doyle's studio."[123] Those windows had only four panes, Johnson concedes, but if one counts in the bars of the fire escape beyond, then a real "source" can be found for the drawings' effects. Lippard's interpretation is as holistic as Johnson's is literal. Borrowing Hilton Kramer's description of the imagery as "at once fragile and yet very firmly conceived," she sees them "as a metaphor for the way the artist was living her life at the time they were made."[124]

My own view is that these windows are at once more and less specific and encompass more in the range of their meanings than has thus far been suggested; I think too that the motif is not confined to drawings alone, or to a few years' time. I take it to imagine a return in representation to the scene of the suicide of Hesse's mother: remember that she died after jumping from a window. From its earliest appearance Hesse's window imagery has two concerns: there is the issue of demarcating the frame and the problem of characterizing (or refusing to characterize) what lies beyond. As she repeats the motif, she rings the changes on possible treatments of both elements, and (necessarily) their interaction. The frame can be a simple, regular line of wash, which makes it seem co-extensive

FIGURE 88. *Eva Hesse,* Untitled, *1968, brown ink with wash, 13 × 13 in. (33.1 × 33.1 cm.). Sondra and Charles Gilman Jr. Collection.*

with the edge of the paper, or it can bristle with the marks of a pen, and thus become an object on or in a field (fig. 88; plate 29). Sometimes, as in figure 89, the edge has the appearance of being wrapped, in a way reminiscent of her eventual treatment of the framing edge of *Hang Up* (see plate 27). Particularly in the later group of drawings, it can be summoned complete with sill, moldings, and the like, and its presence is emphasized by a back-and-forth hatching that is sometimes repeated till it has a barbed, sharp-edged density (fig. 90). What appears within the frame is equally varied: sometimes in the earlier drawings there are dark, vaguely humanoid shapes with round heads (on two different sheets is grouped a small family of such figures—four in all, just as in Hesse's own family; fig. 91). Sometimes the frame holds an orb with a spiraling or concentric center. Sometimes (again, particularly in the earlier drawings) it is filled with smaller compartments that in turn contain their own quasi-organic,

FIGURE 89. *Eva Hesse, Untitled, ca. 1961, black and brown ink washes on paper. 8⅞ × 5⅝ in. (22.5 × 14.3 cm.). Collection of Gail and Tony Ganz.*

mysterious shapes. Or the compartments—by 1964 Hesse had named them *boxes*—may be empty. In the later series, by contrast, the space within the frame is most often given over to effects of light and air, or their utter absence (figs. 92, 93). The illusions of luminosity and atmosphere suggest some space beyond the frame, while dark opacity revokes it completely.

The effects of these pictures encompass both the desire to see beyond the frame, and the fear of so doing. They alternately indulge that desire and prohibit it. They offer up the experience as either full or empty. These effects,

FIGURE 90. *Eva Hesse, Untitled, 1969, pencil and gouache on paper, 21⅜ ×
17 in. (54.7 × 43.2 cm.). Collection of Susan Englander.*

moreover, are carried over into Hesse's sculpture again and again. Her brand of
sculpture is pictorial, as has long been noted, not least by the artist herself, yet
as sculpture it simultaneously exposes and defeats the limits of pictorial repre-
sentation. *Hang Up* is the canonical example. The work is both picture frame
and window frame, with this simultaneous possibility making literal the cen-
tral metaphor of painting. And the frame is both full and empty: full of the
void, full of the literal world, and full of the emptying desire to see beyond it.
Its very emptiness means that the old pictorial protocols have been turned inside

FIGURE 91. *Eva Hesse, Untitled, 1960–61, gouache and ink on paper, 4½ × 6 in. (11.4 × 15.2 cm.). Private collection, New York.*

out. The space that ought to be behind the frame is now before it, delimited by the scooping arc of the wire jutting from it. The wire threatens to catch the viewer up into its new, materialized pictorial space.

Hang Up is an object, I am arguing, that though singularly empty, is packed full of a special understanding of the space beyond the frame. It takes the form of effectively confusing the boundaries and status of the two, playing them off against each other. That same equivocal position toward space and the viewer—what is inside, outside, and beyond—is reiterated by many of Hesse's sculptures, and the viewer is again and again reached out to, or refused access to the sculptural object. Hesse specializes in objects using surfaces and voids and compartments and ropes, and whatever their differences, all are similar in the overtures they make to the viewer. Those overtures involve solicitation and refusal—they throw us a rope, sometimes literally, always figuratively—but we can never be sure if we will be climbing in or out. Are we offered an exit, or being forced into a confrontation?

FIGURE 92. *Eva Hesse, Untitled, 1969, gouache, watercolor, crayon, colored ink, and pastel on paper, 22 × 17 in. (55.9 × 43.2 cm.). Gioia Timpanelli Collection, New York.*

These are real questions: that they cannot be answered is part of the point, part of the visual and conceptual excitement of conflating painting and sculpture in this way. Yet in asking them we risk losing sight of the workings of Hesse's unconscious—a notion that, after all, was the motivating impulse of this dis-cussion. But the artist and her unconscious are not far away. I hope it is clear that, among other possibilities, "the viewer" in the preceding paragraphs is Hesse herself. It is easy to slip back into an analysis of the pictorial and the sculptural and their redefinition of Hesse's hands, and to replace her by "the

FIGURE 93. *Eva Hesse, Untitled, 1969, gouache, black ink, watercolor, silver paint, and pencil, 22½ × 15 in. (57.2 × 38.1 cm.). Collection of Gail and Tony Ganz.*

viewer," because those representational issues are part of her conscious inten-tion: such an analysis is necessitated by the sheer intellectual scope of her visual idea. The forms repeatedly taken by those ideas, however—the consistent ter-minology of their repeated involvement with the frame and the void—are un-derwritten by their unconscious resonance for the artist. Not, however, that this is how she herself would have spoken of what she had done in *Hang Up*. At

the time she simply made the thumbnail sketch in her visual accounting of seven months' work. Here is some of what she said about it later, in 1970: *Hang Up* is

> the most important early statement I made. It was the first time my idea of absurdity of extreme feeling came through. . . . It is extreme and that is why I like it and don't like it. It's so absurd to have that long thin metal rod coming out of that structure. And it comes out a lot, about ten or eleven feet out, and what is it coming out of? It is coming out of this frame, something and yet nothing, and—oh! more absurdity!—it's very very finely done. The colors on the frame were carefully gradated from light to dark—the whole thing is ludicrous. It is the most ridiculous structure that I ever made and that it is why it is really good. It has the kind of depth I don't always achieve and that is the kind of depth or soul or absurdity or life or meaning or feeling or intellect that I want to get.[125]

To take Hesse's account of *Hang Up* as an adequate description of the work (which I think it is) means reading the various claims it registers about the piece. For a start, she suggests that in naming what it expresses we need not choose among "depth or soul or absurdity or life or meaning or feeling or intellect," but instead can grant it a measure of all these. Ludicrousness and absurdity are above all a matter of formal structure: Hesse is referring to its sabotage of the conventions of representation—the frame, chiaroscuro, spatial illusion—as she encountered them: her destructive handiwork fills her with glee. *Hang Up* is something, yet it is also nothing, despite the craft it took to make it. Yet while intellect and depth, and even meaning, may well follow from these important points, life and feeling must nonetheless be lodged elsewhere in the work. I think they are to be found in the intensity of its play with the spectator's responses—an intensity that likewise leaves its maker/spectator in two minds: "It is extreme and that is why I like it and don't like it." Like and dislike are the product, I wager, of the work's return to the scene of wish and prohibition.

Let me emphasize that in offering this line of argument I am not meaning to advance a singular, exclusive interpretation of Hesse's art. Although the practice of both drawing and sculpture may have been in some definitive sense the products of unconscious processes—and as such among the means she used to come to terms with the loss of her mother—their status as part of that process does

not in any sense provide a sufficient account of their appearance. Their uncon-scious content was screened or propped behind "strictly artistic" concerns, which in and of themselves could be taken, by viewers and artist alike, to pro-vide an adequate explanatory framework for her work, even though they might not explain it entirely.

One test of any interpretation involves a reckoning of the kind and range of phenomena it can account for. My view of Hesse's preoccupation with the win-dow motif, as well as the various visual phenomena that follow from it, makes carefully delimited claims. It speaks to some aspects of Hesse's work—but only some; above all it claims that her animation of minimalist forms (and minimalist theatricality) with effects able to elicit desire and fear might have arisen from a possible overlap between those forms and personal fantasy. I am not arguing, however, that Hesse offers us her *own* fantasy as the legible subject of her art. I think, rather, that she solicits responses that are considerably more metaphoric in kind. The animation of her work—her use of materials and shapes that might be said to grant her objects the status of substitute bodies—always occurs in a formal context assertive enough to remove the work (if it is considered seri-ously) from a purely personal range of meanings. Note too that it is *only* from this perspective that we can see Hesse's project as proposing a new subject for Minimalism: in retrospect that subject might be termed fantasy, though Hesse herself used a different term, one consistent with the conceptual tenor of her moment. In 1968 she wrote, "I don't ask that *Accession* be participated with other than in thought." To substitute "fantasy" in this formula is to recognize that the viewer's "thought" will respond to those aspects of Hesse's art that most thoroughly revise the Minimalist protocol, as well as those that retain it. It is to acknowledge too the emphasis she herself placed on such responses, rather than her own.

The body in question is likewise not so importantly Hesse's as the viewer's, in that the presence of the sculpture summons from the viewer such bodily analogies as his or her personal experience and mentality will allow. And the body is also that of the sculpture itself. Note, however, that though Hesse and the viewer were one and the same while any work was being made (and her bodily experiences thus implicated in the process of making), the recognition that Hesse was her own first viewer does *not* mean that she therefore imagined herself as the best or only one. She was inevitably aware that on completion art

becomes subject to other protocols of viewing, the transition effected by the terms of its adherence to a set of formal conventions. The various orders to which Hesse submitted her art—the regularity of the grid, the rhythm of a sequence or series, the compulsive staccato of repetition—are meant to open up the work to interpretations that are more (and less) than purely personal. A sculpture that utilizes the aggression and absurdity of the Minimalist grammar, however loosely or willfully, expects somehow to profit from that use. For Hesse, the payoff comes in the way that system can be made to invoke the conditions that are its conceptual opposites, without surrendering its claim to legibility or relevance within the artistic orders of the day.

This means that when we speak of Hesse's sculpture, we are not licensed *by it* to speak of frailty instead of strength, or chaos instead of order, or flesh instead of latex, or absence instead of presence. Instead there is always frailty and strength, chaos and order, flesh and latex, absence and presence. Nor are these terms necessarily experienced as discrete pairs or crisp oppositions, as Hesse's description of *Hang Up* can remind us once again. If it is useful to speak of them that way, this is because to do so is to register the rare scope and achievement of her art: its ability to exemplify such powerful dualities in singular material form and to have found a form that leaves them unresolved. Looking at the works, in other words, we cannot stay with a purely naturalistic model of the body, cannot see the sculpture as evoking firm and precise knowledge of an empirical real. Yet this impossibility does not thus permit the opposite view: the sculpture does not promote an understanding of the body as purely constructed, summoned only through the agency of language as pure difference. The sculpture is literal about the body, we could say, at the same time as it explodes the whole notion of literalness. It insists on its language-like character—its structures of repetition and transformation—at the same time as it maps those properties onto evocations of a carnal world. The body is there somewhere, at the intersection of structure and reference. Though that somewhere may seem close, Hesse's art insists that it is permanently out of reach.

The Cancellation of Difference

Speaking of Hesse's art many years after her death, Tom Doyle claimed, "The artist who had the most influence on Eva was Adolf Hitler."[126] The statement

was uttered as he aired his objections to some of the current responses to Hesse: he took issue particularly with the view that the late Joseph Beuys, whose work she had encountered in Germany, had meant much for the ultimate direction of her work. Beuys's art, according to Doyle, is "too Nazi" in tone, while Hesse's is anything but. This opinion appears here, however, not because it makes particular *artistic* sense—Doyle was not talking about style—but because it offers a frame for some conclusions about the purpose and meaning of Hesse's art.

Taking Hitler's "art" of genocide as the ultimate influence on Hesse—the circumstance to which her work most aimed to respond—helps give scale to her ambitions as an artist. I am thinking of her imagery more than her remarkable determination to succeed, even though the latter meant much to the path of her career. Already in 1959, just out of Yale, she was beginning the process of making a name for herself: she set her sights on inclusion in the MoMA exhibition *Sixteen Americans,* and was deeply chagrined when (unlike Jay DeFeo) she was not selected. By 1959 she had exhibited only on the Yale campus, yet she apparently had no compunction whatsoever about setting her sights on the top: no demurring, no self-abasement. Her confidence seems to have wavered a bit in the early 1960s—this was the period, remember, which she later saw as a regression. Once she had turned to making sculpture, however, she did not lose confidence in her art. She thought it was good, and she believed it was important, and she was right on both counts. Nor did she think that those two qualities were a function of her gender alone.

It is rare in the history of art to encounter an artist (a woman) who believes so confidently in her own practice (with so much reason) and rarer still to find such assurance echoed in the initial reception of her art. That confidence—we might call it entitlement—might have been "wrong," in the sense that it cannot be said to follow logically from the social and economic position of the majority of American women at this particular moment in history, or to reflect that position. The case of Hesse is an exceptionalism accounted for by the precise terms of the intersection, in this instance, between personal and historical circumstance. These are conditions that include the accidents of birth and family history, and their various consequences; the ideology of artistic selfhood current at the time; the urgencies and priorities of contemporary artistic practice; and so on. Their conjunction, in Hesse's case, enabled the staking out of a position which, "wrong" or not, was one of considerable strength.

Hesse's sense of entitlement, I have argued, concerned the protocols of modernism above all—protocols manifest in a variety of ways. Consider the assurance with which she was able to identify herself—or at least the artist she was at the outset of her career—as "an Abstract Expressionist." The label seemed to fit her practice and her identity adequately enough to override the apparent gender prescriptiveness of the role. And what about the artists to whom, at the end of her career, she claimed to feel the greatest affinity: Jackson Pollock, Claes Oldenburg, Bruce Nauman, Carl Andre, Andy Warhol, and Richard Serra? These were not casual or shallow identifications, summoned for the sake of conversation when an interviewer came to call. Hesse, for example, visited Serra's 1969 Guggenheim installation of lead props and jotted a series of sketches on an envelope, notes that in rapid sequence capture the gist of his main sculptural ideas (figs. 94, 95). (The drawing is one of only a few copies by Hesse of works of other artists to have survived; others transcribe images by Leonardo da Vinci.) The sketches give fragmentary evidence of a process demonstrated in extenso by her sculpture, namely, Hesse's profound engagement with the main artistic ideas of the day. Her embrace of the workings and reworkings of the modernisms exemplified by these various artists fueled the motor propelling her own work. I find no indications within it that these relations were other than productive for its range and scope; it might be equally productive for current viewers to learn to see these artists through Hesse's eyes. To do so would be to foreground their reliance on the fantasmatic and hyperbolic, the absurd and the irrational; these new emphases would help to deflate and undermine the totalizing claims (not just those of these artists) for the phallic power of their art.

Her art relates to their practices—and differs from them—by virtue of its effort to address and rectify modernism's apparent alienation from the real. Like Pollock, Warhol, Serra, and the others, Hesse took this problem as her point of departure. At issue in her art, as in theirs, is a conception of the aesthetic that defines its concern as the field of intersection between the bodily and the ideal, the empirical and the imaginary; her art likewise takes as its purpose the redefinition of the terms of that interaction.[127] Hesse's contribution to the modernism of her moment was the insistence, communicated in her art, that the aesthetic need not re-create the effect of bodily alienation that is the hallmark of modern life, but rather should counter that alienation by its insistent summoning of the sensual realm. Her work provides an experience of frailty within

FIGURE 94 (top). *Eva Hesse, Sculptures in Richard Serra's Guggenheim exhibition, 1969, pen on envelope, recto. Allen Memorial Art Museum, Oberlin College, Oberlin, Ohio.* FIGURE 95. *Eva Hesse, Sculptures in Richard Serra's Guggenheim exhibition, 1969, pen on envelope, verso. Allen Memorial Art Museum, Oberlin College, Oberlin, Ohio.*

order, disorder within unity; it urges no fictions of coherence, power, and completeness without broaching their opposite as a matter of course. Nor do I think that it offers any fictions of the female. To claim that Hesse's work looks the way it does because she was female is to claim very little: the statement is true because she was not male—this is historical fact—and not because the work can thus be said to offer a version of "the female experience." To think of the subject of Hesse's work as being, in some profound sense, "human" experience, rather than specifically female, is to make better sense of her ambitions as a modernist and as a historical subject working in the wake of the Holocaust (this is the "Hitler influence" of which Doyle spoke). It is likewise to resist

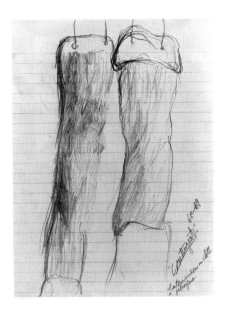 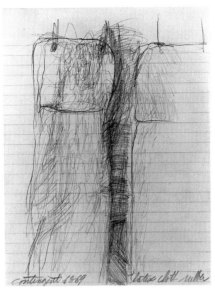

FIGURE 96 *(above, left). Eva Hesse, Study for* Contingent, *pencil on yellow lined paper, 11 × 8¼ in. (27.9 × 21 cm.). Allen Memorial Art Museum, Oberlin College, Oberlin, Ohio.* FIGURE 97. *Eva Hesse, Study for* Contingent, *pencil on yellow lined paper, 11 × 8¼ in. (27.9 × 21 cm.). Allen Memorial Art Museum, Oberlin College, Oberlin, Ohio.*

reinscribing both Hesse and her viewers within an ideology of the female that it has been feminism's main purpose to contest.

Such a refusal aims to acknowledge the lack of gender fixity of her imagery and to admit the equal status of male and female as mere flesh, fragile matter, both heir equally to disorder and death, and both invoked as such by her art. Sometimes, it is true, her imagery does stabilize to summon the male more than the female, or the female more than the male; "breast and penis" are each suggested at particular moments in her art, and the effects that evoke them are sometimes visually separable. Yet it is striking that when Hesse used this phrase to describe her imagery back in 1965 (such separable effects had been leached from her art by the end of the following year), she linked them as if their pairing (like "horse and carriage" or "oil and water") was mutually necessary, even inevitable. Later, however, specifically gendered references were erased, though in some cases their initial presence is documented by drawings that testify to a process of elimination. The preliminary drawings for *Contingent*, for example, make use of an explicitly phallic imagery (figs. 96, 97): they visualize the ele-

ments that will become the work's eight hanging parts as having a kind of bodily energy and a quasi-organic thickness and substance: rather than hang, they seem to stand or rise, and sometimes culminate in a thick protuberant head. These references are banished in the final work, along with any direct experience of bodily substance; now the work hangs, rather than stands, and it was partly this surrender of a prime sculptural property (the resistance to gravity) that allowed Hesse to speak of *Contingent* as painting rather than sculpture. Nor is *Contingent* the phallus. Hence Hesse could say, when Nemser asked her whether she thought of male or female forms: "I don't see that at all. I'm not saying female/male when I work at it and even though I recognize that is going to be said, I cancel that."[128]

"CAN CEL: 1. to make void, revoke; annul: *to cancel a reservation*. 2. to mark or perforate (a postage stamp, admission ticket, etc.) to render it invalid for reuse. 3. to neutralize, counterbalance; compensate for: *His sincere apology canceled his sarcastic remark*." It is impossible to cancel difference—Hesse's seat within the economy of gender was reserved for her from birth—yet that circumstance did not keep her from imagining another possibility, one that might compensate for the male/female polarity, even try "to render it invalid for reuse." The result was an art that comes to define its purpose as the incorporation (the embodiment) of difference just so as to neutralize that term. To "incorporate difference," by Hesse's lights, is to produce a sculpture invariably made up of parts. Its elements are distinct; they signify as separate pieces; their presence seems necessary to the work as a whole. I am thinking for example, of the gridded latex hemispheres of *Schema* (fig. 98) or the dented buckets of *Repetition Nineteen III* (plate 30). Yet Hesse's description of her concerns in the former work "as involving what is common to all members of a class" is a clue to the fate of difference in these contexts.[129] It certainly exists: the variations among buckets or hemispheres or any of the other components of the various pieces are there for scrutiny and description. But the most meaningful thing we can say of this or that buckle or dimple is that it exists "because she did it that way"—not a trivial verdict, of course, since an apparent distinction of Hesse's art from other Minimalist practice is thus secured—and the way thus opened to gendered interpretations.[130] But these corporeal differences are nonetheless never meaningful in and of themselves; instead individual variation is made meaningless by the place each element is assigned as a subordinate within a whole.

Hesse's concern to cancel difference has a range of other manifestations; indeed, some of them emerge in further work linked with *Schema* and *Repetition Nineteen*. *Schema*, for example, has a sequel called (what else?) *Sequel* (fig. 99), which both maintains and reverses the concerns of the earlier piece. Order cedes to disorder, parts (the hemispheres) yield to wholes (though an opening maintained in each sphere makes it evident they are less than complete). *Schema* is certainly different from *Sequel*—but that difference is only ever intelligible through their linkage, as a result of their mutual dependency and interreliance. And a similar point can be made via one of the offshoots of *Repetition Nineteen*: it is not another work of art, in this instance, but a series of photographs in which Hesse recorded four different arrangements of the first version of the piece (fig. 100). The snapshots document a key aspect of the work—that no one arrangement is definitive—but they also declare that differences of placement, though determinant of the work's fundamental character, cannot therefore erode or destabilize its overall import as a collection of cognate things.

This attitude toward difference has still other consequences. When asked by Nemser to describe her "opinion of the position of women artists in the art world" (the context was the letter to the artist setting up the 1970 interview), Hesse scrawled an immediate declarative reaction on the bottom of the page: "The way to beat discrimination in art is by art. Excellence has no sex." She was speaking in shorthand: when the statement is unpacked, she seems to be saying something like, "the woman who wants to beat discrimination in art must make work so good that it can elude its critics. The standard of excellence in art is universal, thus outside gender." I think that these phrases are an adequate rendering of Hesse's beliefs about art: I have tried to point to their origins, and to demonstrate that they are profoundly ideological, rather than simply rule them out of court. (It might have been tempting to do so, since they do not echo my own.) Accordingly, my stress has fallen on the ways this ideology proved itself enabling to Hesse's art—even when her actual experience ran counter to its ostensibly meritocratic ideals. Bound up within its assumptions, moreover, are materials useful to understanding her art. Excellence, as summoned in this statement, is clearly meant as a property both of maker and objects: it has implications for viewers as well. An excellent artist makes excellent works that are outside gender, and that, still paraphrasing Hesse, aim to "cancel female/ male." Such a cancellation does not propose androgyny as some kind of sexless

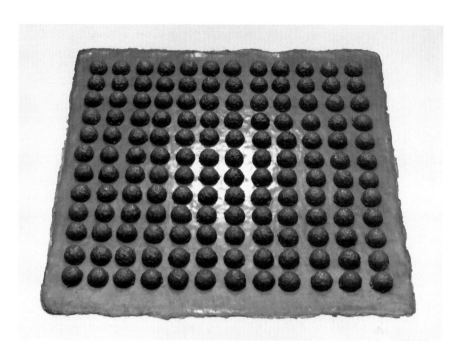

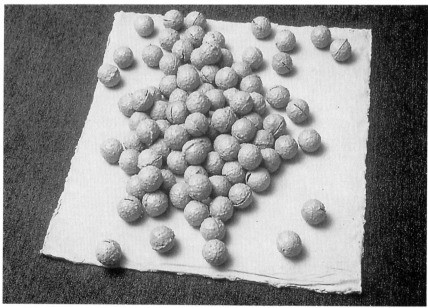

FIGURE 98 (top). Eva Hesse, Schema, 1967, latex, 42 × 42 in. (106.7 × 106.7 cm.). Philadelphia Museum of Art, Gift of Dr. and Mrs. Paul Todd Makler. FIGURE 99. Eva Hesse, Sequel, 1967, latex, 30 × 32 in. (76.2 × 81.3 cm.). Lannan Foundation, courtesy Robert Miller Gallery, New York

FIGURE 100. *Eva Hesse (?), Four photographs of various arrangements of* Repetition Nineteen I, *1968, plaster, Allen Memorial Art Museum, Oberlin College, Oberlin, Ohio.*

third term, or intend a version of sexual ambiguity, as might be the case in other instances. Instead it envisions viewers (viewers of "excellent art") who are human before and after they are male or female, embodied and sensate in ways more profoundly similar than different. Like Hesse's objects themselves, their similitude means that they can admit to difference, without that difference operating in ultimately disruptive ways. Here is an impressive project, yet one that might seem nowadays to exist at a real cultural remove. Thus the question arises: Has the notion of a profoundly human art become merely utopian or, worse, incorrect and illegible, the casualty of cultural amnesia and regulation? Have human embodiment and mortality become simultaneously so prosaic and sensationalized as to make us forget that they are what we most share?

To claim that Hesse's art aims to remember and express a common human quality or experience is not the same as attributing to it some universal force or

purpose. In other words, it gives *its own account* of that experience, an account that this chapter has made a stab at describing. We ourselves should remember that one source of that purpose is Hesse's "memory," as a Jew born in Hamburg in 1936, of the Holocaust—a memory that intersects her art and its criticism at many points, including this essay. Let us not fail to talk about that. Yet like "masculinity" or "femininity," "blackness" or "whiteness," this is a personal circumstance that nonetheless can never be only or simply personal. Nor, for that matter, is Hesse's art.

Making a Difference
to Modernism: An Epilogue

The Savage is flying back home from the New Country
in native-style dress with a baggage of sensibility
to gaze on the ancestral plains with the myths thought up
and dreamed in her kitchens as guides

 She will be discovered
as meaning is flocking densely around the words seeking a way
any way in between the gaps, like a fertilisation

 The work is
e.g. to write 'she' and for that to be a statement
of fact only and not a strong image
of everything which is not-you, which sees you

The new land is colonized, though its prospects are empty

The Savage weeps as landing at the airport
she is asked to buy wood carvings, which represent herself

 Denise Riley, ''A note on sex and
 'the reclaiming of language' ''

The volume recently added to the catalogue of Jackson Pollock's work is a triumph of thoroughness. It brings more works to the Pollock corpus—not just paintings and drawings, but a carved bone, a "totem pencil," a restaurant place mat webbed with doodles, even his paint-spattered studio floor—and more detail to our knowledge of Pollock's life and art. One new drawing comes from the household checkbook: a colon connects a spiky K to a resonating P. The terms of the linkage can only be deliberate. Pollock is proposing a ratio rather than an equivalence; "K is to P" is his claim.[1]

The new Pollock catalogue uses this small drawing as its colophon (fig. 101).[2] Scattered through its pages, the design also serves as the hallmark of cultural stasis and change. Stasis, in that given its context (to say nothing of its bristles and throbs), the sign might be a variation on the theme of "Adam's Rib." To make such a linkage a sign for *Pollock*, however, is a departure from the customary usage, which has by and large preferred to let the artist stand alone; if anything, "K:P" is the way *Krasner's* identity has more familiarly been understood.

Yet what if we were to consider this ratio as something more than a marital monogram, the hallmark of its household accounts? Let us detach "Krasner is to Pollock" from marriage, money, and their attendant ideologies: what then becomes striking is the incompletion of the phrase. It advances a proposition, fixes two quantities in a relationship, but does not spell out its terms. The reader is led into a state of uncertainty—with potentially complicating and tonic effect. Is this ratio to be thought of as a mathematical one: "the relation between two similar magnitudes in respect to the number of times the first contains the second: *the ratio of 5 to 2, written 5 : 2 or 5/2*"?[3] This definition has its possibilities, yet it is not the only one to come to mind. Might the sign be borrowed from the grammarian's tool kit, where it serves "to mark a major division in a sentence, to indicate that what follows is an elaboration, summation, implication, etc., of what precedes"?[4] More possibilities still—yet might not these letters' linkage also leave some larger comparison unstated? Krasner is to Pollock as. . . . As what? How are we to fill in the blanks?

I wrote this book as an effort to address such questions in both specific and general terms. They concern Hesse and O'Keeffe, as well as Krasner, and how the art of each might be defined. They likewise involve Doyle and Stieglitz and Pollock, albeit in different ways. Each instance, however, is one subset in a larger field of questions about the impact of social hierarchy and order, relation-

FIGURE 101. *Colophon from* Jackson Pollock: A Catalogue Raisonné of Paintings, Drawings, and Other Works, *supplement number one, 1995. From a drawing by Jackson Pollock, ca. 1946. Reproduced by permission of The Pollock-Krasner House and Study Center, East Hampton, N.Y.*

ship and difference, in key instances of twentieth-century American art. In addressing them I hope to make a difference to the ways those instances (and others like them) are seen and understood. I have returned to the familiar ratio, female to male, to make visible its inherent complexity and incompleteness—and above all to show that those qualities are importantly a matter of visual form. When transposed to visual representation, the relationship need not always—did not always—involve subordination and dependency. I think it is high time we learned to think more deeply about the representational purposes and ambitions of work by women, and to assess their place in a cultural dialogue. Only if we do so will we begin to give them their due. What would be better than to stimulate even deeper interest in the paintings and sculpture women have made, and to fuel other efforts to explicate them? Such efforts are always necessary to understand works of art, but they are specially necessary when the artist is a woman.

The necessity stems, not from the *fact* of womanhood, but from the social and cultural circumstances of female life—from the circumstances of sexual difference, in other words. Difference determines position and inflects experience; it has enforced subordination and dependency. And it also shapes psychic accommodations to bodily facts: it shapes fantasy. If we ask, "Different from

what?"—the question inevitably haunts any usage of this word—the answer is not "man" or "men" but the way these terms are privileged both in practice and ideology. By now these are the *doxa* of feminist thinking and scholarship: they are claims with which I agree.

Yet what I have argued in my three case studies is that "difference determines differently." I have claimed that women's position and women's experience, while marked by certain apparent social constants—by the institutions of sociability within modernity (by education and marriage, for example, conceived of as an economic and juridical relationship as well as a "personal" one)—are not most usefully thought of as marked by a correlative uniformity. Those experiences are inflected and rewritten by race and class, and within history. Not only is the category *women* obscured by the word *woman*, with its illusory homogeneity, but *women* too cannot be added up to form a unity. These ideas are not difficult; each study of the experience of women—when they are a part of Nazism or fundamentalism, for example, or mobilize a suffrage movement, or live as lesbians in the military, or work as authors and women of color—makes this abundantly clear. Work done lately on the redescriptions of sexuality by medicine and its technologies is another case in point: the transformations in the uses, powers, and limits ascribed to the body's basic organs mean that notions of "women" and "men" have not stayed—could not have stayed—the same over time.

The most recalcitrant category in this play of difference, however, is fantasy. Because fantasy negotiates fact and circumstance and experience, rather than describes them, it may be marked by difference in a backhanded way. It may be the means or locus for denial or refusal or negation of bodily conditions; claims for power and mastery may there be lodged. Such claims may be illusory, but this does not mean they may not be registered as discrete effects of behavior or language or the like. Perhaps it is in fantasy, more than anywhere, that the complications of gender and its recalcitrance as a category of definitive meanings may best be gauged.

Art, of course, is not the same as fantasy, even though it may aim to mine or suggest its effects—indeed may convey them, whether purposely or despite itself. Art is a social category and a perceptual experience; by definition the recognition of its existence establishes an admission of likeness, of belonging, with others: with artists, with viewers, with some wider culture or context

to which one's imagery is (imaginatively) addressed. To make art is to signal belonging, as much as difference; in this quite ordinary sense, it is like making a speech: one only does so in a language and with a rhetoric that others can be expected to grasp. Art in the West has traditionally been a male preserve. There is, if not an absolute stalemate, then at least some friction, between the concepts "art" and "difference." That friction is evident from both logical and practical points of view.

We need to spell out these few provisos because they name (once again) the conditions I have sought to explore. I have tried to instance the experience, as artists, of three women, and likewise to describe the experience, as women, of three artists—though this second topic has gotten somewhat shorter shrift. Their experiences were not the same. Some aspects of that experience—particularly the critical reception of their art—seem to have depended more on their status as women than on the characteristics of their work, even though critics have valued that status in very different ways. For O'Keeffe, to be a woman was everything, or nearly everything—it secured the main term of estimation for her art, tethering it to "the feminine" for good and all. She aimed to be an artist and a woman, and to claim those conditions as both distinct and mutually compatible. Lord help a woman with such an ambition in 1950: "wife" and "woman" were terms of diminution at that moment, as Krasner was to discover at her cost: no endorsement, however limited, followed from their use.

In Hesse's case the circumstances are different again. And though her work has served as the final study in this volume, it marks a beginning as well. Its confidence in using and inflecting and re-creating the existing artistic order was echoed in the practice of other artists of her generation—women such as Lynda Benglis and Jackie Winsor, Nancy Graves and Mary Miss. At the same time, the sustained commitments of certain older artists—Louise Bourgeois, for example, or Agnes Martin, Nancy Spero or Alice Neel—became visible for the first time. Hesse's art emerged at a moment marked by the claiming of new entitlements—a time of access and ambition and authorization and (re)emergent politics that, though now temporally distant, continues to shape artistic and critical practice today.

One of the things that strikes me most in thinking about Hesse's art is how ready and willing it seems to court comparisons, how open are its encounters with the assumptions and procedures of other art. (It is equally intent on seek-

ing comparison with itself.) Where O'Keeffe learned to mask her modernist ambitions, and Krasner to quell, even ventriloquize, her authorial voice, Hesse seems to have been bound by no such operative constraint. The phrase "Hesse is to . . ." might still be useful as an interpretative lever in the face of the work Hesse did, but now the ellipsis has no predetermined form or content. Fill in the blank: Hesse is to . . . Doyle? Pollock? Morris? Benglis? Allegiance and likeness and difference and refusal can all figure in these analogies, if in different measures. Her work seems in some sense to be the fulfillment of the image offered in Denise Riley's poem "A note on sex and the 'reclaiming of language'" as the emblem of artistic success:

> The work is
> e.g. to write 'she' and for that to be a statement
> of fact only and not a strong image
> of everything which is not-you, which sees you

The twists of Riley's thinking summon the artist's task as stating the fact of her gender *as fact*—"the work is / e.g. to write 'she'"—rather than reflecting the fiction of identity offered from outside. It is not so easy as it sounds. Nor has it been "her"—the artist's—only goal.

Yet the phrase still matters here. "The work is / e.g. to write 'she'" : one way to summarize the project of this book is as an exploration of that claim, above all as it concerns artistic authorship. Though the result may describe "the work"—the purposes—of these three artists, it also shows conclusively that their purposes have not been accomplished in any single—or even similar—way. Each woman fashioned her statement from different materials, and did so with different implications for the womanhood of her art; each understood rather differently who "she" was, and how to represent that sense. Confirmation, exaggeration, deflection, avoidance—the terms name only some of the ways. Not always as fact, in other words, but as performance or circumlocution or willed invisibility. Or even as fact. I think that Hesse came closest to that goal, in that she was the most concerned with keeping her formal vocabulary (whether grid or cube, wall plane or hanging sheet) separable from its possible fantasmatic effects. Such a separation, as Hesse understood it, insists that fantasy become the province and property of the viewer, rather than the maker herself.

But when do facts become fictions? When do they not, in art? Do not some facts contradict others, or court contradiction in their turn? What is at stake when they provoke from the viewer his or her own fictions in response? These questions begin to name some of the further problems broached by my chosen cases. And they begin to home in on some of the advantages offered my three artists by the modernisms of their day. These various formal strategies proved themselves pliable tools. They were the means to imagine other realms of figuration and different experiences and to depict them in ways that refuse to totalize, refuse to have "figuration" equal "figure" or "experience" equal "she."

These last phrases—I realize they can all too easily function these days as a post-modern mantra—are meant instead to take the reader back in time. And back through the pages of this study—to the oppositions in O'Keeffe's pictures between bodily illusion and absence, surface and center, coherence and dispersal. They are meant to invoke Krasner's deflections of meaning and coherence, as well as the "breaks" in her artistic voice. They aim finally to call back Hesse's delight in absurdity and the oxymoron, repetition and the hybrid form. Think too of her work with absence, vision, and objecthood. These are all effects summoned out of the modernist archive; to make use of them means grasping that they were potentially present within modernist practice itself. And as realized in such uses, they serve to demonstrate modernism's incompleteness as an object in history.

This understanding is, I think, one of the things these artists have to teach us: their special grasp of what modernism was in practice and what it could be made to do. No doubt these women's understandings of modernism worked against the grain, and were often thrown back in their faces—both O'Keeffe and Krasner are cases in point—but in retrospect they look not merely poignant, but also prescient, full of a consciousness to come. For these artists to see that modernism could be different—that they could use it in other ways—was to grasp the difference in modernism, and to turn it to new ends. And the matter does not stop there: it has made a difference to modernism that it was seen through these women's eyes. Laid bare are modernism's absences and its claim to coherence, its limits, its malleability, the strengths it did not know it had. "Words seeking a way / any way in between the gaps." Modernism will never be the same again.

The Art of Georgia O'Keeffe
by Mabel Dodge Luhan

The art of Georgia O'Keeffe is unconscious. It is the poignant speech of her living plasm talking while she sleeps, for her work is the production of a sleepwalker and one feels indelicate looking upon these canvases—for here are the utterances of one taken unawares; here indeed is made manifest the classical dream of walking naked on Broadway.

In the Stieglitz (Intimate, does he call it?) Gallery, O'Keeffe has found her protection, for here the art of sleepwalking is cultivated more passionately than in any other milieu I can recall. The Cult of the Unconscious—that is the Stieglitz hobby—the cult of coincidence and of accident.

That there may be a law underlying coincidental occurences, seems not so significant to Stieglitz as the sense of wonder contained in the ignorance regarding this law. For Stieglitz, the Apple of the Hesperides is the surprise package in the commonplace of life, and he says continually "Where the apple reddens, never pry, lest we lose our Eden—you and I: . . .

So the Stieglites [sic] move in an ecstasy of unreality, their heads in a cloud— "in the cloud of unknowing." So Georgia O'Keeffe externalises the frustration of her true being out on to canvases which, receiving her out-pouring sexual juices, lost while in the sleep of Unconscious Art, permit her to walk the earth with the cleansed, purgated look of fulfilled life!

But my God! we have heard of remedies for lost manhood and for other disorders of man's sexual function . . . Where shall we look for help for lost womanhood and for the power wasted and emitted in sleep?

There have always been those who favor catharsis: since the Greeks we look for this type of relief. The deposits of art, then, lie all about us, no more significant than the other deposited accretions and excrements of our organisms. Art purging us of our unused powers and of our energies, permits us to unload them on the ground, but they turn to poison in our blood.

Art *does not* transform raw energy into being—it runs it off onto canvas and paper, into stone and wood. Art is a safety valve and these materials are the non-conductors of cosmic fire. The art of today is the negation of being . . . the art in these *"Intimate"* galleries! It is well to call them intimate, for they are among the other "comfort stations" of our civilized communities.

So take Georgia O'Keeffe, then, and look boldly at her work. It is there for you to see. Do not feel embarrassed. Quiver and flush as you look and you will delight the showman. (We cultivate sensitiveness here in this Intimate Gallery.) Speak of feeling and of power, of woman, and of the soul . . . The showman will burn a trifle warmer at your recognition of this woman's vibrant sex. But he will not know why he burns, nor why his eyes glow with a deeper, darker fire.

Oh no! We do not wish to *know* here; we wish *not* to know. So to keep more firmly sealed from life the fountains that rise about us. So to keep from transformations more challenging to our maturity these energies that may remain *ours* only so long as they do not transform.

This woman's sex, Stieglitz, it becomes yours upon these canvases. Sleeping, then, this woman is your thing. You are the showman, here boasting of her faculty. More—you are the watchman standing with a club before the fate of her life, guarding and prolonging so long as you may endure, the unconsciousness within her.

You have not harvested these fruits, Stieglitz, you have not transformed these fires into purer being. You were not able to do this. Now, then, you immure them in an "Intimate Gallery" and we others, we go to look at this filthy spectacle of frustration that you exalt and call by the name of *Art*. You are a *camera-man*, Stieglitz, and the essential objection to photography applies to you. You do not create. Endlessly you re-present. . . . You photo-graph.

When will we rebel against you, I wonder? When shall we call you—cards on the table? Give up, Stieglitz, let live. Let live this somnolent woman by your side.

But, Camera-man, do you dare, I wonder, face the sun?

Beinecke Rare Book and Manuscript Library,
Yale University, New Haven, Conn.
Mabel Dodge Luhan Papers

Notes

Chapter 1

1. Linda Nochlin was well aware of its annoyances when she used it as the title for her notorious 1971 essay "Why Have There Been No Great Women Artists?" reprinted in *Women, Art, and Power and Other Essays* (New York: Harper and Row, 1988), 145–78; the essay was first published as "Why Are There No Great Women Artists?" in *Women in Sexist Society: Studies in Power and Powerlessness*, ed. Vivian Gornick and Barbara K. Moran (New York: Basic Books, 1971), 480–510; also reprinted as "Why Have There Been No Great Women Artists?" in *Art News* 69:9 (January 1971) and in Thomas B. Hess and Elizabeth C. Baker, eds., *Art and Sexual Politics* (New York: Collier, 1973), 1–39.

2. Anne M. Wagner, "Lee Krasner as L.K.," *Representations* 25 (Winter 1989): 42–57; reprinted in *The Expanding Discourse*, ed. N. Broude and M. Garrard (New York: Harper Collins, 1992), 422–35.

3. Elaine de Kooning with Rosalyn Drexler, "Dialogue," in Hess and Baker, *Art and Sexual Politics*, 56.

4. This criticism is leveled by Michael Leja in *Reframing Abstract Expressionism: Subjectivity and Painting in the 1940s* (New Haven and London: Yale University Press, 1993), 266–67. Leja concludes that "Krasner's work thematizes a situation that faced all aspiring Abstract Expressionists who were women." His conclusion is sympathetic, but not presented with the analysis of painterly practices necessary to its support. Note too Denise Riley's detailing of the uses, from Rousseau to one Captain Maxse, of the charge of "overpersonalisation" to question female analytic abilities. See *"Am I that Name?" Feminism and the Category of "Women" in History* (Minneapolis: University of Minnesota Press, 1988), esp. 37, 88.

5. Roberta Smith, "Scant Space for Show by Women," *New York Times*, June 24, 1994.

6. For an example of serious questions put to 1980s feminism, see the contributions of Adrian Piper and Yvonne Rainer to "Questions of Feminism: Twenty-five Responses," *October* 71 (Winter 1995): 35–37.

7. Anne M. Wagner, "How Feminist Are Rosemarie Trockel's Objects?" *Parkett* 33 (September 1992): 60–74 (in English and German).

8. Elizabeth Murray, in Lilly Wei, "Talking Abstract," *Art in America* 75 : 7 (July 1987): 92.

9. Lynn F. Miller and Sally S. Swenson, eds., *Lives and Works: Talks With Women Artists* (Metuchen, N. J., and London: Scarecrow Press, 1981), 129.

10. Jutta Koether, "Interview with Rosemarie Trockel," *Flash Art* 134 (May 1987): 40–42.

11. Ruth Leys, "The Real Miss Beauchamp: Gender and the Subject of Imitation," in Judith Butler and Joan W. Scott, eds., *Feminists Theorize the Political* (New York and London: Routledge, Chapman and Hall, 1992), 167–214.

12. Dolores Hayden, in *The Grand Domestic Revolution: A History of Feminist Designs for American Homes, Neighborhoods, and Cities* (Cambridge and London: MIT Press, 1981), uses the Victorian notion of "woman's sphere" as her point of departure and in fig. 1.7 provides a graphic illustration of the concept from *The Housekeeper's Annual and Lady's Register* (1844). Cécile Whiting has helpfully discussed the imagery of women's roles in the 1960s; see "Figuring Marsiol's Femininities," *RACAR* (*Revue d'art canadienne/ Canadian Arts Review*) 17 : 1–2 (Spring 1991): 72–90.

13. Joan Riviere, "Womanliness as a Masquerade," first published in *International Journal of Psychoanalysis* 9 (1929): 303–13; quotation from *The Inner World and Joan Riviere: Collected Papers, 1920–1958* (London: Karnac Books, 1991), 91.

14. Lucy R. Lippard, *Eva Hesse* (New York: New York University Press, 1976), 24–25.

15. Catherine A. MacKinnon, *Towards a Feminist Theory of the State* (Cambridge and London: Harvard University Press, 1989); Gilbert Y. Steiner, *Constitutional Inequality: The Political Fortunes of the Equal Rights Amendment* (Washington, D.C.: Brookings Institution, 1985).

16. These often-quoted phrases are from a statement composed by the artist for publication in *Alfred Stieglitz Presents One Hundred Pictures: Oils, Watercolors, Pastels, Drawings, by Georgia O'Keeffe, American* (New York: Anderson Galleries, January 29–February 10, 1923); reprinted in Barbara Buhler Lynes, *O'Keeffe, Stieglitz, and the Critics, 1916– 1929* (Ann Arbor and London: UMI Research Press, 1989), 184–85.

17. Although histories of the experiences of American women in art education have begun to be written, they have not yet been undertaken from a critical point of view. See Gail Levin, "The Changing Status of American Women Artists, 1900–1930," in *American Women Artists, 1830–1930*, ed. Eleanor Tufts (Washington, D.C.: National

Museum of Women in the Arts, 1987), 12–26; and Randy Rosen et al., *Making Their Mark: Women Artists Move into the Mainstream, 1970–1985,* ed. Catherine Brawer (New York: Abbeville Press, 1989).

18. Lippard, *Eva Hesse,* 21–22.

19. May Stevens, in *Lives and Works* (as in note 9), 224–25.

20. Mary Kelly, "Re-viewing Modernist Criticism," *Screen* 22:3 (Autumn 1981): 41.

21. Ibid., 42.

22. Griselda Pollock, "Screening the Seventies: Sexuality and Representation," in *Vision and Difference: Femininity, Feminism, and the Histories of Art* (London: Routledge, 1988), 159.

23. Griselda Pollock, "Feminism and Modernism," in *Framing Feminism: Art and the Women's Movement, 1970–1985,* ed. Rozsika Parker and Griselda Pollock (London: Pandora Press, 1987), 103.

24. Lisa Tickner's discussion of women, modernism, and sexual difference offers further helpful support for these ideas. See "Men's Work? Masculinity and Modernism," *Differences* 4 (Fall 1992): 1–37.

25. Rozsika Parker and Griselda Pollock, *Old Mistresses: Women, Art, and Ideology* (New York: Pantheon Books, 1981), 134.

26. Ibid., 169.

27. Nochlin, *Women, Art, and Power,* 149.

28. As Carol Duncan pointed out in "When Greatness Is a Box of Wheaties," *Artforum* (October 1975): 60–64; reprinted in Duncan, *The Aesthetics of Power: Essays in Critical Art History* (Cambridge: Cambridge University Press, 1993), 121–32. Cindy Nemser's *Art Talk: Conversations with Twelve Women Artists* (New York: Scribner, 1975) makes a concerted effort to refute Nochlin's claim.

29. See both Duncan, ibid., and Parker and Pollock, *Old Mistresses,* for articulate enunciations of this position.

30. John Guillory, *Cultural Capital: The Problem of Literary Canon Formation* (Chicago and London: University of Chicago Press, 1993), xiv.

31. Michael Baxandall, "The Language of Art History," *New Literary History* 10 (1978–79): 454–55.

32. Georgia Collins and Renee Sandell, *Women, Art, and Education* (Reston, Va.: National Art Education Association, 1984).

33. Guillory, *Cultural Capital,* 10.

Chapter 2

1. Ernst Kris and Otto Kurz, *Legend, Myth, and Magic in the Image of the Artist: A Historical Experiment* (New Haven and London: Yale University Press, 1979).

2. Marsden Hartley, "291—and the Brass Bowl," in Waldo Frank et al., eds., *America and Alfred Stieglitz: A Collective Portrait* (New York: Literary Guild, 1934), 240.

3. The most extensive discussion of the individual's sensations of externality to social identifications of gender categories is Denise Riley, *"Am I That Name?" Feminism and the Category of "Women" in History* (Minneapolis: University of Minnesota Press, 1988).

4. The Museum of Modern Art and Philadelphia Museum of Art, *Marcel Duchamp,* ed. Anne d'Harnoncourt and Kynsaton McShine, 1973, 212–13.

5. This list of O'Keeffe's early exhibitions is culled from the chronology given in Jack Cowart and Juan Hamilton, with Sarah Greenough, *Georgia O'Keeffe: Art and Letters* (Boston, Toronto, and London: National Gallery of Art with Little, Brown and Company, Bulfinch Press, 1987), 291–94.

6. Thomas Craven, *Modern Art: The Men, the Movements, the Meaning* (Garden City, N.Y.: Halcyon House, 1950), 311; this edition is a reprint of the revised edition of 1940; the text was first published in 1934.

7. Henry Tyrrell, "New York Art Exhibition and Gallery Notes: Esoteric Art at '291,'" *Christian Science Monitor,* May 4, 1917, 10; reprinted in Barbara Buhler Lynes, *O'Keeffe, Stieglitz, and the Critics, 1916–1929* (Ann Arbor and London: UMI Research Press, 1989), 167.

8. The 291 exhibitions are listed in Dorothy Norman, *Alfred Stieglitz: An American Seer* (New York: Aperture Foundation, 1960); and Sue Davidson Lowe, *Stieglitz: A Memoir/Biography* (London: Quartet/Or! Books, 1983).

9. Craven, *Modern Art,* 313.

10. *Lovingly, Georgia: The Complete Correspondence of Georgia O'Keeffe and Anita Pollitzer,* ed. Clive Giboire (New York: Simon and Schuster, "A Touchstone Book," 1990), 40.

11. Pollitzer to O'Keeffe, January 1, 1916, ibid., 115–16.

12. This detail is reported by Benita Eisler, *O'Keeffe and Stieglitz: An American Romance* (New York: Doubleday, 1991), 7. It has been confirmed to me in a letter of December 9, 1994, from Patricia C. Willis, Curator of American Literature at the Beinecke Rare Book and Manuscript Library, Yale University. She identifies the phrase "Finally, a woman on paper" as "probably written in Pollitzer's hand."

13. [Alfred Stieglitz], "Georgia O'Keeffe—C. Duncan—Réné Lafferty," *Camera Work,* no. 48 (October 1916): 12–13; reprinted in Lynes, 166–67.

14. Lynes, 167.

15. For a discussion of this linguistic transformation, see Nancy F. Cott, *The Grounding of Modern Feminism* (New Haven and London: Yale University Press, 1987), 13–20.

16. Norman, *Alfred Stieglitz,* 120–22.

17. Tyrrell (as in note 7); reprinted in Lynes, 167–68.

18. Marsden Hartley, *Adventures in the Arts: Informal Chapters on Painters, Vaudeville, and Poets* (New York: Boni and Liveright, 1921), 116–19; reprinted in Lynes, 170.

19. Paul Rosenfeld, *Port of New York: Essays on Fourteen American Moderns* (New York: Harcourt, Brace, 1924), 205; reprinted in Lynes, 207.

20. Paul Rosenfeld, "The Paintings of Georgia O'Keeffe: The Work of the Young Artist Whose Canvases Are to Be Exhibited in Bulk for the First Time This Winter," *Vanity Fair* 19 (October 1922): 112; reprinted in Lynes, 178; note that Rosenfeld uses this same passage in *Port of New York*, 206 (reprinted in Lynes, 207).

21. See above, note 7.

22. "Henri Matisse" and "Pablo Picasso," *Camera Work*, special issue (August 1912): 23–25, 29–30. Stein contributed a brief text to Frank, *America and Alfred Stieglitz*, 280. Sarah Greenough, in Cowart and Hamilton, *Art and Letters*, 135 and 138–39 n. 6, notes a similarity between O'Keeffe's style and Stein's but does not claim direct influence.

23. Hugh M. Potter, *False Dawn: Paul Rosenfeld and Art in America, 1916–1946* (Ann Arbor: UMI Press for the University of New Hampshire, 1980), 125–26; Potter quotes Mumford, "Beyond Musical Criticism," *Dial* 78:5 (May 1925): 413, who is replying to Gorham Munson, "The Mechanics for a Literary Secession," *S4N* 22 (November 1922): quoted in Potter, 123.

24. Munson's phrase seems homophobic enough to open the possibility that enthusiasm for O'Keeffe was once read as a sign of a gay sensibility, an idea that is the more likely given the fraught relationship of the Stieglitz circle to contemporary notions of masculinity. For a discussion of some of these relationships, see Casey Nelson Blake, *Beloved Community: The Cultural Criticism of Randolph Bourne, Van Wyck Brooks, Waldo Frank, and Lewis Mumford* (Chapel Hill and London: University of North Carolina Press, 1990).

25. Simone de Beauvoir, *The Second Sex*, trans. and ed. H. M. Parshley (New York: Alfred A. Knopf, 1952), 162; first published in French as *Le Deuxième Sexe* (Paris: Gallimard, 1949).

26. A passage from Paul Rosenfeld's first essay on O'Keeffe gives an impassioned view of the role of 291 and its painters in opposing the specially American version of contemporary materialism: "For after all, America is not 'materialistic'; for pure materialism one must go to Europe; Americans do not love money; they squander it madly. The protest of 291 was made against the fierce disregard of the value of human life, of the value of materials, forests, sky, against the ruthlessness of destructive children that is so terribly the Western malady. To the hate and fear of nature that cloaks itself under the vaulting ambitions of the business world, there was opposed, always with the accent on their quality, their humaneness, their personal reference, the revolutionary works of contemporary Europe and America. The inhuman world had entrenched itself in the field of art by means of the belief that all good work had been done in past time, that this was the age of the machine, and there was something fresh, young, and athletic in the disregard for the irresponsibly beautiful." Lynes, 173.

27. This and the above quotations from David Arkin to Alfred Stieglitz [July 1927],

Stieglitz Papers, Beinecke Rare Book and Manuscript Library, Yale University, New Haven, Conn. Though Arkin's letter is undated, it was mailed from Paris on July 3, 1927.

28. Lewis Mumford, *Findings and Keepings: Analects for an Autobiography* (New York and London: Harcourt, Brace, Jovanovich, 1975), 356.

29. Jeffrey Hogrefe, *O'Keeffe: The Life of an American Legend* (New York: Bantam Books, 1992), 328.

30. Judy Chicago, *Through the Flower: My Struggle as a Woman Artist* (New York: Anchor/Doubleday Books, 1975), 142.

31. This point has also been made by other writers on O'Keeffe. See Lynes, 160; Laurie Lisle, *Portrait of an Artist: A Biography of Georgia O'Keeffe* (Albuquerque: University of New Mexico Press, 1986), 355.

32. Lisle, 355; Chicago, 166.

33. Chicago, 177.

34. Ibid.

35. O'Keeffe to Doris McMurdo, July 1, 1922, Cowart and Hamilton, *Art and Letters*, 170.

36. O'Keeffe to Mitchell Kennerley [Fall 1922], ibid.

37. O'Keeffe to Doris McMurdo, July 1, 1922, ibid., 169.

38. *Vanity Fair* 18 (July 1922): 50; reproduced in Lynes, 175.

39. O'Keeffe to Mabel Dodge Luhan [1925?], Cowart and Hamilton, *Art and Letters*, 180.

40. Mabel Dodge Luhan, "The Art of Georgia O'Keeffe," Mabel Dodge Luhan Papers, Beinecke Rare Book and Manuscript Library, Yale University, New Haven, Conn. The presence of the manuscript among Luhan's papers, rather than O'Keeffe's, suggests that the painter never saw it; I know of no copy, at any rate, among her own effects.

41. Ibid.

42. O'Keeffe to Blanche C. Matthias [March 1926], Cowart and Hamilton, *Art and Letters*, 183.

43. Blanche C. Matthias, "Georgia O'Keeffe and the Intimate Gallery: Stieglitz Showing Seven Americans," *Chicago Evening Post Magazine of the Art World*, March 2, 1926; reprinted in Lynes, 247.

44. Ibid.

45. O'Keeffe to Sherwood Anderson, February 11, 1924, Cowart and Hamilton, *Art and Letters*, 176.

46. Samuel M. Kootz, *Modern American Painters* (New York: Brewer and Warren, 1930), 19.

47. Ibid.

48. Arthur Dove to Alfred Stieglitz [December 5, 1930], in Ann Lee Morgan, ed.,

Dear Stieglitz, Dear Dove (Newark: University of Delaware Press; London and Toronto: Associated University Presses, 1988), 201. Stieglitz informed Dove that he had sent Kootz a copy of his note on O'Keeffe in a letter of December 20, 1930, and reported that Kootz "liked it much." See Morgan, 204.

49. Gladys Oaks, "Radical Writer and Woman Artist Clash on Propaganda and Its Uses," *New York World*, March 16, 1930, woman's sec., 1, 3.

50. The following discussion warmly acknowledges its debt to ideas advanced by Lucia Tripodes in a paper written for my seminar at the University of California, Berkeley, in Spring 1992.

51. Sarah Whitaker Peters devotes the first chapter of her book *Becoming O'Keeffe: The Early Years* (New York: Abbeville Press, 1991) to discussing the various visual sources, including Art Nouveau and the teachings of Arthur Wesley Dow, with which O'Keeffe might have come in contact or which were part of the various contexts of her education.

52. O'Keeffe had a variety of terms for this process: for example, in a letter of September 1923 to Sherwood Anderson, she called it "making your unknown known." She wrote: "I feel that a real living form is the natural result of the individuals [*sic*] effort to create the living thing out of the adventure of his spirit into the unknown—where it has experienced something—felt something—it has not understood—and from that experience comes the desire to make the unknown—known." Cowart and Hamilton, *Art and Letters*, 174.

53. The internal history of the making of the *Specials*, which shows ideas and formats being developed, restated, and revised, as well as O'Keeffe's notable predilection for working in series (a highly comparative format), is evidence in favor of this view.

54. Precise dating of these series is somewhat vexed. Though those titled *Red and Blue* are customarily dated 1916, no document known to me ties them to that year. Peters, *Becoming O'Keeffe*, 186, places the *Portraits* in the wake of O'Keeffe's spring 1917 visit to New York. The date hinges on the artist's sending at least one from the group to Paul Strand in mid June 1917 on her return to Texas. Peters follows Roxana Robinson in dating the nudes to spring 1918. A terminus post quem is supplied by a Stieglitz letter from late May or early June 1918 that makes it clear that at least some of them were by then in his hands. See Peters, 109–12; Roxana Robinson, *Georgia O'Keeffe: A Life* (New York: Harper and Row, 1989), 199. According to Robinson, the Portrait series represents a mechanic called Kindred M. Watkins.

Nine drawings by Rodin were reproduced by photogravure in *Camera Work*, April–July 1911, 34–35.

55. In O'Keeffe's account of her early career, her response to the Rodin show serves as a notable emblem of negation, as well as of her sense of alienation from male argument about art: "The drawings were curved lines and scratches with a few watercolor washes and didn't look like anything I had been taught about drawing. The teachers

at the League thought that Stieglitz might just be fooling the public with the name Rodin, or that Rodin might be fooling both Stieglitz and the public with such drawings. I think that some of them were supposed to have been done with his eyes shut. At that time they were of no interest to me—but many years later, when I was settling Stieglitz's estate, they were the drawings I most enjoyed.

"The boys began to talk with Stieglitz and soon the conversation was heated and violent. I went to the end of the smallest room. There was nothing to sit on—nothing to do but stand and wait. Finally, after much loud talk the others came for me and we went down to the street." Georgia O'Keeffe, *Georgia O'Keeffe* (New York: Viking Press, 1976), n.p.

56. I am grateful to Michael Fried, whose suggestion that the nudes seemed to him like drawings done from photographs spurred me to articulate these ideas concerning the odd fixity of their forms.

57. O'Keeffe to Sherwood Anderson, February 11, 1924, Cowart and Hamilton, *Art and Letters*, 176.

58. Sheldon Cheney, *Expressionism in Art* (New York: Liveright, 1934), 341.

59. Edmund Wilson, "The Stieglitz Exhibition," *New Republic* 42 (March 18, 1925): 97–98; reprinted in Lynes, *O'Keeffe, Stieglitz, and the Critics*, 228: "In other pictures it seems plain that these anomalies [of color] are deliberate and significant and we recognize them as analogous to the dissonances of modern poetry and music." Marya Mannes, "Galley Notes: Intimate Gallery," *Creative Art* 2 (February 1928): 7; reprinted in Lynes, 282: "Much of her color, however, strikes me as shrill and acidulous, thinly dissonant."

60. Louis Kalonyme, "Georgia O'Keeffe: A Woman in Painting," *Creative Art* 2 (January 1928): xxxiv–xl; reprinted in Lynes, 282.

61. Mannes, "Gallery Notes," 282–83.

62. "Exhibitions in New York. Georgia O'Keeffe. An American Place," *Art News*, January 24, 1931, 9.

63. Henry McBride, "Paintings by Georgia O'Keefe [*sic*]: Decorative Art That Is Also Occult at the Intimate Gallery," *New York Sun*, February 9, 1929; Lewis Mumford, *New Yorker*, February 10, 1934, 48. McBride made something of a specialty of reporting on viewers at O'Keeffe's shows; as he said in this same review, "It's the behavior of the people who attend it that counts." In his *New York Sun* review of January 2, 1932, "Skeletons on the Plain: Miss O'Keeffe Returns from the West with Grewsome [*sic*] Trophies," he reported that more men than women were present: "There is cause for suspicion that Miss O'Keeffe's clientele is changing its sex. And that, as they say, would be news."

64. "Georgia O'Keeffe," An American Place, January 22–March 17, 1939, Archives of American Art, Whitney Museum Papers, roll N679, frame 168.

65. *Georgia O'Keeffe*, n.p.

66. O'Keeffe to Waldo Frank, January 10, 1927, Cowart and Hamilton, *Art and Letters*, 185.

67. The scene occurs in chapter 3. See D. H. Lawrence, *Women in Love* (first published 1921). "Nature responds so beautifully" is the first line of "Roses." See *The Complete Poems of D. H. Lawrence*, ed. V. de Sola Pinto and W. Roberts (Harmondsworth: Penguin, 1977), 831.

68. Chapter 10, *Women in Love*. The passage is also quoted by Anaïs Nin, *D. H. Lawrence: An Unprofessional Study* (Paris: Lecram Press, 1932), 131.

69. Paul Strand, "Georgia O'Keeffe," *Playboy: A Portfolio of Art and Satire* 9 (July 1924): 16–20; reprinted in Lynes, *O'Keeffe, Stieglitz, and the Critics*, 217.

70. Perhaps the inappropriateness and incongruity of this imagery as a synonym for "O'Keeffe" lies at the root of the claim lodged by Sue Davidson Lowe, the photographer's biographer and grandniece, that the pictures were "love-note" paintings for Alfred; see her *Stieglitz: A Memoir/Biography*, 310.

71. That the phallic sexuality claimed in the *Jack* series did not become a permanent attribute of O'Keeffe's reputation is testified to by a variety of sources—none so explicit as a passage from Anaïs Nin's erotic novel *Delta of Venus* [1940] (New York: Bantam, 1977), 174, in which a character describes the art of a painter clearly meant to be recognizable as O'Keeffe: "One of them was talking about the woman painter who was filling the galleries with giant flowers in rainbow colors. 'They're not flowers,' said the pipe smoker, 'they're vulvas. Anyone can see that. It is an obsession with her. She paints a vulva the size of a full-grown woman. At first it looks like petals, the heart of a flower, then one sees the two uneven lips, the fine center line, the wavelike edge of the lips, when they are spread open. What kind of a woman can she be, always exhibiting this giant vulva, suggestively vanishing into a tunnellike repetition, growing from a larger one to a smaller, the shadow of it, as if one were actually entering into it. It makes you feel as though you were standing before those sea plants which open only to suck in whatever food they can catch, open with the same wavering edges." This vignette was clearly not written to the requirements of Nin's patron; on the contrary, his stipulation that she "leave out the poetry" has become notorious. It seems appropriate to see this passage, in a novel published by its author as evidence of the beginnings of a female erotic imagination, as expressing its writer's opinion and, likewise, to see its question as Nin's own.

72. Clement Greenberg, *The Collected Essays and Criticism*, II, ed. John O'Brian (Chicago: University of Chicago Press, 1986), 87; reprinted from *Nation*, June 15, 1946.

73. Lewis Mumford, "Sacred and Profane," *New Yorker*, February 10, 1934.

74. Pollitzer to O'Keeffe, August 1927, O'Keeffe, *Complete Correspondence*, 273.

75. Susan Glaspell, *The Verge* (Boston: Small, Maynard, 1922), 20–21.

76. Anna C. Chave, "O'Keeffe and the Masculine Gaze," *Art in America* (January 1990): 119–20.

77. Ibid., 124.

78. I am thinking of the books by Jeffrey Hogrefe and Benita Eisler. Eisler's claims to intimate knowledge of O'Keeffe's sexual life are so misleading that Naomi Rosenblum, in a review of the book (and of other recent work on O'Keeffe) was at pains to document her conversation with Patricia C. Willis, Curator of American Literature at the Beinecke, in which Willis attested that Eisler had not had access to these materials. See Naomi Rosenblum, "Georgia O'Keeffe," *Art Journal* 51 : 1 (Spring 1992): 113 n. 4.

79. *Two Lives: A Conversation in Paintings and Photographs*, ed. Alexandra Arrowsmith and Thomas West (New York: Harper Collins Publishers/Callaway Editions in Association with The Phillips Collection, 1992); for the parallels cited here, the shed and flagpole at Lake George, and the diagonal motif (in the case of Stieglitz it occurs in a photograph of O'Keeffe's neck, while for O'Keeffe it is found in a painting of leaves), see 72–73 and 68–69.

80. *An Exhibition of Photography by Alfred Stieglitz—145 Prints, over 128 of Which Have Never Been Publicly Shown, Dating from 1886–1921*, February 7–21, 1921.

81. Paul Rosenfeld, "Stieglitz," *Dial* 70 : 4 (April 1921): 398.

82. Peters, *Becoming O'Keeffe*, 148–49, has used Stieglitz's letters to Paul Strand to document this point.

83. *Georgia O'Keeffe: A Portrait by Alfred Stieglitz* (New York: Metropolitan Museum of Art, 1978), n.p.

84. Ibid. [5].

85. Ibid. [8–9].

86. Ibid. [11].

87. Ibid. [9].

88. Alfred Stieglitz to Paul Strand, November 17, 1918, Center for Creative Photography, Paul Strand Collection, University of Arizona, Tucson, cited in Sarah Greenough and Juan Hamilton, *Alfred Stieglitz: Photographs and Writings* (Washington, D.C.: National Gallery of Art, 1983), 231 n. 30.

89. Herbert J. Seligmann, "A Photographer Challenges," *Nation*, February 16, 1921, 268. The quotation continues: "What is this man, this woman? If he or she can look pleasant, then that pleasantness is only the gesture concealing something of which that human being is afraid. Very well. Move the camera closer. Push farther the limits of chemistry, of developing and printing, of paper and mounting. Photograph every pore in that person's face at the extremes of looking pleasant and of terror. A Stieglitz portrait, then, becomes one, two or three or half a hundred photographs."

90. Ibid.

91. Stieglitz's catalogue "Statement" for this exhibition makes this intention explicit in a famous passage: "My ideal is to achieve the ability to produce numberless prints from each negative, prints all significantly alive, yet indistinguishably alike,

and to be able to circulate them at a price not higher than that of a popular magazine or even a daily paper. To gain that ability there has been no choice but to follow the road I have taken." Quoted here from Herbert J. Seligmann, "291: A Vision through Photography," in Frank, *America and Alfred Stieglitz,* 116. The "Statement," it should be noted, was reproduced at the time in the daily press as well as in the catalogue: Henry McBride, for example, quoted the whole text in the *New York Herald,* February 13, 1921.

92. The men in Stieglitz's photographs are attributed their own kind of "difference," psychic abnormalities that make them entirely unable to meet the challenge of the camera. This is how Paul Rosenfeld describes the portraits of "the group of workers that centered in 291": "Men these are, but men strangely tied, strangely contorted. They seem a new sort of fish peering through aquarium walls of glass. One, his neck wrapped in a muffler that is like a vice, gazes out of his shell in fright and in hopeless straining to be loosed. Another, a ghastly Greco whiteness on his shirt, sits in a chair as if that chair were the electric executor in the death-house at Sing-Sing. Another, a sort of young Albrecht Dürer, slumps dejectedly; still another peeps timidly and elfishly out of a silvery murk. Others seem pressed in upon themselves by black weights, sit folded up in themselves, hold up their heads into a white aureole of mad conceit, stand minuscule amid a debris of pictures, shoulder their way ruthlessly and uncouthly, appear on the point of coming to pieces and drifting away into nowhere. Only one, a negro, gazes out in warm, unselfish devotion." "Stieglitz," 407–8.

93. In his poem "Stieglitz: Early Photographs of O'Keeffe," David Dooley responds to this and other aspects of these images. See "From O'Keeffe and Stieglitz," *Hudson Review* (Winter 1990): 578–90.

94. This necessity is demonstrated by the fact that although Stieglitz executed other composite portraits—for example, he took hundreds of pictures of his daughter, Kitty—none has the standing of *Georgia O'Keeffe: A Portrait* in the making of his reputation. It is notable for my interpretation of the rhetorical meaning of the Portrait that there are no composite portraits of men.

95. Peters, *Becoming O'Keeffe,* 157, thinks that this gesture "comes straight from" a drawing by Rodin, *Standing Female Nude Squeezing Breasts Together,* ca. 1900, which was shown at 291 in 1908, and reads it as a gesture of "self-fertilization." While it seems probable that O'Keeffe's gesture echoes Rodin's drawing—particularly if, as may be surmised, they both held erotic resonance for Stieglitz—the notion of self-fertilization may misread or overstate the tactile quality of the gesture.

96. Ruth Leys, "The Real Miss Beauchamp: Gender and the Subject of Imitation," in Judith Butler and Joan W. Scott, eds., *Feminists Theorize the Political* (New York and London: Routledge, Chapman and Hall, 1992), 167–214, esp. 169–87.

97. In this Henry McBride offers a typical example: "Georgia O'Keefe [sic] is what

they probably will be calling in a few years a B.F., since all of her inhibitions seem to have been removed before the Freudian recommendations were preached upon this side of the Atlantic. She became free without the aid of Freud. But she had aid. There was another who took the place of Freud. . . . It is of course Alfred Stieglitz that is referred to." *New York Herald*, February 4, 1923; reprinted in Lynes, *O'Keeffe, Stieglitz, and the Critics*, 187.

98. O'Keeffe to Sherwood Anderson [September 1923?], Cowart and Hamilton, *Art and Letters*, 174: "I wonder if man has ever been written down the way he has written woman down—I rather feel that he hasn't been—that some woman still has the job to perform—and I wonder if she will ever get at it—I hope so—."

99. Lowe, *Stieglitz*, 241, suggests that Stieglitz withheld some of the most explicit images; Lynes, 43 and 330 n. 25, cites Stieglitz's comment in the exhibition catalogue accompanying the show: "Some important prints of this period are not being shown, as I feel that the general public is not quite ready to receive them."

100. *Georgia O'Keeffe: A Portrait* (as in note 83), [9].

101. A similar effect seems to be achieved by another story that circulated about the exhibition, the anecdote that has Stieglitz pricing one nude photograph at $5,000, then an outrageous sum for a single photo. It had the effect of making the work (and thus, by extension, the circumstances of its production) rare and precious metal, unavailable to the average (male) purchaser. The story is told by Henry McBride, among others. See "Modern Art," *Dial* 70:4 (April 1921): 480–82. Not really a Stieglitz intimate, McBride is happy to point out the contradictions in the photographer's project, above all between a practice that is "essentially aristocratic and expensive," and quintessentially artful, and the real conditions of modernity—the anonymous snapshot, the movie—to which the "democratic" Stieglitz pays only lip service.

102. For a discussion of the relationships between Strand's and Stieglitz's photographs of women, see Belinda Rathbone, "Portrait of a Marriage: Paul Strand's Photographs of Rebecca," *J. Paul Getty Museum Journal* 17 (1989): 83–98.

103. Chave, "O'Keeffe and the Masculine Gaze," 120.

104. Alfred Stieglitz to Mitchell Kennerley [1928?], box 4, Mitchell Kennerley Papers, Manuscript Division, New York Public Library. Lawrence's letters to Stieglitz also discuss both the photographer's and O'Keeffe's responses to the book. See *The Letters of D. H. Lawrence*, ed. A. Huxley (New York: Viking, 1932), 750–51, 760.

105. Lewis Mumford, "The Metropolitan Milieu," in Frank, *America and Alfred Stieglitz*, 56. Stieglitz himself occasionally returned to artiness in the nude, as for example in the awkwardly posed *Georgia Engelhard*, 1922, palladium print, 9⅝ × 7⅝ in. (24.5 × 19.3 cm.), National Gallery of Art, D 496, reproduced in *Alfred Stieglitz: Photographs and Writings*, no. 50.

106. These images include NGA 1980.70.277, *Buttocks and Thighs*; 1980.70.274, *Torso*; 1980.70.275, *Torso*; 1980.70.278, *Buttocks and Thighs*; 1980.70.279, *Buttocks and Thighs*; 1980.70.280, *Buttocks and Thighs*; 1980.70.276, *Torso*. The series seems to

be a reprise of a format first attempted in 1922: see the photograph *Thighs and Buttocks* at the National Gallery of Art (1980.70.184), dated 1922 in Stieglitz's hand.

107. Joan Riviere, "Womanliness as a Masquerade," first published in *International Journal of Psychoanalysis* 9 (1929): 303–13; reprinted in *The Inner World and Joan Riviere: Collected Papers, 1920–1958* (London: Karnac Books, 1991), 90–101.

108. Riviere, *Inner World*, 91.

109. Ibid.

110. Ibid., 95.

111. Ibid., 96.

112. Ibid., 94.

113. O'Keeffe to Pollitzer, October 30, 1916, O'Keeffe, *Complete Correspondence*, 210.

114. The line comes from "New Heaven and Earth," Lawrence, *Complete Poems* (as in note 67), 257.

115. Maurice Merleau-Ponty, *Phenomenology of Perception*, trans. Colin Smith (London: Routledge and Kegan Paul, 1962), 171; quoted in Riley, "Am I That Name?" 114.

116. Mary Ann Doane, "Film and the Masquerade: Theorizing the Female Spectator," in *Femmes Fatales: Feminism, Film Theory, Psychoanalysis* (New York and London: Routledge, 1991) 31; first published in *Screen* 23 (September–October 1982): 74–87.

117. J. Laplanche and J.-B. Pontalis, *The Language of Psychoanalysis*, trans. Donald Nicholson-Smith (New York: W. W. Norton, 1973), 311.

118. Luce Irigaray, *This Sex Which Is Not One*, trans. Catherine Porter with Caroline Burke (Ithaca, N.Y.: Cornell University Press, 1985), 134.

Chapter 3

1. Cindy Nemser, *Art Talk: Conversations with Twelve Women Artists* (New York: Scribner, 1975), 5.

2. Nemser, 100. The sensation that her painting was autobiographical grew particularly acute as Krasner's life neared its end, perhaps as a result of that circumstance. She noted to John Bernard Myers, for example, that "the self-portraits . . . make it clear that my subject matter would be myself." John Bernard Myers, "Naming Pictures: Conversations between Lee Krasner and John Bernard Myers," *Artforum* 23 (November 1984): 71.

3. Nemser, 103.

4. Ibid., 102.

5. Barbara Rose, in *Lee Krasner: A Retrospective* (New York: Museum of Modern Art, 1983), 95.

6. The document was supplied to O'Connor, and by him to Krasner. See the Lee Krasner Papers, Archives of American Art (hereafter AAA) for the various materials O'Connor assembled.

7. "Women Artists in Ascendance," *Life* 42 (May 13, 1957): 74–77. The five

artists represented were Helen Frankenthaler, Grace Hartigan, Nell Blaine (b. 1922), Joan Mitchell (b. 1926), and Jane Wilson (b. 1922). Not one was shown with a brush in her hand.

8. "Nineteen Younger Americans," *Life* 36 (March 20, 1950): 82 – 93. Three of the artists presented—Aleta Cornelius, Honoré Sharrer, and Hedda Sterne—are female.

9. I am grateful to Ellen G. Landau, who in conversation called my attention to this insistence on Krasner's part.

10. Krasner tells the story to Nemser, *Art Talk*, 84.

11. Sidney Janis, *Abstract and Surrealist Art in America* (New York: Reynal and Hitchcock, 1944), 79, fig. 51.

12. Hans Hofmann, address delivered February 16, 1941, at the Riverside Museum, New York, to a symposium on abstract art held during the 1941 American Abstract Artists exhibition. Reprinted in Cynthia Goodman, ed., *Hans Hofmann* (New York and Munich: Whitney Museum and Prestel-Verlag, 1991), 165.

13. Janis, *Abstract and Surrealist Art*, 55, fig. 31. Now in the National Museum of American Art, Smithsonian Institution, the work was signed "L. Krassner," only after being reproduced in Janis (where Krasner is called Leonore Krassner and her birth date given as 1911); it is reproduced without a signature in Rose, *Lee Krasner* (as in note 5), 49, fig. 43. According to Landau, the signature was added by Pollock. Robert Carleton Hobbs dates the painting 1939 in *Lee Krasner* (New York, London, Paris: Abbeville Press, 1993), 29, fig. 22, but provides no justification for so doing.

14. Janis, *Abstract and Surrealist Art*, 50.

15. Nemser, *Art Talk*, 85.

16. If, as Robert Hobbs argues, these arrangements transform and rework the nude female body into geometric objects, that controlled transformation seems notably overdetermined. Hobbs advances this claim in his *Lee Krasner*, 25 – 26, 30. Hobbs's assertion, while provocative, is unargued. It involves the questionable assumption, moreover, that Krasner saw the female form as an equivalent of herself. There is no logical basis for this idea.

17. Nemser, 85.

18. Transcript of an unmicrofilmed interview with Lee Krasner conducted in 1972 by Dolores Holmes, AAA.

19. Rose, *Lee Krasner* (as in note 5), 24.

20. Goodman, *Hans Hofmann*, 168.

21. Ellen G. Landau, in Sandor Kuthy and Ellen G. Landau, *Lee Krasner–Jackson Pollock* (Bern: Kunstmuseum, 1989/90), 88 n. 7. Landau is reporting on a conversation with Ruth Stein, the artist's sister, in 1989. One of these photographs has also been attributed to Maurice Berezov.

22. AAA, roll 3771, frames 18 – 26. O'Connor sent Krasner these various pieces of information with a letter dated December 19, 1967.

23. Barbara Rose, "American Great: Lee Krasner," *Vogue* 159 (June 1972): 121.

24. Nemser, *Art Talk*, 88. Note that in the same interview, right on the heels of telling the L.K. story, Krasner denied that she signed her pictures L.K. to conceal her status as a woman:

> CN: I am interested that you signed your works L.K. Did you use your initials because you didn't want it to been [sic] known that you were a woman?
>
> LK: No. Some of my paintings are signed L.K. and some have my name. Even today I do the same thing. At that time I didn't think that my problems had to do with being a woman. Now there is a consciousness about that. I view it on a different level.

25. Louise Elliott Rago, "We Interview Lee Krasner," *School Arts* 60 (September 1960): 32. Consulted in the Krasner Papers, AAA, roll 3771, frame 143.

26. Rose, *Vogue* (as in note 23), 121.

27. Transcript of an interview with Emily Wasserman, January 9, 1968. AAA, roll 3774, frame 329.

28. Nemser, 97.

29. Holmes interview (as in note 18), AAA, 9–10.

30. Rose, *Vogue* (as in note 23), 154.

31. Rago, *School Arts* (as in note 25), 32.

32. In the three paragraphs of Roueché's brief piece, Krasner opines, "Jackson's work is full of the West. That's what gives it that feeling of spaciousness. It's what makes it so American," and she utters the phrase "unframed space," which Roueché took as the title of his piece. [Berton Roueché], "Unframed Space," *New Yorker*, August 5, 1950, 16.

33. G.T.M. [Gretchen T. Munson], "Man and Wife," *Art News* (October 1949): 45. In a letter to me, Jeannene Przyblyski has pointed out an apposite prefiguration of Munson's responses; it comes from the pen of a particularly mischievous, misogynist George Moore: "Women astonish us as much by their want of originality as they do by their extraordinary powers of assimilation. I am thinking now of the ladies who marry painters, and after a few years of married life, exhibit work identical in execution with that of their illustrious husbands—Mrs. E. M. Ward, Madame Fantin-Latour, Mrs. Swan, Mrs. Alma-Tadema. How interesting these households must be! Immediately after breakfast, husband and wife sit down at their easels. 'Let me mix a tone for you, dear,' 'I think I would put that up a little higher,' etc. In a word, what Manet used to call *la peinture à quatre mains.*" "Sex in Art," *Modern Painting* (New York: Scribner, 1893), 226–27.

34. B. H. Friedman, *Jackson Pollock: Energy Made Visible* (New York: McGraw-Hill, 1972), 245.

35. H. Rosenberg, "The Art Establishment," *Esquire* 62 (January 1965): 114.

36. Friedman, *Pollock*, 246.

37. Lee Krasner, undated interview with B. Cavaliere, typescript, AAA, roll 3774, frame 289; published as Barbara Cavaliere, "An Interview with Lee Krasner," *Flash Art* 94–95 (January–February 1980): 14ff. Note, however, that the published interview differs markedly from the AAA transcript and the quotation in my text is not included there. A copy of Rosenberg's *Esquire* article is among the Krasner papers; see AAA, roll 3777.

38. Cavaliere interview typescript, AAA.

39. Mark Rothko to Barnett and Annalee Newman, July 31, 1945, Newman Papers, AAA. I am grateful to Michael Leja for sharing with me his research on artistic culture in New York during the 1940s, including this reference.

40. Krasner Papers, AAA, roll 3774, frame 309. The document in question is an undated statement, which, on the basis of internal evidence, must be put later than 1977. I have transcribed the text as it was typed, presumably from a taped interview. A hand other than Krasner's has edited it, making suggestions for cuts and clarification; these I have ignored. It seems possible that these ideas were put together to be used as an acceptance speech: Krasner received several awards after 1977, including the Outstanding Achievement Award of the Women's Caucus for Art.

41. Correspondence between Lee Krasner and the Museum of Modern Art, October 24, 1956, and June 26, 1956, AAA, roll 3047, frames 58, 87. Note that the October 24 letter had initially proposed slightly lower values for *Portrait and a Dream* (i.e. $4,200) as well as other pictures of 1951; the higher valuations given here were written in on the letter by Krasner herself.

42. See letter of July 29, 1960, from David Gibbs (Krasner's agent in London) to Louis Santini, AAA, roll 3047, frame 350.

43. The way that the sale of *Blue Poles* to Canberra redefined Pollock prices can be seen in the history of Alfonso Ossorio's efforts to sell *Lavender Mist: Number 1, 1950*. Valued at $175,000 in 1967, it was offered to the Museum of Fine Arts, Boston, in the summer of 1973 through the efforts of John Coolidge and Kenworth Moffitt, then respectively director and curator, for $950,000. The painting was transported to Boston, and after it was examined there, the claim was made that it had deteriorated since Pollock painted it. Ossorio was asked to lower his price by $200,000, which he was unwilling to do. Negotiations came to a standstill when the news of Ben Heller's sale of *Blue Poles* was made public in September. In 1976 *Lavender Mist* was sold to the National Gallery, Washington, for $2 million. See the Alfonso E. Ossorio Papers, roll 2000, AAA.

44. Krasner moved from the Stable Gallery to Martha Jackson, and then in 1960 to Howard Wise. The Krasner file in Stable Gallery Papers at the Archives of American Art contains no information concerning the gallery's dealings with her. A letter from the director, Eleanor Ward, to Wilfred Zogbaum, who was also represented by the gallery, sheds some light on the break: ". . . did go through some high temperament

with Lee Krasner who left the Gallery outraged because I wouldn't give her the two floors for her forthcoming show. Rumor has it that she has gone to Martha Jackson" (October 14, 1957). Zogbaum's reply is dated November 7, 1957: "Was sorry to hear about your difficulties with Lee Krasner but it did not come as a great surprise. Although she has been a friend of mine for twenty years there is that extreme ambition in her that is at times a bit frightening. One doesn't know whether to admire or despise it." Zogbaum was a student of Hans Hofmann's from 1935 to 1937; his photographs of Krasner and Pollock are discussed in this chapter.

45. This was the case at least after 1958. In that year, however, Krasner herself seems to have readied for the market a large group of Pollocks, which were variously framed, cleaned, relined, varnished, restored, etc., by Kulicke Framers, for about $2,000. Some sixty-five works are mentioned on the invoice, which apparently covers work done mostly in October; note that Krasner's own exhibition in 1958 dates from earlier in the year, making it less likely that the paintings not mentioned as Pollocks on the invoice were actually done by her.

46. See Francis V. O'Connor and Eugene V. Thaw, eds., *Jackson Pollock: A Catalogue Raisonné of Paintings, Drawings, and Other Works* (New Haven and London: Yale University Press, 1978), I, vii.

47. Francine du Plessix and Cleve Gray, "Who was Jackson Pollock?" *Art in America* 55 (May–June, 1967): 48ff. Ellen G. Landau, in her monograph *Jackson Pollock* (New York: Harry N. Abrams, 1989), 270, gives a list of eighteen interviews with Krasner, including her own; transcripts of most of these are at the Archives of American Art; to them should be added those published interviews—of which there are some ten—for which transcripts are not at the Archives or which are unmentioned by Landau.

48. Donald Judd, "Jackson Pollock," *Arts Magazine* 41 (April 1967): 32.

49. Clement Greenberg, [Letter to the Editors], *Evergreen Review* 2:5 (1958): 160; for his obituary of Pollock, see *Evergreen Review* 1:3 (1957): 95–96.

50. Clement Greenberg, "The Jackson Pollock Market Soars," *New York Times Magazine,* April 16, 1961, 136.

51. Jeffrey Potter, *To a Violent Grave: An Oral Biography of Jackson Pollock* (Wainscott, N.Y.: Pushcart Press, 1987), 248. First published by Putnam, 1985.

52. Steven Naifeh and Gregory White Smith, *Jackson Pollock, An American Saga* (New York: Clarkson N. Potter, 1989), 379.

53. Ibid., 695.

54. Potter, 142.

55. Naifeh and Smith, 571.

56. Ibid., 880.

57. Ernst Kris and Otto Kurz, *Legend, Myth, and Magic in the Image of the Artist: A Historical Experiment* (New Haven and London: Yale University Press, 1979).

58. Greenberg 1957 (as in note 49), 95.

59. B. H. Friedman, "An Interview with Lee Krasner Pollock," in *Pollock Painting*, ed. Barbara Rose (New York: Agrinde Publications, 1980), n.p.

60. Hans Namuth, "Photographing Pollock—A Memoir," in ibid., n.p.

61. Krasner repeated most of these stories in her 1968 interview with Emily Wasserman, AAA (as in note 27).

62. *Pollock Painting*, n.p.

63. Nemser, *Art Talk*, 86.

64. Rose, *Vogue* (as in note 23), 154. These terms are Krasner's preferred vocabulary when speaking of Pollock's impact on her: for one final example, see Grace Glueck, "Scenes from a Marriage: Krasner and Pollock," *Artnews* 80 (December 1981): 58. There Krasner is quoted as being "'bowled over' by the paintings she saw on the wall of Pollock's studio. 'They were Picasso-esque, and they moved me to a point that doesn't happen very often. There was a living force in them, and he could see I responded.'"

65. Clement Greenberg, *The Collected Essays and Criticism*, ed. John O'Brian (Chicago: University of Chicago Press, 1986–93), I, 205. These phrases come from a review that first appeared in the *Nation*, April 22, 1944. The relevant sentences are these: "Tobey's great innovation is his 'white writing'; the calligraphic, tightly meshed interlacing of white lines which build up to a vertical, rectangular mass reaching almost to the edges of the frame; these cause the picture surface to vibrate in depth—or, better, towards the spectator. Yet this seems little out of which to compose an easel painting. The compensation lies in the intensity, subtlety, and directness with which Tobey registers and transmits emotion usually considered too tenuous to be made the matter of any other art than music."

66. Transcript of a tape recorded interview with Lee Krasner, by Dorothy Seckler, December 14, 1967, p. 8. AAA.

67. V.R. [Vivian Raynor] "In the Galleries: Lee Krasner," *Arts Magazine* 35:4 (January 1961): 54.

68. Apposite at this juncture is Norbert Lynton's view of Krasner's debt to Pollock (he was reviewing her 1965 Whitechapel show): "From Pollock Miss Krasner took concepts of form, format and manner, always selecting aspects that could become part of an expressive action fundamentally different from Pollock's. There was a fragility about Pollock's spirit that I do not see in her. His work could at times become brittle and fidgety; her's [sic] has breadth and assurance and it is noticeably the more assertive elements of Pollock's art that she has taken over. What makes any ultimate assessment of their relative roles impossible is that as Pollock's wife Lee Krasner's existence as a painter must to some extent have been consumed in his, so that element that we recognize in her work as stemming from his may directly or indirectly originate in her." "London Letter," *Art International* 9 (November 1965): 32–33.

69. Ellen G. Landau, *Lee Krasner: A Catalogue Raisonné* (New York: Abrams, 1995), no. CR 370, pp. 195–96. Landau details the circumstances of the painting's discov-

ery, and Krasner's claims for it. X-rays demonstrate that she painted it over one of her earlier works. I should note that the present study was completed without the benefit of Landau's catalogue, but that every effort was made to verify my information against her data.

70. Ellen G. Landau, "Lee Krasner's Early Career, Part One: 'Pushing in Different Directions,'" *Arts Magazine* 56 (October 1981): 110–22; "Lee Krasner's Early Career, Part Two: The 1940's." *Arts Magazine* 56 (November 1981): 80–89.

71. Nemser, *Art Talk*, 100. The events Krasner names are not those of 1961; she is referring to the circumstances of her life in the late 1950s. Note that in the context of another interview, one conducted by Richard Howard in 1978 (see note 88 below) she makes clear her view that an event and its painterly impact can be distant in time: "But I have observed, though I've never had an opportunity to explore, that the time sequence between what one feels and what is happening is not simultaneous—that is to say, it's as though you were descending once more, bringing forth from the unconscious, subconscious, or whatever area you bring forth from, as one does in dream. . . . What I feel at the moment is not necessarily what's being brought forth in the painting."

72. I owe this formulation to Philippe Lejeune, *On Autobiography* (Minneapolis: University of Minnesota Press, 1989), 110. Lejeune uses the phrase in the negative: "Perhaps painting is unable to use the first 'person,'" he writes, expressing his sense that the line between portraiture and self-portraiture is all too unclear. In this essay I am attempting a broader view of painterly autobiography.

73. Michael Leja has gone the farthest to document the terms of accord between abstract expressionism and contemporary ideologies of the self. See his *Reframing Abstract Expressionism: Subjectivity and Painting in the 1940's* (New Haven and London: Yale University Press, 1993).

74. Lejeune, 6.

75. Paul de Man, "Autobiography as De-Facement," in *The Rhetoric of Romanticism* (New York: Columbia University Press, 1984), 70.

76. Rose, *Krasner* (as in note 5), 48.

77. For Meyer Schapiro's remarks on Gorky, see Robert Carleton Hobbs and Gail Levin, *Abstract Expressionism: The Formative Years* (Ithaca, N.Y., and London: Cornell University Press, 1978), 68. Irving Sandler provides the lexicon of dismissive criticism, as well as the "Picasso of Washington Square" story, in *The Triumph of American Painting* (New York and Washington: Praeger, 1970), 47; his sources are Schapiro and Rosenberg.

78. Julien Levy, foreword to William C. Seitz, *Arshile Gorky: Paintings, Drawings, Studies* (New York: Museum of Modern Art, 1962), 7.

79. Harold Rosenberg, *Arshile Gorky: The Man, the Time, the Idea* (New York: Horizon Press, 1962), 62–63.

80. See Rose, *Krasner* (as in note 5), 37–38.

81. See Rose, *Krasner*, 45–48, for an account of Krasner's contacts with Graham; for Gorky and Graham, see Donald Kuspit, "Arshile Gorky: Images in Support of the Invented Self," in Michael Auping, ed. *Abstract Expressionism: The Critical Developments* (New York and Buffalo: Harry N. Abrams, in association with the Albright-Knox Gallery, 1987), 52–57.

82. Nemser, *Art Talk*, 93.

83. These phrases are taken from the following reviews of Krasner's show: R.G. [Robert Goodnough], *Art News* 50 (November 1951): 53; D.A. [Dore Ashton], *Art Digest* 26 (November 1, 1951): 58–59; Stuart Preston, *New York Times*, October 21, 1951; undated clipping, "Abstract and Real," October 1951, roll N68–67, frame 123, Betty Parsons Papers, AAA. It should be said that Krasner was not the only abstract expressionist artist to receive poor notices following a solo show this year; the response to Newman's exhibition was equally disastrous. And of course the issue of differing from Pollock confronted male artists too. My emphasis here falls on the ways the "normal" phenomena of careers in art—criticism, exhibitions, and influence, for example—can become more problematic when the artist is female.

84. Nemser, 93.

85. Rose, *Krasner* (as in note 5), 72. Note that for Rose the pictures in dialogue with Mondrian include both the MoMA and the Miller canvases.

86. Greenberg, *Collected Essays and Criticism*, II, 113.

87. de Man (as in note 75), 75–76.

88. Richard Howard, "A Conversation with Lee Krasner, December, 1978," in *Lee Krasner: Umber Painting, 1959–1962* (New York: Robert Miller Gallery, 1993), n.p.

89. de Man, 70.

90. Ibid., 81.

91. Nemser, *Art Talk*, 93–94.

92. Ibid., 93.

93. Myers, "Naming Pictures" (as in note 2), 71.

94. Bryan Robertson, in *Lee Krasner: Collages* (New York: Robert Miller Gallery, 1986), n.p.

95. Nemser, *Art Talk*, 95–96. The information Rose gives that *Prophecy*'s title was due to Ossorio, in *Krasner* (as in note 5), 95, is unconfirmed by Landau, author of the catalogue raisonné of Krasner's work (as in note 69).

96. This detail, as well as the description of *Prophecy*'s backroom installation, is provided by Parker Tyler in his notice of the show, "Reviews and Previews," *Art News* 57 (April 1958): 15. The following works were in the Martha Jackson show, which was held February 24–March 22, 1958: *Collage*, 1953, Mr. and Mrs. Oliver Schnabel Collection; *Candlelight*, 1955, Mr. and Mrs. Roy R. Neuberger Collection; *Collage*, 1954; *Untitled*, 1949; *Visitation*, 1957; *Upstream I*, 1957; *Upstream II*, 1957; *Earth Green*, 1957; *The Season*, August 1957; *Prophecy*, July 1956.

97. Nemser, 98.

98. Rose, *Krasner* (as in note 5), 100 – 106.

99. Robertson, *Collages* (as in note 94).

100. Tyler, "Reviews and Previews" (as in note 96).

101. Several other canvases of these years, including *Birth* (see fig. 41), *Visitation,* and *April,* repeat the eye form at more or less the same spot.

102. Irving Sandler, "New York Letter: A Selection of One-man Shows," *Art International* 4 (December 31, 1960): 26; Sandler reviewed Krasner's 1960 Howard Wise Gallery show for *Art International, Artnews,* and the *New York Post;* the second and third reviews simply repeat the adjectives of the first version in *Art International.*

103. Six paintings, *Woman I–V* and *Woman with Bicycle,* were shown in 1953. *Woman VI* was shown at Janis in 1954, and *Woman as a Landscape* was at Martha Jackson in 1955; *Woman Ocher* was the cover illustration for the catalogue of the show. See National Gallery of Art, Washington, *Willem de Kooning: Paintings,* 1994, 127–30, 136nn.20, 22.

104. Holmes interview (as in note 18), 5.

105. Ibid.

106. B. Cavaliere interview (as in note 37), 11.

107. Arthur C. Danto, "Lee Krasner: A Retrospective," in *The State of the Art* (New York: Prentice Hall, ca. 1987), 33. The James citation comes from *Italian Hours* [1909] (New York: Grove Press, 1959), 187–88.

108. May Natalie Tabak, "Small Change," *Kenyon Review* 30:122:5 (1968): 627–51.

109. Undated letter from John Reed, Krasner Papers, AAA, roll 3777, frame 416.

Chapter 4

1. Solomon R. Guggenheim Museum, New York, *Eva Hesse: A Memorial Exhibition,* 1972. Organized by Linda Shearer, with essays by Shearer and Robert Pincus-Witten. The show traveled to the Albright-Knox Art Gallery, Buffalo; the Museum of Contemporary Art, Chicago; the Pasadena Art Museum; and the University Art Museum, Berkeley. The stop originally planned at the Contemporary Art Museum, Houston, and listed on the catalogue's title page was canceled and replaced by the visit to Berkeley. The second retrospective was at Yale University Art Gallery, New Haven; the catalogue, Helen A. Cooper et al., *Eva Hesse: A Retrospective,* 1992, includes essays by Maurice Berger, Anna C. Chave, Maria Kreutzer, Linda Norden, and Robert Storr. The show traveled to the Hirshhorn Museum and Sculpture Garden, Washington, D.C.

2. Cindy Nemser, "My Memories of Eva Hesse," *Feminist Art Journal* 2:1 (Winter 1973): 12.

3. Here, in the order listed in the text, are full citations for the articles mentioned:

Paul Richard, "Heartache amid Abstraction," *Washington Post*, October 25, 1992; Hank Burchard, "Fragile Artist's Agonized Life," *Washington Post: Weekend*, October 23, 1992; Joyce Purnick, "A Portrait of the Artist: Tortured and Talented," *New York Post*, December 13, 1972; Kay Larson, "The James Dean of Art," *New York*, January 30, 1983, 50; Anna C. Chave, "Eva Hesse: A 'Girl Being a Sculpture'" in Cooper et al., *Eva Hesse: A Retrospective*, 99–117; Arthur C. Danto, "Growing Up Absurd," *Art News* 88:9 (November 1989): 118–21. With the exception of the Chave essay, these texts were consulted as clippings in the artist files of the library of the National Museum of American Art, Washington, D.C.

4. Douglas Davis, "Cockroach or Queen," *Newsweek*, January 15, 1973; the phrase "cockroach or queen" is here attributed to a "friend" of Hesse's (probably Cindy Nemser); it is meant to convey Hesse's conflicting sensations of inferiority and superiority.

5. Danto, 1989, 121.

6. Ibid., 118.

7. The essays in question are by Chave (as in note 3) and by Maria Kreuzer, "The Wound and the Self: Eva Hesse's Breakthrough in Germany," in Cooper et al., *Eva Hesse: A Retrospective*, 75–84. Chave has stated her objections to my criticisms of her work in a letter to *October*'s editors. See *October* 71 (Winter 1995): 146–48.

8. Barbara Rose, "A Special Woman, Her Surprise Art," *Vogue* 161 (March 1973): 50.

9. According to a note in the files of the Fischbach Gallery, Hesse's dealer at the time, Charash was equally prompt in blocking more sensationalist interest in her sister's life and death: she specifically forbade any release of Hesse's X rays without her express permission. AAA, Fischbach Gallery Papers.

10. Robert Pincus-Witten, "Eva Hesse: Last Words," *Artforum* 11:3 (November 1972): 74–76.

11. John Perreault, "Knotted and Split at the Seams," *Village Voice*, December 21, 1972, 31–32.

12. "Interview with Walter Erlebacher, conducted by Anne Schuster Hunter for the Archives of American Art," unmicrofilmed typescript, AAA, 144.

13. Hilton Kramer, "An Enlightening Portrait of Eva Hesse," *New York Times*, March 20, 1977.

14. Details on the production of the monograph can be gleaned from the unmicrofilmed Lucy R. Lippard Papers, AAA.

15. An inventory of the Charash gift is given in Bill Barrette, *Eva Hesse: Sculpture* (New York: Timken, 1989), 250–51, Appendix C. All subsequent citations from Hesse's notebooks and correspondence refer to materials in this collection; dates are provided in text or notes.

16. Rosalind E. Krauss, *Eva Hesse: Sculpture, 1936–1970* (London: Whitechapel Art Gallery, 1979), n.p.

17. Cindy Nemser, "An Interview with Eva Hesse," *Artforum* 8:9 (May 1970): 59–63.

18. Ibid., 59; ellipses in original.

19. Lucy R. Lippard, *Eva Hesse* (New York: New York University Press, 1976), 5.

20. Hesse's admiration for Oldenburg is stated in the course of the Nemser interview; the citation, from Oldenburg's manifesto "I am for an art . . ." (1961, 1967), is taken from Barbara Rose, *Claes Oldenburg* (New York: Museum of Modern Art, 1970), 190. The definitive text was first published in *Store Days* (New York: Something Else Press, 1967).

21. Cindy Nemser, *Art Talk: Conversations with Twelve Women Artists* (New York: Scribner, 1975), 223–24. It should be noted that the conditions under which Nemser conducted and published her interview with Hesse have complicated its status as a text. The first publication in *Artforum* reduces to a twelve-page article a transcript that is almost one hundred pages long; the principles by which Hesse's speeches were assembled radically reconfigured the interview as a whole, bringing together as single connected answers responses that were much more disjointed, and, moreover, uttered in quite different sessions of the interview. The text in *Art Talk* is more faithful to the original transcript.

22. In conversation with the author (August 1994), Mel Bochner offered the suggestion that the drawing is an idea for a double-page catalogue spread, perhaps for the pages devoted to Hesse in the *Anti-Illusion* catalogue; if so, the idea was not ultimately used.

23. Lippard, *Eva Hesse*, 6.

24. Helen A. Cooper, "Eva Hesse: Diaries and Notebook," in Cooper et al., *Eva Hesse: A Retrospective*, 18.

25. Ibid.

26. In an excerpt from the present study, "Another Hesse," *October* 69 (summer 1994), 49–84, I have cited Anna C. Chave's argument (see note 3 above) as an example of historically determined special pleading; her proposal of Hesse's work as an articulation of "elements of that which is so often denied or repressed about feminine experience: its repugnant and piteous inheritance of pain" (113) has roots in the wider fascination with "the abject" that figures so importantly in late-twentieth-century cultural writing, as a (distanced, class-blind) response to the violence and disease of this historical moment. It is striking, in light of Chave's views, that a Washington reviewer could take Hesse's diary as identical to "almost any career woman's diary" — as a typical product that is, of another 1980s cultural property cum stock character, the successful woman struggling to cope. See Burchard, "Fragile Artist's Agonized Life" (as in note 3).

27. Joyce Purnick, "A Portrait of the Artist" (as in note 3).

28. Davis, "Cockroach or Queen" (as in note 4), 73.

29. Peter Schjeldahl, "Eva Hesse at the Guggenheim," *Art in America* 61 (March–April 1973): 98.

30. Lippard, *Eva Hesse*, 180.

31. Burchard, "Fragile Artist's Agonized Life" (as in note 3).

32. Kasha Linville Gula, "Eva Hesse: No Explanation," *Ms.* (April 1973): 39–42; cited by Lippard, *Eva Hesse*, 182.

33. Robert Pincus-Witten, "Eva Hesse: Post-Minimalism into Sublime," *Artforum* 10 : 3 (November 1971): 34.

34. Hesse's work appears in "It's All Yours," *Seventeen* (September 1954): 140–41, 161. Plath's New York experience and its aftermath are documented, in excerpted form, in Sylvia Plath, *Letters Home: Correspondence, 1950–1963*, ed. Aurelia Plath (London and Boston: Faber and Faber, 1975), 115–26. There is only one brief journal entry from that summer in *The Journals of Sylvia Plath*, ed. T. Hughes and F. McCullough (New York: Dial Press, 1982), 81–82.

35. The phrase comes from Sandra M. Gilbert's essay "'A Fine White Flying Myth': Confessions of a Plath Addict," in Harold Bloom, ed., *Modern Critical Views: Sylvia Plath* (New York and Philadelphia: Chelsea House, 1989), 50. Gilbert remembers reading a Plath story in *Seventeen* and was herself "initiated" as a guest editor at *Mademoiselle* four years after Plath.

36. Plath's mother was born in the United States to Austrian parents; she spoke no English before she was sent to school. Her father, of German-Polish background, emigrated to America at the age of sixteen.

37. Aurelia Plath, in *Letters Home*, 13.

38. Paul Alexander, *Rough Magic: A Biography of Sylvia Plath* (New York: Viking and Penguin, 1991), 61.

39. Aurelia Plath, in *Letters Home*, 38.

40. Plath, *Journals*, 62.

41. It is not clear whether Hesse ever gave her father a copy of this letter, for which the version in the Oberlin archive would have served as a draft; ellipsis in original.

42. Plath, *Journals*, 328.

43. Ibid., 30.

44. Nancy Milford, "The Journals of Sylvia Plath," in Linda J. Wagner, ed., *Critical Essays on Sylvia Plath* (Boston: G. K. Hall, 1984), 75.

45. "The Applicant" is dated October 11, 1962. Sylvia Plath, *Collected Poems*, edited with an introduction by Ted Hughes (London and Boston: Faber and Faber, 1981), 221–22.

46. Betty Friedan, *The Feminine Mystique* (New York: W. W. Norton, 1963), 66.

47. Plath, *Journals*, 271; her therapy, according to Plath, involved "the permission" to hate her mother.

48. Plath, *Journals*, 62.

49. Gertrude A. Brenner to Dr. Helene Papanek, February 24, 1954.

50. Dr. Helene Papanek to Louise R. Meyer, Executive Director of the Educational Foundation for Jewish Girls, May 19, 1956. It is important to underline the bonds of affection that linked Papanek and Hesse. Hesse's salutation in her letters to Papanek was usually "Dear Helene." Papanek, for her part, closed a letter to Hesse of August 5, 1955, "Enjoy your few more weeks in camp, little girl! . . . Yours affectionately, H. Papanek." Papanek was replying to Hesse's request that her doctor look over the letter Hesse would send out in search of a scholarship: it is clear that Papanek was very actively supportive of Hesse's ambitions; they stayed in contact until Hesse's death.

51. Excerpt from a letter of recommendation, fall 1954, from Dr. Ruth Barnhouse, quoted by Alexander, *Rough Magic*, 151.

52. I borrow this phrase from the title of a 1975 work by Hans Haacke, *On Social Grease*. Haacke took the term from corporate America's explanation of its art patronage as a kind of "social grease."

53. The evidence for Hesse's suicidal impulses comes from a letter of March 30, 1959, in the Papanek file in the Hesse Archive; Papanek is describing Hesse's state of mind to Dr. Friedman, of the Yale medical staff. Papanek attributed these feelings to the impending end of her studies at Yale, and prescribed Compaxine.

54. Erlebacher interview (as in note 12), 11.

55. Nemser, *Art Talk*, 204.

56. Lionel Trilling, *The Liberal Imagination* (New York: Viking, 1950); this quotation from the paperback edition (New York: Doubleday, 1953), 162. The particular essay cited here, "Art and Neurosis," was first published in 1945.

57. Ibid.

58. From a notebook used at Yale; this page is dated September 1959.

59. Letter to Dr. Helene Papanek, September 21, 1957.

60. Letter to Dr. Helene Papanek, October 10, 1957.

61. Nemser, *Art Talk*, 206.

62. Rosalind Krauss, *The Optical Unconscious* (Cambridge and London: MIT Press, 1993), 309.

63. Letter to Dr. Helene Papanek, May 1, 1958.

64. These numbers are calculated on the basis of the program of the Yale commencement, 1959, Hesse Archives, box 3. Note that other documents in the group show that Hesse was one of eighteen women in the Design course at Cooper Union, from which she graduated in 1956.

65. Letter to Dr. Helene Papanek, December 20, 1958.

66. Letter to Dr. Helene Papanek, January 1959.

67. List of sculptors drawn up March 1, 1958. Given the reading that has been made of the phrase, "Is it right for a girl to be a sculpture?" (discussed in note 101

below), it is notable that she also substitutes "sculpture" for "sculptor" when speaking of artists who are male.

68. Lippard, *Eva Hesse*, 15.

69. Ibid., 17.

70. Ellen H. Johnson, "Order and Chaos: From the Diaries of Eva Hesse," *Art in America* 71 : 6 (summer 1983): 110–18.

71. In Cooper et al., *Eva Hesse: A Retrospective*, 20.

72. Since some of this editing was done at the last moment, between galleys supplied to reviewers and the appearance of the book itself, its effects were immediately evident and commented upon. See, for example, the selection of reviews reprinted in Linda W. Wagner, ed., *Sylvia Plath: The Critical Heritage* (London and New York: Routledge, 1988), and especially Nancy Milford, "The Journals of Sylvia Plath" (as in note 44), 77–83. Jacqueline Rose in her fine book *The Haunting of Sylvia Plath* (London: Virago, 1991), 65–113, has provided the most subtle meditation on the effects of the editing.

73. Plath, *Journals*, 67.

74. Note, however, that Hesse's stepmother shared the name Eva, a fact that adds irony and ambiguity to the artist's various uses of the name.

75. Robert Smithson, speaking to Lucy R. Lippard in an interview, June 5, 1973; cited in Lippard, *Eva Hesse*, 6.

76. Gene R. Swenson, *The Other Tradition* (Philadelphia: Institute of Contemporary Art, 1966), 32.

77. Nemser transcript, 6. The published version makes an odd change here, quoting Hesse as saying, "I think my family is half like the Kennedys." There seems to be no evidence for this reading in the transcript.

78. Summer 1966.

79. Lucy R. Lippard, *From the Center: Feminist Essays on Women's Art* (New York: E. P. Dutton, 1976), 3. The rest of the group was Robert Lyman, Sol LeWitt, Robert Mangold, Frank Lincoln Viner, Ray Donarski, Sylvia Mangold, and of course Doyle.

80. Hans Haacke, in conversation with the author, August 24, 1993.

81. Nemser transcript, 31.

82. Lippard, *Eva Hesse*, 35, cites most of this letter.

83. Ethelyn Honig to Eva Hesse, undated letter, "Tuesday" ca. 1964–65. Lippard, *Eva Hesse*, 205, cites Hesse's eloquent reply to this letter.

84. Letter from John Burris to Eva Hesse, late 1965. One reason the issue of the "masculinity thing" is raised in this letter is that Doyle had had a vasectomy, which meant he could not father children. It is clear from the context that Hesse had shared this information with Burris.

85. Tom Doyle recalls that this cartoon was the work of Stanley Landsman, an artist friend who, with David Weinrib, visited Doyle and Hesse frequently in Woodstock.

The reference to bluestone in the cartoon's text concerns Doyle's contemporaneous turn to bluestone as a medium; at this time he produced a series of bluestone sculptures whose parts were epoxyed together. Conversation with the author, September 1994.

86. My gratitude to Tom Doyle for bringing my attention to this photograph.

87. The most provocative study of Smith's notebooks is still to be found in Rosalind E. Krauss, *Terminal Iron Works: The Sculpture of David Smith* (Cambridge and London: MIT Press, 1971). Note that at Smith's death in 1965 Doyle made *Bouquet for David Smith*; according to Doyle, it is still in the possession of F. A. Scheidt.

88. In the case of Doyle, the notebook in question is at the AAA; Hesse's notebook is among her papers at Oberlin.

89. Joyce Wadler, "Artists in New York II: Tom Doyle, Sculptor," *New York Post*, July 12, 1975.

90. Lippard Papers, box 5, AAA. These sentiments, the letter makes clear, were sparked by a discussion with Hans Haacke and another, unnamed, sculptor. Lippard's article is "Space Embraced: Tom Doyle's Recent Sculpture," *Arts Magazine* 40:6 (April 1966): 38–43.

91. Dennis Adrian, *Artforum* 4:9 (May 1966): 51–52. Consulted in Tom Doyle Papers, AAA.

92. Lippard, "Doyle's Recent Sculpture," 42.

93. Ibid., 38.

94. Hilton Kramer, "Art: There's Nothing like Thinking Big, Sometimes," *New York Times*, March 12, 1966.

95. B.S., "Reviews and Previews," *Art News* (December 1971): 14.

96. Robert Pincus-Witten, *Artforum* 10:6 (February 1972): 82.

97. Corinne Robins, "Tom Doyle at 55 Mercer," *Art in America* 62:6 (July 1974): 86.

98. Robert Pincus-Witten, "Tom Doyle: Things Patriotic and Union Blue," *Arts Magazine* 54:1 (September 1979): 145.

99. Ibid., 142.

100. Pincus-Witten, *Artforum* (as in note 96), 82.

101. Note that this question, which provides Chave with both a title for her essay in Cooper et al., *Eva Hesse: A Retrospective*, and a conceptual point of departure, is more difficult to gloss than is usually acknowledged. Lippard, *Eva Hesse*, 15 and 215 n. 5, claims it is written on a "dance program" and dates it ca. 1967. In fact it is written on a flyer/invitation to an "artist's holiday discotheque" held in New York on December 29, 1965. The phrase "'Is it right for a girl to be a sculpture?'" is scrawled across the top—hardly a "musing," as Chave calls it. That the question is in quotes further complicates the matter: who or what is being cited?

102. Erlebacher interview (as in note 12), 143–45.

103. Barrette, *Eva Hesse: Sculpture*, 226.

104. Chave, in Cooper et al., *Eva Hesse: A Retrospective*, 101.

105. Lippard, *Eva Hesse*, 164.

106. Fischbach Gallery Papers, AAA.

107. Chave, in Cooper et al., 103.

108. Ibid., 101.

109. Ibid., 109.

110. For a fuller characterization of Chave's position, see my essay cited above in note 26. A few weeks after the appearance of that essay, Briony Fer published "Bordering on Blank: Eva Hesse and Minimalism," *Art History* 17 : 3 (September 1994): 424–49, which, though it proceeds using strategies rather different from mine, maintains a quite similar stance toward the question of how Hesse's work means: "What is . . . interesting is how Hesse's work may bear the marks of the body, or have bodily connotations, without being *of* the body, and without being symbols in the sense of individual forms standing in for parts of the body" (426). Fer's purpose is to provide a reading of Hesse's art that locates its visual operations within a field of modernist (and Kleinian) metaphors—"between blank space and a stain, between light and obscurity, between the horizontal and the vertical, between visibility and invisibility, between elevation and a fall" (446).

111. Chave, in Cooper et al., 102.

112. Lucy R. Lippard, "New York Letter," *Art International* 10 (May 1966): 64.

113. Gilbert J. Rose, "The Springs of Art—a Psychoanalyst's Approach," *Canadian Art* 100 (January 1966).

114. Swenson, *The Other Tradition*, 35.

115. Mel Bochner, "Eccentric Abstraction," *Arts Magazine* 41 : 1 (November 1966): 58.

116. Not all critics conceded that mastery straightaway: Fer (as in note 110) observes Hilton Kramer's 1966 response to *Metronomic Irregularity* as a kind of secondhand Pollock. Kramer, however, was soon to change his estimation of Hesse's art; he did so well before her death.

117. John Perreault, "The Materiality of Matter," *Village Voice*, November 28, 1968.

118. Theodor W. Adorno, "Heine the Wound," in *Notes to Literature*, I, ed. R. Tiedemann (New York: Columbia University Press, 1991), 80.

119. Ibid., 82–83.

120. Barrette gives a good account of the interdependency of notions of order and chaos in this work, in *Eva Hesse: Sculpture*, 234, no. 101.

121. Both Chave and Lippard have noted this wish. See Chave, in Cooper et al., *Eva Hesse: A Retrospective*, 105; Lippard, *Eva Hesse*, 23.

122. My statement relies on an entry in Hesse's journal for October 19, 1964: "I am now 28, afraid to say almost 29 and really fear never getting well. I seem to have felt like this since 8 years old."

123. Johnson, 1983 (as in note 70), 22.

124. Lippard, *Eva Hesse*, 158.

125. Ibid., 56.

126. Conversation with the author, August 12, 1994.

127. This formulation is derived from a discussion by Susan Buck-Morss of the concerns of modernist aesthetics in "Aesthetics and Anaesthetics: Walter Benjamin's Artwork Essay Reconsidered," *October* 62 (Fall 1992): 4–10. Buck-Morss relies in turn on Terry Eagleton, *The Ideology of the Aesthetic* (London: Basil Blackwell, 1990).

128. Nemser, as cited by Lippard, *Eva Hesse*, 206.

129. Barrette, *Eva Hesse: Sculpture*, 156.

130. This possibility—the notion that the work looks a certain way "because she did it that way"—becomes more and more part of the *illusion* of her art, for as her career advanced, she began to rely on fabricators and to employ assistants to execute her work. I am grateful to Blake Stimson for his suggestions concerning this point.

Chapter 5

1. Francis V. O'Connor, *Jackson Pollock: A Catalogue Raisonné of Paintings, Drawings, and Other Works. Supplement Number One.* (New York: Pollock-Krasner Foundation, 1995), 56. The checkbook, in the collection of the Pollock-Krasner House and Study Center, is for an account opened by Krasner in 1946.

2. Its use is the main departure from the design of 1977 established by Alvin Eisenman for the first four catalogue volumes. The reworked design is credited to Dean Bornstein and Jerry Kelly.

3. *Random House Dictionary of the English Language*, unabridged edition, s.v. "ratio."

4. Ibid., s.v. "colon."

Selected Bibliography

Primary Sources

Allen Memorial Art Museum, Oberlin College, Oberlin, Ohio
 Eva Hesse Archive

Archives of American Art, Smithsonian Institution, Washington, D.C.
 Downtown Gallery Papers
 Tom Doyle Papers
 Fischbach Gallery Papers
 Lee Krasner Papers and Interviews
 Lucy R. Lippard Papers
 Alfonso E. Ossorio Papers
 Betty Parsons Gallery Papers
 Jackson Pollock Papers
 Stable Gallery Papers
 Ruth Vollmer Papers
 Whitney Museum Papers
 Howard Wise Papers

Beinecke Rare Book and Manuscript Library, Yale University, New Haven, Conn.
 Mabel Dodge Luhan Papers
 Georgia O'Keeffe Papers
 Alfred Stieglitz Papers

Manuscript Division, New York Public Library, New York, N.Y.
 Mitchell Kennerley Papers

Secondary Sources

Adorno, Theodor W. *Notes to Literature.* Vol. 1. Edited by R. Tiedemann. New York: Columbia University Press, 1991.

Alexander, Paul. *Rough Magic: A Biography of Sylvia Plath.* New York: Viking and Penguin, 1991.

Althusser, Louis. *Lenin and Philosophy.* Translated by Ben Brewster. London: New Left Books, 1971.

Auping, Michael, ed. *Abstract Expressionism: The Critical Developments.* New York and Buffalo: Harry N. Abrams, in association with the Albright-Knox Gallery, 1987.

Barrette, Bill. *Eva Hesse: Sculpture.* New York: Timken, 1989.

Beauvoir, Simone de. *The Second Sex.* Translated and edited by H. M. Parshley. New York: Alfred A. Knopf, 1952.

Blake, Casey Nelson. *Beloved Community: The Cultural Criticism of Randolph Bourne, Van Wyck Brooks, Waldo Frank, and Lewis Mumford.* Chapel Hill and London: University of North Carolina Press, 1990.

Bloom, Harold, ed. *Modern Critical Views: Sylvia Plath.* New York and Philadelphia: Chelsea House, 1989.

Butler, Judith. *Gender Trouble: Feminism and the Subversion of Identity.* London and New York: Routledge, Chapman and Hall, 1990.

Butler, Judith, and Joan W. Scott, eds. *Feminists Theorize the Political.* New York and London: Routledge, Chapman and Hall, 1992.

Chadwick, Whitney. *Women, Art, and Society.* London: Thames and Hudson, 1990.

Chave, Anna C. "O'Keeffe and the Masculine Gaze." *Art in America* (January 1990): 115–25, 177, 179.

Chicago, Judy. *Through the Flower: My Struggle as a Woman Artist.* New York: Anchor/Doubleday Books, 1975.

Christie, J. R. R., and Fred Orton. "Writing on a Text of the Life." *Art History* 11 : 4 (December 1988): 544–64.

Clark, T. J. "Jackson Pollock's Abstraction." In *Reconstructing Modernism: Art in New York, Paris, and Montreal, 1945–1964,* edited by Serge Guilbaut. Cambridge and London: MIT Press, 1990.

Cooper, Helen A., et al. *Eva Hesse: A Retrospective.* New Haven and London: Yale University Press with Yale University Art Gallery, 1992.

Cott, Nancy. *The Grounding of Modern Feminism.* New Haven and London: Yale University Press, 1987.

Cowart, Jack, and Juan Hamilton, with Sarah Greenough. *Georgia O'Keeffe: Art and Letters.* Boston, Toronto, and London: National Gallery of Art with Little, Brown and Company, Bulfinch Press, 1987.

de Lauretis, Teresa. *Technologies of Gender: Essays on Theory, Film, and Fiction.* Bloomington and Indianapolis: Indiana University Press, 1987.

de Man, Paul. *The Rhetoric of Romanticism.* New York: Columbia University Press, 1984.

Doane, Mary Ann. *Femmes Fatales: Feminism, Film Theory, Psychoanalysis.* New York and London: Routledge, 1991.

Duncan, Carol. *The Aesthetics of Power: Essays in Critical Art History.* Cambridge: Cambridge University Press, 1993.

Eisler, Benita. *O'Keeffe and Stieglitz: An American Romance.* New York: Doubleday, 1991.

Frank, Waldo, et al., eds. *America and Alfred Stieglitz: A Collective Portrait.* New York: Literary Guild, 1934.

Friedan, Betty. *The Feminine Mystique.* New York: W. W. Norton, 1963.

Goodman, Cynthia, ed. *Hans Hofmann.* New York and Munich: Whitney Museum and Prestel-Verlag, 1991.

Green, Jonathan. *Camera Work: A Critical Anthology.* Millerton, N.Y.: Aperture, 1973.

Greenberg, Clement. *The Collected Essays and Criticism.* Edited by John O'Brian. 4 vols. Chicago: University of Chicago Press, 1986–93.

Greenough, Sarah, and Juan Hamilton. *Alfred Stieglitz: Photographs and Writings.* Washington, D.C.: National Gallery of Art, 1983.

Guillory, John. *Cultural Capital: The Problem of Literary Canon Formation.* Chicago and London: University of Chicago Press, 1993.

Hess, Thomas B., and Elizabeth C. Baker, eds. *Art and Sexual Politics.* New York: Collier, 1973.

Hobbs, Robert Carleton. *Lee Krasner.* New York, London, Paris: Abbeville Press, 1993.

Hobbs, Robert Carleton, and Gail Levin. *Abstract Expressionism: The Formative Years.* Ithaca, N.Y., and London: Cornell University Press, 1978.

Hogrefe, Jeffrey. *O'Keeffe: The Life of an American Legend.* New York: Bantam Books, 1992.

Irigaray, Luce. *This Sex Which Is Not One.* Translated by Catherine Porter with Caroline Burke. Ithaca, N.Y.: Cornell University Press, 1985.

Kelly, Mary. "Re-viewing Modernist Criticism." *Screen* 22:3 (Autumn 1981): 41–62.

Kootz, Samuel M. *Modern American Painters.* New York: Brewer and Warren, 1930.

Krauss, Rosalind E. *Passages in Modern Sculpture.* Cambridge and London: MIT Press, 1977.

———. *Eva Hesse: Sculpture, 1936–1970.* London: Whitechapel Art Gallery, 1979.

———. "Stieglitz/Equivalents." *October* 11 (Winter 1979): 129–40.

———. *The Optical Unconscious.* Cambridge and London: MIT Press, 1993.

Kris, Ernst, and Otto Kurz. *Legend, Myth, and Magic in the Image of the Artist: A Historical Experiment.* New Haven and London: Yale University Press, 1979.

Landau, Ellen G. "Lee Krasner's Early Career." *Arts* (October 1981): 110–22; (November 1981): 80–89.

———. *Jackson Pollock.* New York: Harry N. Abrams, 1989.

Laplanche, J., and J.-B. Pontalis. *The Language of Psychoanalysis.* Translated by Donald Nicholson-Smith. New York: W. W. Norton, 1973.

Lee Krasner: A Retrospective. Essay by Barbara Rose. New York: Museum of Modern Art, 1983.

Lejeune, Philippe. *On Autobiography.* Minneapolis: University of Minnesota Press, 1989.

Lippard, Lucy R. "Space Embraced: Tom Doyle's Recent Sculpture." *Arts Magazine* 40:6 (April 1966): 38–43.

———. *Eva Hesse.* New York: New York University Press, 1976.

———. *From the Center: Feminist Essays on Women's Art.* New York: E. P. Dutton, 1976.

Lisle, Laurie. *Portrait of an Artist: A Biography of Georgia O'Keeffe.* Albuquerque: University of New Mexico Press, 1986.

Lowe, Sue Davidson. *Stieglitz: A Memoir/Biography.* London: Quartet/Or! Books, 1983.

Lynes, Barbara Buhler. *O'Keeffe, Stieglitz, and the Critics, 1916–1929.* Ann Arbor and London: UMI Research Press, 1989.

Makowsky, Veronica. *Susan Glaspell's Century of American Women: A Critical Interpretation of Her Work.* New York and Oxford: Oxford University Press, 1993.

Messinger, Lisa Mintz. *Georgia O'Keeffe.* New York: Thames and Hudson and The Metropolitan Museum of Art, 1988.

Morgan, Ann Lee, ed. *Dear Stieglitz, Dear Dove.* Newark: University of Delaware Press; London and Toronto: Associated University Presses, 1988.

Mulvey, Laura. *Visual and Other Pleasures.* Bloomington and Indianapolis: Indiana University Press, 1987.

Mumford, Lewis. *Findings and Keepings: Analects for an Autobiography.* New York and London: Harcourt, Brace, Jovanovich, 1975.

Nemser, Cindy. *Art Talk: Conversations with Twelve Women Artists.* New York: Scribner, 1975.

Nin, Anaïs. *D. H. Lawrence: An Unprofessional Study.* Paris: Lecram Press, 1932.

Nochlin, Linda. *Women, Art, and Power and Other Essays.* New York: Harper and Row, 1988.

Norman, Dorothy. *Alfred Stieglitz: An American Seer.* New York: Aperture Foundation, 1960.

O'Connor, Francis V., and Eugene V. Thaw, eds. *Jackson Pollock: A Catalogue Raisonné of Paintings, Drawings, and Other Works.* 4 vols. New Haven and London: Yale University Press, 1978.

O'Keeffe, Georgia. *Georgia O'Keeffe.* New York: Viking Press, 1976.

———. *Lovingly, Georgia: The Complete Correspondence of Georgia O'Keeffe and Anita Pol-litzer.* New York: Simon and Schuster, "A Touchstone Book," 1990.

Parker, Rozsika, and Griselda Pollock. *Old Mistresses: Women, Art, and Ideology.* New York: Pantheon Books, 1981.

———, eds. *Framing Feminism: Art and the Women's Movement, 1970–1985.* London: Pandora Press, 1987.

Peters, Sarah Whitaker. *Becoming O'Keeffe: The Early Years.* New York: Abbeville Press, 1991.

Pincus-Witten, Robert. "Tom Doyle: Things Patriotic and Union Blue." *Arts Magazine* 54:1 (September 1979): 142–47.

Plath, Sylvia. *Letters Home: Correspondence, 1950–1963.* Edited by Aurelia Plath. London and Boston: Faber and Faber, 1975.

———. *Collected Poems.* Edited with an introduction by Ted Hughes. London and Boston: Faber and Faber, 1981.

———. *The Journals of Sylvia Plath.* Edited by Ted Hughes and Frances McCullough. New York: Dial Press, 1982.

Pollock, Griselda. *Vision and Difference: Femininity, Feminism, and the Histories of Art.* London: Routledge, 1988.

Potter, Hugh M. *False Dawn: Paul Rosenfeld and Art in America, 1916–1949.* Ann Arbor: UMI Press for the University of New Hampshire, 1980.

Radway, Janice A. *Reading the Romance: Women, Patriarchy, and Popular Literature.* Chapel Hill and London: University of North Carolina Press, 1984.

Rathbone, Belinda. "Portrait of a Marriage: Paul Strand's Photographs of Rebecca." *J. Paul Getty Museum Journal* 17 (1989): 83–98.

Riley, Denise. *"Am I That Name?" Feminism and the Category of "Women" in History.* Minneapolis: University of Minnesota Press, 1988.

Riviere, Joan. *The Inner World and Joan Riviere: Collected Papers, 1920–1958.* London: Karnac Books, 1991.

Robinson, Roxana. *Georgia O'Keeffe: A Life.* New York: Harper and Row, 1989.

Rose, Barbara, ed. *Pollock Painting.* New York: Agrinde Publications, 1980.

Rose, Jacqueline. *Sexuality in the Field of Vision.* London: Verso, 1986.

———. *The Haunting of Sylvia Plath.* London: Virago, 1991.

Rosenfeld, Paul. "Stieglitz." *Dial* 70:4 (April 1921): 397–409.

———. *Port of New York: Essays on Fourteen American Moderns.* New York: Harcourt, Brace, 1924; reprinted 1961, University of Illinois Press, with introduction by Sherman Paul.

Seligmann, Herbert J. "A Photographer Challenges." *Nation,* February 16, 1921, 268.

Showalter, Elaine, ed. *These Modern Women: Autobiographical Essays from the Twenties.* Rev. ed. New York: The Feminist Press at the City University of New York, 1989.

Silet, Charles L. P. *The Writings of Paul Rosenfeld: An Annotated Bibliography*. New York and London: Garland Publishing, 1981.

Silverman, Kaja. *The Acoustic Mirror: The Female Voice in Psychoanalysis and Cinema*. Bloomington and Indianapolis: Indiana University Press, 1988.

Swenson, Gene R. *The Other Tradition*. Philadelphia: Institute of Contemporary Art, 1966.

Tickner, Lisa. "Feminism, Art History, and Sexual Difference." *Genders* 3 (1988): 92–128.

———. "Men's Work? Masculinity and Modernism." *Differences* 4 (Fall 1992): 1–37.

Trachtenberg, Alan, ed. *Classic Essays on Photography*. New Haven, Conn.: Leete's Island Books, 1980.

Wagner, Anne M. "Lee Krasner as L.K." *Representations* 25 (Winter 1989): 42–57.

———. "How Feminist Are Rosemarie Trockel's Objects?" *Parkett* 33 (September 1992): 60–74.

———. "Fictions: Krasner's Presence, Pollock's Absence." In *Significant Others*, edited by Whitney Chadwick and Isabelle de Courtivron. London: Thames and Hudson, 1993.

———. "Another Hesse." *October* 69 (Summer 1994): 49–84.

Wagner, Linda W., ed. *Critical Essays on Sylvia Plath*. Boston: G. K. Hall, 1984.

———. *Sylvia Plath: The Critical Heritage*. London and New York: Routledge, 1988.

Whiting, Cécile. "Figuring Marisol's Femininities." *RACAR* (*Revue d'art canadienne/ Canadian Art Review*) 17:1–2 (spring 1991): 72–90.

Index

Designer: Nola Burger
Compositor: G&S Typesetters
Text: 10.75/14.5 Deepdene
Display: Futura
Printer: Friesens
Binder: Friesens